ALL THE EMPTY PALACES

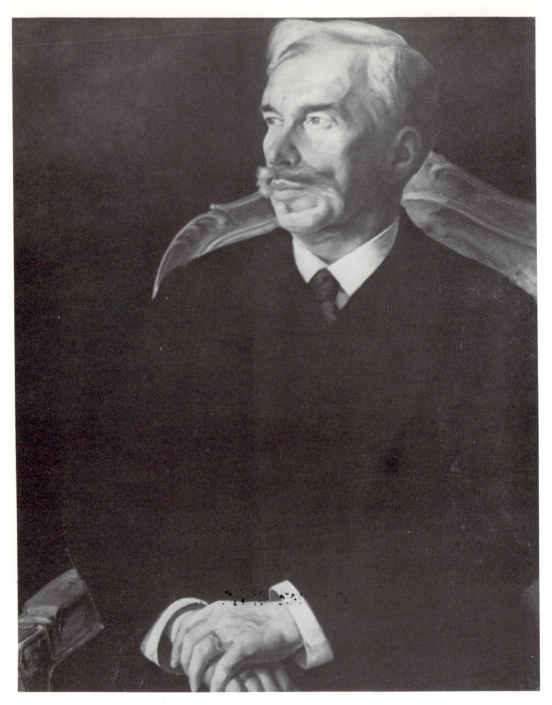

D.I. Melnikov: *Portrait of S.I. Shchukin*, 1915

ALL THE EMPTY PALACES

The Merchant Patrons of
Modern Art in Pre-Revolutionary Russia

Beverly Whitney Kean

UNIVERSE BOOKS
New York

Published in the United States of America in 1983
by Universe Books

381 Park Avenue South, New York, N.Y. 10016

© 1983 by Beverly Whitney Kean

82 83 84 85 86/10 9 8 7 6 5 4 3 2 1

Printed in Great Britain

Library of Congress Cataloging in Publication Data

Kean, Beverly Whitney.
 All the empty palaces.

 Bibliography: p. 337
 Includes index.
 1. Shchukin, Sergey Ivanovich, 1854–1936–Art
collections. 2. Morozov, Ivan Abramovich–Art
collections. 3. Art patronage–Soviet Union–History–
20th century. 4. Impressionism–(Art)–France.
 5. Post-impressionism–France. 6. Painting, French–Soviet
Union. 7. Painting, French–Influence. I. Title.
N5276.2.S5K4 1983 759.4′074′07 82–8536
ISBN 0–87663–412–9 AACR2

The rich man has wept, he who is poor has laughed,
When Kaledin sent a bullet into himself.
And the pace of the Constituent Assembly rang out.
And the empty palaces dimmed.

Velimir Khlebnikov, *Zangezi Plane VII*
Translated by Robin Milner-Gulland

CONTENTS

ILLUSTRATIONS

All reproductions of works by Pablo Picasso, Henri Matisse and Alexandre Benois as listed below are by permission of SPADEM, Paris:
© SPADEM, Paris, 1983

All reproductions of works by Marie Laurencin, Mikhail Larionov, Marc Chagall and Natalya Goncharova as listed below are by permission of ADAGP, Paris:
© ADAGP, Paris, 1983

COLOUR

Henri Matisse: *Dance*, 1909–10. The Hermitage, Leningrad. Formerly Shchukin Collection

Henri Matisse: *Music*, 1910. The Hermitage, Leningrad. Formerly Shchukin Collection

Paul Gauguin: *Self-Portrait*, 1890. The Hermitage, Leningrad. Formerly Shchukin Collection

Henri Matisse: *Girl with Tulips*, 1910. The Hermitage, Leningrad. Formerly Shchukin Collection

Kazimir Malevich: *Portrait* (gouache on paper), c.1910. The George Costakis Collection, Athens: illustrations copyrighted 1981 George Costakis. Photo courtesy The Solomon R. Guggenheim Museum, New York

Pablo Picasso: *Factory at Horta*, 1909. The Hermitage, Leningrad. Formerly Shchukin Collection

Aristarkh Lentulov: *St Basil's Cathedral, Red Square*, 1913. Tretyakov Gallery, Moscow

MONOCHROME

Frontispiece: D. I. Melnikov: *Portrait of S. I. Shchukin*, 1915. Courtesy the late Ivan Sergeyevich Shchukin, Beirut

CHAPTER 1: MOSCOW VERSUS ST PETERSBURG

Pages 11–14

Icon of St Nicholas, c.1300 (Novgorod). Photo courtesy Wide World Photos, Inc.

Icon of the Saviour of the Fiery Eye, fourteenth century (Moscow). Palace of Arms Museum, Moscow

Simon Ushakov: *Icon of the Spreading of the Tree of the State of Moscow*, 1668. Tretyakov Gallery, Moscow

Portrait of Yakov Turgenev, the Jester of Peter I, first quarter of the eighteenth century. Artist unknown. State Russian Museum, Leningrad

Rembrandt: *David's Farewell to Jonathan*, 1642. The Hermitage, Leningrad

Dmitry Levitsky: *Portrait of Yekaterina Nelidova*, 1773. State Russian Museum, Leningrad. Photo courtesy Novosti Press Agency (APN)

Vladimir Borovikovsky: *Portrait of the Grand Duchess Yelena Pavlovna, Daughter of Paul I*. Photo courtesy A La Vieille Russie, Inc., New York; Helga Photo Studio, Inc., New York

Fresco depicting a musician, eleventh century. Cathedral of Hagia Sophia, Kiev

Henri Matisse: *Music* (sketch; oil on canvas), 1907 (Summer), 29 × 24 in.

Collection, The Museum of Modern Art, New York. Gift of A. Conger Goodyear in honour of Alfred H. Barr, Jr

CHAPTER 2: HIGHLIGHTS OF ST PETERSBURG'S GOLDEN AGE

CHAPTER 3: THE GREAT MERCHANT PATRONS

Savva Mamontov's house at Abramtsevo (photograph). Courtesy Institute of Modern Russian Culture, Blue Lagoon, Texas

Ilya Repin: *Portrait of Valentin Serov in his Youth*

Viktor Vasnetsov: *Drawing of a chapel*, 1891. *Mir iskusstva*, Vol. 9, 1899

Church at Abramtsevo (photograph). Courtesy Institute of Modern Russian Culture, Blue Lagoon, Texas

Iconostasis of the church at Abramtsevo (photograph)

Viktor Vasnetsov: *The Palace of Tsar Berendey*: design for *Snegurochka*, 1885. Tretyakov Gallery, Moscow. Copyright 1979 Aurora Art Publishers, Leningrad

Viktor Vasnetsov's costume design for Frost (*Snegurochka*). Copyright 1979 Aurora Art Publishers, Leningrad

Viktor Vasnetsov: *Tsar Ivan the Terrible* (detail), 1897. Tretyakov Gallery, Moscow. Copyright 1979 Aurora Art Publishers, Leningrad

Nikolay Ryabushinsky (photograph). Courtesy Institute of Modern Russian Culture, Blue Lagoon, Texas

Pavel Kuznetsov: *Self-Portrait*, 1907. Tretyakov Gallery, Moscow. Photo courtesy *Apollo*

Interior of The Black Swan, Ryabushinsky's villa in Moscow (photograph). Courtesy Institute of Modern Russian Culture, Blue Lagoon, Texas

CHAPTER 4: THE MOROZOVS

Pages 117–20

Valentin Serov: *Portrait of Mariya Fyodorovna Morozova*, 1887. State Russian Museum, Leningrad

Savva Timofeyevich Morozov (photograph). Courtesy *Apollo*

Valentin Serov: *Portrait of Mikhail Morozov*, 1902. Tretyakov Gallery, Moscow. Photo courtesy *Apollo*

Valentin Serov: *Portrait of Ivan Morozov*, 1910. Tretyakov Gallery, Moscow. Photo courtesy *Apollo*

Henri Matisse: Triptych – *Window at Tangier*, 1912; *Zorah on the Terrace*, 1912–13; *Entrance to the Casbah*, 1912. The Hermitage, Leningrad

Pablo Picasso: *Acrobat on a Ball*, 1905. Pushkin Museum, Moscow

Pablo Picasso: *Portrait of Ambroise Vollard*, 1910. Pushkin Museum, Moscow

Paul Cézanne: *The Smoker*, 1896–98. The Hermitage, Leningrad. Formerly Morozov Collection

Paul Cézanne: *Man with a Pipe*, 1896. Pushkin Museum, Moscow. Formerly Shchukin Collection

CHAPTER 5: THE SHCHUKINS

Pages 139–42

Sergey Ivanovich Shchukin; Lidiya Shchukina; Yekaterina Sergeyevna Shchukina (photographs). Courtesy Count Rupert de Keller, Paris

Kolomenskoye Palace, completed at the end of the seventeenth century (engraving). Courtesy Society for Cultural Relations with the USSR

Pyotr Shchukin Museum, Moscow (photograph). Courtesy the late Ivan Shchukin, Beirut

Interior of room in the Pyotr Shchukin Museum, c.1895 (photograph). Courtesy Institute of Modern Russian Culture, Blue Lagoon, Texas

Private church on the Black Sea, built for the Moscow tea merchant Aleksandr Kuznetsov in the late nineteenth century (photograph). Courtesy Michael Waldy

The Shchukins in India (photograph). Courtesy the late Ivan Shchukin, Beirut

Aleksandr Ivanov: *Head of John the Baptist*. Tretyakov Gallery, Moscow

Vasily Surikov: A study for *Boyarina Morozova*, 1886. Tretyakov Gallery, Moscow

Fernand Maglin: *Townscape with a Cathedral*, 1899. The Hermitage, Leningrad

Fritz Thaulow: *Winter Landscape*. Shown in the *Mir iskusstva* exhibition of 1899

CHAPTER 6: THE PARIS SCENE

Pages 169–72

Henri Matisse: *Study for a Portrait of Sergey Shchukin*, 1912. Collection of Pierre Matisse, New York

Henri Matisse: *The Fisherman*, 1905. Formerly Museum of Modern Western Art, Moscow

Henri Matisse: *Marguerite*, 1906–07. Picasso Collection, Paris

Marie Laurencin: *Group of Artists*, 1908. Baltimore Museum of Art, Baltimore, Maryland. Cone Collection

Charles Guérin: *Lady with a Rose*, 1901. The Hermitage, Leningrad

Pablo Picasso: *After the Ball*, 1908. The Hermitage, Leningrad

Henri Matisse: *Arab Café*, 1912–13. The Hermitage, Leningrad

Pablo Picasso: *Violin and Guitar*, 1913. The Hermitage, Leningrad

CHAPTER 7: SHCHUKIN'S COLLECTION

Pages 185–92

Henri Matisse: *Joy of Life*, 1905–06. The Barnes Foundation, Merion Station, Pennsylvania; photograph copyright 1983 by the Barnes Foundation

Henri Matisse: *Game of Bowls*, 1908. The Hermitage, Leningrad

Henri Matisse: *Nymph and Satyr*, 1909. The Hermitage, Leningrad

Henri Matisse: *Bather* (oil on canvas), 1909 (Summer), $36\frac{1}{2} \times 29\frac{1}{8}$ in. Collection, The Museum of Modern Art, New York. Gift of Abby Aldrich Rockefeller

Henri Matisse: *Dance* (Composition No. I) (watercolour), 1909. Pushkin Museum, Moscow

Henri Matisse: *Dance* (first version), 1909 (early), oil on canvas, $102\frac{1}{2} \times 153\frac{1}{2}$ in. Collection, The Museum of Modern Art, New York. Gift of Nelson A. Rockefeller in honour of Alfred H. Barr, Jr

Henri Matisse: *Dance* (Composition No. II) (watercolour), 1909. Pushkin Museum, Moscow

Henri Matisse: *Music* (early sketch), 1910. Pushkin Museum, Moscow

Henri Matisse: *Music* (second study), 1910. Pushkin Museum, Moscow

Henri Matisse: *Still Life with the Dance*, 1909. The Hermitage, Leningrad

Henri Matisse: *Nasturtiums and the Dance*, 1912. The Hermitage, Leningrad

Pablo Picasso: *Nude with Drapery (Dance of the Veils)*, 1907. The Hermitage, Leningrad

Pablo Picasso: *Three Women*, 1908. The Hermitage, Leningrad

Interior of the Trubetskoy Palace (photograph). Courtesy the late Ivan Shchukin, Beirut

Matisse Room at the Trubetskoy Palace (photographs). Courtesy Count Rupert de Keller, Paris

CHAPTER 8: OPEN HOUSE

Pages 221–28

Courtyard and dining room of the Trubetskoy Palace (photographs). Courtesy Count Rupert de Keller, Paris

Mikhail Larionov: *Bare Feet and Foliage*, 1905. Private collection, Paris

Mikhail Larionov: *Horses on a Hill*, 1907. Private collection, Paris

Claude Monet: *Rocks of Belle-Île*, 1886. The Hermitage, Leningrad

Mikhail Larionov: *Sunset on the Black Sea*, 1902. The Hermitage, Leningrad

First page of an article about Matisse in the *Mirror*, Moscow, 1911. Courtesy the late Ivan Shchukin, Beirut

First page of a letter from Shchukin to Matisse, August 22, 1912. Courtesy Pierre Matisse

ACKNOWLEDGMENTS

One of the unexpected rewards in writing this book was the encounter with eminent and dedicated figures who extended as much interest and concern to a newcomer as they would have to an old and valued colleague.

My gratitude goes to several leaders in the field: the late Dr Alfred H. Barr, Jr, who provided initial encouragement and original material; Professor John E. Bowlt, whose formidable criteria are equalled by a passionate interest in his subject; and John Rewald for the time he took from his own book to supply counsel and valuable documents.

Others to whom I am particularly indebted include Mme Marguerite Duthuit who, in one memorable afternoon in Paris opened a reservoir of remembrances; Daniel-Henry Kahnweiler, a historic figure in the annals of twentieth-century art, who found a new project interesting and supplied fresh information; Pierre Matisse for his invaluable contribution; and Dr Sergius Yakobson, head of the Slavonic Division of the Library of Congress, whose family ties to the merchant community of Old Russia created insights both personal and intellectual. Michael Waldy's unceasing interest and support supplemented his experiences with Shchukin and Morozov and life in Moscow before 1917.

Count Rupert de Keller, despite a desire for privacy, furnished family pictures and recollections; Herman de Keller's hand-written reminiscences were a treasure. I am deeply grateful to both; also to Countess Irene de Keller, daughter of Sergey Shchukin, and Count Boris de Keller, for their description of the collector's life in Paris after the Revolution.

Mme Irina Kuznetsova, Curator of European Painting in the Pushkin Museum, Moscow, was very generous, as was George Costakis. My thanks to Michael Hodson for his guidance and meticulous concern with the early stages of the book. Dr George Z. F. Bereday, valuable friend, deserves particular mention as critic and mentor. Warmest acknowledgments are due to Adair Russell for her constant help and advice, and Susan Summer for cooperation beyond the norm.

To Antony Wood, an editor whose standards and knowledge of Russian culture made a traditionally difficult process stimulating and instructive, my deepest appreciation.

A special place is reserved for the memory of Ivan Shchukin, the son of Sergey Ivanovich. Brilliant, informative, enlightening, he made a generous gift of time.

Finally, my thanks to all those valued friends who, over a protracted period, never counselled moderation.

Transliteration from the Cyrillic

Whilst every effort has been made to follow a consistent system, I have chosen to retain spellings of certain names which have become well established in the West even though they are not in accordance with the policy of transliteration generally adopted in this book.

PREFACE

In Moscow at the turn of the century, there appeared a short-lived phenomenon, a new aristocracy, the merchants of the time. Bankers, industrialists, textile manufacturers, importers, builders of railroads, they were in many cases the sons and grandsons of peasants – even serfs. In a country emerging from the isolation and inertia of centuries, the concept of industrialization, modernization and expanding trade was becoming a reality, and these men evolved out of the economic and social needs of the period. The merchants would not be worth remembering if they had been merely the newly rich of their era. They lasted for less than three generations and were swept away, but their energy was so fierce, their appetites so insatiable, and their vision so extravagant, that they left an indelible mark on the art and culture of Russia.

The influence of this group was evident in every area of the arts: theatre, opera, ballet and painting. Their support was not merely passive or financial; at best they participated actively, innovatively – opened museums and libraries, produced operas, financed art journals such as *Mir iskusstva*, influenced the Ballets Russes and created the Moscow Art Theatre. Above all, they collected paintings.

In the great house at Number Eight, Bolshoy Znamensky Pereulok lived one of the most extraordinary members of this group. In 1918, a seal personally signed by Lenin was placed on the door nationalizing the contents of the house and thereby recognizing that what had been accumulated here was an invaluable national resource. This was the home of Sergey Ivanovich Shchukin, a wealthy merchant and collector non pareil, who within two decades assembled the most important single collection of modern Western art in existence today. Together with the paintings owned by his friend Ivan Morozov, these works comprise the celebrated group of Impressionist and Post-Impressionist paintings now on view at the Hermitage in Leningrad and the Pushkin Museum in Moscow. Of the two collections, Shchukin's was by far the more daring and exerted incomparably greater influence on the Russian artists of the day. However, the miracle is that

both were assembled in Russia at a time when critical and public reaction to this new art in France and elsewhere was hostile and even violent.

For the first forty-three years of his life, Shchukin's priorities were fixed. He remained more merchant than aesthete, and with his shrewdness and drive built one of the greatest textile empires in Russia. He lived through the critical political and artistic revolutions of the early twentieth century and was intimately affected by both. It was due to his brilliance and foresight that the Trubetskoy Palace in Moscow eventually became known as the 'Museum of Matisse and Picasso'.

In order to understand the presence of these paintings in Russia it is necessary to see the collector within the society which produced him and the times which shaped him. Throughout history, art in Russia has been linked more closely to the political process than in most other lands. In the earliest days when the interests of Church and State were inseparable, great cathedrals were erected to commemorate victory in battle, and historical icons sanctified the policies of the rulers. The first easel art, the art of the court, symbolized the Western orientation of St Petersburg, and was answered by the nationalism and populism of Moscow. Each major artistic phase was an extension of political and economic events.

A vital element in this process was the emergence of the merchant-industrialist. Through him, the artists of Russia were exposed to the most important works of the Western avant-garde. Hilton Kramer (*New York Times*, January 22, 1978) called Cubism 'the Finland station, the point of crucial departure' for the art of the Revolution. When Shchukin opened his home to the public in Moscow he introduced Cubism into Russia and thereby catalyzed an explosion of radical art which epitomized the first two decades of the twentieth century in his country.

In 1917, after the Revolution, when Shchukin's business was evaluated at thirty million rubles, he was to remark, 'I didn't know I was so rich.' His real wealth, however, measured by today's standards, was the gift of insight which enabled him to see fifty years ahead of his time, to amass a collection which would influence the course of Russian art, and to leave in his country a legacy which would become a priceless national treasure.

I

MOSCOW VERSUS ST PETERSBURG: HISTORY OF A SCHISM

They be nowe called Russyans, Moscouites, and Tartariens.

Sir Thomas Elyot (1538)

The artistic explosion which took place in Russia at the turn of the century was the culmination of years of rivalry between two sources of power within the country, Moscow versus St Petersburg, Slavophile versus Occidentalist. The classifications serve to identify the protagonists in uncomplicated terms, and for over two hundred years this division permeated every area of national life: philosophy, history, government and the arts.

In the fifteenth century, Moscow was the heart of Old Russia, the embodiment of its ancient legends, home of the Tsars and the Church, the symbol of political power. This hegemony endured until the accession of Peter I to the throne in 1682, when the subsequent dominance of St Petersburg shifted the gravitational centre of the country, divided loyalties and created a giant national schism. There ensued an ideological battle between the two cities which, in time, resulted in two distinct and mutually antagonistic schools of art. The struggle for aesthetic ascendancy was resolved when the merchant patrons, in the fifty years preceding the Revolution, brought about the final renaissance of Moscow as the wellspring of modern Russian painting. Their lives and accomplishments are the main subject of this book.

The story of the nineteenth-century Moscow merchants and their role in the world of the arts is not merely a chronicle of their day, but reflects forces contending for supremacy throughout the country's history: nationalism or Westernization, Orthodox traditionalism versus the thirst for technology. A

broad outline of these warring influences which shaped Russian cultural taste
may serve to illuminate the circumstances that prepared the new Russian
bourgeoisie to accept the 'bizarre exaggerations' of Van Gogh, Gauguin, Matisse
and Picasso.

Before Peter, the Church dominated Russian art, and the cathedrals, icons,
frescoes and mosaics of Moscow were the supreme form of artistic expression.
When European standards prevailed in the new capital under Peter, church
influence was diminished, the icons of Moscow gave way to easel painting, the
sacred images of the ancient tsars yielded to the Western masterpieces acquired
by Catherine II. The establishment of the St Petersburg Academy of Art placed
the official stamp of approval on European criteria.

In 1870 the young artists of Moscow rebelled against the Western touchstone
by founding the Peredvizhniki (Wanderers), a deeply nationalist group of
painters whose style became immensely popular throughout Russia and brought
about the old city's revival as a vital source of art. St Petersburg's last attempt to
shape Russian taste was exemplified by Sergey Diaghilev's *Mir iskusstva* (*World
of Art*), a journal which from 1898 to 1904 reasserted the Petrine preference for
Western art without embracing its most radical manifestations.

Moscow's final resurgence occurred at the beginning of the twentieth century
with the impetus provided by a powerful group of industrialists and traders. A
few among them were the first to recognize that Impressionism signalled the
beginning of a new era in art. Because of their perception, the city was opened to
the most extreme examples of contemporary painting, and Moscow, up to and
through the early revolutionary period, became the scene of an eruption of
avant-garde experimentalism which established it firmly as the locus of modern
Russian art.

When Moscow became the custodian of the national tradition in the fifteenth
century, her art was a compendium of influences: a Byzantine foundation
modified by the characteristics of three ancient city-states, the grandeur of Kiev,
the grace of Vladimir-Suzdal and the stately reserve of Novgorod. To these she
added her own imprint: the violence of her early history, the aggressive energy
which characterized her rulers and her people and, above all, the deep religious
mysticism which had been implanted by centuries of church dominance.

The coming of Christianity in the tenth century was the occasion for the first
coherent form of architectural expression within the country. In Kiev, the
birthplace of Russian civilization before Moscow existed, the Cathedral of the
Assumption, a cruciform structure built in 989, was the beginning of a
spectacular line of edifices which served as a proclamation of the new faith.
Though now it is known only through excavated fragments, it is still possible to
envisage the marble pillars, the rich mosaics and frescoes which decorated the
walls and floors. This church was particularly important as a training ground for

Russian artisans; local ignorance of stone construction necessitated the importation of Greek builders, and the style was reminiscent of Byzantium. However, the Hagia Sophia begun in Kiev in 1037 was a revelation of the Russian genius for architecture. It changed the face of the Kievan landscape; the thirteen domes symbolizing Christ and the apostles, which rose out of the flat countryside, were distinct from any Byzantine design. It was the first of many instances of the Russian ability to absorb and transform outside influences. The interior housed the earliest forms of pictorial expression in Russia. The tessellated image of Christ Pantocrator lined the dome like a benediction, the full-length, painstakingly inlaid depictions of the saints, the luminous colours, the occasional glimmer of a gold cube, and above all the direct and sombre gaze of the faces – all proclaimed a public art, compelling and immediate.

The Kievan contribution to Moscow is the stately and imposing presence of the first official architecture, the deliberate grandeur which represents the political unity and power of Church and State.

In the lesser known principality of Vladimir-Suzdal, art had a different aspect and function. Situated approximately one hundred and fifty miles east of what would become Moscow, this state, which flourished briefly between 1150 and 1250, produced an art remarkable for its delicacy and tenderness. Where the cathedrals of Kiev had been the art of the government, 'monumental and frontal',[1] this was the art of the aristocracy, distinguished by the extravagant loveliness and comparative intimacy of its architecture and icons. It was the beginning of the palace church in Russia. The damascene work on the doors, a lavish use of gold to highlight decorative details, the silver and gold candelabra and gold frames which enclosed the icons, imparted a sense of richness and harmony. Those icons that remain reveal the same preoccupation with form and grace that distinguishes the architecture; they are touched with a humanity, an expressiveness uncharacteristic of the period. The icon of the *Virgin Orans* from the twelfth century, one of the few surviving masterpieces, is the embodiment of compassion.

Though the area was heavily forested, the churches were of white sandstone. Ecclesiastical doctrine proscribed figural sculpture, but the princes, remote from the metropolitans of Kiev, managed to escape their scrutiny, and the structures were remarkable for their exterior carvings, from the discreet geometrical patterns of the early period to the later high-relief representations of saints in the style of Byzantium and the West, and a dense array of winged lions, griffins and other mythical creatures with Scythian overtones. During the short span of its existence, the builders of this community blended the features of Byzantine and Romanesque architecture to achieve an identifiable Russian style. When Ivan III ordered the Cathedral of the Assumption to be built in Moscow in the fifteenth century, he instructed his Italian architect Rodolfo Fioravanti – dubbed

'Aristotle' by the Russians – to use as his inspiration the Cathedral of the Assumption built in Vladimir three hundred years earlier.

Novgorod, the last major influence from the past on the art of Moscow, was in effect a republic with an elective process which chose the sovereign from among the princely families. Never a warrior state, the city's survival was based on commerce, and the wealthy traders were the true source of power. As it became an increasingly vital economic centre, Novgorod negotiated treaties with neighbouring states to defend its security and successfully repulsed several incursions from Moscow. A comparatively high proportion of the population was literate, and to satisfy the need, a series of imaginatively illuminated manuscripts was produced, and scientific and religious works were illustrated profusely. Here, in a sense, was the first merchant art of Russia, for increasingly this group was responsible for the security, economic health and cultural dynamism of the community.

The pronounced austerity of the early icons is emphasized by the deliberate elongation of the figures. These powerful and forbidding images give little promise of a merciful judgment, and in many, the extreme stylization approaches the distortion of the twentieth century. The Novgorodians were unique also for the skill with which they created their historical icons. Limned on a small surface were great scenes of battle, horses, archers, soldiers, flying standards and avenging angels. The balance and delicacy with which the artists assembled their scenes and placed the figures to re-create an epic moment in miniature has seldom been equalled.

Moscow inherited from Novgorod the memory of secular participation in the arts, of merchant involvement in aesthetic life. The Old Testament severity of the icons, the symmetry and jewel-like colours were typical of the Novgorodian school. The introduction of the iconostasis and the first historical painting stemmed from this richly productive society. Above all, the simplicity and scale of Novgorod's architecture are memorable. The Hagia Sophia Cathedral, completed in the eleventh century, has neither the royal overtones of the contemporary Kiev Cathedral nor the opulent decoration of the churches of Vladimir-Suzdal. Novgorod saw the beginning of the typically Russian onion domes which replaced the flatter shapes of Byzantium; the great gleaming crosses atop these rounded shapes, the irregular placement of the domes, the soaring, unadorned vertical lines of the drums supporting the spheres, all are typical of this classical period of Russian architecture.

Moscow assimilated these earlier traditions, but it added to them the spirit of its own past. It was a military state, dominated by a succession of militant and acquisitive rulers who ceaselessly expanded their domain through conquest or purchase.

In the fourteenth century, the metropolitans of the Church settled in Moscow,

and following the fall of Constantinople in 1453, Moscow became the seat of political power, the centre of the Orthodox Church in Russia. The erection of the great cathedrals in the fifteenth century reflected the influence which had accrued to this dynamic principality since its founding three hundred years earlier. The rulers in the Kremlin used this ecclesiastical presence to consolidate and expand their leadership, and the city was now regarded by many Russians as the 'third Rome', successor to Byzantium, guardian of the true faith. Since the only Russian art at that time was religious, Moscow was a natural repository for the artistic heritage of old Russia.

A blend of theology and militarism permeated every area of Moscow's art. Still to be seen in the Kremlin museums, the splendidly barbaric artefacts of the old city are witness to the turbulence of her history: maces with bulbs of crystal and blades of steel, hand-made chain-mail shirts, a child's suit of armour, seventeenth-century guns lovingly inlaid with mother-of-pearl. The early icons were in the same harsh tradition, celebrating massive victories and the immolation of the enemy. The superb Byzantine *Saviour of the Fiery Eye*, commissioned for Moscow in the fourteenth century, is a spectacular example of Moscow's taste. Everything moves in this work: the series of swirling lines etched into the forehead and curving around deep-set eyes, the broad sweep of the cheek-bones, the long rectilinear lines of the nose, ending abruptly in a small, puckered mouth. The extreme distortion produces an image of implacability. As Moscow absorbed the styles developed in the surrounding cultures, a gentler nuance was imparted. When the renowned religious painter Theophanes the Greek left Novgorod and settled in Moscow around 1400, he extended the boundaries of church art and brought with him a sense of freedom and grace which was a revelation to the Muscovites. Another great painter of icons, Andrey Rublyov, without copying the Greek master, moved even further from the rigid Moscow style. The intense spirituality of his work was expressed simply, without superfluous adornment. Thus the original force of Moscow art ripened and developed with the absorption of the surrounding cultures.

In the last half of the seventeenth century, iconic art began to move away imperceptibly from exclusively sacred representations. In addition to the heroic leaders and warrior saints such as Aleksandr Nevsky and the martyred brothers Boris and Gleb, who had been canonized, there was an increasing trend toward the representation of political figures, tsars and court members. The most significant indication of this tendency was the *Tree of the Moscow State* (1668) painted by Simon Ushakov, a serf artist in the Kremlin workshop. In this icon, the image of the Vladimir Madonna is at the centre of the tree and the surrounding branches hold the likenesses of twenty of Russia's earliest rulers. The political symbols placed so carefully throughout this work reaffirm the bond between Church and State. Ushakov was one of the first to sign his work, an act

which presaged the emergence of the individual painter and the decline of the collective.

The new workshops of the Stroganovs renewed a demand for iconic art, but although they excelled in technical skill, the purity and force of the early works had been lost. Temporal art was still hobbled, the court was rich and splendid, but the tradition of secular painting was largely unknown and the royal commissions so common to Europe were non-existent in the old capital.

The variety of Moscow's ancient architecture is startling. Like a giant palimpsest, each succeeding stage of the city's history is memorialized by a great structure. Always the glory of the ruler found expression in the Church; Boris Godunov's bell-tower of Ivan Veliky, topped by its giant golden dome, rises over all other edifices in the Kremlin. The lack of coherence echoes the divisions that permeated political and religious life. The ancient tent-shaped church, for example, is a reminder of the seventeenth-century schism which pitted the Raskolniki (Old Believers) against the advocates of church reform who considered the domed structures to be the only permissible expression of the faith.[2] The conflict between East and West, between tradition and reform, was always present. There were no overtly foreign buildings; alien models were resisted by the prelates. The Italian architects who had been brought in by the princes for the glorification of the Church created their cathedrals according to Russian taste. European styles were modified; a feeling for the Renaissance imparted by an Italian builder, or the Baroque brought back from Poland, were absorbed and somehow changed by the Russian ambience. The word Kremlin means citadel, and its walls enclosed a population steeped in the legends and cruelties of a despotic court, of Simeon the Proud, Basil the Blind and Ivan the Terrible. The vast physical expanse of the land, its remoteness from Western Europe, the memory of two centuries of Tatar incursions, all these factors contributed to a deep suspicion of outsiders. As a result, the art of Old Russia fed on itself.

Despite the cultural isolation of early Moscow, the city was a centre of commerce. A strategic location between the Oka and Upper Volga rivers contributed to the growth of the community, and trade had always been a path by which the stranger might enter Russia. As merchant vessels anchored outside the walls and caravans from Asia and Persia converged on the market square an awareness of foreign customs was gradually introduced. Wariness and insularity were woven into the national character, however, and when merchants from Holland, Britain and Germany arrived in Russia, they were forbidden to circulate freely within the country. The Russian Orthodox Church, fearing subversive Roman influence and a corruption of its ritual, was particularly hostile to foreigners, and intimate contacts between Russians and visitors were discouraged. In 1652 Westerners were relegated to a single area outside Moscow

in which they were required to live, and with the creation of this 'German suburb' the Church helped to bring about what it feared most. Rather than scattering throughout the country, the foreigners were ghettoized, their tastes, traditions and customs preserved intact, and it became fashionable for influential Russians to visit the enclave. The various languages and styles were adopted by many of the nobles, and it was here that Peter the Great developed his preoccupation with the West.

When Peter I imposed his obsession with Western standards and technology on this medieval society, he rejected Moscow as a stronghold of reaction, a symbol of the dark primitivism which he feared would condemn Russia to live forever in antiquity. In 1703 he began the construction of his new capital in the north, importing European planners to realize a dream of a classical Western city seen through a Byzantine glass, subtly touched and altered by its setting, and by the Russian appetite for size and grandeur. European concepts were lifted whole and undigested and set down in the midst of an alien landscape. Under Peter, a society which had continued unchanged for centuries was torn apart, an obsolete cultural and educational system was restructured and the benefits of science and industrialization were introduced into the country.

A special class of Western-educated bureaucrats was created to govern Russia, a set of resident-aliens who had little in common with the Slavic traditions which informed the great mass of their countrymen. Moscow became a political back-water. In 1714 the Senate moved to St Petersburg, and four years later the ministries settled in the new capital. The old city lapsed into somnolence and disrepair, a museum in which were stored artefacts and memories. The Tsar's new metropolis was designed to represent the end of isolation and the eclipse of Moscow. It also created the socio-cultural division which endured into the twentieth century.

Peter's aesthetic interests were mainly architectural; the accomplishments of the Western architects and landscapists imported during his reign are legendary. Yet he was the first Russian ruler to encourage secular art, though he valued painting mainly as a political weapon. To be immortalized by the greatest artists of his time was an act of State which served to enhance his role in history. But there are instances of a broader awareness. During his rule, Russia acquired one of the most mysterious Rembrandts now in the Hermitage: *David's Farewell to Jonathan* (1642). He commissioned the engravers Adriaen Schoonebeck and Pierre Picart to reproduce pictorially his ships and his cities, and his emissaries throughout Europe were empowered to purchase freely hundreds of Western works of art. In addition to Rembrandt, Peter was said to admire Van Dyck and Rubens. Seascapes were a great favourite as well as Gobelin tapestries, and antique statues were placed in his gardens. Peter's edict ordering the preservation of archaeological discoveries of ancient Russian art was responsible for the magnificent cache of Scythian objects, pre-historic amulets and decorations,

and highly stylized representations of birds and animals entwined, which today is still one of the most memorable features of the Hermitage collection. According to Pierre Descargues, the Tsar also 'tried to acquire the *"Last Judgment"* altarpiece from the Marienkirche in Danzig'.[3] When Peter and his wife Catherine I visited Western Europe they sat for Jean-Marc Nattier in Amsterdam in 1715, and these portraits are now in the Hermitage.

The monarch had attempted earlier to persuade Nattier to come to Russia, but when he was unsuccessful he settled for a lesser artist, Louis Caravaque, who arrived in St Petersburg in 1715. From that time on a swarm of Italian, French, Dutch, English and German artists worked for the Imperial Court.[4] They painted the nobles, royal favourites, military figures and ministers and taught the earliest Russian painters to work in the Western manner.[5] The aristocracy finally accepted non-religious art. As enormous palaces were built throughout the country, a desire for wall decorations and social prestige resulted in a body of remarkably skilful portraits commissioned from unknown local artists or gifted serfs. Before Peter's time, easel art was unknown, and when the Tsar rejected the old iconic emblems, he liberated Russia's painters.

The tradition of the great Russian art collector did not begin, however, until thirty-seven years after his death, when Catherine II, who reigned from 1762 to 1796, inherited and extended his goals. Under Catherine, Russian as well as European architects submitted designs for the beautification of the capital. The European baroque creations of Bartolomeo Rastrelli were augmented by Giacomo Quarenghi, and by a new generation of native architects which included Vasily Petrovich Stasov, Vasily Ivanovich Bazhenov, and Ivan Yegorovich Starov. Catherine's taste emphasized the neo-classical style exemplified by Quarenghi's Aleksandrovsky Palace, a design of remarkable delicacy and purity; the occasional naïveté and excess of the earlier period was absent. St Petersburg had become a city of rare harmony, of palatial private residences and cathedrals, of great squares connected by broad boulevards and majestic colonnaded public buildings.

> Tall towers and graceful palaces
> Jostle on the teeming banks;
> From every corner of the earth
> Ships hasten to the wealthy quaysides;
> The Neva is arrayed in granite,
> Over her waters bridges hang,
> Emerald gardens deck her islands.
> Before the younger capital
> Moscow loses all her lustre,
> As the dowager in purple
> Before the new-proclaimed tsaritsa.[6]

Like Peter, Catherine was simultaneously generous and despotic. With the gift of a crown estate to a favourite, she could turn an entire population into serfs, yet her correspondence with Voltaire had the warmth and idolatry of a schoolgirl. Although she would not hesitate to imprison or execute a dissident writer within her own country, she deeply desired recognition within Western intellectual circles as a humane and progressive ruler. Her relationship with Diderot was a curiosity, the absolute Empress and the rational encyclopaedist. It was Diderot who suggested Falconet to execute the famed equestrian bronze of Peter and who kept her informed about the important works of art which might become available in Paris. When he was in need, and contemplated selling his vast library, Catherine purchased the collection, placed him in charge with a fifty-year retainer, and with this gesture, secured her position as doyenne of the patrons of the French left. However, at the outbreak of the French Revolution when she became disenchanted with liberal theories, she ended the flirtation and reverted to an absolutism worthy of the ancient tsars. But her infatuation with the arts never ended.

In 1776, when this monarch composed her own obituary, she listed her virtues: 'indulgent, easy-going, republican in spirit ... liked work, loved society and delighted in the arts.'[7] This benevolent self-appraisal was accurate in at least one particular. The Rembrandts, Titians, Hals and Cranachs now in the Hermitage are evidence of her discernment and appetite.

Her agents in Europe were shrewd and knowledgeable: Prince Golitsyn, Baron Friedrich Melchior von Grimm, and Diderot were among the most successful. She frequently bought entire collections at one time. Tiepolo's *Maecenas Presenting the Arts to Augustus* (c.1743) had been acquired by Count Heinrich von Brühl who had been Chancellor to Augustus III, Elector of Saxony and King of Poland. When the Empress was informed in 1769, after his death, that the von Brühl estate was heavily in debt, she empowered the Russian minister in Dresden to purchase its entire collection of paintings. In addition to the Tiepolo, there were among the more important works four Rembrandts, five Rubens and two Watteaus. Her ministers and envoys were instructed to keep her advised of the important sales, and of the personal crises which might lead to major acquisitions. In 1774 she purchased *A Family Group* (1620–21) by Anthony Van Dyck and Velasquez's *The Repast* (1618). Rembrandt's *Saskia as Flora* (1635) was in the Hermitage a year later in 1775. Count Coblentz, the Austrian Minister, was the source of five important works by Rubens and approximately six thousand drawings.

One of Catherine's greatest triumphs was the private purchase in 1771 of the rich assortment of paintings which had been amassed by the French collector Pierre Crozat. After his death the collection had been expanded by his heirs, in particular Louis Antoine, Baron de Thiers. When the Baron died in 1770, the

Paris art world expected a sensational sale, but with the help of Falconet and after extensive private negotiations by Diderot, it was announced that the paintings would leave the country for Russia. Despite an outcry by the French public, the ship carrying the rare cargo sailed from the port of Paris in May and arrived in St Petersburg in November, and the crates were unloaded on the Neva docks near the Hermitage. As a result of this episode, Russia acquired four Veroneses including *Dead Christ with the Virgin Mary and an Angel* (1580), Louis Le Nain's *A Visit to the Grandmother* (1640s), a historic assortment of Rubenses, Poussins, Watteaus, Van Dycks, a Raphael and a Tintoretto.

Catherine's age also saw the emergence of Russian court painters who distinguished themselves for the skill with which they adapted to the Western ideal. The most prominent of these was Dmitry Grigorevich Levitsky, whose pearly, idealized court beauties in their crackling, gleaming taffetas were reminiscent of Watteau. During the eighties and nineties, Levitsky painted several portraits of the Empress, one of which, *Portrait of Catherine the Great as Lawmaker* (c.1783), is a marvel of skilful deference and a deification of royal majesty. But upon occasion, he could dissect, wickedly and impudently, a pink-faced aristocrat in his cups. Levitsky's portrait of Diderot, painted in 1773, pleased that sophisticated and demanding savant to such an extent that he purchased it and took it back with him to France. It was unusual for its naturalism and an early instance of concern with character in Russian art.

Like Levitsky, his pupil V.L. Borovikovsky was born in the Ukraine; neither travelled abroad, yet each possessed the ability to invest his portraits with a sophisticated virtuosity which was a reminder of Romney or Gainsborough. Borovikovsky's *Portrait of Catherine II Walking in Tsarskoye Selo* (c.1794), painted near the end of the Empress's life, catches the debilitating mutations of old age. It is an interesting contrast to the imperial Catherine of Levitsky which had been painted only eleven years earlier.

It has been said that 'The Russian artists of the eighteenth century possessed both knowledge and technical skill, but they lacked imagination and freedom.'[8] Yet when one remembers that at that time, secular painting in Russia had been in existence for less than a century, their facility is amazing. In addition, though foreign artists and court favourites were well treated, the majority of Russian painters in this era worked under miserable conditions. In an effort to emulate the court, the gentry had trained its own artists, and these men were frequently servants or serfs. Between their menial tasks, they painted, and if the results were displeasing, the punishment could be swift and bitter. Serfs were chattels which could be sold, beaten or lost in a wager. Despite the hardships, the native artists displayed aptitude and skill and many attained the level of their foreign instructors. Since the teachers were European, their art conformed to the

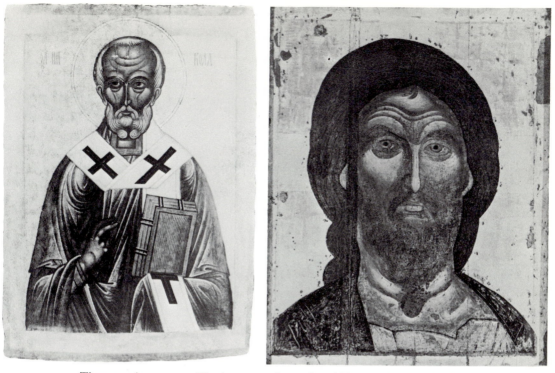

These two icons exemplify the contrasting styles of Novgorod and early Moscow
Above left: Icon of St Nicholas, c.1300 (Novgorod)
Above right: Icon of the Saviour of the Fiery Eye, fourteenth century (Moscow).
Palace of Arms Museum, Moscow
Below: Simon Ushakov: *Icon of the Spreading of the Tree of the State of Moscow*, 1668.
Tretyakov Gallery, Moscow. The politicization of the icon was a significant development
in the history of Russian art

ꙗКОВЪ : ТꙊРꙀГЄНЄВЪ :

*Portrait of Yakov Turgenev,
the Jester of Peter I*, first quarter
of the eighteenth century.
Artist unknown. State Russian Museum,
Leningrad. A somewhat iconic example
of the earliest easel art in Russia
during the reign of Peter I

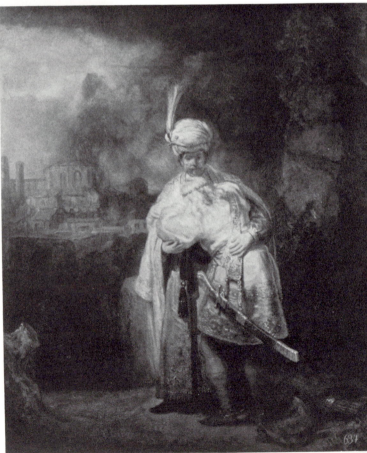

Rembrandt:
David's Farewell to Jonathan, 1642.
The Hermitage, Leningrad.
Purchased during the reign
of Peter I: his most notable
acquisition

Two Russian court painters
in the Western style.
Both were favoured by Catherine II

Right: Dmitry Levitsky:
Portrait of Yekaterina Nelidova, 1773.
State Russian Museum, Leningrad

Below: Vladimir Borovikovsky:
Portrait of the Daughter of Paul I.
A La Vieille Russie, Inc., New York

Fresco depicting a musician,
eleventh century. Cathedral
of Hagia Sophia, Kiev

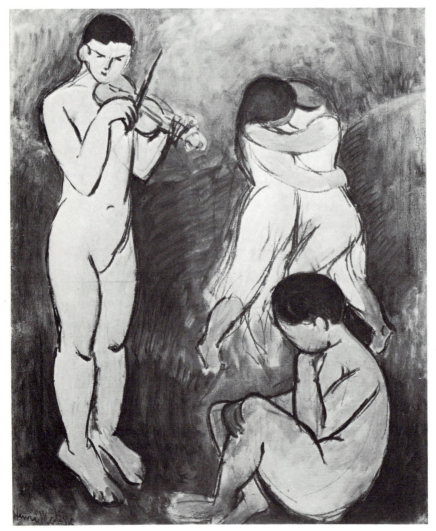

Henri Matisse:
Music (sketch), 1907.
Collection, The Museum of
Modern Art, New York.
Gift of A. Conger Goodyea
in honour of Alfred H.
Barr, Jr. The stylized art
of ancient Russia was
closer to the School
of Paris than to
the Wanderers

Western mould. A painter-serf who attained recognition during Elizabeth's reign in the eighteenth century was Ivan Petrovich Argunov who belonged to the household of Count Boris Sheremetev. He was sent to study painting with George Grooth in St Petersburg and absorbed the techiques of the popular portraitist. The play of light on a satin sleeve, the softness and texture of fur, the soft fall of a chiffon scarf, all the trappings of wealth were skilfully reproduced. Several of his works were enlivened by an evocation of personality, rare for the period. His painting of the Countess Sheremeteva, the wife of his patron, was considered by Diaghilev to be one of the best productions of eighteenth-century Russian painting. Argunov was never really free to work as he wished, however, for he had been placed in charge of the Count's museum purchases and increasingly, his time was taken up with these duties. Later, another serf, Mikhail Shibanov, owned by Prince Grigory Aleksandrovich Potyomkin-Tavrichesky, painted a bravura portrait of Catherine II in a fur hat.[9] In Russia at this time, art was the exclusive domain of the court, the nobles and the landed gentry, totally removed from the great mass of the people.

The St Petersburg Academy of Art was founded in 1757, during the reign of Elizabeth, daughter of Peter the Great. It was built by Vallin de la Mothe who worked on the project with his cousin Jacques François Blondel, and a Russian architect, Aleksandr Filippovich Kokorinov. The Imperial Academy was reorganized by Catherine II in 1763, a year after her accession to the throne, and it attained the peak of its influence during her reign.

In 1766, the Empress commissioned from Jean-Baptiste Chardin the painting *The Attributes of the Arts*. A cool, carefully structured, supremely organized work, somewhat Flemish in feeling and colour, it represented the Academic ideal. The first exhibition of paintings at the institution was held in 1770.

Vallin de la Mothe, who later taught architecture at the Academy, was an exponent of the neo-classical style of which Catherine also approved, and his design was appropriate to the new centre of cultural power in St Petersburg. An enormous edifice, square and imposing, with an aura of Louis XV grandeur, it was situated on the bank of the Neva, with a landing on the river guarded by two great stone sphinxes from Thebes. The stateliness reflected the authority of a conservative artistic establishment. The faculty was composed of foreign artists and Russian epigones, and the halls were filled with students drawn from all over Russia. Many dreamed of becoming the next Levitsky, Borovikovsky or Rokotov.[10] Nothing from Russian art was permitted to intrude; the models were Watteau and Fragonard.

The Academy's Gold Medal, one of the highest honours, was accompanied by a grant to study abroad. Those who successfully completed their training hoped to receive private commissions, to paint wealthy and prominent clients, to teach, or to enter government service. The entire future life of the aspiring artist was

dependent on this institution. The condition exacted was that the student must conform, must immerse himself in the classical style.

The Imperial Academy remained the sole arbiter of artistic taste in Russia until 1870, when it was challenged by the emergence of a new national art. Until that time, Russian infatuation with Western ideals continued to dominate every area of national life: court circles pursued the fashion and elegance of foreign capitals, the liberal intelligentsia drew its ideas of political reform from the Enlightenment and dreamed of establishing a constitutional state on the European model. In art, Catherine's successors continued the pattern.

*　　　　*　　　　*

The challenge to the Russian infatuation with Western art did not grow out of artistic developments in Europe, but rather received its impetus from the domestic political climate in the nineteenth century.

Two dates, 1825 and 1848, were crucial to the revival of Slavism as a vital force. In 1825, the failure of the Decembrist uprising and the subsequent brutal repression by the new tsar, Nicholas I, were the beginning of reassessment for the intelligentsia; and a realization that Russia's social ills were unique and might not be cured by Western solutions. In 1848 these doubts were reinforced by the collapse of revolutionary movements throughout Europe. Out of fear of political unrest and foreign ideas, St Petersburg initiated a ruthless persecution of intellectuals. It was a time of secret police, university purges, imprisonment or exile for dissidents. A strict censorship was imposed and all perceptible glimmerings of Western liberal influence vanished.

With the death of Nicholas I in 1855, the surviving remnants of political opposition emerged hardened, activist, more convinced than before that socialism must be translated into a Russian idiom: freedom for the serfs, agrarian reform, alleviation of the misery of the peasant population. This new self-awareness resulted in a strengthening and revitalization of the Slavophile movement. The artists of Moscow believed that Russian history, tradition and art were superior to those of the West. Now their conviction was reinforced by those social critics who were disenchanted with Western solutions. After 1848, the gulf between Moscow and St Petersburg, between Russophile and Westerner, had become unbridgeable. Where before it had been possible to have a civil dialogue among men who differed, the enmity was now so bitter that no genuine communication was possible. Ivan Sergeyevich Aksakov, the writer and editor of *Rus*, expressed the depths of this adversary relationship in a letter in 1859: 'You simply cannot fathom the hatred and suspicion with which St Petersburg regards Moscow, nor the fear and apprehension the word *Narod-nost** creates in St Petersburg. Not a single Westerner or Russian socialist is as

* The word indicates the spirit of the people, or populism.

feared by the government as a Slavophile from Moscow.'[11] Aksakov was vehement in his exhortations to his fellow Muscovites for he believed that it was essential to the rebirth of national pride for the true Russian to loathe St Petersburg with all his heart – 'It is impossible to consider oneself a citizen of Russia and St Petersburg at the same time.'[12] Years after the Revolution, Alexandre Benois confirmed the lingering depth of this feeling: 'The very act of the Bolsheviks in transferring the capital back to Moscow can be regarded in a way as a "settling of accounts", a long-awaited revenge.'[13]

In the 1860s Russian literature exemplified and defined the contending forces within the country. Together with the legacy of the major political theorists, polemicists and activists, Vissarion Belinsky (1811–48), Aleksandr Herzen (1812–70), Mikhail Bakunin (1814–76) and Nikolay Chernyshevsky (1828–89), Russian writers not only reflected but influenced Russian thought. In comparison, the painters had been slow to express the turbulence of their time, but soon they were to provide a dramatic illustration of the divisions between East and West.

Though Moscow was the centre of Slavic unrest, it was the St Petersburg Academy which was the site of the first protest against the foreign domination of Russian art. Providing as it did the only access to classical training, patronage, scholarships and the bureaucracy which dominated cultural affairs, this institution attracted students of all artistic beliefs. For many, it was the Academy or nothing. When a handful of artists declared their opposition to this monopoly, it was the Moscow idea that motivated them. Later, this same nationalist impulse led to the emergence of the Wanderers, who reactivated the Slavic strain in the arts and gave the city a new significance.

In 1863 the St Petersburg Academy held its annual competition. The Gold Medal and a coveted opportunity to work in the West were to be awarded for the best pictorial study of an allegorical theme, 'Banquet in Valhalla'. To a small group of rebels the Teutonic legend and the Hall of Odin seemed insignificant and remote. For these men the Russian heritage was infinitely more stirring than the saga of distant warrior-gods. On November 9, this group of students denounced the competition and broke away from the security of the establishment to form their own commune, the Artel Khudozhnikov. Their leader, Ivan Nikolayevich Kramskoy, an intense, doctrinaire painter in his twenties, was articulate in his belief that Russian art was a vital, independent force without need of Western precepts: 'It is time the Russian artist stood on his own feet and rejected foreign influences.'[14] He despised the Academy copyists and it was his evangelistic nationalism that sparked the rebellion. Kramskoy was also convinced that the artist had a responsibility to portray the Russian experience. He argued that the artist's role was social as well as aesthetic. Relevance is a compelling word to a new generation, and at that time there was no country in

Europe that offered a comparable prospect for artistic involvement in a great historical drama. Though the St Petersburg revolt is usually referred to as the 'rebellion of the thirteen', the Artel Khudozhnikov was composed of fourteen members: thirteen painters and one sculptor.[15]

The challenge to the Academy took place during the reign of Alexander II, a time of alternating repression and amelioration. There was a social promise in the Great Reforms which affected the army, legal and educational systems. Serfdom, which had been at the economic heart of the old order, had been abolished two years earlier, and a fundamental change had been effected in a situation previously rigid and immutable.

However, the liberalism was fragile and sporadic. 1863 was the year in which Chernyshevsky, the idol of the young radicals, had written his classic novel of the revolutionary movement, *Chto delat?* (*What is to be Done?*), a work which earned him a twenty-four-year sentence in Siberia.[16] Chernyshevsky is particularly important to any narrative of art in Russia, because he was the first and most effective spokesman for the idea that the artist's work must advance the social and political rights of the people. This 'anti-aesthetic' viewpoint was anathema to the partisans of the Academy, but it made him a hero and theoretician to men like Kramskoy and his group. One of Chernyshevsky's earliest works, *The Aesthetic Relation of Art to Reality* (1855), in which he expounded his thesis that art must serve to educate and enlighten the public, had a profound and lasting effect on subsequent socialist thought and influenced Lenin's concept of the artist's function in the social structure.

Kramskoy's initiative was successful for a time in guiding the fortunes of the rebels and holding them together. Under his leadership the Artel accepted what commissions were available for portraits, copies of old works and book illustrations. However, they were all desperately poor, and emotional commitment was not sufficient to guarantee the longevity of the movement or to overcome what one critic called 'the pitiable Russian apathy'.[17] The revolt collapsed after seven years, and would have disappeared sooner but for an event which was a forerunner of the Moscow merchant patrons' support for the arts. An early example of the cultural influence of Moscow occurred when the Kramskoy Artel obtained financial aid from Pavel Mikhailovich Tretyakov. An account of Tretyakov will be given later. It is enough to note here that this textile magnate of enormous wealth, the archetype of the Moscow merchant collector, was among the first to support those artists, unfashionable at the time, who drew their inspiration from indigenous themes. Tretyakov purchased many paintings from the St Petersburg collective, but despite his efforts, the protest died.[18] This was due in part to weariness, internal dissension and the constant struggle to survive against harrowing odds. Yet Kramskoy remembered later,

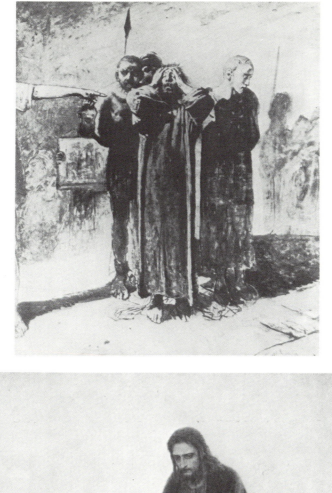

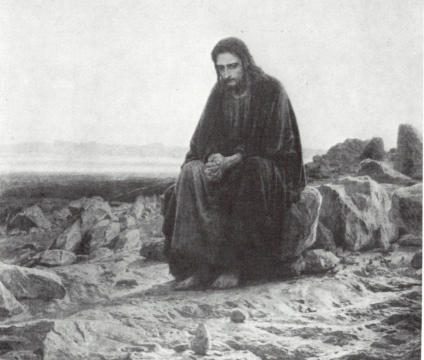

Top: Nikolay Ge: *Golgotha*, 1892. Tretyakov Gallery, Moscow
Above: Ivan Kramskoy: *Christ in the Desert*, 1872. Tretyakov Gallery, Moscow

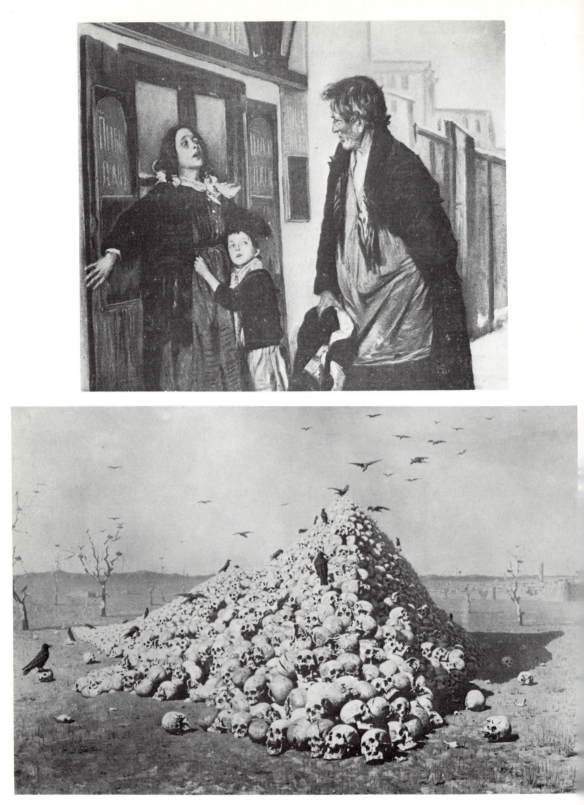

Top: Vladimir Makovsky: *You May Not Pass*, 1892. Tretyakov Gallery, Moscow

Above: Vasily Vereshchagin: *Apotheosis of War*, 1871. Tretyakov Gallery, Moscow

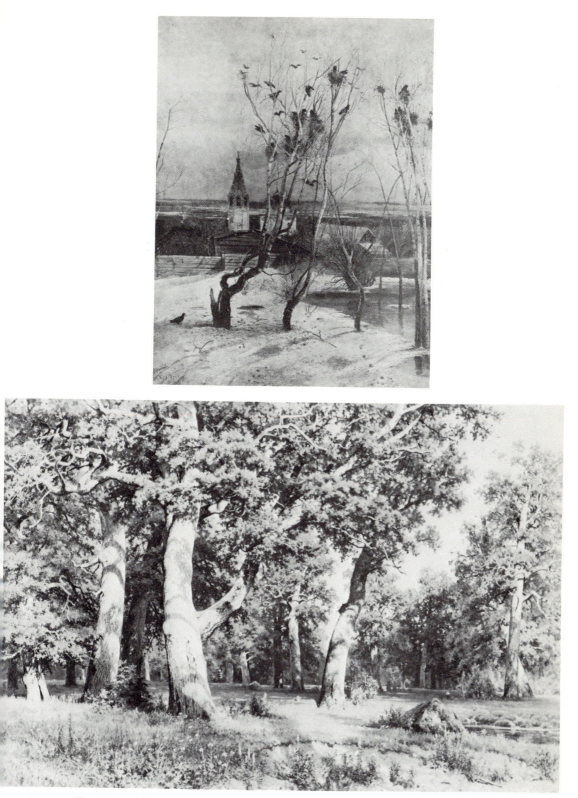

Top: Aleksey Savrasov: *The Rooks Have Flown In,* 1871. Tretyakov Gallery, Moscow

Above: Ivan Shishkin: *Landscape,* 1887. Tretyakov Gallery, Moscow

Above left: Ilya Repin: *Portrait of Tolstoy*, 1901. State Russian Museum, Leningrad

Above right: Ivan Kramskoy: *Portrait of Ivan Shishkin*, 1880.
State Russian Museum, Leningrad

Below: Ilya Repin: *The Nevsky Prospekt*, 1887. State Russian Museum, Leningrad

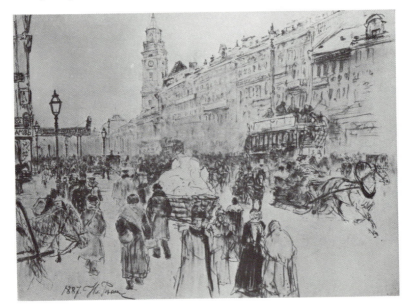

'Our main concern was looking after each other. It was a wonderful moment . . .
for our art had arrived.'[19]

The majority of Russians had yet to be persuaded of the possibility of liberty
for themselves. Thus the cause of freedom in art was an abstraction, of little
immediate concern. The dissidents had not disturbed the serenity of the
Academy, and their names are scarcely known today, but their revolt was the
beginning of an era of the artist as propagandist in Russia, a new genus which
flowered in the years immediately following 1917, in the works of Vladimir
Tatlin, Kazimir Malevich and Lazar (El) Lissitsky.

The year that saw the demise of the Artel, 1870, was also marked by the
formation of the Peredvizhniki (Wanderers), the coalition of Slavophile painters,
mainly Muscovites, who successfully challenged the precepts of the Academy.
Once again, Kramskoy was the voice and spirit of the rebels, their link with the
earlier insurgents. The Wanderers were so named for their intention to take art
out of Moscow and St Petersburg where it had been confined, and to travel with
it to the main cities of Russia. This decentralization, they believed, would bring
their work to the people, and thus restore and illumine Russian values. They had
as their goal the depiction of Russian themes, finding beauty in the landscape, in
the endurance and daily life of the peasant. Just as in France Rousseau and
Millet had rejected the Classicists, the Wanderers turned from the formality of
the Academy toward realism and nature; in Rousseau's words: 'to make the
manifestation of life our first thought, let us make a man breathe, a tree really
vegetate.' The Wanderers were, in effect, the Barbizon painters of Russia,
spiritually linked to Corot and Courbet. They sensed that standards were
shifting, that painting was no longer to be confined to palaces, remote and
unattainable, portraying only dead civilizations and alien values. It was to
become a narrative, familiar and meaningful, that would enlighten and invite
popular response.

The original members were egalitarian and idealistic, inspired by ideas of
social change, and determined to use their skill as a means to that end. The
ideology that art must be a manual of life was drawn in part from Chernyshev-
sky: 'The reproduction of life is the basic distinctive characteristic of art. . . .
Forms of art often have another significance as well – they explain life's
phenomena.'[20] Inevitably, with this goal, the emphasis was on content as
opposed to form. Pure beauty, or art for art's sake, was scorned as a luxury
appropriate to the private collections of St Petersburg. Kramskoy summed up
the Wanderers' disdain for beauty without social purpose in a comment on
Hellenic art. It was his opinion that after the art of the Greeks had ceased to be
motivated by the lofty themes of religion, it had 'degenerated into an
amusement', a sumptuous ornamentation; it had not lasted, 'having become
mannered and lifeless'.[21] Taking to heart these strictures, the Wanderers' style

was declarative and frequently naïve, but the populist approach was in harmony with the times, and their simplicity was combined with talent and energy. Their output was divided into four main categories: religious and narrative painting, landscapes and portraits. Suddenly the viewer was caught and involved, confronted by a universe with which he could identify, a familiar scene of muzhiks, serfs, soldiers and landowners, themes of spiritual devotion, injustice and beauty. The country's history seemed woven into the canvas.

If Chernyshevsky and the traditions of old Moscow supplied the motivation for the Wanderers, their aesthetic and emotional ideals stemmed from an earlier generation of Russian painters among whom Aleksey Gavrilovich Venetsianov (1780–1847) and Aleksandr Andreyevich Ivanov (1806–58) were prominent. Venetsianov had been the originator of Russian peasant themes and an important realist. His rise had coincided with the emergence of a merchant class which provided a new audience for painting, for an art which was familiar, less rarefied and polished than that favoured by St Petersburg court circles.

Ivanov was a direct spiritual precursor of the Wanderers and an example of the division within Russian painting. He received his training at the St Petersburg Academy and his early canvases are replete with the mythological themes approved by that institution. Pictures such as *Apollo, Hyacinthus and Zephyrus* (1831–34), skilfully executed, earned him the opportunity to study in Rome. He lived in Italy for nearly three decades and produced scenes of Roman festivals, the coast of Naples and *Water and Rocks at Palazzuola* (c.1850). However, an intense, inescapably Russian spirituality becomes evident in his painting. The head of a slave or of John the Baptist, the watercolour *Prayer in the Garden of Olives* (1850), each has an anguished humanity which is related to the work of Nikolay Ge, Ivan Kramskoy and later, of Vasily Surikov. Ivanov worked for twenty years on his best known painting, *Christ Appearing to the People* (1837–57), which he finished in the year before his death. He was the first Russian painter to work in the open air, an important development in the history of Russian art.

The work of a later artist, Vasily Vasilevich Vereshchagin (1842–1904), also made a great impression on the Wanderers. A friend of Ilya Repin's, though not a member of the Wanderers, Vereshchagin had studied with Gérôme in Paris and his strength was in the impact of his narrative paintings. A pacifist, his gift for drama earned him a popular following in Russia. In 1874, after General Kaufmann's victorious campaign in Turkestan, the artist exhibited two canvases in St Petersburg which were extremely controversial. One, *The Apotheosis of War* (1871), was a pyramid of skulls dedicated 'To all conquerors, past, present and to come'. The second, *Forgotten*, depicted a lone Russian soldier, dying and

abandoned on the battlefield while birds of prey circled overhead. Both pictures provoked the displeasure of Tsar Alexander II and were removed from the showing on his orders. *Forgotten* was also the inspiration for one of Mussorgsky's dramatic ballads. The incident illustrates the power of genre painting to agitate and to move public opinion in Russia.

A consideration of the Wanderers' membership must start with Ivan Kramskoy. He is interesting for the manner in which he embodied the conflicting currents within the intelligentsia at the end of the nineteenth century. In his mixture of insurgency and religious belief he resembled his close friend and idol Dostoyevsky, whose picture he painted when the writer was dying. In Kramskoy's utterances one finds an addiction to pragmatic dogma characteristic of Chernyshevsky's followers. But in addition, like Ivanov, he possessed a strong mystical quality which was revealed in his biblical scenes. Kramskoy's *Christ in the Desert* (1872) places a despairing figure in a simple rough robe in the midst of a rocky, barren setting, a peasant with unseeing eyes, hands clasped in endless endurance. In contrast to the emotionalism of his sacred paintings, Kramskoy's portraits were distinguished by a meticulous exactitude. He had worked as a photographic retoucher in Kharkov and St Petersburg before entering the Academy in 1856 and his portraits were a minute catalogue of details, carefully assembled to reveal the personality and idiosyncrasies of his subjects. His portrayal of the artist Ivan Shishkin (1880), bearded, hair dishevelled, the vest imperfectly buttoned, a stray hair on the shoulder of a rumpled black suit, brush of green paint across the sleeve, is the ultimate portrait of the artist *engagé*. Shishkin (1832–98), an early member of the Wanderers and a close friend of Kramskoy's, was famous for his forest scenes.

Another landscapist, and one of the first members of the Wanderers, was Aleksey Kondratevich Savrasov (1830–97), an early exponent of *plein-air* painting in Russia. His scenes of Moscow and the snowy views of the rugged countryside were an invigorating contrast to the plushy interiors and cool vistas of the St Petersburg school.

An example of the close ties between the Wanderers and the major literary figures of the time was Nikolay Nikolayevich Ge (1831–94), an intensely devout painter, close friend and philosophical ally of Tolstoy. In 1886, when he sketched a *Head of Christ*, his vision, like that of Tolstoy, was of an intensely suffering, human Saviour without the remote gloss of divinity. His frantic, tortured *Christ in Golgotha* (1892) was offensive to the Church; Alexander III was said to regard the work as a 'butchery', and the picture was removed from exhibition. Tolstoy, who regarded Ge as one of the world's greatest artists, considered the incident to be a 'triumph' for Ge and defended him against those who wished to see Christ portrayed as an icon. Upon the death of Ge, Tolstoy sent a letter to Pavel Tretyakov advising him to buy all of the painter's remaining

work so that the Tretyakov Gallery, 'i.e. the Russian national gallery, should not be deprived of the works of the very best painter in the history of Russian painting.'[22] Tretyakov was not convinced. In answer to Tolstoy he wrote: 'The one [painting] that is most comprehensible to me is Kramskoy's *Christ in the Desert*. I consider this an outstanding work and I am so happy that it was done by a Russian artist.'[23] In this exchange there is some indication of the immediate emotional impact of the Wanderers on major figures in Russian life and thought.

Artistically, the landscapes and portraits are the most enduring, but taken within the context of the period, the group's narrative works are the most instructive, for they provide a comprehensive view of a historic moment, a cyclorama of a country in flux. They were not merely illustrations of the revolutionary forces which swept the country, they were part of them.

To capture a Russian audience, the performer must tell a story, and the Wanderers were masters of genre painting – an effective weapon for these pious social activists: views of servitude, careless cruelty, political repression, the uncaring brutality of a feudal system were reproduced with a realism and immediacy which is still pertinent. Vladimir Yegorovich Makovsky (1846– 1920), whose brother Konstantin had been a member of the band of fourteen insurgents, was an emotional chronicler. His painting *You May Not Pass* (1892), showing the fearful homecoming of a political exile to a family to whom he has become a danger and an embarrassment, depicts the after-effects of official persecution and is a scene with which any dissident might identify today. It ranks with Repin's *They Did Not Expect Him*.

Ilya Yefimovich Repin (1844–1930) was undoubtedly the most famous associate of the Wanderers, the embodiment of the Slavic ethic. Though he did not exhibit with the Society until 1878, he represented and articulated the views of this school of national painting better than any other. Born in the Ukraine, he worked as an icon painter before coming to St Petersburg in 1864. In 1870, while still at the Academy, he began his famous painting *Burlaki* (*Volga Boatmen*), and upon his graduation in 1871, he received a grant to study in Paris. His crucial meeting in that city with the Moscow industrialist and Slav sympathizer Savva Mamontov banished any ambivalence he may have felt about the orientation of his work. He realized that his future lay in Russia. After he returned to Moscow, he spent several summers at Abramtsevo, Mamontov's estate where the industrialist had founded a famed art colony, working with various members of the Wanderers. Repin was not hampered by any sense of reserve or understatement. He tackled the great themes with zest. When he completed *Volga Boatmen* in 1873, all the misery of the peasant was contained in this gargantuan canvas. The straining, ragged body of men pulling the heavy craft agonizingly over the endless, icy landscape dramatized a recognizable fact

of life. With its raw emotionalism, it was the ultimate contrast to the Banquet in Valhalla.

Repin painted Tolstoy in 1901, when the writer was seventy-three, in a white *rubashka* or tunic, the pocket sagging under the weight of a red volume, possibly a bible, hands tucked into a leather belt. In this forest setting, surrounded by birches, Tolstoy is barefoot, a part of the soil, a peasant ascetic. Like many of the Wanderers, Repin was an exceptional historian; and he excelled in portraying the great Slavic figures: Tretyakov, Mussorgsky, Shalyapin. His sketches of Tolstoy and Mamontov are among the most convincing of his works.

The Wanderers brought to art the same chthonic devotion that the ancient Slavs had conferred on the Church. In a letter to Vladimir Stasov, leading advocate of a nationalist art, Repin expressed this attitude: 'I love art above all ... I love it secretly with a love jealous and incurable, like an old drunkard. It is part of me, in my head, in my heart, my desires, the best and most mysterious.'[24]

On November 29, 1871, the Wanderers opened their first travelling exhibition in St Petersburg, the capital of Western painting, and achieved a breakthrough. With the continuing sponsorship of Tretyakov, they created a new audience for art and became the heroes of the progressive press. The critic and social satirist Mikhail Saltykov-Shchedrin recognized the significance of the event: 'This will mean that the works of Russian art hitherto confined to St Petersburg alone, within the walls of the Academy, or buried in the galleries and museums of private individuals, will become accessible to all the inhabitants of the Russian Empire.' He noted that Kramskoy's *Head of a Peasant* brought a rush of recognition to one visitor: 'Mother, look – it's me!', and Savrasov's wintry scene *The Rooks Have Flown In* (1871) was part of a cycle familiar to every Russian. Ge's historical painting *Peter the Great Interrogating His Son* (1871) was a particular success – 'and herein lies the secret of art, that the drama is clear in and of itself. ... Art will cease to be a secret ... it will invite everyone and grant all the right to judge its accomplishments.'[25]

Vladimir Vasilevich Stasov (1824–1906) was the Wanderers' most ardent champion. Art historian, theatre and music critic, archaeologist and polemicist, he was a friend and ally of Mamontov, Shalyapin and Glinka, and a supporter of the composers who formed the 'Five': Mussorgsky, Cui, Borodin, Balakirev and Rimsky-Korsakov. Of Western artists he admired Hogarth and Goya: 'they were both filled with ... an inner fire ... with a real spirit of life, they could not glance indifferently at what was going on around them.'[26] Stasov believed that art should imbue the people with a sense of their national heritage, and he compared the Wanderers to the Academicians who had preceded them: 'Here before us stands a new breed of artist, full of vigour and reason, casting

aside the trinkets and idle amusements with their art, rejecting everything that is currently fashionable and finally, concentrating a serious gaze on history as the source of not only historical trappings, but the deep-rooted characteristics of the olden days. On their canvases they portray the characteristic types and the events of daily life that Gogol was the first to study and re-create.'[27]

The Wanderers' movement owed little to European socialism. It was a peculiarly Russian blend of religion, social concern and the isolationism of old Moscow. The group advocated a major change in art and the societal structure, yet their inspiration lay not in the Enlightenment but rather in the communalism of the peasant. Their passion for social change was entwined with a deep sense of religion; thus they expressed the two basic drives of the masses of the Russian people. They re-established Russian values and the worth of the Russian past. But their triumphs did not last, and from today's perspective it is possible to perceive the source of their artistic decline. In answer to the decorative irrelevance of the Academy, the theoreticians within the Wanderers elevated subject-matter to a pinnacle and encouraged a contempt for experimentalism. As a result, many of the later works appear obvious, and like poster art, lacking in vitality. With success, these artists became as doctrinaire as the Academy which preceded them.

Eventually the failure to develop new techniques, to study or appreciate the work which was being created in the West at the time, was a disaster. Had the Wanderers done so, they might have reinvigorated their movement and combined Russian intensity with new forms. It is not a totally improbable mixture, for in one sketch of the Nevsky Prospekt painted in 1887, Repin created a scene delicate and light, akin in spirit to Monet's *Boulevard Capucines* (1873). However, Repin, Kramskoy and their compatriots remained rigidly opposed to the Impressionists. Their ideal was realism, and for them, the splintering of that reality was the work of idlers and dilettantes. Their passion for 'truth' permitted no distortion. Kramskoy tacitly recognized the attraction of Western art for young artists when he reacted to Impressionism as a positive danger. In a letter to Tretyakov in 1876, he thus evaluated the work of the Impressionists: '... among even the most celebrated there are some who approach the naïveté of my son painting in oils.'[28] Art has been defined as a lie which enables the observer to see the truth, but the Wanderers had no patience with shading or subtlety.

The Wanderers, like all other movements in pre-revolutionary Russia, sought for the ultimate solution to a gigantic social dilemma which could not be solved by compromise. Each canvas was a declaration. Twenty-eight years earlier Belinsky had written: 'Our time longs for convictions, it is tormented by hunger for the truth ... our age is all questioning, questing, searching, nostalgic,

longing for the truth.'[29] The Wanderers provided the artists' response to this universal desire.

Their influence lasted for thirty years[30] and left its mark on succeeding generations of Russian painters, but ultimately the Wanderers' was a reactionary revolution, radical in concept and ideals, retrogressive in content. Always looking to the past, they advocated change and marched backwards. It was as a response to the nationalism and social consciousness of the Wanderers that *World of Art* was born in 1898.

2

HIGHLIGHTS
OF ST PETERSBURG'S
GOLDEN AGE

By nature we all belonged to Europe rather than to Russia.
Alexandre Benois

At the end of the nineteenth century, art in Russia was polarized. From Moscow there emanated an atavistic pull toward all things Russian, a basic need to find and preserve the Slavic identity. St Petersburg represented the attractions of the West, the fashion and intellect of Paris and Munich, the monumental scale and royal splendour of eighteenth-century France. Despite the influence and ascendancy of the nationalist trend, there were always those who longed for the sheer hedonism of art for art's sake, who mistrusted the pull of social activism. Such people were unaffected by the cause of the Wanderers, and in St Petersburg they staged that city's major artistic renaissance.

St Petersburg had become the most beautiful and elegant centre in Russia. The flow of history since Peter's era was reflected in the harmony and grandeur of its architecture. Rastrelli's vast Winter Palace was enhanced by the surrounding squares and parks, the broad avenues, bridges and canals that veined the city. The palatial private residences bore such fabled names as Stroganov, Yusupov, Shuvalov and Yelagin, and their colonnaded façades fronted the Fontanka Canal and the Moyka, lined the Nevsky Prospekt and rose out of the small islands on the Neva. Every phase of baroque and neo-classicism was mirrored in these extravagant dwellings, and even the great bulk of St Isaac's Cathedral with its golden dome seemed mundane and unimaginative by comparison. To the west of the city was the fantasy of Peterhof with its

shimmering fountains, cascades and formal gardens, a Russian Versailles, an appropriate adornment for a brilliant capital.

Every aspect of art and fashion continued the Western bias which had been part of the cultural climate of the city since its creation. Alexandre Benois, the brilliant St Petersburg artist and art historian, wrote of the phenomenon: 'Everything from abroad was accepted with delight.'[1] St Petersburg was a magnet for foreign businessmen, tourists, diplomats and government functionaries.

The journey by express train from Paris to St Petersburg took less than two days, the steamer from London arrived once a week, and the linkage was psychological as well as actual. The Hôtel d'Europe provided a luxurious and familiar haven for visitors; French and German were spoken in the shops. Fabergé displayed its treasures on Morskaya Street, and if the visitor tired of caviare or partridge, it was possible to satisfy a yearning for Italian food at Privato's. In addition to theatres and night clubs, there were Quarenghi's colonnade of shops, or the gaiety of the St Petersburg fairs: painted scenes from a child's book, a mélange of gingerbread, puppet shows, trained bears, tumblers, and at the centre, a brilliant carousel. Splendidly uniformed officers were spots of colour in a throng of babushkas and children of all ages. The Merchants' Club or the Nobles' on the Nevsky Prospekt provided sanctuaries as elegant and sacrosanct as any in London or Paris, where it was possible to ignore for a time the political unrest within the country; the inequities were lost in the beauty of the setting. St Petersburg had the charm and timelessness of a Canaletto and the residents tended to dismiss Moscow as a cultural outpost.

In the capital city, cultural and intellectual life had a special sheen. The Maryinsky Theatre, built in the time of Nicholas I, offered *Coppélia* and *La Bayadère* in a cream and turquoise setting. In 1887, the Director of the Imperial Theatres had commissioned Tchaikovsky to create the music for a new ballet with choreography by Marius Petipa. Alexander III was present in the Royal Box when *The Sleeping Beauty* opened on January 15, 1890. Two years later *The Nutcracker* was introduced and in 1894 *Swan Lake* was revived. *Cavalleria Rusticana* delighted audiences, Wagner's *Ring* was produced in 1890 when it received a mixed reception. One of the great events of 1890 was the appearance of the Duke of Meiningen's famed theatre company with its productions of Shakespeare, Schiller and Molière. Benois wrote of their influence, and Stanislavsky remembered the historical truth and 'amazing discipline' of their presentations: 'I did not miss a single one of their performances. I came not only to look but to study as well.'[2]

Despite the burgeoning of theatre, music, literature and dance, public taste in painting remained oddly old-fashioned in a city which valued the latest

European influences. The Academy, which set the fashion, had become a shell
in which the same themes were reproduced mechanically and endlessly. There
had been occasional attempts to modify the general conservatism. In 1875, a
year after the first Impressionist exhibition, Emile Zola had been hired as the
Paris correspondent on the arts by the St Petersburg paper *Vestnik Yevropy*
(*Messenger of Europe*), at the suggestion of Ivan Turgenev. Writing from the
French capital, he told his Russian readers that 'art is in bourgeois hands',[3] an
observation which applied to Russia at the time even more than to France. Zola
praised the simplicity of Puvis de Chavannes, 'a truly original talent who
developed apart from all academic influences',[4] but his greatest hopes were
centred on his friend Edouard Manet whom he considered a revolutionary
painter, a harbinger: 'he is at the head of a whole group of artists, a group which
is constantly enlarging and to which the future obviously belongs.'[5] He
concluded: 'The anarchy of today's art does not seem to be a death struggle, but
rather a renaissance.'[6]

However, despite Zola's encouraging words, in Peter's city a taste for
contemporary art was confined to a few connoisseurs, and the preference of the
majority remained unchanged, believing with Flaubert that there is no art
without form. Painting was becalmed, drifting between the classical copyists of
the Academy and the Slavic output of the Wanderers.

This vacuum was filled by a group of young painters, musicians and writers
who were wary of the social tendentiousness of Moscow art and bored by the
ritualism of the Academy's curriculum. These leaders of the final renewal of St
Petersburg's art did not reject the heritage of ancient Russia – the lavish
decorativeness, the beauty and power of the architecture and the icons – but they
wished to move the country into the Western mainstream, to introduce into
public consciousness an appreciation of contemporary European values. Con-
demning revolutionary intent on one side and deadening traditionalism on the
other, they were unable to endorse the latest manifestations of the Paris avant-
garde, but wished to transcend the bureaucratic and sterile copying of old forms.
Their response to Moscow and the Academy was to propagate a new aesthetic
ideal through publication.

Russia's first major journal of the arts, *Mir iskusstva* (*World of Art*), was
created in St Petersburg in 1898 by Sergey Diaghilev. Alexandre Benois joined
him in the enterprise a few months later. More than a provocative and illustrious
magazine, ultimately it became a movement, an influence which was responsible
for a broadening and redefinition of taste in Russia.

The genesis of this publication was to be found ten years earlier in a diverse
fraternity of students, artists and intellectuals whose friendships had been
formed at the Gymnasia and in the art circles of St Petersburg. Exuberant,
idealistic and occasionally over-serious, they called themselves the Nevsky

Pickwickians, and at first glance appeared to differ little from any other group of undergraduates, except that they reflected a society in which 'intelligentsia' was a complimentary term and 'uncultured' the ultimate derogation. Unlike their Moscow counterparts, the majority of whom had to struggle to support themselves, they enjoyed an absence of financial worries that permitted time for abstract discussion; a background filled with paintings, books and foreign periodicals encouraged a familiarity with European trends, and the regular meetings distilled an atmosphere of privilege, aristocratic bias and intense philosophical competition.

The Nevsky Pickwickians were drawn to the excellence and discipline of Cranach, Holbein and Dürer, and in contrast to the Wanderers and Kramskoy, found the purity and remoteness of Greek art completely satisfying. The sophistication of the ancient Egyptians was admired, and among the moderns, the favourites were James McNeill Whistler, Aubrey Beardsley, Lovis Corinth, Max Liebermann and Gustav Klimt. If this list seems somewhat conservative in light of the work being done in France at the end of the nineteenth century, it should be remembered that French influence on the intellectuals and the aristocracy had diminished after 1812. Even after the Franco-Russian rapprochement of 1872 and the rebirth of interest in French culture, Germany was still a major force in forming Russian taste. This was illustrated by the popularity among progressives of Wagner, Corinth, the Austrian Klimt, and the passion for Biedermeier among the Russian bourgeoisie.

In 1892 a young official at the French Consulate, Charles Birlé, attended the group's meetings for a year. He had recently been a student in Paris, and he brought with him a great enthusiasm for Van Gogh, Gauguin and Seurat, names that were largely unfamiliar to the young Russians. Though they were avid for the latest news from France, their reaction to these artists was surprisingly muted. Within this circle the French moderns remained subordinate and the work of the Impressionists and their successors received little attention. This could have been due in part to the influence of Alexandre Benois, the founder of the group.

Benois, as a decorative artist, could have been expected to respond immediately to the incandescent colours of the Impressionists, but he was inescapably a man of the eighteenth century and the absence of form alienated him. He characterized his band of friends as the 'Society for Self-Improvement', and it met in his home to determine the best in Russian and European music, literature and painting, contemporary as well as traditional. The scope and catholicity of the project would have been discouraging to any but the very young, but as Benois remarked, 'in those days we were all encyclopaedic-eclectics and extremely immature ones at that.'[7] Benois was born in St Petersburg in 1870, his French, German and Italian ancestors having been part

of the migration to Russia in the time of Peter the Great. Though he had no Russian forebears, his attitudes and perceptions were influenced strongly by his early years in the Russian capital. His father, an influential architect and a favourite of Nicholas I, had designed the Imperial Stables at Peterhof. He encouraged his son's interest in painting, and as a result, Alexandre had become like the city itself, a mixture of Russian and Western cultures.

At seventeen, Benois had attended night classes at the Academy where the standard entrance exam was the drawing of a plaster head to be completed within two hours. He had left after four months, discouraged by the rigidity and bloodlessness of the teaching, but the alternative, the heavy earnestness of the Wanderers, was anathema to him. He had always been attracted to the art of the West, yet this orientation did not translate into a denigration of his own land. 'In Russia, much that was characteristically Russian annoyed us by its coarseness, triviality and unattractive barbarism. It was this coarseness that we longed to fight and uproot. But the problem had to be solved with the greatest care so as not to harm or break what was really precious.'[8]

In 1889, by the time he had left school, Benois was the centre of the cluster of gifted and quirky friends who eventually became the nucleus of *Mir iskusstva*. Even then they speculated about the possibility of launching an art review at some time in the future, a collective effort which Benois referred to as a 'concrete dream'.[9]

In the autumn of 1889, before entering the University, they decided to organize their informal sessions into a more structured 'club' with regularly scheduled meetings, written reports and debates, and the Nevsky Pickwickians were formally established. A year later, Bakst and Diaghilev joined the society. It was in this early, informal setting that Diaghilev first displayed the combination of drive and imagination that won him international recognition and proved to be so effective for *Mir iskusstva* and the point of view that it represented.

The original gatherings included Yevgeny Lancéray, Benois's nephew, only five years his junior, whose talent for graphic art would figure prominently in the pages of the journal; Konstantin Somov, painter, student at the Academy, son of a curator at the Hermitage; and Walter Nouvel, musical authority and a steadying influence on this volatile company. At this stage the participants' ambitions were not defined, they met to explore a world of art unrestricted by traditional boundaries, a blend of music, literature, painting and philosophy. Each was free to choose his field: Nouvel gave a course on the history of opera, Benois selected the great artists of the German school and French paintings of the nineteenth century. Another member, Dmitry Filosofov, delivered an analysis of the reign of Alexander I.

A special mention should be made of Dmitry Filosofov and his family. He was

the bibliophile and literary authority, and even in this highly individualistic company he was notable for his idiosyncrasies. He was 'a true Russian', a member of the minor nobility, and his family was a microcosm of the conflicting pressures within the country. Languid and aristocratic, his principal interests were philosophy, literature and mysticism, and he shared the general aloofness from current political events that was a hallmark of this association. Dmitry's mother, Anna Pavlovna, was a creature out of the pages of Chekhov. Lovely, feminine, a vivacious hostess, always perfectly gowned, she was also a social worker, feminist and labour agitator with links to the subversive elements of St Petersburg's intelligentsia. Her husband, an austere disciplinarian, had become Councillor of State under Alexander II. Twenty years older than Anna, he was an adoring and indulgent partner, even when her activities became an embarrassment and a danger to his office. His wife's radical views were tolerated for a time because of her charm and his high position, but eventually there came a moment when it was no longer possible to shield her. In 1879 she had aided in the escape of Vera Zasulich, a well-known revolutionary who had attempted to assassinate General Trepov, Governor-General of St Petersburg. Anna Pavlovna thereby became extremely dangerous in the eyes of the authorities and was temporarily exiled for her activites. When she was finally permitted to return home she had learned a measure of discretion, but all her life she remained a quiet rebel. Despite his mother's activities, or perhaps because of them, Dmitry remained determinedly indifferent to ideas of liberal reform.

In 1890 the group acquired three of its most gifted members. Nicholas Roerich, the first, was a superb delineator of the Russian past, whose work was a pageant of heroic knights and primitive Varangians. While still a student at the St Petersburg Academy, he was planning a great series of paintings, *The Beginning of Old Russia: The Slavs*. The theme suggests the Wanderers, but though he had ties with the group, Roerich had nothing of their contemporary realism; he was imaginative and theatrical in his approach with a sense of fantasy which for a time made him acceptable to *Mir iskusstva*. His stylized theatrical designs for the operas *Tsar Saltan* and *Snegurochka* (*The Snow Maiden*) recreated the ornamental richness of Old Russia. In 1909, Roerich's evocation of the Russian steppes for the Ballets Russes production of *Prince Igor* caused a sensation in Paris. He also designed the décor for Diaghilev's production of Stravinsky's *Le Sacre du Printemps* in 1913.

Léon Bakst, who was later responsible for the most sumptuous spectacles of the Ballets Russes, was the second to join the Benois circle in 1890. A shy, bespectacled young man from a commercial family, he was an exception to the general ease and affluence. After the death of his father, he had become the sole provider for his mother, a grandmother, a brother and two sisters. Born Lev Samoylovich Rozenberg in 1866 in Grodno, he had taken the maiden name of

his grandmother to whom he was very close. Bakst had met Benois's brother Albert in 1890 when both had been studying at the St Petersburg Academy, and soon after, he and Alexandre became friends. Benois was genuinely fond of 'Lyovushka'; 'his near-sighted eyes and very fair lashes, his sibilant voice and slight lisp imparted something half-comical and touching to his personality.'[10]

Yet despite his affection for Bakst, Alexandre was not above ascribing certain traits in his friend's character, his tenacity and persistence, 'the talent for extracting the greatest advantage of every situation',[11] to Bakst's Jewish heritage. Occasionally one forgets that for all the enlightenment and culture, this was Russia at the end of the nineteenth century. The time he had spent at the Academy had been hard and hurtful for Bakst.

He dreamed of becoming a significant and important artist, and this ambition could be dangerous for his work. Occasionally his oils were turgid and somewhat leaden, and the religious themes tended to be unsettling, as when he attempted to portray Judas as the most devoted of Christ's disciples. But his talent for watercolour, for the shimmering decorative opulence which later became his trademark, was unique. Benois, whose own gifts in this area were considerable, wrote that his friend had the 'technique of a virtuoso and an incomparable intensity of colour'.[12] Bakst's grandiose canvases, vivid colours and Russian inspiration were scorned as crude and inelegant by the St Petersburg Academy. In 1886 he entered the Silver Medal competition for the best version of the *Pietà*. He was an admirer of Vladimir Makovsky, and out of his esteem for the early Wanderers he created an image more Russian than Western, devoid of the classical nuance so beloved of the professors. He drew on the life of the *shtetl* for inspiration and his Madonna was all too human: an old woman, her face contorted with grief at the loss of her son. The outrage was immediate and violent, for the Academy was not only artistically reactionary, but overtly anti-Semitic. The jury summoned him and it was said that he found their decision announced by two lines slashed in crayon across the surface of his canvas.[13]

Diaghilev was introduced into the circle by his cousin Dmitry Filosofov, and in time this flamboyant recruit proved the catalyst for *Mir iskusstva*. The son of a cavalry guardsman, he had come from the provincial atmosphere of the Perm countryside to attend the University. The entrance of this aggressive, supremely ambitious personality into the relaxed and intellectual gathering occasioned some disquiet. Benois considered his taste rudimentary, and his 'society manners' set Alexandre's teeth on edge; he believed that if the young man had not been a member of Filosofov's family, the relationship would not have endured. At the outset it was a singularly unpromising encounter.

Diaghilev was ostentatiously bored by the philosophical arguments which absorbed his friends. In a group scornful of fashion and social activity, he energetically courted the wealthy and prominent members of society, scattering

his calling cards diligently throughout St Petersburg. He dressed meticulously, with a quality of foppish elegance, which is apparent in the photographs and portraits that remain. He and Bakst were the only dandies in the group, and from the outset the newcomer was regarded as a dabbler and a poseur. His interest in music provided the link between himself and his more earnest colleagues. Piano duets with Nouvel and arias from *Boris Godunov* sung in an unexpectedly fine baritone momentarily stilled the criticism of his new friends. A familiarity with Mussorgsky's music gave him a particular cachet, for despite the composer's reputation, Mussorgsky's works were not then played at St Petersburg's concerts.

Despite his foibles, Diaghilev's magnetism finally made him a pivotal figure at the Pickwickian gatherings. He had entered the Society as an unsophisticated outsider, and though he never lost the brashness that the group found disturbing, he was eager to learn from his companions. Benois, who loved to teach, in time became his close friend and mentor.

After his graduation from the University in 1895, Diaghilev, in an effort to banish any lingering traces of Perm, embarked on an extensive European tour. A letter of introduction from Benois to a distant relative, the painter Hans Bartels, was instrumental in introducing him to the art world of Munich. It was Bartels who helped him to acquire his first Western paintings. Upon his return at the beginning of 1896, Diaghilev wrote several articles of art criticism for the St Petersburg paper *Novosti*. It was Benois's opinion that his friend's life entered a new phase with that experience; he discovered the pleasures of an audience, it produced his first taste of recognition and confirmed his belief in the uses of publicity as a means of advancing his career.

His ambition to present Russian art to the West was forming even then. In a letter to Benois who was living in Paris at the time, he wrote of his plan to organize an exhibiting society which would enlist the support of Russians living abroad; first on the list was Benois, then Mariya Yakunchikova, a promising artist later to be associated with *Mir iskusstva*, and Fyodor Botkin, the Russian expatriate who that year introduced Shchukin to Durand-Ruel and Impressionism. Despite these plans for the future he did not neglect the immediate present.

Early in 1897 Diaghilev presented an exhibition of contemporary German and British watercolourists at the Stieglitz Art Institute. The choice of this delicate medium was, in effect, a rejection of the heavy literalism which permeated Russian painting at that time. Cautious examples of art for art's sake, the pictures offered nothing but charm and dexterity, and they offended some critics with their triviality and irrelevance. With this exhibition, however, Diaghilev attracted an influential admirer, the Princess Tenisheva.

In the autumn of 1897, he organized a showing of modern Scandinavian artists.[14] Despite the popularity of Strindberg and Ibsen in Russia, the work of

Scandinavian painters was as yet unknown, and once again Diaghilev made a mark as an innovator. He had adjusted easily to the luxury and cosmopolitanism of St Petersburg, and now he was proceeding to transform distant goals into reality. It was during this period that he made his second important contact. Savva Mamontov arrived unexpectedly at the exhibition surrounded by a coterie of painters whom he sponsored. At his first meeting with Diaghilev he is supposed to have asked, 'From what soil has this mushroom sprung?'[15] but eventually his admiration for the young entrepreneur provided Diaghilev's initial experience with Moscow backing.

In January 1898, for his third project, Diaghilev took the unheard-of step of presenting contemporary Finnish and Russian artists in tandem. In Russia before that time, art had always been compartmentalized: foreign art or Russian, St Petersburg, Moscow, Academy, Wanderers – each category exhibited separately for its adherents. Diaghilev refused to be hampered by this tribalism; he featured not only his St Petersburg friends, but many of the Moscow school of painters: Konstantin Korovin, Mikhail Vrubel and Aleksandr Golovin. Viktor Vasnetsov, a particular favourite of Savva Mamontov, was included. Two prominent artists, Isaak Levitan and Valentin Serov, considered heirs of the Wanderers, also accepted Diaghilev's invitation. Benois was jubilant. The presence of Serov, one of Russia's most popular figures, was a coup; his participation guaranteed that the exhibition would be a notable event. Diaghilev had gained a major ally, one with access to many of Russia's most important families.

This exhibition occasioned the first use of the word 'decadence' in conjunction with Diaghilev and his circle. The selections were a direct challenge to the hegemony of the Wanderers, and their most articulate supporter, Vladimir Stasov, reacted violently. He was shocked at the temerity of these young pretenders who hoped to supplant an honest and honourable art: 'See the things that the gentleman running the exhibition admires; deluded in his artistic raptures, he presents them to us as models of the new genuine art with which he wishes to replace the old. To procure these monstrosities, he has journeyed far, solicited, persuaded, chosen, and spent a great deal of money, only to end up with rubbish which he uses to dupe others.'[16] Diaghilev understood the uses of controversy; he welcomed the confrontation: 'We have been called the children of decline and stoop to wear the debasing label "decadents".'[17] He deliberately placed Vrubel's enormous decorative panel in the most prominent spot in the hall, near the door. Vrubel was the most alienated, albeit the most gifted, of the 'Moscow' artists. Benois considered him a genius, but the special distorted world which he created was not destined for easy popularity. When he died in a sanitorium in 1910, the artist left a legacy of work strewn with demons, poetry, fantasy and despair. Stasov's most cutting words were reserved for Vrubel's

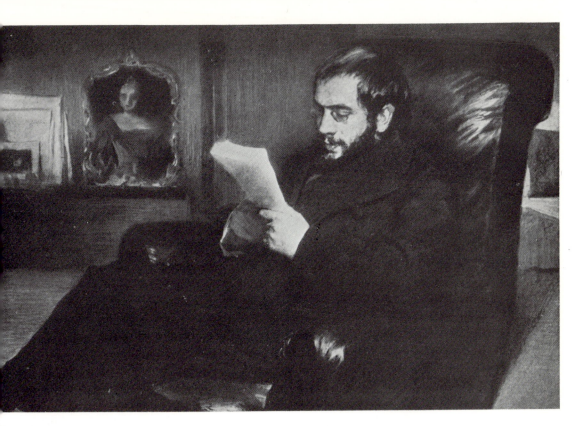

Top: Leon Bakst: *Portrait of Alexandre Benois*, 1898

Above: Valentin Sefrov: *Portrait sketch
of Sergey Diaghilev,* c.1900

Left: Alexandre Benois: *Leon Bakst Waiting for the Train
at Martychkino Station, near St Petersburg,* 1896.
Private collection, Paris

ЛОЖНЫЕ ВОПРОСЫ.

Нашъ Мнимый Упадокъ

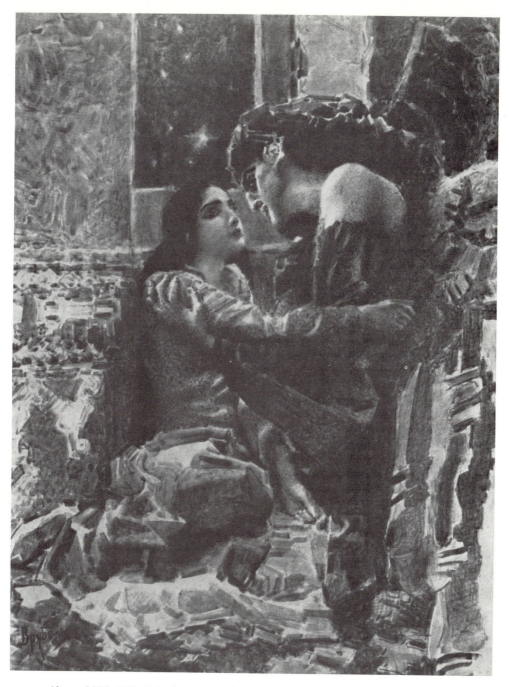

Above: Mikhail Vrubel: *Tamara and the Demon* (watercolour), 1890–91.
Tretyakov Gallery, Moscow

Opposite above: Viktor Vasnetsov: illumination for *Mir iskusstva*, Volume One, 1899.
Headpiece for Diaghilev's article 'Complicated Questions'

Left: Viktor Vasnetsov: *St Nikita, Nestor and Scribe*
(at St Prokopiy Ustyuzhsky), *Mir iskusstva*, Volume One, 1899.
The inclusion of this work by Vasnetsov in the first issue nearly
precipitated Benois's withdrawal from *Mir iskusstva*

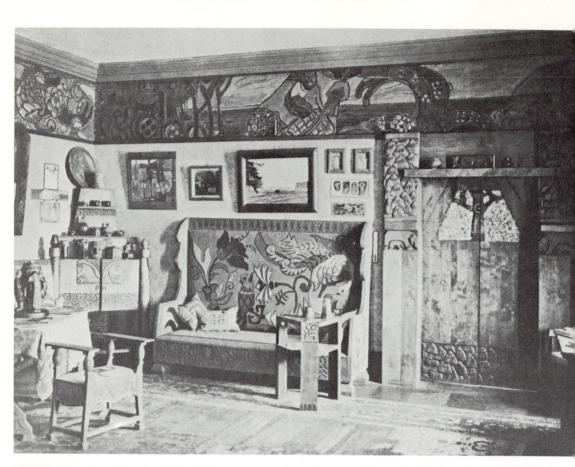

Top: The traditions of Old Russia were emphasized at Talashkino, Princess Tenisheva's estate and artists' colony near Smolensk.
The frieze is by Roerich

Above: Interior of the church at Talashkino

Left: Princess Tenisheva at Talashkino

canvas. 'From beginning to end there is nothing here but utter madness, anti-artfulness and repulsiveness. ... No matter where you look ... all you see is rubbish and more rubbish ... ugliness, ugliness, ugliness.'[18]

Despite this violent opposition, many of Russia's most promising artists were attracted to Diaghilev's banner. His three exhibitions served as rehearsals for the famous show of 1899, the first to be sponsored officially by *Mir iskusstva*, one which broadened dramatically the taste of the Russian public. The journal and its activities marked the moment at which Diaghilev emerged as a recognizable public figure in St Petersburg and in Russia.

* * *

It is difficult to classify *Mir iskusstva*; it was an umbrella which sheltered a variety of activities. At the outset an association of friends and colleagues, it became a journal of the arts, an exhibiting society and eventually a point of view.

Diaghilev foresaw that a lack of capital would be only a temporary handicap. In his efforts to raise the necessary funds he was responsible for the brief alliance between two of Russia's most illustrious and unpredictable patrons: one, Princess Mariya Klavdiyevna Tenisheva, an aristocrat who bent all her efforts toward the support and revival of Russian folk art; the other, one of the earliest and greatest of the Moscow merchant-patrons, a backer of the Wanderers, Savva Ivanovich Mamontov.

Diaghilev's assiduous early pursuit of powerful and affluent members of Russian society was helpful in securing this support. In October 1897, while Benois was still in Paris, he received a letter from his friend: 'The Princess Tenisheva is in St Petersburg and we have entered into a *great friendship*. She is full of enthusiasm and, I believe, money.'[19] The Princess was no stranger to Benois. That same year she had employed him to catalogue and organize an exhibition of her collection, and in 1898 he returned to St Petersburg to supervise its installation in the Russian Museum of Alexander III. During the early stages of their relationship, Benois credited himself with widening Tenisheva's artistic outlook. He regarded her concentration on Russian art as limiting: 'I was able gradually to guide her tastes, to share with her some of my learning, rid her of many prejudices, and teach her to be a more circumspect observer of contemporary art.'[20] If Diaghilev was occasionally mistrusted as a mere showman, his association with the scholarly Benois was a reassuring element for the prospective investor.[21] Though Tenisheva was considered eccentric by some, this handsome, imposing woman was a generous patron. Dedicated to preserving the artistic heritage and artisanship of Russia, she had established a well-known craft centre and artists' retreat on her estate at Talashkino near Smolensk.

The house was a testimonial to her devotion to the art of the Russian past.

Roerich had created the striking wall frieze *The Heavenly Mother over the River of Life* which evoked memories of a pre-Petrine era. The massive, intricately carved furniture, heavy embroidered fabrics and ornate bibelots were complemented by the imaginative versions of folk art which had been created in the workshops and kilns of the estate by contemporary Russian artists: elaborate wood carvings, brilliantly glazed enamel work and embroideries. A memorable souvenir of Vrubel's presence was the lavishly decorated balalayka with its fanciful scene of sea, sky and mermaid; a work of art and a cultural artefact. Diaghilev and his cousin, the elegant Filosofov, visited the Princess here several times, and in this atmosphere reminiscent of Tolstoy and Old Russia, surrounded by retainers in white tunics and black boots, the two unnervingly brilliant young men spoke of the emerging trends in Russian art, and the role she might play in influencing the future.

As the financial negotiations progressed, it was decided to invite Mamontov, a friend and rival of Tenisheva's, to participate. In light of his recently expressed interest, Diaghilev was optimistic that the merchant might also be persuaded to lend his financial support to *Mir iskusstva*.

Thus, according to Benois, 'along with Tenisheva thirsting for noble fame, the well-known Moscow patron – the unrestrained "mad" Savva Mamontov – appeared on our horizon.'[22] With Mamontov's acceptance, the pace of the discussions accelerated and soon it was agreed that Tenisheva would pay half the expenses (12,500 rubles) and the balance would come from Mamontov.

It is interesting to speculate what argument Diaghilev used to persuade these friends and upholders of the national tradition and the Wanderers to sponsor *Mir iskusstva*. His belief in the strength of Russian art was genuine, and the Princess Tenisheva, with her love of craftsmanship and ornamentation, must have been attracted by the idea of integrating decoration and design into every aspect of daily living. Diaghilev's admiration for Art Nouveau, so similar to early Russian decoration, the emphasis on ornamental objects and interiors, carvings and exotic glassware, the beautification of everyday objects, all of which formed a part of the *Mir iskusstva* ethos, coincided with her aim of revitalizing and utilizing old Russian forms. Also for this occasion, Diaghilev undoubtedly emphasized his concern with the arts and antiquities of ancient Russia and minimized his disdain for the early Wanderers, the followers of Chernyshevsky with their 'narrow utilitarian tendentious quality in art. . . .'[23] He was too clever to attack the Wanderers directly. Repin and Viktor Vasnetsov, both friends of Mamontov and Tenisheva, could be given credit for their challenge to Academic art, but Diaghilev considered them only the beginning of a long path, 'the primitives of the renaissance of our art in the national Russian spirit'.[24] He was convinced that Russian art, freed of parochialism, would attain international recognition. A year earlier he had declared, 'I want to care for Russian painting,

purify it, extol it, and above all, take it to the West.'[25] These sentiments would
have been an effective approach to his new sponsors and must have had a special
appeal to the ambitious Mamontov. Timing was unarguably an element in
Diaghilev's success with Tenisheva. For some time she had been a friend and
patron of Repin. She had opened a studio for him in St Petersburg to which
young people from all over Russia came to study, and had sat for numerous
portraits for which he charged her husband five thousand rubles apiece. Lately
however, she had grown weary of the painter's dogmatism and what she
perceived as his arrogance. She had been disturbed by a growing commercialism
in his work, by his constantly escalating fees and by his tendency to exploit his
relationship with Tolstoy. She wrote that Repin 'lived off' the writer, and in his
pursuit of prominent and popular figures, she found something 'artificial and
unpleasant'.[26] These sentiments could have precipitated her backing of the new
publication.

Though Prince Tenishev warned his wife that Diaghilev cared little for her
goals and opinions and was interested only in her money, the arrangements were
concluded in an atmosphere of high expectations. The collaboration of
Mamontov and Tenisheva in the venture was celebrated at a gala dinner given
by Tenisheva, and in March 1898, the editorial contract was signed. But the
initial enthusiasm soon dwindled. The alliance was stormy from the beginning,
an unpromising combination of divergent tastes, strong wills and unforeseen
circumstances, and the agreement proved to be only temporary. In 1899
Mamontov was arrested and imprisoned on charges of embezzlement and
financial manipulation. A year later he was found not guilty and released, but he
was completely bankrupt and unable to fulfil his commitment.

Thus the Princess Tenisheva found herself exclusively responsible for the
solvency of *Mir iskusstva*, and she was alarmed constantly by Diaghilev's
extravagance. Perfectionism is costly and he had kept the price of the review
low: ten rubles for an annual subscription of twenty-four issues. It was clear that
the projected circulation of four thousand would be insufficient to cover the
spiralling expenses. The financial problems of the early issues were ameliorated
in part by a series of advertisements for leading Russian business firms: the
Morozov warehouses, phonographs, pianos, high button shoes and the latest
ladies' fashions, wasp-waisted, lavishly embroidered and trimmed with fur.

Because of her romanticism and idealism, her unstinting dedication to the arts
and crafts of Old Russia, Tenisheva had always endured the ridicule of a
'sophisticated' part of St Petersburg society, but *Mir iskusstva* heightened her
vulnerability without granting her a commensurate role in editorial policy. Later
she wrote, 'Diaghilev was becoming increasingly audacious, meeting with his
friends openly to compose their chronicles, ridiculing everyone and everything
and wounding people in their most sensitive spots'.[27] She was particularly

pained by the scathing evaluations of V.V. Vereschchagin which appeared
regularly. On the occasion of a London showing of his work, this small item was
noted: 'Poor England is being threatened by exhibitions of the Russian artists
Yu. Klever and V. Vereshchagin. How can we protect Russian art and the
English public from such an awful surprise?'[28] The mockery angered her: 'I
thought it unforgivable to use our journal to bait people who had long ago earned
a reputation, who were appreciated by society, and who had done a great deal for
Russian art.'[29]

The cabals and intrigues within the board were destructive, and Tenisheva's
relationship with Benois was deteriorating rapidly because of his constant
emphasis on Western standards. In addition she was becoming alarmed by the
hostility that Diaghilev engendered among many of her friends. In her role as a
female Croesus, the Princess was lampooned mercilessly in the Russian press.
One biting cartoon portrayed her as a cow being milked by Diaghilev, while
Filosofov stood by, pitcher in hand.[30] 'Fighting over money, paying colossal
sums and receiving only difficulties both from the one to whom the money was
paid and from those disturbed with the journal's escapades. . . . But what was
most painful was that my husband's words about Diaghilev came true.'[31]

These cumulative frustrations became unbearable and finally Tenisheva
withdrew after a series of clashes and personal difficulties with Diaghilev. With
her good works and lofty aims, she was an easy target for his sophisticated wit
and misogyny, but although she was undoubtedly annoying at times, the lady
deserved better; her backing while it lasted was sufficient to launch the
enterprise.[32]

Diaghilev never permitted a temporary lack of funds to impede his
momentum. His optimism was justified. Two admirers, Dr Sergey Botkin, the
son of one of Russia's most eminent physicians, and Ilya Ostrukhov, a
prominent Moscow businessman, combined briefly to fill the financial void. In
1900 when Serov was commissioned to paint the portrait of Nicholas II[33] he
used his entrée to the Tsar to persuade him to contribute, for the continuation of
the journal, 10,000 rubles annually from his private funds. This royal subsidy
continued until 1904, the final year of publication.

The policies and standards of *Mir iskusstva* were decided in a series of
informal meetings by a gathering of precocious and inexperienced pioneers.
Diaghilev had anticipated that for his project he would need not only money, but
the special talents of the Pickwickians. As with many such fraternities, the
members had disbanded, each to his own career and preoccupation, but in
response to his urging, several of them reassembled to form the core of *Mir
iskusstva*. With this undertaking, Diaghilev found his vocation. The supreme
impresario, he orchestrated the different contributions and opinions with
consummate skill.

A vignette of the early editorial sessions provides an interesting backstage glimpse. The first conferences were held every day at teatime from four to seven o'clock in Sergey's apartment in a big house at the corner of Liteyny Prospekt and Semyonovskaya Street. It was a ponderous setting for a young man; high backed, ornately carved armchairs, gilded furniture and a handsome Blüthner piano. Scattered conspicuously throughout the rooms were photographs of famous contemporary figures, all warmly inscribed. Whenever Diaghilev travelled abroad and visited Beardsley, Zola, Verdi or Massenet, he returned from these forays with autographed evidence of their esteem. It was Benois's wry observation that his friend's pilgrimages to these prominent figures were prompted less by respect than by a desire to impress his compatriots. It was possible to follow Diaghilev's changing artistic tastes by noting the paintings. Benois had written of the selections: 'The place of honour was occupied by three portraits by Lenbach, two drawings by Menzel, some watercolours by Hans Herrman and Bartels, a pastel portrait by Puvis de Chavannes and several sketches by Dagnan-Bouveret.'[34] After his arrival from Perm he had purchased works by the most uncompromising of the Wanderers: studies by Kramskoy and Shishkin, and Repin's small sketch of a woman kneeling. Gradually, as he responded to the internationalism of St Petersburg and the influence of Benois, these were displaced by more worldly fare. This collection was echoed in a second room by a series of unsparing, sometimes brutal caricatures by Bakst and Serov. All guests were fair game, their foibles dissected and their likenesses pinned to the wall like a collection of rare butterflies.

In the elegant, slightly unreal atmosphere of these pre-publication meetings, the host functioned as general editor and Filosofov as literary adviser. In June 1898, in a letter to Benois when he was still in Paris, Nouvel described the proceedings: 'The composition of our editorial board is as follows: Dima [Filosofov] on the right, myself on the left, while the chairman, Seryozha [Diaghilev] listens to the declarations of the left, and upholds the right.'[35] These literary novices gathered around a sixteenth-century writing table littered with paste pots, scissors, writing materials and a gleaming samovar, and out of the clutter, managed to create one of the most authoritative reviews in Russia. The sense of intimacy was heightened by the presence of Diaghilev's old nurse, who tended the shiny brass urn, served strong tea with thin slices of lemon and sat quietly in a corner when she wasn't needed. Bakst's well-known portrait of Sergey in this setting preserves the moment; an urbane, sybaritic, slightly rotund young man, surrounded by his possessions, and on a stool in the background, the old woman with faded, watchful eyes.

The product of these meetings was the appearance in November 1898[36] of the first issue of *Mir iskusstva*. It was largely the result of the editorial collaboration between Diaghilev and his lieutenant, Filosofov. The other participants and

advisers gradually assembled: Bakst, Nouvel, Korovin, Serov and Alfred Nurok. Nurok had been introduced to the Pickwickians in 1893 by Charles Birlé, the French consular official who had been so enthusiastic about the Post-Impressionists. Nurok was something of an actor, boasting of his success with the ladies, always with an erotic book jutting out of his pocket, though his bald head and spectacles did little to make his romantic pretensions credible. But his talent for music was authentic. A gifted pianist and composer, he collaborated with Nouvel on the excellent and progressive *Musical Chronicle* which favoured the music of Wagner, Delibes and Skryabin, among others. Nurok had contributed several articles to *Pipifax*, a satirical magazine published in German in St Petersburg, and Diaghilev had placed him in charge of the 'Satirical Sketches' for *Mir iskusstva* where his acerbity and talent for irony frequently embroiled him in controversy.

Korovin, a popular Moscow artist and a friend of Savva Mamontov, was a charmer and raconteur whose theatrical designs and canvases were full of the colour and energy which seemed to typify the Moscow School. Serov, though only seven years older than Diaghilev, had become the father-figure of the group. His approval meant a great deal, even to Diaghilev, for as Benois remarked, 'We needed him for the care of our souls and for the collective soul of our circle.'[37]

At the time the first issue was being prepared, Benois, recently married, was still living in France, despite repeated pleas from Diaghilev to return home to work on the journal.[38] As a result of his absence during this crucial interval, Benois was to become involved in bitter disagreement with Diaghilev and Filosofov.

One of the strongest characteristics of *Mir iskusstva* was the combativeness of its progenitors. An example of political differences between these powerful egos was provided in the first issue of 1898–99. During Benois's absence in France, Filosofov and Diaghilev were working closely together. With his strain of spiritualistic nationalism, Filosofov responded to the contemporary painters of old Russian themes, as opposed to the merely aesthetic art of the Westerners. After returning from a journey to the old capitals of Kiev and Moscow, Diaghilev and Filosofov decided to feature the work of two of the most popular of the Moscow painters: Viktor Vasnetsov and Isaak Levitan, both of whom were protégés of Mamontov. The majority of the group, including Benois, Somov, Nouvel and Bakst, admired Levitan, but the choice of Vasnetsov was bitterly divisive. Benois, still in France, detected Filosofov's hand in the unexpected decision. In Nouvel's words, Filosofov had come to regard Vasnetsov as 'the torch of a new Russian art . . . a genius, a radiant herald of the new Rus.' The painter was undeniably a great public favourite, but the opponents argued that the inclusion of his heraldic religious figures and allegories vitiated everything that *Mir iskusstva* represented. The intensity of

these arguments was reflected in their terminology. Filosofov characterized the works of the French artists Steinlen and Forain, preferred by the Westerners, as 'brothel art'; Nouvel described one of Filosofov's treasured pictures as not only 'primeval' but in 'bad taste' – a devastating slur; and finally Dmitry accused Bakst and Nouvel of being 'foreigners', of not understanding 'the Russian soul'.[39] Diaghilev cast his vote with Filosofov.[40] Undoubtedly economics played a part in his decision, for Mamontov's name was on the masthead. However, despite the monetary pressures, a compromise based solely on financial considerations was rare. Diaghilev was influenced by Filosofov, but his own response to Vasnetsov's naïve images was probably genuine. There was still a vein of Slavic primitivism under his worldly veneer.[41]

The policy which was to shape the journal was outlined by Diaghilev in the opening editorial:

> Those who accuse us of blindly loving whatever is modern and of despising the past, have not the slightest conception of our real point of view. I say and repeat that our first masters and our Olympian gods were Giotto, Shakespeare and Bach, yet it is true that we have dared to place Puvis de Chavannes, Dostoyevsky and Wagner at their sides. Nevertheless, this is a perfectly logical development of our fundamental position. Having rejected every accepted standard, each and every one of these artists has been weighed up strictly in accordance with what we personally demand, and we have gazed at the past through a modern prism, and have worshipped only what we personally found worthy of adoration.[42]

Despite this serene avowal, the editors of *Mir iskusstva* continued to be fractious. Violent arguments erupted frequently; they would coalesce and divide with the inevitability of amoebae, drawn together by a perceived theory, separated by a deviation.

When Benois finally resumed full participation in *Mir iskusstva* it became an extension of his personality and that of Diaghilev. The combination produced a creative tension. In the midst of Diaghilev's artistic innovation and uproar, Benois's balanced contribution was always identifiable, running like a thread through the paper. He had absorbed the beauty and strange poignancy of his Russian homeland, filtering them through the subtlety of his own perceptions. The resulting amalgam of Russian fairy-tale and French sophistication found its expression in *Petrushka* and *Mir iskusstva*.

In its sheer polish and cultivation, the publication was a reflection of the values which typified the capital. To pick up a copy today is to re-enter a world in which decoration, harmony and technical excellence were the dominant criteria. Bakst had designed an appropriately exotic logo, a Russian eagle, its great talons curving over a globe, set against a starry sky and a sliver of moon. In a letter to Benois, Bakst explained the meaning of his design: '*Mir iskusstva* is

above all that is earthly, it is with the stars where it reigns arrogantly, secretively and alone, as the eagle above the snow, and in this case, it is the eagle of the lands of the midnight sun, i.e. northern Russia.'[43]

There had been a shortage of good paper at first, and the quality used in the early issues had been poor, but gradually the pages acquired a thick, glossy texture and this, in combination with the ornate eighteenth-century type, heightened the sumptuous effect. Articles were frequently not separate sections of text and illustration but a historiated combination of the two. The decorative head pieces were gold leaf; flowers and Russian thistles in blue or deep rose-pink curved around the margins. Because of Diaghilev's refusal to compromise, the journal set a standard for printing which upgraded publishing in Russia for years to come.

At the outset *Mir iskusstva* was conceived as a review of all the arts: a fresh exploration of music, theatre, painting and literature, but over a period of time the focus narrowed and the visual element became predominant.

Diaghilev's talent for self-aggrandizement supplied an atmosphere of unpredictability and excitement which added to the popular appeal of the magazine. The enthusiasm with which it attacked the ideas of an entrenched artistic establishment added greatly to its audience. There were many who read *Mir iskusstva* to discover what they were against.

For all its innovations, controversy and dedication to change, the magazine was essentially a product of the intellectual bourgeoisie. The leaders considered themselves rebels against the St Petersburg Academy, but their greatest differences were with the Wanderers whose simplistic nationalism they deplored.

To Benois and Diaghilev, the chauvinism of the Wanderers was a rude artistic irrelevancy. Nevertheless, *Mir iskusstva* recognized certain members as national resources: the landscapes of Levitan transcended dogma, and Repin's dramatic force and technical ability were conceded. Even Benois admitted that *Volga Boatmen* possessed qualities of vitality and organization, and Repin's portraits of Tolstoy and Tretyakov appeared in the early issues of 1899. Initially Repin had welcomed the advent of an art publication; the presence of Tenisheva and Mamontov provided reassurance and his own position was acknowledged. But the ingredients for basic disagreement were always present.

When Diaghilev published an article attacking the work of the Polish historical artist Jan Matejko (1838–93), a former colleague of Repin's, as being without artistic merit 'other than patriotic',[44] Repin, noted for his temper, retaliated in a devastating fashion. He painted a picture of himself in a Russian tunic, as a divine and righteous prophet, pushing away a Diaghilev who resembled a slatternly female with large breasts and a satanic countenance; the caption: 'Get thee behind me, Satan.' Russian feuds were often deadly and

deeply personal. In addition, he later wrote a letter to the editor of *Niva* which was published in *Mir iskusstva*. It purported to be a rebuttal of the criticism of Matejko, but in reality it was a defence of his own values and a stinging public attack on the tactics of *Mir iskusstva* and the effeteness of its ideas. It opened with the announcement of his withdrawal from any further association with the publication and ended with an excoriation of Diaghilev and company.

Repin could no longer bear the idealization of Western standards and the airy unconcern with reality which characterized *Mir iskusstva*. Diaghilev in turn contended that the Wanderers were still 'speaking in Chernyshevsky's words ... painting games and rags on canvas.'[45] Forty years had passed since Chernyshevsky set down his theory of social utilitarianism in art, but for some, the idea was still pertinent.

Despite the hostility of Repin and his followers, *Mir iskusstva* continued to flourish and for a time the polite forms of St Petersburg dominated the art scene in Russia. But the magazine was slow to recognize the significance of the Impressionists. It was not until the final issue in 1904 that *Mir iskusstva* carried the work of Van Gogh, Gauguin, Cézanne and Bonnard. This indifference to the French avant-garde was a factor in the decline of the publication and the return of the centre of gravity of the Russian art world to Moscow.

<center>* * *</center>

An illustration of the final stage of the rivalry between Moscow and St Petersburg is contained in the art exhibitions arranged by *Mir iskusstva*. The first was particularly brilliant and successful, for, like illustrations to a text, it served to clarify the philosophy which governed the magazine. Diaghilev's theatrical gifts were invaluable on these occasions. The first showing under the imprimatur of *Mir iskusstva* took place in 1899.

The setting for this exhibition was created with great care. The Stieglitz Art Institute was no cold, echoing marble shell, but an inviting scene of elegant furnishings, hyacinths, greenery and soft music. Here the impresario established the style which he was to employ over the years in Russia and France: the lavish mise-en-scène with which he surrounded his offerings.

The opening section featured Diaghilev's version of international folk art: crystal and jewelry from Lalique, Art Nouveau fantasies in glass designed by Louis Comfort Tiffany, together with ceramics and embroideries from Mamontov's studios at Abramtsevo and the Talashkino colony of Tenisheva. The sumptuous surroundings contained every aspect of contemporary Russian painting, from the 'Impressionism' of Konstantin Korovin to Apollinary Vasnetsov's 'artistic reconstructions of old Moscow'.[46] The founders and shapers of *Mir iskusstva* were shown with the Wanderers' epitomist, Repin. Benois took pride in the fact that the best Russian work was shown without regard to political

attitudes or labels. Mamontov's favourites, Viktor Vasnetsov, Vasily Polenov and Mikhail Nesterov, were displayed generously. Repin was represented by a single portrait of Prince Sergey Volkonsky, a leading progressive force in St Petersburg's art circles and an admirer of *Mir iskusstva*. There were nine landscapes by Levitan, whose lyrical scenes of the Russian countryside had been a part of the Wanderers' exhibitions from 1884 onwards, and seemed to span the gulf between the Slavs and the Westerners.[47] Also among the Moscow artists, Golovin was represented by three scenes of Old Russia, Sergey Malyutin, a protégé of Tenisheva's, sent one work, and Serov loaned three striking portraits, as well as four landscapes in pastels and watercolours, reminders of his early work. Vrubel was not listed in the catalogue, but his painting *Rusalka* (*Sea Maiden*) was purchased from the show by Princess Tenisheva to the further distress of Repin.

Diaghilev cultivated his foreign contacts carefully; European painters and dealers had learned from his previous exhibitions that it was possible to create a lucrative market in Russia under his sponsorship. As a result, he was able to display an unusually comprehensive collection of Western art. There were five glossy works by Boldini and, from the British school, the watercolours of Sir Frank Brangwyn and Charles Conder. The show included many of Diaghilev's personal preferences: seven paintings by Max Liebermann, four Whistlers and three landscapes by the Norwegian Fritz Thaulow.

The list of French artists is revealing. Twenty years after the début of the Impressionists, when many important examples were available in Paris, there were two minor pictures by Monet and two by Renoir. After his stay in Paris, Benois claimed to have developed a taste for the Impressionists, but among his favourites in the group he listed Degas, Delacroix, Corot, Daumier and Courbet. *Mir iskusstva*'s predilection for Art Nouveau was implicit in the seven paintings by Gustave Moreau. The French section was heavily studded with salon stars: Lucien Simon sent seven paintings, Eugène Carrière showed three, and the fashionable world of Jean Louis Forain was reflected in two canvases. Puvis de Chavannes was represented by three works. Many of these pictures were seen in Russia for the first time and entered local collections as a result of this exhibition.

The single Impressionist whose work was shown in depth was Degas, whose works, of all the Impressionists, were the most structured. Princess Tenisheva had personally brought from Paris one or two spectacular canvases and the painter was represented by a total of eight pictures, including *La Repasseuse*, *La Toilette*, a marvellously bored and indifferent nude, and several animated racecourse scenes. It was *Mir iskusstva*'s admiration for these works which provoked a further outburst from Repin:

One cannot escape of course without a genius, without an idol. Recently, such was the modest mediocre Puvis de Chavannes. He died. A new one, also inoffensive,

not yielding an affirmative definition, is needed – an artist little valued in his insignificance, something acquired long ago by the all-powerful dexterous merchant, Durand-Ruel. Degas, the half-blind artist, living his life in poverty – here is the idol of painting. Pay attention, heathens!

The dealer Durand-Ruel was a particular focus of Repin's resentment because of his early sponsorship of the Impressionists. The Russian considered him merely 'an adroit shopkeeper'. Repin disdained *Mir iskusstva* for commercialism and accused the editors of creating a market for Western art and making it 'fashionable'. The prices brought by the works of Degas in Russia and America activated his resentment. He wrote of 'Jockeys', which sold for 40,000 rubles: 'top price for this painting should have been 400 rubles.'[48] In essence, Repin's rhetoric was a plea for recognition of the contribution of those like himself who had pioneered in a movement that had restored pride in the Russian tradition; the cry of a man who had lost the next generation.

Though Repin railed against the 'fanatical arrogance' of a world gone mad which he found at the exhibition, and the display was attacked in the press for debasing public taste and perverting the innocent, a cursory consideration of the paintings makes it clear that *Mir iskusstva* was far from subversive in its selections.

The excitement of this first exhibition led Diaghilev to put on others, none of which however equalled the impact of the original. After the exit of Princess Tenisheva at the end of 1899, he could no longer afford the expenses incumbent upon the importation of foreign works. He was forced to rely on the talents of the best young Russian painters, and increasingly these were coming out of Moscow.

After the exhibition of 1900, a growing restlessness was apparent among the Moscow contingent. The causes were ideological and personal. Ideologically, the Muscovites resented the domination of St Petersburg, the emphasis on linear elegance, graphic art and eighteenth-century France which was becoming increasingly apparent in *Mir iskusstva* and its exhibitions. On a personal level, Diaghilev's authoritarianism was resented, particularly his arbitrary selection of the works to be shown. In December 1901, the dissidents formed a group – The 36 – to show their work in Moscow independently of *Mir iskusstva*. The insurgents were led by Mamontov's protégé Apollinary Vasnetsov, and a landscapist, Sergey Vinogradov. They rejected Diaghilev's 'jury', and invited those of the St Petersburg group who were interested to join them in an exhibition. Bakst, Lancéray and Somov were shown with Nesterov, Andrey Ryabushkin, a painter of seventeenth-century Moscow scenes, and Vrubel. The occasion was important mainly as a declaration of independence by the rebels and as evidence that St Petersburg artists could be counted on to collaborate.

The growing strength of Moscow's art was demonstrated when the *Mir*

iskusstva exhibition opened in the St Petersburg Arcade in March 1902. Sets and costumes by Bakst were set next to Benois's graceful scenes of Versailles. But Moscow's intensity and vigour were demonstrated by the vivid works of Korovin, Leonid Pasternak and Ryabushkin. An indication of change in the Moscow ranks was the presence of Pavel Kuznetsov and Nikolay Sapunov, who within three years were to form the nucleus of a new wave, the symbolist painters of the Blue Rose. The most overpowering work in the show was Vrubel's giant canvas *The Demon Downcast*. With its shattering impact and haunting sense of the abyss, it attracted the attention of every visitor and seemed to signal the re-emergence of Moscow as a vital force in Russian art. It was Moscow's rampant colour, inventiveness and occasional roughness versus St Petersburg's exquisite sense of decoration and patrician concern with form.

Diaghilev's recognition of the challenge was implicit in a letter he sent to Serov on October 15, 1902, in which he urged him to use his influence to persuade the members of the Moscow group to affiliate themselves with *Mir iskusstva*:

> You have to take care of the Moscow artists, i.e. before anything else you should go to see Malyavin. ... Convince him to exhibit something new – this is a must. ... Then you'll need to talk to 1) Vinogradov, 2) Pasternak, 3) M. Mamontov. We must tear them out of the clutches of the '36'! Then you are responsible for the young ones: Petrovichev, Kuznetsov, Sapunov – they must be 'ours'.[49]

In 1903, the Union of Russian Artists was formed in Moscow and gave its first showing at the Stroganov Institute, a move which presaged the dissolution of the St Petersburg series of exhibitions as well as of *Mir iskusstva* itself.

After the opening of the magazine's final exhibition in 1903, a meeting was held in Diaghilev's editorial office to discuss a merger between the Union of Russian Artists and *Mir iskusstva* for the purpose of joint exhibitions. The entire membership of the magazine was present and 'all of Moscow was there as well.' Benois wrote later that the death sentence of *Mir iskusstva* was pronounced at this assembly. Diaghilev opened with a conciliatory speech, acknowledging that there had been dissatisfaction with the selections committee, and asked for suggestions. Gradually as the members began to take the floor, it became evident that there was more at stake than a 'dictatorial' jury. Igor Grabar, the Impressionist painter, writer and art historian who later became the Curator-Director of the Tretyakov Gallery, was present. He realized suddenly that he was witnessing 'an open battle between Moscow and St Petersburg'. Diaghilev and Filosofov sat in silence, and unexpectedly, Benois rose to support the formation of a new society. Finally 'everyone stood up and Filosofov pronounced loudly, "Well, thank God that's the end of it".'[50]

The last important event in Russia with which Diaghilev was associated occurred in 1905 after the closing of the journal. The Tauride Palace Exhibition was the final triumph left to him in his own country. This footnote to the St Petersburg period illustrates the complexity of his character and the tumult of the era.

* * *

1905, that fateful year in Russian history, had begun with the uprising and massacre before the Winter Palace in St Petersburg. The savagery with which the demonstration had been put down by the troops, the shocking loss of life and subsequent government-instigated pogroms, had hardened the resolve of the revolutionaries and radicalized much of the middle class. Many of the country's most successful artists joined in the protests. Valentin Serov, who had spent his life idealizing the court figures of St Petersburg and the exemplars of Moscow's wealth and power, produced several incendiary works in the aftermath of this revolution. *Harvest* is a prophetic sketch, in India ink on paper, in which sheaves of bayonets are stacked in the Russian fields. Another sketch, *The Year 1905: After Quelling a Riot* was even more damning: a dessicated and foppish officer pinning a medal on a member of his rigidly proud troops against a backdrop of carefully laid out civilian corpses of men, women and children. Perhaps the most electrifying of Serov's efforts in this area was a great tempera and charcoal on cardboard. *Soldiers, Soldiers, Heroes Every One* is painted from the vantage point of the Cossacks at the moment of charge, as the officer's arm is raised and the swords are unsheathed. Huddled across the square is a dark, faceless, human mass. Yevgeny Lancéray of *Mir iskusstva* contributed a drawing to *Adskaya Pochta* (*Hell's Post Office*), a satirical journal published in 1906. In this sketch, *Feast After a Massacre* (1906), the porcine officers in their revels foreshadow Georg Grosz. These painters were not born revolutionaries, and their efforts reveal the depth of the alienation and revulsion of even the most privileged members of Russian society at this time.

There was a pervasive air of foreboding in the year in which Diaghilev assembled a retrospective of Russian portraits dating from 1705 to 1905. Against an unsettled background, he had travelled throughout the country to the great old houses of Russia, persuading the owners to lend treasured family portraits, or scouring the storage rooms for those which had been discarded.

The exhibition was an epic unfolding of two centuries of Russian history at a time, and in a setting which was particularly appropriate. Diaghilev chose a characteristically magnificent environment, the Tauride Palace, which had been built for Grigory Potyomkin by Catherine the Great. The palace, designed by Ivan Yegorovich Starov, one of the first Russian architects to be trained at the Academy, had been built between 1783 and 1789 and was a combination of St Petersburg's favourite colours: yellow walls, white columns and a green roof. It

was a spacious shell of a house with enormous rooms, a winter garden laced with footpaths, and at the centre, a temple with a statue of the Empress Catherine. The garden led into a vast oval-shaped Colonnade Hall and beyond, to a smaller circular Cupola Hall. Bakst had transformed the scene into a fantasy of trellises, greenery, columns and sculpture in which were housed over three thousand works of art – a panorama of two hundred years of the Russian past. The earliest examples of Russian easel painting were disinterred: the serf-artists, Argunov and Ushakov, then Levitsky, Borovikovsky, Rokotov; the recognized and the nameless, all part of a tradition that was under siege.

Under the patronage of the Tsar, it was a rediscovery and a celebration of an area of Russian art which had been largely forgotten. The Tsar had grown wary of Diaghilev and the controversy which surrounded him, but on this occasion, the reaction was everything the organizer could have wished. However, despite the brilliance of the gathering and the seeming inviolability of the occasion, there was an atmosphere of twilight to which Diaghilev responded. In the midst of this glittering tribute to the old order, he later acknowledged a sense of impending loss. At a dinner given in his honour by Ilya Ostrukhov and a group of Moscow admirers a short time after, he was unusually reflective:

> Don't you feel that the long gallery of portraits depicting great and lesser people with which I attempted to populate the magnificent halls of the Tavrichevsky Palace, is only a grandiose and convincing summation of a brilliant, alas, now deceased, period in our history? I have earned the right to say this loudly and definitely, since with the last gust of the summer breezes, I have just ended my long journeys across boundless Russia. And it was after these acquisitive wanderings that I became particularly convinced that a time of reckoning had arrived. I saw that not only in the magnificent images of our predecessors, so far removed from us, but primarily in their descendants. The end of a way of life is at hand. The quiet, gloomy palaces, frightening in their dying glory, are inhabited today by charming, mediocre people who can no longer bear the anguish of former parades. When their lives are ended, not only people will be lost, but pages of history. And this is when I became convinced that we are living in the awesome time of a turning point. We have been doomed to die so that a new culture may be born, a culture that will sweep away what remains of our tired wisdom. . . . And thus it is, that without fear or lack of faith, I raise my glass to the ruined walls of the beautiful palaces as well as to the new commandments of a new aesthetic. And the only hope that I, as an incorrigible sensualist, can have is that the forthcoming struggle will not insult the beauty of life and that death will be as resplendent as the Resurrection.[51]

It was a prescient and moving assessment from a man who boasted of his lack of political insight. The following year, 1906, Diaghilev left for Paris to install the Russian section at the Salon d'Automne.

The artistic movement associated with *Mir iskusstva* manifested itself not only in the art exhibitions and the influence on Russian painting, it also infused a new force into the world of the theatre. 'Synthesis of the arts', a somewhat opaque phrase, is frequently used to describe the aim of the journal. In the theatre it translated into a blending of music, dance, drama and painting which formed a single aesthetic unit, one in which the scenic element was as important to the production as any other.

The entrance of the *Mir iskusstva* members into the theatrical field had an unplanned, almost implausible flavour. None of them had been involved professionally in this area until Diaghilev was invited by Prince Sergey Volkonsky to join the Imperial Theatres in St Petersburg in 1899. An admirer of *Mir iskusstva* and a literary contributor, Prince Volkonsky wished to eliminate the overlay of predictability which had dulled the St Petersburg productions. Diaghilev was assigned to renovate the *Yezhegodnik imperatorskikh teatrov* (*Annual of the Imperial Theatres*) for 1889–90, and as usual, he surrounded himself with friends whom he trusted. The decorative talents of Bakst and Somov were employed to turn the volume into a collector's item; Benois contributed an article, and Diaghilev, who had never attended a ballet until three years earlier, wrote a detailed account of the ballets performed at the Imperial Theatres during the previous seventy-two years. The result was a dazzling and scholarly display of bibliophilic art which was praised by the Tsar.

After his success, Diaghilev was scheduled to direct his first ballet, but his tenure was shortened by a violent disagreement with Prince Volkonsky and he was dismissed in 1901. However, the experience had exposed him and his friends to a milieu which would provide the opportunity for their most memorable work. It was a modest beginning for a collaboration which would revolutionize stage design in the West a few years later. As Benois observed, 'It was no accident that what was afterwards known as the Ballets Russes was originally conceived, not by the professionals of the dance, but by a circle of artists linked together by the idea of Art as an entity.'[52] They introduced the concept of a theatre in which scenic design was no longer a subsidiary factor, not merely a backdrop turned out by artisans against which the performance took place, but a prime element, which at its best heightened the mood, projected the author's intentions and drew the audience into the action.

Diaghilev has been credited with originating the idea of theatrical synthesis, and unquestionably, with the Ballets Russes he developed and exported the formula magnificently. The theory derived, however, as we shall see, not from Diaghilev, but from Savva Mamontov. Fifteen years before the Ballets Russes, Mamontov employed the talents of some of the country's foremost artists – Vrubel, Korovin, Roerich, Vasnetsov – to design the productions for his spectacular cycle of Opéras Privés in Moscow. Diaghilev had attended many of

these presentations. It was his interpretation of Mamontov's achievement which led to the Paris productions of ballet and opera in which the greatest painters of the time replaced the craftsmen, and designed the costumes and scenery for a memorable series of theatrical events. After 1909, Diaghilev involved, among others, Matisse, Bonnard, Utrillo, Rouault, Braque and Derain in his productions. In the end, perhaps the true meaning of synthesis was the willingness of strongly motivated, ambitious, egoistic artists, each with his own special field, to set aside his personal plans for a moment to join in a common endeavour in order to create more than he could have attained on his own.

With *Mir iskusstva* and the exhibitions it sponsored, young Russian painters found a counter-force to the twin monopolies of the Academy and the Wanderers. In the field of contemporary art the publication strove to break down the barriers between Russia and the West, and at home, those between St Petersburg and Moscow. It afforded the younger Moscow artists the opportunity to escape the strictures and rigid boundaries set by Stasov, Makovsky and the champions of a purely nationalist art. Korovin, Roerich, Ryabushkin, Levitan and Vrubel, whose works were full of Moscow's colour, mingled with Benois, Bakst, Somov and Lancéray, exponents of St Petersburg's linear discipline. If the association was not always tranquil, *Mir iskusstva* nevertheless succeeded in prodding the Russian public into an increased interest in its own contemporary artists, as well as an awareness of current Western developments.

<p style="text-align:center">* * *</p>

In a more leisurely era, *Mir iskusstva* might have lasted for decades. The participants were clever, sensitive and erudite, emotionally involved in the artistic currents which surrounded them. But what killed the magazine was the fact that the brilliant attempts at rebellion were shackled by elegance. There was an intangible air of mannerism in this last resurgence of St Petersburg's art. The reforms did not go far enough. These combatants lacked the vital force, the sheer hubris and occasional vulgarity of the liberated serfs, the kulaks and Old Believers, the merchants of Moscow. They could not free themselves from the upper-class caution to which they had been born. Time was running out for St Petersburg, its society and its art.

The demise of *Mir iskusstva* in 1904 has been attributed variously to the outbreak of the Russo-Japanese war, which necessitated a withdrawal of the Tsar's support, or to the possibility that the group felt that its task was accomplished. A more comprehensive assessment would have to include the growing dissension which marked the exhibitions, and the pull of other ideas and obligations which fragmented the leadership. In 1903–04 both Diaghilev and Benois were absorbed in plans for the Tauride Palace Exhibition; Nouvel and Nurok had inaugurated a series of Evenings of Contemporary Music, and

Filosofov, who had become increasingly involved with theology and Symbolism, departed to work with Dmitry Merezhkovsky. After the closure of his friend's journal *Novyy put* (*New Path*), Filosofov settled in Paris with the Merezhkovskys. Diaghilev's association with the Imperial Theatres had brought him to the attention of many influential patrons. Pragmatic, impatient with delay, he had no intention of being bogged down in the artistic feuds and minutiae which absorbed his colleagues. Benois observed that his friend, who was growing increasingly weary of the 'incorrigible provincialism' of his associates, believed that 'nothing more could be achieved in Russia, and therefore it was indispensable to transfer his activity beyond her borders'.[53] His absences grew more prolonged and without his constant presence, the factionalism which had been so valuable to the enterprise initially, deteriorated and soured. The linchpin had been lost. In 1904 Diaghilev alternated with Benois in the role of editor; his issues were dedicated to modern art, those under Benois's supervision covered art history.

In the same year 1904, it became obvious that *Mir iskusstva* was foundering. After a final abortive attempt by Diaghilev to involve Tenisheva once again, it was decided to suspend publication. Diaghilev had been aware for some time of a growing French interest in Russian art. When he had been in Paris in 1900 for the Exposition Universelle, he had seen Serov awarded a Gold Medal, and the panels commissioned from Korovin and Nikolay Klodt by Mamontov for the Moscow–Yaroslavl Railway receive the highest praise. The products of Abramtsevo had been purchased by the French government and the ornate designs and embellishments of the Russian Pavilion designed by Korovin and Golovin had proved to be the outstanding attraction of the Exhibition. Now once again, his friend Korovin was decorating the Russian Pavilion in the French capital. With his faultless eye for fashion and emerging trends, Diaghilev recognized that Paris was ripe for a major invasion of Russian culture and he was moving in that direction.

The principal failing of *Mir iskusstva* was its inability to recognize Impressionism as the beginning of twentieth-century art, as a demarcation after which nothing would ever be quite the same. The editors preferred Munich to Paris, Menzel to Monet. A leading scholar and dealer has written: 'Starting with the Impressionists, the general public could no longer read the work of real painters.'[54] For twenty-seven years the Wanderers had dominated the Russian art scene with their social preachments. Now their successors, a new generation of Moscow artists, restless and experimental, backed by the merchant-patrons, were beginning to perceive the elemental change which had taken place in the West. It was not that Moscow's painters, when exposed to Impressionism, slavishly turned out canvases in the manner of Pissarro or Monet, but rather that they discerned the principle implicit in the new movement. Impressionism

represented a break with the realism of the past. In Moscow, where painting had been diagrammed for so long, where permissible limits had been drawn so narrowly, Impressionism was a declaration of freedom. More than the images were shattered; the old rules which had shaped the techniques and defined the boundaries were fragmented. The Muscovites adapted the basic tenets to their own needs with zest and imagination and then moved on. This dynamism the art establishment of St Petersburg could never quite duplicate. Perhaps it is unreasonable to expect more from two young Russians than from the French public and critics, but they were so geared to the future, so sensitive to the latest developments in Europe, that one can only wonder at the lapse. Writing in *Mir iskusstva* in 1899, Benois stated, 'For art in general, the theories of the Impressionists do not have particular importance.'[55]

It was his belief that the effect of their theories would be only temporary, as the painters themselves had already been discarded by their successors. Benois regarded the search for the 'first impression' as a crippling limitation: insofar as the Impressionists were expert and skilled in their technique, they violated their own rule. Out of the effort to portray a single instant in nature would come 'a completed colour photograph ... the beginning of the end of art.'[56] Most importantly, in his eyes, these artists had removed themselves from their work. Preoccupied with small beautiful dots, they were 'mute.... In these sketches (even those by Degas) there is nothing internal, the artist himself is absent. That which is primary in art is missing: poetry.'[57] He revealed the core of his reaction in *Mir iskusstva* in 1899 when he wrote: 'There are those artistic natures for whom these first impressions simply do not exist.'[58] Yet Benois conceded that 'In the midst of second-rate masters we still find much that is good ... the quaint provincial corners painted by Pissarro, Sisley's respectable studies, even Renoir, generally an extremely unsavoury artist, has painted some things that are distinctively clear and light'; however, 'in the best instances these paintings may serve as trompe-l'oeil to remind but superficially of some scenes, some locales.'[59] He noted that Monet, despite his 'slovenly technique' and 'confused' drawing, could be considered a great master, though his works were studies rather than completed paintings. His views had been conditioned by the cool order and *Poussinisme* of the St Petersburg school.

Diaghilev, despite his pursuit of innovation, was attracted consistently to Russian romantic fantasies, to the ornate embellishments of Art Nouveau, the mannered refinements of Beardsley, the pale classicism of Puvis de Chavannes. He inhabited an interior world; the freshness and vigour of the Impressionists, the sense of sunlight and open air, were not appealing to him. For these two brilliant and gifted men at that time, Puvis was the wave of the future. It was as if they had missed a crucial sign in the road and proceeded to a decorative cul-de-sac. *Mir iskusstva* radiated the polish and discrimination which characterized

the St Petersburg establishment, and by these standards, Impressionism seemed impetuous and unschooled.

Perhaps in the end the decisive factor was timing. In an era of rising nationalism and revolution, the decorative aesthetic, the intellectual framework which distinguished *Mir iskusstva*, was too brittle. In its preoccupation with eighteenth-century France, Art Nouveau, crinolines and Puvis de Chavannes, it epitomized the art of the aristocrat in the era of the common man. Tasteful and elegant were not words suited to a revolutionary epoch. The most distinguished art review that had ever been published in Russia, *Mir iskusstva* produced few bad paintings but no great ones, for among the founders there was a sense of Brahmanism, of a special knowledge too remote, too refined for the period.

Logically it should have been St Petersburg, with its openness to Western culture, which first accepted Impressionism as the matrix of modern painting. Instead, it was Moscow, the citadel of Old Russia and new commerce, in which the most revolutionary art was assembled.

3

THE GREAT
MERCHANT PATRONS

Yes, the Russian merchants liked victory, and they *vanquished*.
They vanquished poverty, obscurity, the insults of uniformed
chinovniks and the blank disdain of aristocratic snobs and
dandies. ... I have never encountered anything to equal the
lavishness of the Russian merchant. I do not believe Europeans
could have any idea of its scale.

Fyodor Shalyapin

After 1904 the story of Russian art was centred on Moscow, and at the heart of
the city's pre-eminence were the merchant patrons. Their artistic interests were
as diverse as the milieux from which they originated. Some subsidized theatre,
others financed art publications, still others supported opera; they established
museums, organized artists' colonies and built a great symphony hall in
Moscow.

The appearance of the new bourgeoisie coincided with the resurgence of
nationalism historically represented by the old capital. As the taste of St
Petersburg was formed by the court and the bureaucracy, so Moscow was the
city of commerce and the clergy. An anomaly in an agricultural land, the new
urban industrialist was understandable only within the Russian frame of
reference. The rise of this class was meteoric, its ascendancy brief, yet in its
vividness, ruthlessness and creativity, it was unequalled. After 1917, the
merchants vanished as completely as the dinosaur. However, before they were
uprooted, they left a substantial imprint on the economy and culture of their
land, as indelible as a fossil in a rock.

The last years of the nineteenth century saw a renaissance of the old strong-
hold based on the growing industrialization and commercial needs of the country.

The bureaucracy of St Petersburg was ill equipped to handle this economic expansion, and power began to flow once more from Moscow. Out of this development came another élite, an aristocracy invested not by birth, title or blood-lines, but rather by the dynamism with which its fathers and grandfathers had clawed their way up from poverty and serfdom. The salons and academies of St Petersburg retained their gloss, but they were becoming pale and outmoded remnants of an antique way of life. The newly rich Moscow merchants were frequently disdained as gauche and pushy by the St Petersburg establishment; their city was a reminder of Slavic traditions, and as such, vaguely discomfiting and foreign to the polished elegance of Peter's capital.

The rapid growth of the arts in Russia at the beginning of this century was an extension of the political and social turmoil; the restlessness and drive, the frantic pace, were fuelled in some measure by a sense of limited time. A way of life was coming to a close. In this setting, the new boyars were the industrialists, builders of railroads, bankers, merchants, manufacturers and entrepreneurs. The names – Tretyakov, Mamontov, Morozov, Shchukin, Botkin, Ryabushinsky among the most eminent – were a litany of the self-made. The Russian Fricks, Carnegies, Harrimans and Rockefellers of their time, they were the de facto rulers of Moscow, and for the most part it was a benign, if paternalistic, reign.

These powerful families were scattered throughout the city in mansions and palaces. Some of the imposing residences were two hundred years old, purchased from impoverished members of the nobility; others were modern monuments to new riches. Moscow's architecture lacked the planned consistency of St Petersburg; the great houses reflected the whims and eccentricities of their owners. The Igumnov domicile was like a giant wedding cake, topped with painted towers in the fashion of seventeenth-century Russia, a diverting contrast to the sleek Art Nouveau of Stepan Ryabushinsky, now the Gorky Museum. Spasso House, now the American Embassy, was the home of Nikolay Vtorov, banker, munitions dealer and textile merchant. The Morozov houses ranged from Mikhail's stately structure in the Empire style to the mansion of his brother, Arseny, which had been built in 1895–99. This exact replica of a Spanish castle created to order was a landmark of Moscow; today it serves the Soviet government as the House of Friendship.

The society of Moscow merchants was by no means exquisite or rarefied, but the tokens and perquisites of success were entwined with learning; culture was a word which carried prestige in this upwardly mobile community and it subsidized the arts to an unprecedented degree. In 1883, theatre, ballet and opera had been released from state control and were no longer subject to rulings from the censor. Two years later, Savva Mamontov introduced his innovative Opéra Privé to Moscow, and in 1898 Konstantin Alekseyev opened a new

theatrical company in the city. This young man, son of a wealthy linen merchant, had implemented a life-long infatuation with the theatre years earlier when he joined with a group of affluent friends to stage an amateur production of *The Mikado* in Russian. Now as Stanislavsky, he introduced the Moscow Art Theatre to the Russian public. In the decade which followed, there were the legendary productions of Turgenev, Gorky and Gogol, Ostrovsky, Chekhov, Beaumarchais, Shakespeare, Ibsen and Leo Tolstoy. Stanislavsky, who had been influenced by Mamontov's productions, and whose Moscow Art Company was rescued from financial disaster by a member of the Morozov family, called the merchants 'conscious creators of the new life'.[1]

Stanislavsky's work was the beginning of pure theatre. The state-supported Bolshoy presented a completely different theatrical experience. There the audience was an integral part of the spectacle. In the vivid red and gold interior, the promenade during the entr'acte featured Moscow's loveliest women, 'languid, beautifully created out of muslin foam and diamond constellations like so many Venuses,'[2] gowned in creations by Worth of Paris or Lamanova of Moscow. It was a group as glittering as any in St Petersburg, the single noticeable difference being in the matter of male dress. Uniforms predominated at the Maryinsky; rows of gleaming medals and braid, polished boots and the small insistent clicks of military ritual were in contrast to the starched grandeur of Moscow's civilian attire.

Russian painting reflected Moscow's revival. In this mercurial, constantly shifting scene, the role of the artist assumed new importance. Suddenly money was available. From the time of Catherine, collecting had been a fashionable activity in Russia; the view of art as decoration reached its acme during her reign. Now the aristocracy was supplanted by the bourgeoisie, and where Catherine's carriages had been painted by Watteau or Boucher, the ceiling in the home of a contemporary banker might be adorned by Vrubel or Kuznetsov. It was Benois's thesis that painting in Russia had not been created in answer to a deep need of the people, but rather that its genesis had lain in the desire of the nobility to emulate the traditions of the West.

In turn, many of the merchants were driven by ambition to duplicate the life-style and privileges of the court. Frequently they were scorned by the artists they helped. Andrey Bely wrote a scathing appraisal of Vladimir Girshman, an extravagant patron who collected the delicate work of Somov and the Russian-Impressionist landscapes of Grabar: 'this clean shaven red-mustachioed banker, a stranger to art, his chest sunken in with the utmost modesty, made his way between us, stubbornly elbowing his way ... would intrude in our midst ... to swindle something from us ... I could not manage more than a handshake.'[3] But because of this patronage, young Russian painters thrust themselves into the twentieth century, absorbing and discarding every influence available to them –

Impressionism, Fauvism, Cubism, Symbolism, Futurism, Abstraction, each succeeding movement had its adherents; a process which should have taken generations to unfold was telescoped into the two decades between 1897 and 1917.

* * *

A portrait by Repin hangs in the Tretyakov Gallery in Moscow. Painted in 1883, it shows a slender, patrician, dark-bearded man, fine-boned, the eyes introspective and deep-set, a hand delicate and well shaped. There is introversion in the pose, in the crossed arms and meditative gaze and the restraint of the work is more Whistler than Repin. The impression of a poet or philosopher is enhanced by the tantalizing glimpses of paintings in the background.

It is appropriate that Repin surrounded his subject with the heavy rich works of the Wanderers, for the man is Pavel Tretyakov (1832–98), creator of the museum that bears his name, doyen of the merchant collectors and among the first to lend his support to the propagation of Russian art. Today in Moscow, the Tretyakov Gallery stands as a memorial to this self-effacing patron and provides the visitor with a valuable insight into the development of painting in Russia.

In the brief history of the merchants, the Tretyakovs were members of the old guard. In 1782, the name had been registered on the Moscow rolls as one of the families possessing up to five thousand gold rubles in capital. After the ravages of the War of 1812, they tenaciously rebuilt their holdings, and in the 1850s they participated fully in the surge of industrial expansion. Unlike Nikolay Ryabushinsky or Savva Mamontov, Tretyakov is not interesting for his personal idiosyncrasies. His generation had not developed the flamboyance and eccentricities which distinguished its heirs; the struggle was too recent, the rewards too precious.

The seriousness which is so evident in Repin's portrait may have stemmed from the fact that Pavel had inherited the family business when he was eighteen. His father, M.F. Tretyakov, a successful businessman, had died in 1850 at the age of forty-nine, and Pavel found himself, with his brother Sergey, joint heir to a rapidly expanding textile empire. A studious young man who had been sheltered and privately tutored, he had little interest in the active social life of Moscow. However, he had a great love of music and one evening, lured to a party by the promise of a Beethoven trio, he met one of the musicians, Vera Nikolayevna Mamontova, a niece of the industrialist Savva Mamontov, and a short time later, they were married. He had been thrust suddenly into a competitive, aggressive commercial community, and against all logic he prospered. He appeared every day at the family firm, built doggedly and intuitively on his father's accomplishments, and over the years became one of Moscow's leading citizens. His life was a parable of diligence and integrity; these

qualities do not necessarily create a colourful persona, and if it had not been for his single obsession, Tretyakov would have been a footnote in Russian chronicles.

In the decades following the defeat of the French invasion, there had been an upsurge of patriotism in Russia, a reawakened sense of pride and interest in every aspect of the country's artistic tradition. Moscow was particularly responsive to this development. Years before the advent of the Wanderers there had been individualists among the city's collectors who had resisted the Diktat of the St Petersburg Academy and amassed Russian art works.

Kuzma Terentevich Soldatenkov, close friend of Ivan Vasilevich Shchukin, collected Russian works in the 1840s. Guerassime Ivanovich Khludov established a museum at the beginning of the 1850s which displayed the narrative scenes and beguiling interiors of P.A. Fedotov (1815–52), the portraits of Karl Ivanovich Bryullov (1799–1852), and canvases by the gifted marine painter Ivan Konstantinovich Ayvazovsky (1817–1900). Vasily Aleksandrovich Kokorev also began his collection in the 1850s. In 1860 he constructed a special building to house his paintings and opened a public gallery which lasted for ten years. Among the works shown were forty-two by Bryullov and twenty-three by Ayvazovsky. Alexander III purchased the aggregation for display in his projected Russian State Museum.

In 1851 Tretyakov had followed the customary pattern of his peers and bought a splendid house at Tolmachi. An extensive mansion, surrounded by landscaped gardens, with enormous halls, salons and a music room, it had been purchased as a private home, but because of the size and flow of the design, it could accommodate the public without difficulty.

In 1853, Tretyakov acquired a small number of engravings, prints and paintings. Four years later he began the systematic garnering of Russian art which would continue unabated for the next thirty years. When the fourteen dissidents from the St Petersburg Academy formed their artel in 1863, he responded to their reaffirmation of Russian values and supported their endeavours.

In 1870, with the emergence of the Wanderers, the collection took a quantum leap. Tretyakov wished to assemble not merely the works of a few favoured Russian artists, but rather to reveal a complete image of Russian painting, a survey which would rescue and preserve the neglected masterpieces of the past and develop an audience for a new national art. The Wanderers were not a sudden isolated phenomenon; they grew organically out of the times, the visual component of a Slavic renaissance which included Gogol, Dostoyevsky, Tolstoy, Mussorgsky and Borodin. When the artists took their paintings throughout the country, their glorification of a nationalist ideal sparked an elemental response in citadels of Russian history such as Novgorod, Kiev and Moscow. After each annual exhibition of this group, Tretyakov's gallery was

swollen with new purchases. He had made his paintings available to the public and the increasing popularity of the display attracted a growing influx of visitors. In 1872 it became necessary to commission a new building on the premises.

The exterior of the structure and the contents of the interior are noteworthy because of their evocation of Old Russia. Viktor Vasnetsov, the popular painter of ancient Russian themes, decorated the building, which was an appropriate frame for the works it enclosed. There was more art than architecture in the façade, it resembled a watercolour, a scenic design for *Snegurochka* (*The Snow Maiden*), a confluence of curved arches and painted decorations where, high above the entrance, a warrior saint bestrode a rearing horse. When the building was completed in 1874, Tretyakov personally supervised the placement of each canvas, and in the process, re-created the development of painting in his country. The value was not in the individual works; many were worthwhile, a few magnificent, but it was the collective impact and the historical perspective which were enlightening.

It had been only two hundred years since Peter's reign, but now the rooms were overflowing with the works of native easel painters. On the ground floor were hung canvases of the eighteenth and nineteenth centuries by Ivan Nikitin, a favourite portraitist of Peter the Great, Aleksey Antropov, another popular court painter, D.G. Levitsky, V.L. Borovikovsky and F.S. Rokotov. Russian by birth, they belonged in Tretyakov's museum, but their aesthetics were derived from the West. They owed their style to the series of Western artists who had taught at the Academy since the time of Peter. There were touches of Fragonard or Ter Borch in the silks and laces of Levitsky's young girls of the Smolny Institute, and Borovikovsky's court favourites and intellectuals, however skilled, were created according to European formulae.

The emphasis on court figures became less pronounced with the appearance of a new moneyed class in Russia. The result was a broadening of subject-matter calculated to appeal to a wider audience. The village girls of Venetsianov, Bryullov's Byronic students, the lambent marine paintings of Ayvasovsky were the beginning of a new tide.

It was on the first floor that a distinctively Russian school began to emerge. This was the special preserve of the Wanderers, an enclave of *plein-air* painting, narrative scenes of returning sons, weeping mothers, victims of injustice both social and political, and religious works rendered with that emotional intensity peculiar to Moscow. The portraits in this section were not notable for their jewels, rather there was a photographic accuracy in the beards and grizzled faces of the writers, philosophers, poets and musicians which evoked the world of Dostoyevsky and Aksakov.

In 1892 Pavel Tretyakov's brother Sergey died, leaving the museum a bequest of eighty-four paintings of the nineteenth century, the famous Barbizonians of

the Tretyakov. The Corots and Courbets blended effortlessly into the rustic simplicities of the Wanderers.

Tretyakov conceded that he might accept 'a hundred unnecessary things in order not to miss a single necessary one. ... Though it may very well be a mistake, I buy everything that I feel is necessary for a full picture of our painting. ...'4 This policy of constant growth necessitated a periodic expansion of the gallery. In 1882 six rooms were added, and the flow of visitors swelled more than sixfold, from 8,000 in 1881 to 50,000 in 1890. The cost of the enterprise reached 1,500,000 gold rubles. It was becoming apparent that the museum could not continue as a private venture.

Alexander III, who was amassing Russian art for his Russian State Museum in St Petersburg, was eager to acquire the Tretyakov collection but he was frustrated in his aim when in 1892 Tretyakov notified the Duma of his plan to give his institution to the city of Moscow. When the gallery was dedicated in 1894, the donor was absent in an effort to avoid publicity.

There is a paradoxical element to the merchant's support of the Old Russian traditions. The Tretyakovs were textile merchants; apostles and beneficiaries of the commercial expansion which swept Russia in the nineteenth century. With the advent of industrialization, the distinctive decorative genius of the individual craftsmen, the elaborate embroideries and carvings, were replaced by the products of the workshop. The factories, which had uprooted and disoriented village life, supplanted the old wooden churches and made artisanship obsolete, were created by the forebears of men like Tretyakov. These merchants had helped to bring Russia out of feudalism, but their single-mindedness had served to destroy the past. Now, a generation later, the greatest support for the old ways came from their descendants. It was as if the new breed, whose families had been instrumental in the displacement of the old norms, felt a need to restore their heritage, to rediscover their roots in the symbols and memorabilia of a vanished era. Many built their homes in the Old Russian style, renovated the churches, collected the icons and, like Pavel, amassed the Russian-based art which had been neglected for so long.

In a country in which such great emphasis had been given to Western standards, there were those who disdained the effort to restore Russian painting. Tretyakov was without academic credentials or formal education, and despite his wealth and reputation was occasionally vulnerable to the critics who scorned his unsophisticated taste. In June 1890, in a letter to Leo Tolstoy, he confessed his qualms:

Permit me to speak a few words on the subject of my collection of Russian painting. I have wondered frequently, and for a long time, whether there is any point to what I am doing. Several times I have been assailed by doubt, but

nevertheless I continue. It is not for myself, that would be quite mistaken.
In my short lifetime people's views have changed so much that I get lost trying to
decide who is right ... and so I shall continue without assurance about the value,
but with love, for I genuinely love museums and collections where one can find
respite from the constant chores of daily life, and what I love myself I want others
to experience.[5]

In 1898, four years after he presented his museum to the city of Moscow,
Pavel Tretyakov died. He deserves to be remembered as a cultivated, gentle man
who wished to leave to posterity a testament, an appreciation and a complete
record of Russian art.

* * *

In 1885 the curtain rose in Moscow on a new series, the Opéra Privé, pre-
sented in Kamerny Pereulok by Savva Ivanovich Mamontov. This merchant
was one of the grandest, most imposing and formidable of the Russian patrons,
a product of his era, an uncompromising, unregenerate capitalist in the
mould of his American counterpart and contemporary J.P. Morgan. Dark,
with a stocky, powerful build and the slanted eyes of a Tatar, sensuous in
his tastes, a man of overwhelming personality, he was capable of bullying
or charming to get his way. It was impossible to be neutral about Mamon-
tov, for he was a study in contrasts: expansive, moody, cruel and generous,
a successful industrialist who spent most of his years creatively engaged in
the arts.

He made two contributions to the culture of his country. First, as a supporter
of the nationalist movement in painting, he provided an alternative to the
Western orientation of the St Petersburg Academy. Theoretically, nationalism
in art is not an ideal or admirable goal, but within the Russian context it was a
necessary step to counter the slavish admiration of foreign standards which was
smothering Russian artistic identity and producing pallid imitations of Western
masterpieces.

Secondly, Mamontov involved the most prominent Russian painters of his
day in the theatre, and by combining these art forms, created a new idea.
Unexpectedly, this aesthetic nationalist sparked a revolution which had
international repercussions. The Ballets Russes, Stanislavsky and the Moscow
Art Theatre, the post-revolutionary scenic works of Aleksandra Exter and
Vsevolod Meyerhold were influenced by Mamontov's innovation. Theatrical
synthesis, one of Russia's most important exports, had its beginning with this
assertive and controversial patron.

When Savva was seven, his father, Ivan Fyodorovich, a successful govern-
ment tax farmer[6] and an investor in the Baku oil fields, had moved from Siberia

to Moscow with his large family.[7] During the period of economic expansion between 1857 and 1876, the miles of railroad in Russia had increased twenty times over, and Ivan Fyodorovich invested his oil profits in an industry which promised even greater rewards at that time. He joined with other businessmen to establish a railway which would cover the forty-five miles from Moscow to Zagorsk, and with a government subsidy the line was extended to Yaroslavl. Thus the Moscow–Yaroslavl Railway was founded, and with it the Mamontov fortune. The first sale of stock was announced in 1859. Eventually the Mamontovs built the tracks in the north which linked Murmansk, Arkhangel and the coal-rich Donets basin.

Savva Ivanovich matured within the environs of the old city, absorbing the history and traditions of Muscovy which formed his taste and remained with him for a lifetime. In 1861, a period of great political agitation, he entered Moscow University, a centre of Slavophile influence, as a law student, and the nationalism of that institution deepened his commitment to Russian culture. His continuing infatuation with the theatre manifested itself when he joined the University dramatic society and accepted a role in *Groza (The Storm)*, a controversial new play by Aleksandr Ostrovsky which satirized the Moscow merchants and questioned the traditional role of women in Russia. His father, who had always disapproved of his fondness for the arts, was doubly disturbed when he was told, in these uncertain political times, that his son was under surveillance by the authorities. The reason was unclear, but as a safety measure, Savva was shipped off to Baku to work in his father's firm in the oil fields and from there he was sent to Persia. Savva discovered that he enjoyed the challenge and excitement of unfamiliar places, and after three years, at the end of his Persian expatriation, he loaded a caravan with local goods – handicrafts, guns and fabrics – brought it safely through brigand-infested country, and sold it at Nizhny-Novgorod for a substantial sum; a financial coup which heartened the elder Mamontov.

Still there were lapses. All his life Savva Ivanovich remained a frustrated performer. Despite his father's objections, as a young businessman travelling abroad, he took singing lessons in Milan. With a deep, rich baritone, a stormy temperament and a love of Italian opera, he seriously considered a career as a professional singer. He mastered some of the minor roles in the Italian repertory and was on the brink of signing a contract with a small company in Italy when a telegram from his father arrived summoning him home to Russia and reality.

In 1865 Mamontov married Yelizaveta Grigorevna Sapozhnikova, the seventeen-year-old daughter of a wealthy textile merchant, and two great fortunes were merged. A quiet, intelligent, strong-willed girl despite her youth, Yelizaveta was extremely religious and appears to have been rather plain in

contrast to the striking women Savva had always admired.[8] Her family was related to the Alekseyevs, and with this marriage Savva acquired a young cousin whose enthusiasm for the theatre was to surpass even his own – Konstantin Stanislavsky. In time Savva and Yelizaveta had five children.

When the elder Mamontov died in 1869, he left a vast conglomerate of holdings to his family. As students at the University, Savva's brothers had also been suspected by the Third Section of revolutionary sympathies; Anatoly had been arrested and imprisoned in the Peter and Paul Fortress for a short time. Savva, because of his Persian success and a highly desirable marriage, had rehabilitated himself in his father's eyes; in retrospect the theatrical escapades seemed inconsequential, and Ivan Fyodorovich bequeathed the controlling block of stock in the railroad line to him. Gambling was a national pastime for many Russians, but as a banker and head of the Troitse Railway, Savva played for higher stakes. As he began to manipulate and extend his holdings, the opportunity for speculation was always present.

In 1870, Savva Ivanovich and his wife bought an estate near Zagorsk. The previous owner had been Sergey Timofeyevich Aksakov, writer, polemicist, a leading figure in the Slavophile movement and a friend of Gogol and Turgenev, both of whom had visited him here.[9] Abramtsevo was a period piece, a rambling eighteenth-century house with large, sunny rooms; a small river flowed through the thickly wooded property, and the cupolas of the old monastery were just visible in the distance.

In 1872–73, during a tour of Europe with their young son Andrey, the Mamontovs stopped in Rome where they encountered three fellow-countrymen: the art-historian and philologist Mstislav Viktorovich Prakhov (1840–79), who was exploring the Roman ruins, the painter Vasily Dmitrevich Polenov (1844–1927), a member of a well-to-do family whose foreign studies were being sponsored by the St Petersburg Academy and the Imperial Society for the Encouragement of the Arts, and the sculptor Mark Matveyevich Antokolsky (1843–1902). Antokolsky's marble statue *Ivan the Terrible* (1870) had earned him renown at home, but he chose to spend a great deal of time abroad because of his health and because of the difficulties he encountered as a Jew in Russia. V.V. Stasov, the influential critic, admired his work, and aesthetically Antokolsky belonged to the Slavophile movement, being in sympathy with its realism and florid emotional imagery. Yet it was a brotherhood in which he could not join totally, for he knew that the passionate idealization of Slavism could translate easily into chauvinism and bigotry. Because of this, he lived as a partial exile in his own world. Shortly after their meeting, Mamontov began to study sculpture with Antokolsky, and by the artist's own report, he showed great promise. Merchant and artists were drawn together by a shared dissatisfaction with Western painting which they found technically proficient but without

feeling. Mamontov was beginning to assemble the group of friends who would surround him at Abramtsevo.

While on a visit to Paris a few months later, the Mamontovs befriended Valentina Sergeyevna Serova, widow of Aleksandr Nikolayevich Serov, the composer.[10] She was staying in Paris at that time with her young son Valentin. During this same Paris interlude, Ilya Repin also entered the Mamontov circle. Like Polenov, Repin had received a grant from the St Petersburg Academy and was living near Montmartre with his wife and daughter. His painting *Burlaki* had been shown successfully in Europe, and its subsequent purchase by the Grand Prince Vladimir Aleksandrovich had enhanced his reputation at home. Both Mamontov and Repin were hungry for art which reflected the Russian experience; for them, Impressionism was a phase without importance, a theory delicate and vulnerable. Mamontov found this new style emotionally unsatisfying; Repin, a stern formalist who believed in historical content and the logical completion of colour and form, was never able to accept the 'impudent daubs'. Also at this time he considered art without social relevance to be a perversion of the artist's role. The seed of the Abramtsevo colony was planted that year.

After 1873, Vasily Polenov became a fixture at Abramtsevo; a gentle, learned man, he was Mamontov's cultural adviser and most trusted friend among the artists. Eventually he married Yelizaveta's first cousin, Natalya Vasilevna Yakunchikova. Antokolsky was a regular visitor, and another of his giant marble figures, *Christ Before the Judgment of the People* (1872–73), which Savva Ivanovich commissioned after their meeting in Rome, was enshrined in the study of the Mamontov house at Number Six, Sadovaya Spasskaya, in Moscow.[11] The sculptor's comment on this work was typically wry: 'I have put myself in the position that both Christians and Jews will be against me. The Jews will say, "Why do you do Christ?" and the Christians will say, "What sort of Christ has he done?"'[12]

Following their encounter in Paris, the Mamontovs invited Mme Serova and her son to visit them, and after 1875 Valentin spent many childhood summers at Abramtsevo. Repin was a guest for the first time in 1877, and in 1878 he returned with an order from Pavel Tretyakov to paint the portrait of Ivan Sergeyevich Aksakov, son of the former owner of the dacha. Ivan Sergeyevich, himself a journalist, was exiled from Moscow that same year for his Pan-Slavist activities. Thus the art of Abramtsevo yields many historical memories. That summer, Ivan Turgenev, who had organized a group to support Russian artists living abroad, visited the estate after an absence of twenty years. In 1879 Repin introduced two newcomers, the brothers Viktor (1848–1925) and Apollinary (1856–1933) Vasnetsov. Vasily Ivanovich Surikov (1848–1916), the Siberian painter whose panoramic

scenes of Russian history were bathed in the sharp, unadulterated hues of early folk art, joined the community soon after.

Savva Ivanovich believed that Moscow could supplant St Petersburg as the hub of Russian art, and with his vast fortune he provided a haven for those painters who rejected the vapidities of the St Petersburg Academy. At Abramtsevo there were no alien mythological themes, no plaster busts to copy for a passing grade. The countryside was the atelier, the Moscow sense of colour was released from the grey discipline of the professors. Eventually this setting would be discernible in the paintings of many of the visitors: Repin,[13] Vasnetsov,[14] and of course, Serov.[15] Mamontov's young daughter, Vera, treasured the communal album used by the guests. A storehouse of experiments, sketches from nature and 'living studies', this volume held the first intimations of many important Russian paintings. As the political and aesthetic coloration of the colony became known, it attracted the leading members of the Wanderers, and it continued as a locus for the activists of the Russian artistic revival until 1900.

The coterie of Abramtsevo artists was divided into 'generations'. The first, Polenov, Repin, the Vasnetsovs, Surikov and Antokolsky, were unabashedly nationalist, their themes concerned with Russian history, landscapes, social relevance, folklore, or religiosity, all precepts favoured by the early Wanderers. The division was not chronological and there was some overlapping. Mikhail Vasilyevich Nesterov (1862–1942), an extremely devout younger man, was a throwback, the spiritual heir of Ge or Kramskoy.[16] Though Serov had been a member of the colony during its early period, he was, because of his youth and artistic tendencies, closer to the second 'generation'. The leaders of this later group were less doctrinaire: Konstantin Alekseyevich Korovin (1861–1939), Isaak Ilich Levitan (1860–1900) and Mikhail Vrubel (1856–1910). They joined the circle at a time when Mamontov's interest in the theatre was at its height, participated in many of his most memorable productions, and ultimately became associated with *Mir iskusstva*.

In 1873, before his plans for Abramtsevo had matured completely, Mamontov had hired Viktor Aleksandrovich Hartmann (1834–73), a leader in the revival of a national architecture, to design an artists' studio for the estate. A wooden construction in the seventeenth-century style, with an arched roof and decorative carved designs on the façade, it stood as a reminder of the aims of the circle. Ivan Nikolayevich Ropet (1845–1908) created a bath house in the same spirit, and a wooden museum, as fanciful as a Russian doll's house, contained Yelizaveta Mamontova's extensive collection from another era: embroidered Russian costumes, jewelled headdresses and antique utensils, ornately carved and decorated. Yelizaveta was partially responsible for one of the most memorable examples of the work done at the colony: the small flawless church

which was started in 1881 and completed in 1882 with the collaboration of the artists in residence. One of these, Apollinary Vasnetsov, was known for his scenes of old Moscow, the winding wooden streets, the Kremlin wall and tower, the precise rendering of the huddled houses with their intricate decorations. They indicated archaeological research and a knowledge of ancient architecture, and revealed something of the heart and culture of medieval Russia. He and his brother Viktor, 'men who seemed shaped out of the clay of ancient Scythia',[17] had renounced the narrative painting of the Wanderers, for they believed that contemporary Moscow had been exhausted as a source of inspiration;[18] they had returned to the environment and mythology of the distant Russian past. Viktor Vasnetsov's imaginative sketches were particularly important to the project. Vasily Polenov and his sister Yelena were also archaeological scholars, and out of their combined research and imagination there emerged a design for a church, a diminutive version of the twelfth-century structures of Novgorod and Pskov. There were overtones of the Church of the Saviour at Nereditsa in the clean, graceful lines and symmetrical arches, and a memory of Pskov in the curving pediments. A tiny artefact, plucked out of an earlier time and set like a jewel at Abramtsevo, this structure reawakened popular interest in Moscow in the architecture of a remote period. The interior was embellished by Polenov, Repin, Nesterov and other guests at the estate. The sculpture, ceramics and decorations, the iconostasis painted by Vasnetsov, Polenov and Repin, the carvings by Savva Ivanovich himself, all testify to a moving depth of feeling and communal dedication.

Mamontov's greatest quality as a patron was his ability to absorb and blend a limitless range of interests. Painting, music, ceramics, sculpture, drama, an incredible variety of work poured out of Abramtsevo. The merchant's enthusiasm for theatre and opera found its earliest outlet in the plays, concerts and poetry readings which he staged during the 1870s in his Moscow house and at the dacha. These were the modest beginnings of the Opéra Privé which established his theatrical credentials. His cousin Stanislavsky, who attended many of these productions, wrote later:

And what would have happened to Russian opera if Mamontov had not supported it? It would have still been ruled by Italian bel canto, and we would never have heard Shalyapin, who would be silent in the darkness of the provinces. Without Mamontov and Shalyapin we would never have known Mussorgsky who had been pronounced anathema by the wiseacres and called a crazy musician; we would not have known the best compositions of Rimsky-Korsakov, for *Snegurochka, Sadko, The Tsar's Bride, Tsar Saltan* and *The Golden Cockerel* were written for Mamontov's opera and were first produced in his theatre.[19]

Stanislavsky also noted the other aspect of Mamontov's activities:

> We would never have seen the canvases of modern art from the brushes of
> Vasnetsov, Polenov, Serov, Korovin, who together with Repin, Antokolsky and all
> the other great artists of that time may be said to have grown up in the house of
> Mamontov.[20]

To Stanislavsky whose method was so painstaking and deliberate, who never
cared if a performance took a day or a year to perfect, Mamontov's restlessness,
his impatience to 'see his productions realized', were incomprehensible. Also for
the younger man, the merchant's impetuous drafting of neighbours, theatrical
novices, total amateurs as players in his early productions had reinforced his
view of the actor as the most important person in the theatre. Yet despite these
reservations, the future creator of the Moscow Art Theatre had attended
rehearsals frequently, acted in the productions and remembered Mamontov as a
talented director as well as a major conceptualist.

During the winter of 1881–82, the members of the circle gave a reading of
Ostrovsky's play *Snegurochka*. This folkloric tale with its poetic evocation of
Muscovite Russia held a special appeal for the group, and it was decided to
present it once again at Christmas as part of the holiday celebration. Mamontov
acted as producer-director and this time there were costumes and scenery by
Viktor Vasnetsov. Under Savva's sponsorship, Vasnetsov was becoming an
important name to collectors of Russian art. In his youth he had attended the
ecclesiastical seminary with the aim of following his father and grandfather into
the priesthood. A tall, bearded figure out of the Old Testament, with intense
dark eyes, he was said to pray before beginning a new painting. Some
'Westerners' regarded his work as overly pious and simplistic, but Savva
Ivanovich promoted him tirelessly. Before Abramtsevo, Vasnetsov had never
attempted a theatrical design, and he later confessed that when Mamontov first
drafted him for this purpose, he had no idea of what was expected of him. Scenic
perspective, the problems of enhancing a dramatic situation were completely
unfamiliar to him, yet Vasnetsov, working under Mamontov's deadline with a
wide house-painter's brush on a vast canvas spread over the floor, with his own
hands, created four sets for the play: *The Prologue, Berenday's Village, The
Palace* and *Sun-Yarilo's Valley*. He had no way of knowing what the results
would be, but whenever he raised the enormous canvases from the floor in order
to have a better look, Mamontov would appear at his elbow, and after a single
glance, would announce enthusiastically that it was wonderful. After a while the
painter began to understand that he might have created something remarkable.
Out of his total inexperience came, not the usual hackneyed backdrops, but a
mythicized re-creation of northern Russia which complemented the theme and
set the mood of the drama, four giant paintings of depth and dimension against

which the action unfolded. This was an important step toward the theatrical synthesis of Mamontov's vision and it formed the basis of the historic production of *Snegurochka*, with music by Rimsky-Korsakov, which he presented several years later as part of his official opera series.

Mamontov never hesitated to stretch ruthlessly the capacity of an artist to accommodate his own needs, and occasionally his forcefulness could be painful. Vasnetsov remarked on the fierce flow of energy which emanated from his patron, which compelled those around him to satisfy his requirements. Heedless of the effects of his demands on others, the pressure that he applied could be either stimulating or destructive, depending upon the resilience of the artist with whom he was dealing. Vasnetsov, like Korovin and Golovin, thrived on his apprenticeship with Mamontov, to go on after Abramtsevo to the Imperial Theatres in St Petersburg.

In 1883–84 Savva Ivanovich wrote, directed and produced *The Camorra* and *The Black Turban*; the first, a tale of a band of Neapolitan brigands, the second, a romance based on his memories of Persia, a country he remembered fondly. Each play was written within a period of a few days, and if the farce was a trifle boisterous, the naïveté and romanticism excessive, the fantasy delighted the audience, and the sorcerers, magic gardens and exotic locales provided an opportunity for the decorative scenic effects which were increasingly becoming a part of Mamontov's theatrical oeuvre. Wherever possible, he added an orchestral accompaniment, and in light of the subsequent Ballets Russes productions of *Schéhérazade* and *Sadko*, it is easy to understand why his operas caught the imagination of the young Diaghilev. In 1883, *The Crimson Rose*, a play with music, written and directed by Mamontov with décor by Polenov, was staged. This was the year in which the government ban on private theatrical presentations was lifted, and Savva Ivanovich was free to expand his activities.

The first complete season of the Opéra Prive opened in Kamerny Pereulok in Moscow on August 30, 1885 with a performance of Glinka's *A Life for the Tsar*, designed by Levitan.[21] During this first cycle, European operas still predominated: *La Traviata* and *Faust* were staples, *Carmen* was given to Ilya Ostrukhov, a Russian landscapist, and Polenov, the artist-archaeologist, was chosen to create the sets for *Aïda*. For the Russian repertoire, Viktor Vasnetsov brought his imaginative talent to *Rusalka* (*The Water Sprite*), and in October 1885 *Snegurochka* was presented and proved to be a landmark in the history of Russian opera. The result of a collaboration between Vasnetsov, Konstantin Korovin, Levitan and the Polenovs, it provided an example of the impact of an indigenous opera, and encouraged those Russian composers who were seeking a national identity to renew their efforts despite the dispiriting reaction to their music in St Petersburg. Yelizaveta Mamontova's collection of antique costumes and embroideries was employed regularly in these productions to re-create the

opulence and texture of a distant time. This initial series was not commercially successful and in 1892 it was discontinued because of the drain on Mamontov's financial resources.

Stanislavsky, whose own emphasis was on reality and minute detail, on performance rather than décor, nevertheless remembered 'the wonderful decoration of the best artists, and a stage director's idea which created a new era in the decorative art of the theatre and forced the best theatres in Moscow to pay attention. ... The productions of Mamontov interested talented artists, and from that time on, true painters appeared on the horizon of the theatre who gradually began to supplant the horrible house painters who were the only decorators the theatre had known in the past.'[22]

The second cycle of the Opéra Privé, inaugurated in 1896, was a notable success. During this series, Moscow heard Fyodor Ivanovich Shalyapin for the first time. It is in his association with Shalyapin that Mamontov revealed his full creativity as a man of the theatre. He gave the singer the opportunity to create the roles with which he was identified for the rest of his life: Mephistopheles in Gounod's *Faust* and *Boris Godunov*.

The two met in the summer of 1896 during the fair at Nizhny-Novgorod. Throughout the winter, the old city was frozen behind towering Kremlin walls, surrounded by the still, vast expanse of ice and snow which covered the Volga, but when it began to melt, eleven shining towers, like a mirage, became visible in the distance, and summer was celebrated with a fair which lasted from July to September. Throngs of visitors crowded the ancient squares, attracted by the market-place which overflowed with merchandise from Persia and China; an art exhibition, ballet and opera were part of the divertissements. The Mamontov opera had been booked into the new theatre for the season, and Shalyapin who had heard of the industrialist and his Moscow productions had accepted an invitation to join the company for the engagement.

The singer had just completed his first season at the State Theatre in St Petersburg and was deeply discouraged. He had been only twenty-one when he joined the Maryinsky, a towering, raw-boned young neophyte, intense and embarrassingly eager. It had been his ambition to create a series of characterizations in which the dramatic and vocal components would be of equal importance: 'Could not opera and drama combine and would there not be a great gain? ... no kind of singing could express as much as the living word itself.'[23] But he joined an institution mossy with tradition, dominated not by artists but by bureaucrats. Within the Imperial Theatres seniority counted almost as much as talent, and as a newcomer, he was at the bottom of the list. Russian opera, for which he had such an affinity, was scorned as 'third-rate stuff'. On one occasion, the director complained that every time he staged a Russian opera, 'the whole theatre stinks of cabbage soup and gruel.'[24]

All this changed when he met Mamontov. It was at a dinner for the cast that the newcomer first saw a 'Mongolian-looking gentleman'[25] in conversation with Korovin. Savva Ivanovich was fifty-five now, assured and worldly, at the height of his powers, the 'railway king of Moscow'; Shalyapin was twenty-two, 'a rough stranger' conscious of his badly cut clothes and lack of formal schooling. But they had qualities in common, an ebullient love of theatre, indestructibility and toughness. That summer it was as if Mamontov adopted Shalyapin and set out to educate him. First, he introduced him to painting, not the photographic realism which was prevalent, but the controversial work of Vrubel. At Mamontov's instigation, the committee of the Nizhny-Novgorod art exhibition had commissioned two panels for the main hall from Vrubel. After their installation, a special jury had been convened to decide whether they should be retained. Finally they had been rejected for 'decadence'. Furious, Savva Ivanovich had denounced the officials as 'house decorators', and erected a special pavilion to display the pictures. Shalyapin and Mamontov stood in front of Vrubel's *Princesse Lointaine*, and the younger man could see only a work 'in a somewhat queer style, a building up of hundreds of small, multi-coloured cubes. Extraordinarily colourful, but quite beyond my comprehension'.[26] Later, when he found the courage to ask what made this painting unique, superior to the photographic representations which surrounded it, Mamontov spoke of the personal vision of the artist, the emotional impact which pervaded the work. The reply interested Shalyapin; he returned to the pavilion many times during that engagement and noticed that the canvases which had received the committee's sanction began to seem static and dull by comparison.

Shalyapin scored a resounding success that summer and Mamontov invited him to join his company in Moscow.[27] Savva Ivanovich always had supported a national art – Repin, Vasnetsov, Antokolsky, Polenov – now he was presenting a musical extension of that line: Mussorgsky, Rimsky-Korsakov, Borodin and Shalyapin himself.

'Nowadays I still recall with delight those wonderful days in Moscow.' Shalyapin's first performance in Moscow was in 1896 as Susanin in *A Life for the Tsar*. In 1897 he achieved two of his most notable triumphs: the aged Dositheus in Mussorgsky's *Khovanshchina* and Ivan the Terrible in *Maid of Pskov*. Mamontov shared Shalyapin's idea of an opera which gave equal importance to the dramatic portrayals, and the singer remembered his patron's gifts as a director. When he despaired of finding the key to the character of Ivan, Mamontov took him aside at rehearsal: 'You must stop being hysterical, Fedya. . . . There is cunning and hypocrisy in your Ivan, but one does not feel that he is terrible.'[28]

For his remarkable make-up, Shalyapin used what he had learned from Mamontov and drew much of his inspiration from the visual arts. For this he

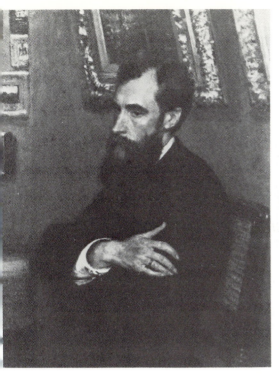

Ilya Repin: *Pavel Mikhaylovich Tretyakov*, 1883.
Tretyakov Gallery, Moscow

Ilya Repin: *Savva Mamontov* (charcoal), 1879.
Abramtsevo Museum, Zagorsk

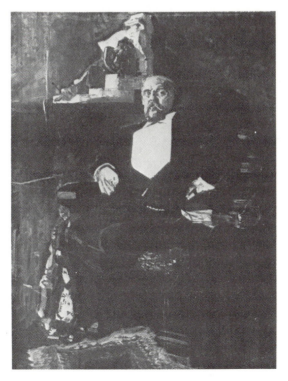

Mikhail Vrubel: *Portrait of Savva Mamontov*, 1897.
Tretyakov Gallery, Moscow

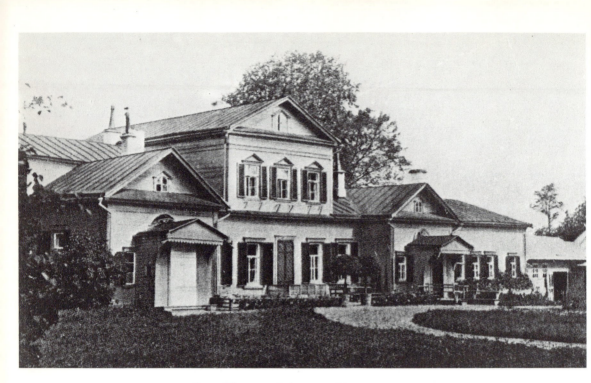

Savva Mamontov's house at Abramtsevo

Below left: Ilya Repin: *Portrait of Valentin Serov in his Youth*. Collection of
Princess Tenisheva. Published in *Mir iskusstva*, Volume Ten, 1899

Below right: Viktor Vasnetsov: *Drawing of a chapel*, 1891. This drawing and a photograph
of the church at Abramtsevo were published in *Mir iskusstva*, Volume Nine, 1899

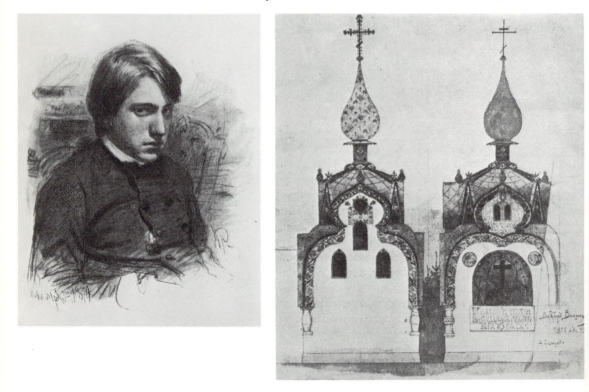

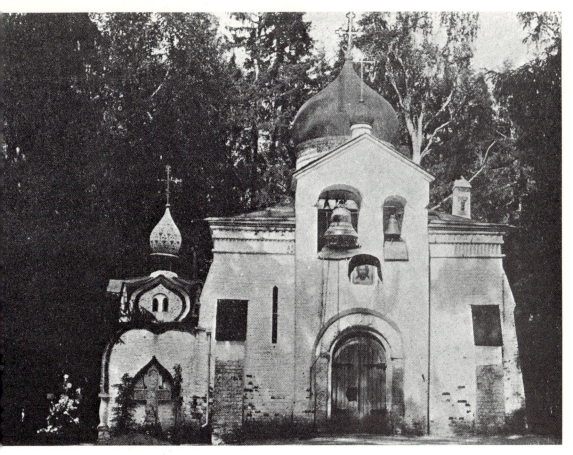

Above: Church at Abramtsevo

Left: Iconostasis of the church at Abramtsevo

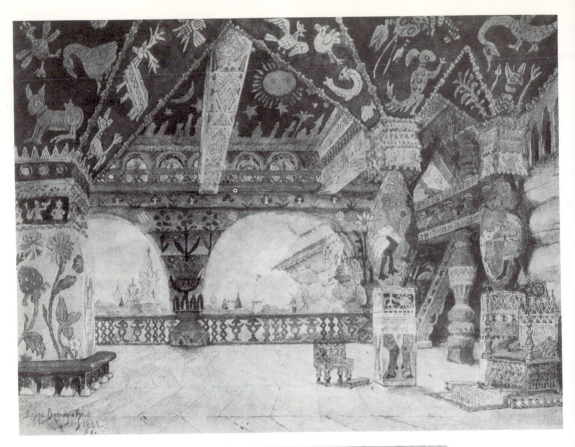

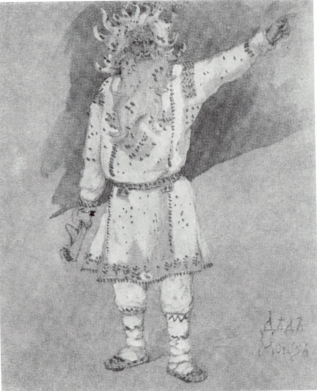

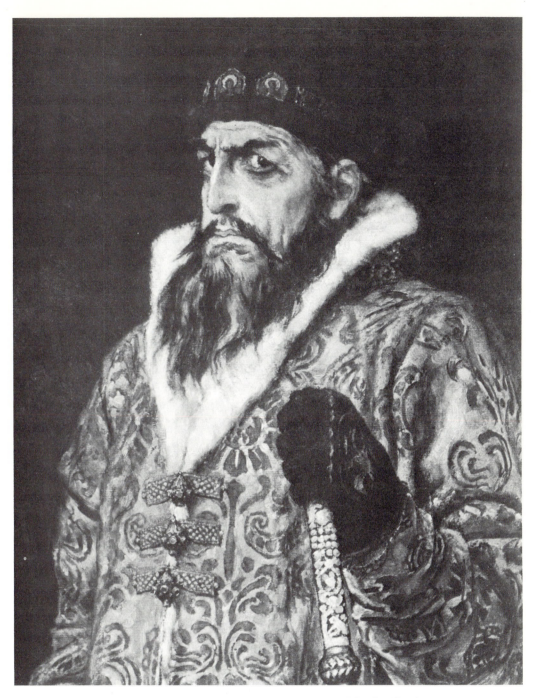

Above: Viktor Vasnetsov: *Tsar Ivan the Terrible* (detail), 1897.
Tretyakov Gallery, Moscow. Shalyapin was inspired by an earlier painting
of the Tsar by Vasnetsov, and after seeing Shalyapin's performance as Ivan
in Mamontov's production of *Pskovitaine*, Vasnetsov in turn painted
this later version

Opposite above: Viktor Vasnetsov: *The Palace of Tsar Berendey*: design for *Snegurochka*,
performed by Mamontov's Opéra Privé in 1885. Tretyakov Gallery, Moscow
Left: Vasnetsov's costume design for Frost (*Snegurochka*)

Nikolay Ryabushinsky

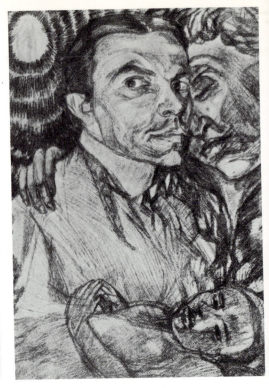

Pavel Kuznetsov: *Self-Portrait*, 1907.
Tretyakov Gallery, Moscow. Kuznetsov was promin
in the Ryabushinsky circle and a major
contributor to *Zolotoye runo (Golden Fleece)*

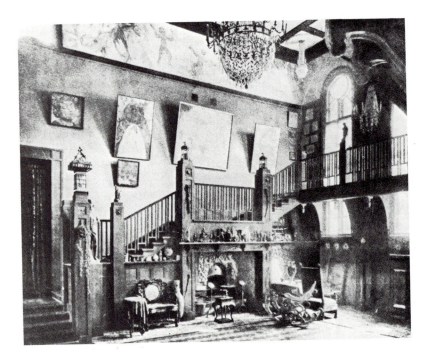

Interior of The Black Swan, Ryabushinsky's villa in Moscow.
The frieze and paintings are by Kuznetsov

had the collaboration of the Abramtsevo circle: Korovin, Ostrukhov, Nesterov, Serov and Vrubel. Vrubel, whose work he had mistrusted initially, exerted an increasing pull on his imagination. He wrote: 'My demon is by Vrubel, so is my Salieri.'[29] To 'establish the face' of Ivan the Terrible, he spent hours in the Tretyakov Gallery. The result was a blend of Antokolsky's figure, paintings by the artist-historian Vyacheslav Shvarts, and by Repin[30] and a forgotten portrait-sketch by Viktor Vasnetsov. 'The features were shown in three-quarters with one blazing eye looking to one side.'[31] That same year after seeing Shalyapin's interpretation of Ivan, Vasnetsov was impelled to create a full-length portrait of the monarch, rich in physical and psychological detail. Shalyapin's success in *Maid of Pskov* was followed by his Moscow début as Mephistopheles in Gounod's *Faust*. Two years earlier when he had sung this role at the Maryinsky, his interpretation and costume had been conventional. Now he visualized the character as sculpture, all line, stripped of clichés, props and non-essentials, beardless, stark and malevolent. In his words, 'the audience rose at me.'[32] Mamontov came backstage after the performance and gave him carte blanche; from then on Shalyapin could choose his roles and if he wanted a new opera, it would be staged for him. Shortly after, he began to prepare for *Boris Godunov*.[33]

In 1898 Mamontov brought his theatre company to St Petersburg. Before the opening, there had been condescending references to 'Mamontov's folly' among the sophisticates.[34] But his vivid and original presentations were an immediate success. He had poured huge sums of money into his experiment: the tantalizing delicacy of Korovin's colourful sets, the impact on a Russian drama of Vasnetsov's pageantry were a revelation, and as Boris Godunov, Shalyapin returned to the capital in triumph. Stasov wrote glowingly of Shalyapin and noted that the Maryinsky Theatre had not known what to do with his superabundance of talent. It had remained for Mamontov to display his gifts properly. Even Benois, who mistrusted Savva's taste and considered him vulgar, was captivated by some of the productions. He wrote of Korovin, 'his brush is fascinatingly nonchalant and the combination of his colours is rich and gives the effect of enamel work.'[35] When he first saw the designs for *Snegurochka*, Benois conceded that Vasnetsov 'inaugurated our fairy-tale painting and led to the Moscow renewal of our decorative art.'[36]

On the final page of his autobiography Shalyapin wrote: 'To me Mamontov stands for everything that is inspiring and creative.'[37] If one accepts his testimony, the patronage of Savva Ivanovich was invaluable. Yet Prince Sergey Shcherbatov, a diligent chronicler of Moscow's leading citizens, summed up Mamontov's contradictions more objectively: 'Merchant, kulak, petty tyrant, and to the fullest extent, a self-starter, he was handsomely gifted with mind and talent.'[38] While many important projects grew out of Abramtsevo, it would be a

mistake to assume that this retreat provided some form of Arcadian idyll. For a few, it was a rustic mini-court, with favourites, pressures, and a ruler as demanding as any in St Petersburg.

There are two contrasting portraits of Mamontov, which when taken together, illustrate the dichotomy of his personality. In the first, Repin sketched him in 1879, six years after their meeting, as an amiable, contemplative, middle-aged figure; a country gentleman, balding, benign and vulnerable, in a rumpled smock. The second version is by Vrubel, who had all the terrors of a lonely, brilliantly gifted artist, totally unable to conform or compromise. Because of his transcendence, alienation and periods of extreme depression, this tragic artist has been called the Van Gogh of Russia. The febrile intensity of his work gives some insight into his anxieties. In 1897, he portrayed an aspect of the merchant's personality which is at variance with Repin's view. Vrubel's painting is electric; there is a Junker arrogance and imperiousness in the round head, the protruding eyes and bristling walrus moustache. The stiffly starched white shirt crackling out over the black vest with heavy gold watch chain, the highly polished shoes resting on an Oriental carpet, suggest opulence and wealth. The velvety splendour of the rug, the carved chair, the painting in the background, comprise a detailed catalogue of possessions, rendered as carefully as any eighteenth-century Russian work. The perspective adds to the deferential effect, as if the artist saw his subject from below. One remembers that for many years in Russia, art had been a commodity commissioned from serfs.

As a student at the St Petersburg Academy, Vrubel had studied with Pavel Chistyakov who had been the teacher of Repin, Surikov and Serov. There were few in the conformist atmosphere of the time who recognized his gifts. Korovin, who later became his great admirer and close friend, noted: 'all his dreams of creation, all the strength and ardour of his personality ... were bathed in a sour atmosphere of petty, vile and mean chuckles. It was not even the mean passion of envy, but cheap, narrow-minded positivism.'[39] During a stay in Italy Vrubel had been drawn to the flexibility and subtlety of Veronese and Bellini, but he continued to believe that Russian art must find its own way, 'not dismembered by distractions from a structured, differentiated and insipid West.'[40] With his emphasis on the Russian tradition, he might have enjoyed the success which accrued to the Wanderers in the 1880s, but his art was subjective and individual, bound up with new forms and techniques. Because of the broken surfaces, Vrubel's work has been described as cubistic, but Shalyapin had reacted to this technique as early as 1896 and it seems more logical to attribute this characteristic to the mosaics which he studied in Ravenna and Venice. When he felt that the work of the Wanderers had become sclerotic and imbedded in the past, he was among the first to speak out. He attacked the use of art as propaganda, deplored their lack of experimentalism

and denounced the didactic smugness which had developed so rapidly in a radical movement.

In 1886–87, Vrubel was living in dismal poverty in Kiev when an important competition was announced. The winner would receive a commission to decorate the interior of the newly completed Cathedral of St Vladimir in that city. The structure had been built as a symbol of the Byzantine revival in Russia, and this was an opportunity to create an enduring masterpiece: a series of frescoes, decorative ornaments, and an iconostasis in an awesome setting. Earlier, as a student at the Academy, Vrubel had helped with the restoration of the twelfth-century Church of St Kyril in Kiev, and the stylized and imaginative remnants of Byzantine art, the figures and designs so dimly seen, had left a mark on his work. Yet his hopes were unrealistic; artistic conformity and archaeological exactitude were mandatory for this project and Vrubel's compulsion to invest his subject with his own imaginings made him an unlikely choice. He had never fared well with committees, but he knew his qualifications: 'I hear an intimate national note which I so want to capture on canvas and ornament.'[41] The dream disappeared when Viktor Vasnetsov was awarded the prize. To his despair, the series of watercolour sketches which he had made for the wall paintings remained unused. He assisted Vasnetsov in the undertaking, but his work was limited to the side naves.

Shortly after, Vrubel moved to Moscow where he encountered Konstantin Korovin. They had met before, and that painter, with his usual impulsiveness, invited Vrubel to share his studio. Korovin described the older man: 'Rather short, thin with the face of a man who has no common simplicity, restrained as if peaceful, he was a real Englishman-foreigner, well coiffed, carefully shaven with strong, delicate hands.'[42] He admired Vrubel's elegance, his education and the fact that he could speak eight languages, but he had been confronted with evidence of his friend's tormented state of mind soon after their first encounter. One day when they were swimming at the estate of a backer, Korovin noticed that Vrubel had many marks on his body as if he had undergone surgery or been cut repeatedly with a knife. 'What are those big white stripes on your chest? They look like scars.' Vrubel's explanation was chilling. He had loved a woman who had not understood him, and he suffered at not being able to explain himself to her: 'I suffered and when I cut myself, the suffering lessened.'[43] Later, in his diary, Korovin wrote of Vrubel, 'He looked like a foreigner, but he had a Slavic soul.'[44]

Korovin had been working at Abramtsevo since the winter of 1884–85. Polenov, who admired his freedom and imaginative use of colour, had sketched a new production of *Aïda* for Mamontov and suggested that the new arrival be entrusted with the execution of his designs. Though he was an early member of the Wanderers, Polenov was unusually open-minded and interested in new

trends in Russian art. As their teacher at the Moscow School of Painting, Architecture and Sculpture, he had supported both Korovin and Levitan in their break with the old guard, the 'genrists' such as Makovsky, Repin and Ge. Both Korovin and Levitan were considered by their earnest predecessors to be mere 'landscapists', trivial artists, lacking in true Russian feeling. Korovin was an excellent choice for *Aïda*; the glamorous setting suited his romantic style and Savva's young son Vsevolod remembered the work vividly, particularly 'the moonlight night along the banks of the Nile. ...'[45] Mamontov had been delighted with the result, and the following year Korovin created the décors for *Carmen* and *Lakmé*.

The reviews in the Moscow press were favourable; Korovin's name was becoming known and Mamontov was beginning to speak of him as Polenov's successor. Despite the recognition, Korovin was uneasy; he feared that the theatrical work was beginning to interfere with his easel painting. Though Mamontov was aware of the needs of his protégés, his own enterprises took priority. Vsevolod Mamontov has written about his father's 'firm and unyielding pressure' on the artists at the estate: 'He was very insistent and demanding, and sometimes decided himself how to organize an artist's work.'[46] His rapid tempo, resulting in 'performances that amazed one and made one angry at the same time',[47] had filled Stanislavsky with frustration, and now Korovin's diaries held references to his patron's drive and egocentricity. Also there was the reality of the painter's financial dependence on his benefactor, a theme which had clouded relations between the artistic and commercial communities for two generations. The atmosphere was lightened for Korovin in 1889, when Serov moved from St Petersburg to Moscow and resumed work at Abramtsevo. The warmth of their friendship restored his natural optimism, and now he, Serov and Vrubel formed a triumvirate, close and supportive, remarkably free from rivalry, and the work of each reflected his association with the others. However, despite their mutual esteem, and Serov's generous appreciation of Vrubel's work, their relationship was marred occasionally by emotional outbursts. Vrubel's moods were volatile, his agonies always close to the surface and he was quick to interpret any criticism of his work as rejection. One evening at a party, Vrubel, apparently wounded by a remark of Serov's, sprang to his feet and exploded: 'You don't have the right to make remarks about my art – I'm a genius and you're ungifted by comparison!' Serov, shaken, left the room and refused to be consoled, maintaining that Vrubel had spoken the truth, and that he was indeed ungifted.[48] The unexpected element is less Vrubel's outburst than Serov's insecurity. Despite his successes, the nagging dread apparently persisted that he was merely a careful technician, a plodder, compared to his brilliant compatriot. In 1889 Korovin and Serov, recognizing Vrubel's need for stability, had introduced him to the Mamontov circle. Within a few months he was living in the Mamontovs' home in

Moscow. To his credit, Savva Ivanovich did not interfere with Vrubel's work, set no tasks and encouraged him to work in whatever medium he chose. When the painter expressed an interest in ceramics, he built him a kiln and a workshop on the estate. Vrubel resumed work on his *Demon* which he had started to paint five years earlier.

The link between literature and painting has always been particularly close in Russia, and in 1890, the three friends Korovin, Serov and Vrubel participated in a commemorative exhibition of Russian literary classics, a project in which established Russian artists were invited to illustrate special editions of the works of the country's greatest writers. The idea had originated with the publisher I.N. Kushneryov, and the first book to be issued was a collection of the works of Lermontov, a volume which marked the fiftieth anniversary of the poet's death. The participants included Repin, Apollinary Vasnetsov and Leonid Pasternak.[49] The illustrations followed two modes: those in the traditional Russian style, which pictured the events recounted in the text and defined the drama, were the work of Repin, Vasnetsov and Pasternak. Vrubel led his friends Korovin and Serov into a world of mystery, moods, unsatisfied longings and a strange, brooding sensuality, more Oriental than Russian. The musical quality of the verse was reflected in his haunting watercolour *The Dance of Tamara*, which stems from this series. Strangest and most unfamiliar was the hermaphroditic aspect of his *Demon*.

Korovin felt that these were the best works that Vrubel had produced, and though he was working on his own version, he tried to enlist Pavel Tretyakov's support for his friend. When the collector came to the studio at Mamontov's house to see Korovin's paintings, the artist invited him to look at Vrubel's canvases. Tretyakov, who had never visited the workroom before, inspected the feverish watercolours, so carefully assembled, and left without saying a word. Korovin was crushed: ' – the essence of his work – the deep human feeling that penetrated every image – was not understood.'[50] The art from this period, the luxuriant tangle of painted flowers, the portraits with their nervous brush-strokes which had unsettled Shalyapin, the improbably delicate abstract form of the Majolica stove which he created at Abramtsevo, testify to the artistic freedom which Mamontov gave to Vrubel. The banker had opened commercial outlets in the city which displayed and sold the work that originated at the colony, and provided some income for the artists. For the first time Vrubel was released from the immediate agonies of economic survival. Mamontov had his detractors, and drove a hard bargain, but the sums he spent to underwrite his activities far outweighed the fiscal returns.

For many years there had been a growing estrangement between Savva Ivanovich and his wife Yelizaveta because of his many infidelities, in particular, his well-known and lasting love affair with Tatyana Lyubatovich, a leading

mezzo-soprano in the opera company.[51] The bitterness of the situation was
increased by the death of their son Andrey in 1891. Vrubel, who had become
fond of the young man, was shaken by the tragedy. This loss, the sombre
circumstances, the pressures of financial and artistic matters, seemed to make
Mamontov more reckless. Vrubel saw his dark side, the worldly, choleric
businessman whose love of 'wine, gypsies and troykas in a true Moscow fash-
ion' was well known in the city. He was exposed by his protector to an environ-
ment for which he was totally unsuited, vulnerable to the dissipation which
Savva could absorb without harm. Prince Shcherbatov, an admirer of the
painter, observed that this way of life was in many ways damaging to Vrubel,
'who had to be cared for like the rarest of treasures, on a completely different
scale.'[52]

Vrubel never learned to handle money. On one occasion after he finished
painting a decorative mural for Savva Morozov's house on Spiridonyevka, he
invited Korovin to join him for a celebration at the Hotel Paris. With his new
funds, he rented a luxurious room, gathered together a group of strangers and
hangers-on and ordered a prodigal feast, complete with ornate service,
candelabra and the finest wines, not the usual fare for a Moscow artist. When
Korovin arrived he found himself among a crowd of noisy revellers, none of
whom he recognized. In the midst of the festivities, Vrubel, wrapped in a
blanket, was asleep on the bed. In the morning, not a trace of food or drink
remained. The unremembered guests had vanished.

There were brighter moments. During his association with Mamontov,
Vrubel married Nadezhda Zabela, a popular prima-donna who starred with
Tatyana Lyubatovich in *Hansel and Gretel* for the Opéra Privé. The portrait
that he painted of Zabela in 1898 is unusually light and untroubled, but even this
liaison could not stem his incipient breakdown. In 1901, Nadezhda Ivanovna
gave birth to a boy whom they named Savva. A year later, Vrubel painted a
portrait of his son which was said to have been filled 'with anxiety and some sort
of terrifying foreboding'.[53] In 1903, the child Savva died. Though he bore up
under the shock remarkably well for a time, Vrubel subsequently passed through
a period of severe depression and he realized that his earlier mental and
emotional symptoms had returned.[54] Soon after, he committed himself to a
hospital. For a time he seemed to improve, even making an unexpected
appearance at Diaghilev's Tauride Palace exhibition, but the illness recurred and
this time it was permanent. His sight began to fade and he no longer recognized
members of his family even when they spoke to him at length. Though
Mamontov was not responsible for his disintegration, the artist had been
unstable for most of his life and he was not strong enough to withstand the
stresses. To men like Shalyapin and Repin, Mamontov's force was stimulating,
but to someone of Vrubel's delicate balance, like a very fine watch, the spring

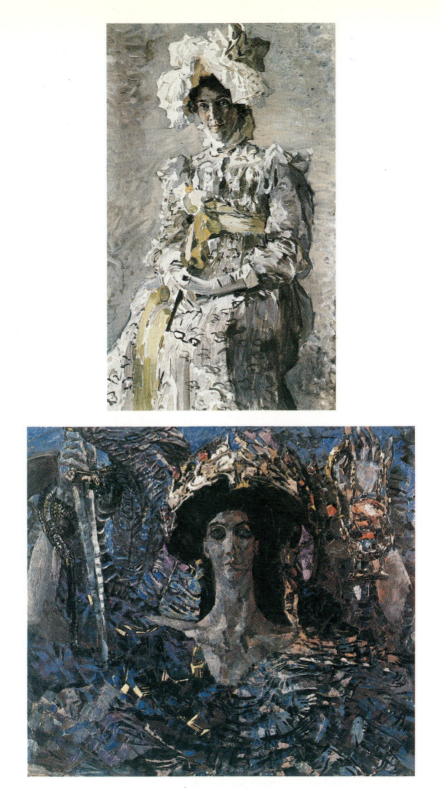

Top Mikhail Vrubel: *Portrait of Nadezhda Zabela-Vrubel*, 1898.
Tretyakov Gallery, Moscow

Above Mikhail Vrubel: *Six-Winged Seraph*, 1904.
State Russian Museum, Leningrad

Even with Cézanne, there is a florid,
romantic quality to Morozov's choice,
in comparison to Shchukin's speculative,
ironic self-portrait

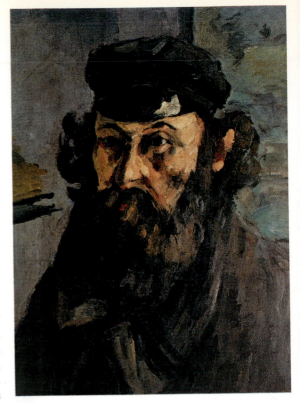

Right
Paul Cézanne:
Portrait of the Artist in a Cap, 1873-75.
The Hermitage, Leningrad.
Formerly in the Morozov collection

Below
Paul Cézanne:
Self-Portrait, 1880.
Pushkin Museum, Moscow.
Formerly in the Shchukin collection

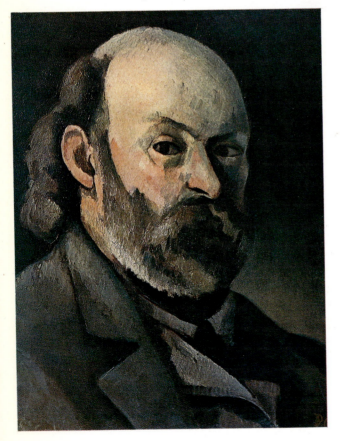

Opposite page, above
Claude Monet: *Poppy Field*, 1887.
The Hermitage, Leningrad.
Mikhail Morozov, potentially one of
the great Russian collectors,
purchased this Monet in 1902,
two years before his death

Opposite page, right
Konstantin Korovin: *Paris by Night*
(*Boulevard des Italiens*), 1908.
Tretyakov Gallery, Moscow.
Korovin's Impressionism at its best

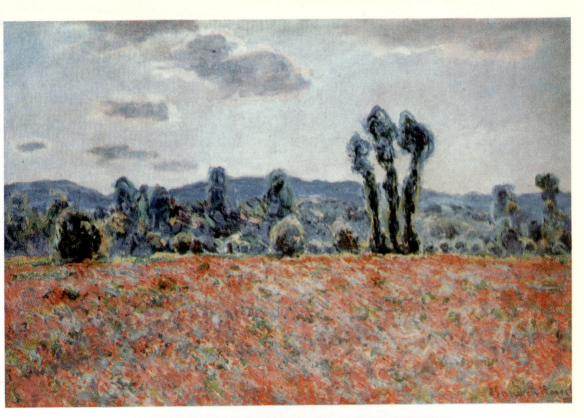

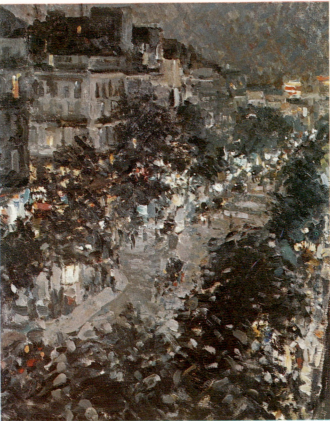

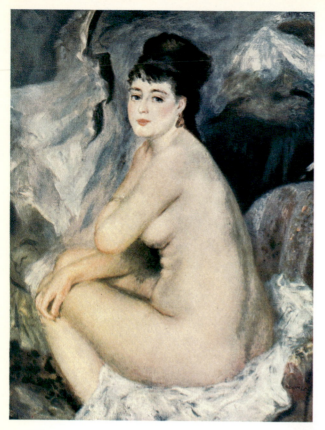

Pierre Renoir: *Anna*, 1876.
The Hermitage, Leningrad.
Purchased by Sergey Shchukin
from his elder brother Pyotr

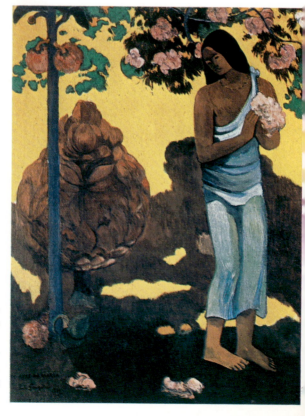

Paul Gauguin:
Tahitian Woman with Flowers
(*Te avae no Maria*), 1899.
The Hermitage, Leningrad.
Purchased by Shchukin from Ambroise Vollard,
who bought it from the artist
shortly before his death in 1903

gave. According to Shalyapin, 'he died in the conflict of spirit and flesh' in a sanitorium in 1910 after a complete emotional collapse.[55]

There were whispers of financial difficulty for Mamontov in 1898, but they were discounted when, apparently unconcerned, he joined with Princess Tenisheva to finance *Mir iskusstva*. A speculator who pyramided his holdings, Savva Ivanovich was planning to build a cultural and commercial centre in Moscow in 1899. The complex was to include a hotel, shops and restaurants and would serve as a permanent site for his opera company. That same year he was involved in preparations for a Russian section of the Exposition Universelle which was to be held in Paris in 1900.[56] He had never seemed more secure and unassailable, but suddenly, tragically, his life collapsed. In September 1899, he was arrested and imprisoned for fraud and embezzlement, and the Mamontov case became a cause célèbre in Russia at the opening of the century.

In addition to his other undertakings, Savva Ivanovich had been obsessed for years with the idea of opening up an area of northern Russia for economic development. In order to implement the plan, it was necessary to provide heavy transportation to a remote frontier, and as a beginning he suggested to his friends in St Petersburg that the State Treasury buy the Donets Railway Line. The merchant's contact and principal source of influence within the government was the Russian Minister of Finance, Count Witte. The complicated transaction involved the purchase of a second railway line by Mamontov, an effort which stretched his own resources dangerously. He charged some of the costs against his Moscow–Yaroslavl–Arkhangelsk Railway, an exercise in book-keeping which was accomplished by an intricate series of stock manoeuvres. Ultimately these were brought to the attention of officials in St Petersburg. When Witte came under attack by Muravyov, the Minister of Justice, for involvement in a private scandal in which he could have been accused of approving an illegal transfer of funds by Mamontov, he abruptly abandoned their agreement and managed to avoid being caught in the débâcle. But Savva Ivanovich was trapped. He desperately tried to borrow funds from private sources and from Rotshtein, Director of the Society for Mutual Credit, to cover his debt, but the amount of collateral demanded was prohibitive. Ironically, it was for personal reasons that Mamontov's most malevolent enemy destroyed his last hope. 'Mamontov's final blow was dealt not by Witte, not by Muravyov, not by Rotshtein, but by the all-powerful State Controller, Terty Ivanovich Filippov. He had been waiting a long time to take revenge on Mamontov who had not let Shalyapin sing at the anniversary concert of the Imperial Choir whose director was (after M. Glinka) Filippov. It was upon Filippov's insistence that the governmental revision was decreed that was the ruin of Mamontov.'[57]

On September 11, 1899 at seven o'clock in the evening, an inspector arrived at Mamontov's home and announced that because of charges which had been

brought against him, the house was to be searched. A few hours later, Savva Ivanovich was arrested for reasons which later proved to be transitory; 'he was taken by convoy through the whole city, he was taken on foot, not even in a cab, from his home on Sadovaya-Spasskaya street to the Taganskaya Prison.'[58] Also charged were his remaining sons, Sergey and Vsevolod, and two of his closest friends and business associates. Four days later, his request to be released because of a heart condition was denied and he remained in prison, in solitary confinement for five months. It was only after an emotional letter from Polenov to the Moscow Procurator, protesting the harsh conditions under which he was being held and citing his fainting spells, difficulty in breathing and damaged heart, that he was placed under house arrest. 'It seemed to me that the state of his health was reaching a dangerous level... to say nothing of the unavoidable moral shock experienced under such conditions. ... Please excuse the resolution with which I ask you to allow Savva Ivanovich to be placed under house arrest. Our long-standing friendship compels me thus.'[59] When Stanislavsky visited him in his home just before the trial, the merchant observed that he was being guarded by 'the whole Moscow police force'.[60]

The trial was held in June 1900, and though the technical and legal violations of Mamontov's financial manipulations were clear, it was felt that the intent to defraud was arguable. He had always run the railway like a personal fiefdom, and now the overriding consensus was that he was a scapegoat for politically motivated outsiders. The trial became a prolonged testimonial to Mamontov; friends and employees of the railway testified to his generosity, civic responsibility and above all, to his role as a patron of Russian art. Finally he was acquitted. Considering the forces arrayed against him, it was a remarkable upset. Maxim Gorky, who encountered Mamontov in Moscow after the verdict, may have summed up the jury's reaction to the accused: 'I saw Mamontov – a singular type! He really doesn't seem like a swindler at heart, but rather that he loves the beautiful too much and gets carried away with his love.'[61]

On July 3 he was released, but the complicated fretwork of his financial holdings had collapsed. Forbidden by law to engage in any business dealings with the railways, he was ruined. During the period of his imprisonment, all of his transportation stocks had been transferred to the Treasury, and it has been said that they were purchased at a reduced price by various relatives of Witte's wife.[62] Mamontov managed to keep Abramtsevo, but his Moscow home was sealed by the authorities and in 1903, house and contents were sold at auction. There is an element of classical tragedy to his fall. The small church at Abramtsevo had seen the funeral services for his son Andrey in 1891, and in 1907 his daughter Vera, Serov's glowing *Girl with Peaches*, was buried from that familiar setting. In 1908, it was the scene of the funeral ceremonies for his wife Yelizaveta.

Mamontov finally settled down at Abramtsevo and worked at the small pottery studio in the outskirts of Moscow near the Muscovy Gate which since 1896 had been named after the country estate. Without funds, forbidden by the government to engage in any of his former business activities, he lived a frustrating and lonely life. He retained his interest in the arts, though without money he was merely a spectator with little influence. He attended the exhibitions presented in Moscow by the Blue Rose, the Golden Fleece and the Donkey's Tail, and Stanislavsky remembered that in 1908, he unexpectedly found himself standing next to Savva Ivanovich at the footlights, applauding Isadora Duncan's Moscow début. Prince Shcherbatov, who visited him at his studio, found him still combative in exile, denouncing 'all that was backwards, stagnant, understanding nothing of real talent ... the official representatives of the art world, the jury, judges, the supervisors and controllers of fate'.[63]

After 1905, he often spent time with Vrubel in the sanitorium. It was said that he was the only caller whom Vrubel recognized. In 1917 the workshop was sold, and on March 24, 1918, Savva Mamontov died of pneumonia and was buried at Abramtsevo. The estate was nationalized that same year and in 1919 it was opened as a museum.

Unlike Pavel Tretyakov, he was not one of Russia's great collectors. There is no splendid aggregation of pictures at Abramtsevo, but there are the records and souvenirs of an authentic creative force, and his contribution to the arts is as solid and lasting as that of his predecessor.

In 1900, during the period of his imprisonment, Mamontov received a letter from a group of his former collaborators. It had been composed and organized by his friend Vasily Polenov and signed by Antokolsky, Repin, Rimsky-Korsakov, Viktor and Apollinary Vasnetsov, Surikov, Ostrukhov, Korovin, Levitan, Nevrev, Vrubel and Serov.

All of us, your friends, remembering the radiant days of the past when we lived so harmoniously near you, so close and happy in the artistic atmosphere of your cordial family, all of us – in these difficult days of adversity want somehow to express our sympathy.... You were our friend and comrade, your family was a warm refuge along our path. It was there that we rested and collected our strength. ...

How many artistic projects were planned and carried out in our circle, and what diversity: poetry, music, painting, sculpture, architecture and stage design, all alternating. ... From your home stage, artistic life emerged into the public, and you, a born artist of the stage, began to create a new world of the truly beautiful. ... Your role in the Russian stage is unassailable, and should be preserved in history.

We artists for whom there is no life without art proclaim your honour and glory in gratitude for all that you brought to our art. ...[64]

It was an acknowledgment of one whose power had vanished, but whose influence remained.

<div align="center">* * *</div>

An effective voice for unifying the divergent artistic impulses on the Moscow scene after Tretyakov and Mamontov was the magazine *Zolotoye runo* (*Golden Fleece*), first published in 1906 by Nikolay Pavlovich Ryabushinsky.

One easily could dismiss Ryabushinsky as a playboy and poseur. Fond of declaring 'I love beauty and I love many women',[65] he bounded across the Moscow stage like a character in a Sacha Guitry farce. Yet like most of the Moscow figures, he was a complex person. Five times married, a darling of the gossip columns and the bane of his more conservative relatives, he was a burly, red-headed giant with inexhaustible vigour and passionate enthusiasm. The immense wealth of the family had come from cotton, paper and the Ryabushinsky Bank which later became the Moscow Bank.

Nikolay had sixteen brothers and sisters. After the death of the patriarch Pavel Mikhaylovich in 1899, the eldest son Pavel Pavlovich had become the undisputed head of the clan and had assumed responsibility for the family's industrial and banking interests. A prominent figure in the merchant community, member of the Moscow Stock Exchange and of the State Soviet, a government body concerned with commercial affairs, a dedicated advocate of the cause of the Old Believers, he was, in addition, the publisher of *Utro Rossii* (*Russian Morning*), the *Wall Street Journal* of Moscow. Pavel was noted for his comparatively progressive social views and in 1905, like many others, he was drawn into public life. Convinced of the merchants' irreplaceable role in the future of the country, he urged his compatriots to preserve their identity and not to lose themselves within the ranks of the nobility. The editorial policy of *Utro Rossii* reflected his personal integrity. In 1911 during the turbulent and dangerous period following the assassination of Pyotr Stolypin, the Minister of Internal Affairs, Ryabushinsky did not hesitate to attack his equally disliked successor, N.A. Maklakov, who rigidly opposed any proposal for political reform. Pavel published an article which satirized the new Minister's personal foibles, and since Maklakov was in favour with the royal family, this was a dangerous business. Ryabushinsky not only authorized publication but assumed the entire responsibility. As a result, his journal became the target of 'severe repression'[66] and a fine of 3,000 rubles. The offence was not forgotten, for later during the war when he was selected to head a committee which would represent the interests of the business community in an audience with the ruler, the Tsar refused to receive the delegation.

Pavel was not the only outstanding brother. Dmitry, the youngest, was an aerodynamicist, a professor and a corresponding member of the French

Academy of Sciences. Vladimir Pavlovich, on the board of the Moscow Bank and involved in the affairs of *Utro Rossii*, was a member of the Moscow Duma. Mikhail Pavlovich filled his mansion with works by Renoir, Degas, Pissarro and Benois, as well as a varied assortment of Vrubels. The family was remarkable for its hierarchical discipline; Pavel was the leader and the others accepted his authority.

Except perhaps Nikolay. In this solid, well-established dynasty Nikolay Pavlovich was the sole non-conformist. Though his inheritance had been substantial, his brothers were frequently called upon to bail him out financially. He was extremely ambitious to establish his own identity and this desire for recognition was implicit in the details of his daily life: his presence at every gala opening night, the conspicuous centrepiece of fresh orchids on his luncheon table at the Hermitage and the constant, self-conscious pursuit of a machismo image. He was viewed by his family as a charming, self-indulgent rogue, and his participation in the Ryabushinsky empire was kept to a minimum.

In addition to his many marriages and love affairs, a major drain on his resources was the Black Swan. In 1907 he commissioned this great manor to be built in Petrovsky Park in Moscow. The formality and grandeur of the façade was in contrast to the bohemian exoticism of the interior. The swirling lines of old Russian designs and Art Nouveau furnishings blended with the iridescence of Favrile glass, bedrooms hung with silk brocade and pervaded with incense; a dazzling succession of wives and mistresses created a colourful backdrop for the eccentric, occasionally wild gatherings which diverted the city's more sober citizens.

Ryabushinsky, an amateur painter, was a magpie collector whose house held an accumulation of the memorable and the mediocre: bizarre carvings acquired during a journey to India next to a superb fourteenth-century Persian enamel vase, 'poison arrows, vases and sinister dragons from Majorca'.[67] There were two first-rate Rouaults: *Head of a Clown* and a rare pastel, *Filles* (1907), as well as a flashing *Dancer in Red* (1907) by Von Dongen. These contemporary works were scattered among assorted canvases by Cranach, Breughel and Ruisdael. But the bulk of Nikolay's modern collection was composed of the new generation of Moscow painters: 'Russian graphics by young left-leaning artists.'[68] This last reference by Prince Shcherbatov is to an affiliation of young painters which had coalesced informally in 1904, exhibited in Saratov[69] under the name of the 'Crimson Rose', and finally attained a collective recognition as the 'Blue Rose' in 1907.[70] This movement lasted for only a brief period, but it was an important phase in the continuum of Russian art, a link between the Westerners of *Mir iskusstva* and the emerging Moscow avant-garde, typified by Larionov, Goncharova and Malevich. The Blue Rose painters under the leadership of Pavel Kuznetsov had turned from the social chaos which surrounded them in

1905, and sought oblivion in the claustrophobic, haunted world of Symbolism. There is an ectoplasmic quality to Kuznetsov's work, to the series of embryos, wraiths, dead-eyed women and cascading fountains which is accentuated by the muted greens and blues of his palette. The group's lack of involvement with the harsh conditions of the period echoed Ryabushinsky's escapism, and he soon became the principal sponsor of the movement. He commissioned Kuznetsov to create the wall friezes for the main hall and gallery of his home and the ghostly figures added to the special effect of the décor.

The garden surrounding the Black Swan was an adolescent fantasy, with cages for the lions and tigers Ryabushinsky proposed to import, and for which he claimed to feel a special kinship. (This project was quickly scotched by the Moscow police.) The bronze figure of a bull was placed near the entrance over a tomb ('mon tombeau'), which was destined eventually to receive the ashes of the irrepressible host. A pharaonic conceit rare even for Moscow, it was one of the many reasons why the practical members of the community could never take Nikolay Pavlovich seriously. They deplored his fondness for theatrics, and yet it was an indication of his greatest gift. Ryabushinsky was a promoter. For most of his life his wealth and eccentricities obscured a genuine twentieth-century talent in this field.

He shared many qualities with Diaghilev: personal ambition, opportunism and a voluptuous love of beauty. Each was a master of self-aggrandizement, a supreme entrepreneur who could somehow elicit the best in an artist's work. Above all, they shared discernment and taste in art, the ability to know what to take and what to leave.

It was obvious that *Mir iskusstva* had been effective, both as a voice for modern art and as a vehicle for Diaghilev's personal ambitions, and in 1906 Ryabushinsky made the decision which thrust his name into an élite company. At the age of thirty-one he became the founder and publisher of *Zolotoye runo*. With his vanity and love of pleasure, he would seem to have been an unlikely figure to make a contribution to the course of Russian art, but like many of his generation, he had grown up surrounded by masterpieces. The icons, Vrubels and Impressionists owned by his family were as much a part of his environment as the Yar restaurant or the Kremlin.

His brother's experience as a publisher was helpful to *Zolotoye runo*, and Nikolay's familiarity with both art and journalism gave him a practical edge. His new enterprise was derided by many as the toy of a self-indulgent playboy, but he had flair, and ultimately the publication became a force in the cultural life of Moscow. The format was similar to that of *Mir iskusstva*. Each journal featured the talent of artists from Moscow or St Petersburg interchangeably, presented contemporary Western art and espoused the virtues of its favourite Russian painters.

The two magazines are interesting both for their similarities and for the nuances of their differences. Where *Mir iskusstva* had been largely analytical and scholarly, the tone of *Zolotoye runo* was mystic and instinctual. The first reflected the intellectuality of seventeenth-century European thought, recreated a world in which there was a planned and ordered aesthetic in the manner of St Petersburg. It named as its 'Olympian gods' Shakespeare, Giotto and Bach. The Moscow journal emphasized 'the close ties between the discovery of religious experience and the ideas of realistic symbolism and synthetic art.'[71] It found release in the world of dreams and symbols, in the spiritual philosophy of Solovyov, Ivanov's idealism, the rhythmic genius of Blok. In the first issue of 1906, Ryabushinsky set down his editorial observations. 'It is at a formidable time that we embark upon our path. Around us, like a raging whirlpool, seethes the rebirth of life. ...' In 'the presence of the cruel responses given by Russian life' he sought to preserve 'the Eternal Values ... Art is symbolic, for it bears within itself the symbol, the expression of the Eternal in the temporal. ...'[72]

Despite their differences, both publications were resolutely uninvolved with Russia's continuing social crisis. Ryabushinsky had little concern with civil unrest or uprisings. For him, these years were as isolated from political reality as the small snow scenes held within a glass ball; when it is shaken, nothing changes, the snow falls and settles again. Diaghilev had been more aware. In 1905, when he raised his glass after the Tauride Palace exhibition, he knew that his society was coming to an end and he preferred not to contemplate the destruction. Ultimately, each was a survivor. Both came through the Revolution and prospered in the West at a time when hardier souls sank without trace.

The first issue of *Zolotoye runo* appeared in January 1906. The cover, designed by Lancéray, featured a sinuous mermaid bearing a lamp, her long hair and coiled, gleaming scales reflecting its publisher's taste for exoticism. The new magazine employed the talents of many of the *Mir iskusstva* group: Bakst, Merezhkovsky, Bely, Blok, Filosofov and Benois.[73] Ryabushinsky shared with Diaghilev the ability to cajole and bully others until they joined him in his current enthusiasm. This was evident when another contributor to *Mir iskusstva* was persuaded to add his efforts to *Zolotoye runo*. The last time Vrubel had been seen in public was at Diaghilev's Tauride Palace exhibition, a shadowy, uncertain figure on the fringes of the crowd.

For some time, Ryabushinsky had been trying to persuade Vrubel to paint a portrait of the Symbolist poet Valery Bryusov for his journal. Now the artist's tragic life, and a growing appreciation of his work among knowledgeable collectors, were creating an audience which made the idea even more desirable. Despite the harrowing circumstances, Ryabushinsky sent artist's supplies to the sanitorium and persuaded Vrubel to continue his work. The portrait of Bryusov,

stark charcoal and chalk, with red slashes of crayon, is one of the painter's most striking pictures. The first issue of *Zolotoye runo* was devoted to Vrubel and to the founder of Russian Symbolism, Viktor Borisov-Musatov, both of whom, according to Ryabushinsky, expressed the journal's credo.

Nikolay Pavlovich shrewdly publicized the private collections. He realized that even the most eminent and unapproachable industrialists welcomed recognition of their cultural achievements. In 1908, issue number one contained reproductions of theatrical sketches by Golovin and Sapunov owned by Ivan Morozov; a portrait of the wife of the merchant collector Vladimir Girshman by Serov, and a detailed survey of the sprawling Mikhail Botkin accumulation of art from the Italian Renaissance. Another issue was devoted mainly to Pyotr Shchukin's massive assortment of ancient Russian, Persian and Indian objects. The old pieces appealed to many Russian collectors, not only for their rarity and beauty, but for their scholarly aura. However, Ryabushinsky's enthusiasm was for the moderns and it was here that he made his greatest impression.

An important variant of his activities lay in the field of exhibitions. In April–June 1908, he presented the memorable exhibition of the Salon of the Golden Fleece. In St Petersburg in 1899, Diaghilev had shown the works of the *Mir iskusstva* group with those of Monet, Degas and Puvis de Chavannes. Now as a reprise, Ryabushinsky combined the canvases of the Russian avant-garde with a French section of one hundred and ninety-seven paintings, a rich and important display which included works by Pissarro, Redon, Vuillard, Degas, Van Dongen, Bonnard, Cézanne, Braque, Marquet, Gauguin, Van Gogh and Matisse. It should be noted that Moscow was a conservative city far from the centre of Europe, and the extent of Ryabushinsky's foresight is underlined by the fact that it was not until two years later, in 1910, that Roger Fry arranged the first showing of Post-Impressionist art in London which introduced the paintings of Cézanne, Van Gogh and Gauguin to a British audience. The Moscow showing, like Diaghilev's earlier efforts, featured music and a buffet. Flanking the staircase, which was banked with fresh flowers and shrubs, was a dramatic circular bas-relief, *Adam and Eve* by Niederhausern-Rodo, opposite Rodin's marble *Walking Man*.

The body of the show contained five major Van Goghs, *The Rocker*, *The Gardener*, *The Zouave*, *Sun in the Trees* and *Night Café*, the last loaned to the show by Ivan Morozov. Morozov also loaned Cézanne's *Portrait of the Artist's Wife* for the occasion. Princess Tenisheva sent two Degas pastels and one of the five Roualts; another, *Head of a Clown*, was from the Ryabushinsky collection. There were six Derains (four views of London) and five Braques, including the Fauve *Port at Ciotat*. Five Matisses and three Gauguins could not compare with those in the Shchukin and Morozov collections. Of the Matisses, *The Hairdresser* and *The Terrace (St Tropez)* were the most important. Unquestion-

ably the most comprehensive view of modern French painting shown in Russia up to that time, the exhibition attracted six thousand visitors.

Kuznetsov and the members of the Blue Rose led the Russian contingent, but their misty, evanescent oeuvre did not compare well with the brilliance of the French. Goncharova and Larionov fared better. Their stylization, vivid tones and imagination enabled them to survive in this company. Symbolism in painting was beginning to decay; some of the artists were turning to new forms and the neo-Primitivism of Larionov and Goncharova would provide a new alternative. Parenthetically, there were three Ryabushinskys in the show.

Zolotoye runo lasted until the end of 1909. During its brief lifetime it sponsored a total of three exhibitions. The second (January 11–February 15, 1909) featured works by Larionov and Goncharova, many in the Impressionist idiom; Fonvizene, Saryan and Kuznetsov were prominent among the Blue Rose members. Kuznetsov showed a taut and revealing *Self-portrait*, a case history in charcoal, crowded with symbols – an overpowering mother-figure, and an oddly withdrawn foetal child under a blazing sun. The Western section was smaller than in the first show; it contained, among others, works by Vlaminck, Braque, Friesz, Van Dongen, Matisse and Marquet. The third exhibition, all Russian (December 27, 1909–January 3, 1910), added several newcomers: Ilya Ivanovich Mashkov, whose Oriental stylization and dazzling colours made him susceptible to Matisse's influence, Pyotr Pyotrovich Konchalovsky, and Robert Rafaylovich Falk who was to become one of the most skilful of the Russian Cubists. In 1910 these three artists joined the Knave of Diamonds, an organization which promoted the formal principles of Cézannism and Cubism. Though their work came to belong to revolutionary art, they never moved on to complete abstraction, their analysis of form remaining linked to reality and the object.

For a moment, Ryabushinsky paralleled Tretyakov's function; within the span of these showings, he mirrored clearly a period of transition in Russian art: the repudiation of the enervating and theurgical morbidity of the Blue Rose, and the artists' reaffirmation of reality and immediacy. These exhibitions presaged the surge toward the Western avant-garde which accelerated after 1909. 'In Moscow, *Zolotoye runo* was ending its days in decadent languor ... the banner raised by Shchukin took up its revolutionary cause. The young artists bristled ... seethed ... became anarchistic, rejecting any and all teaching.'[74]

At this time Ryabushinsky sought to diversify his activities. Recognizing the great Russian art boom, he proposed to construct a Palace of the Arts in Moscow. It was to be a combination of museum, art gallery and auction house. Five hundred shares at one thousand rubles each were to be floated to cover the costs, and the dividends were to be paid out of the sales.[75] This blend of

commerce and culture might have appealed to the merchants eventually, but Ryabushinsky's financial collapse in 1909 ended all hope for the enterprise.

He had poured large sums into the publication, but despite a loyal following, it had never come close to recovering its costs. It had been subject to systematic confiscation of issues by the censors and a barrage of criticism from newspaper critics. However, the magazine maintained a level of enterprise and sophistication despite the straitened circumstances. In 1909, issue number six was devoted to the work and theories of Matisse. It carried the complete translation of the artist's *Notes of a Painter* and an evaluation by Henri Mercereau of Matisse's place in the hierarchy of French artists as well as examples of his latest and most provocative work, thirteen paintings and three drawings. The reproductions included a giant study for *Dance*, which Shchukin had commissioned that year for his Moscow home. For lack of cash, the final issues of 1909 did not appear until 1910. But Ryabushinsky had attained recognition as a legitimate figure in the Moscow art world, and like Diaghilev's, his accomplishment had been praised by the Tsar. In his final editorial he stated his belief that 'the principles of historicism and aestheticism which had governed *Mir iskusstva* would have led to a dead-end in Russian art . . . for the birth of art one must move away from a purely negative, subjective individualism to find a new, religious, life-affirming force.'[76]

Ryabushinsky was a mystic, a brilliant dabbler, easily diverted, a man who lacked the long view; however, any mention of his eccentricities must be tempered by a recognition of his accomplishment in creating *Zolotoye runo* and presenting the most comprehensive selection of modern painting yet shown in Russia. In this area he surpassed Diaghilev, and with true Moscow panache, responded generously and without reservation to the new art.

4

THE MOROZOVS

The Morozov name is linked to the beginning of the influence
and flowering of Moscow merchant power.

P.A. Buryshkin

We are the cream of society, no one is able to outshine us any
longer. Everything revolves at present around capital.

Radion Denissovich Ryalov*

A history of the Morozovs has the exaggeration of a melodrama, studded with
improbable events, tragic figures and an heroic cast. As the generations merge,
the eye is caught first by one character, then another, until it is impossible to
separate the performers or evaluate the pageant. To touch on their accomplish-
ments and failures is to discern a measure of the family's energy and scope and to
catch a glimpse of the society that produced it.

The line of Morozovs to be discussed must include Savva Vasilevich, the
founder of the family, his youngest son Timofey who established the financial
power of the clan, his grandson Savva Timofeyevich, the backer of the Moscow
Art Theatre, and Savva's three nephews, the fourth and final generation of
merchants in Moscow: Arseny, the epitome of the bored young scions of the
Moscow rich; Mikhail, one of the earliest patrons of modern art in Moscow; and
Ivan, the industrialist collector, whose taste in painting made him an
internationally known figure.

The Morozov fortune had its origins in the tiny village of Zuevo on the banks
of the River Klyazma some fifty miles east of Moscow, a community of
approximately one hundred and fifty inhabitants. These families, together with
the houses and livestock, were the property of the local landowner, Count
Ryumin. Savva Vasilevich, the originator of the financial empire, was a serf who
in 1797 had been given permission by his owner to open a small factory in the

* Ryalov, a character in a play by I. A. Sumbatov-Yuzhin, was based upon Mikhail Morozov.

village for the manufacture of silk ribbons. After the War of 1812, when most of Moscow had been razed, the Muscovites returned to their homes but there was little left to salvage. When Savva passed through the Spassky Gate, the city was hungry for merchandise and he carried, strapped to his back, the bundle which was to become the badge of the upwardly mobile. It contained sturdy fabrics, linens, embroideries and delicate ribbons which he and his family had woven in Zuevo. It was the beginning of Morozov enterprises.

By 1820 Savva Vasilevich had four sons. Each had taken his turn at the looms and the money which had been earned was used to buy the freedom of his family. However, in 1823 his son Timofey was born into bondage. Count Ryumin had stipulated that the agreement covered only the family members then living. Timofey, born after the contract was signed, was his property. Ten years passed before Savva could afford the asking price for his youngest son. By 1837 the Morozov factories had expanded to eleven buildings and employed two hundred workers. Savva had seen the growth of the industrial revolution and had grasped the principles and possibilities. When cotton began to supplant wool and flax as the leading fabric, he imported bales of the raw fibre from America and was the first to bring power looms from England into the country. He converted his factories to production of the finished fabric, and with this one move became independent of foreign suppliers and immune to Western economic pressures. By the 1850s the Morozovs had become a significant factor in the economy of the Zuevo area. Savva Vasilevich died in 1860 at the age of ninety, almost fifty years after he had set out from the village for Moscow. The proclamation freeing the serfs was issued in 1861, a few months after his death.

Timofey was his father's successor. Although it was unusual for the youngest child to take over, he was unquestionably the best qualified because of his aggressiveness and intelligence. The prodigious growth of the Morozov complex is attributable to his comprehension and exploitation of a basic rule of industrial organization. Where many Russian merchants derived their enormous wealth from a single transaction, importing and selling a commodity, the Morozovs controlled every stage of their operation, from importation of the raw material through manufacture to sale of the finished product in their own retail outlets to the consumer. Profit was made at every level. It was a classic example of vertical growth; like a modern oil company which integrates each step from the bit to the gasoline pump. By 1880, Timofey had become Russia's most powerful industrialist, a shareholder and director of the Merchants' Society and the Commercial Bank, two of Moscow's most prestigious financial institutions. The only field in which he lost money was the publishing house which he founded with his son-in-law, Professor G.F. Karpov, but he bore the loss with equanimity, for the Morozovs were becoming important in the cultural life of the community.

In the course of his lifetime, Timofey Savvich had been both serf and master; in time he became a force as absolute as Count Ryumin, and his rigidity sparked the first organized revolt against 'capitalist tyranny'. There was a constant simmer of covert organizing and revolutionary activities in the factories, and in 1885 the workers struck for eleven days, rioting throughout the plants and smashing the equipment. The work force now numbered eight thousand and the Zuevo-Nikolsky plant covered two and a half square miles. It was a demonstration of some magnitude and the government had a stake in the outcome. Police and Cossacks ruthlessly put down the rebellion. Six hundred employees were dismissed and shipped back to their villages, the strike leaders were imprisoned and peace was imposed. Seven years elapsed before the next uprising.[1]

A history of the Russian bourgeoisie tends to become a chronicle of the male members, but over the years there were several Morozov women who were exceptional. They wielded power, not only through their husbands, but on their own. The first was Timofey's wife, the formidable matriarch of the family, Mariya Fyodorovna Morozova. She was her husband's equal in strength and will, and above all, in her desire to preserve at any cost the dearly earned status quo. Serov painted her in 1897, eight years after the death of Timofey, an intimidating rock of a figure encased in ruffled black taffeta; under the frivolous little lace cap, a round, twinkly, peasant face with one good eye, shrewd and appraising as any overseer.

After Timofey's death, Mariya had become the largest stockholder in Morozov industries, a dowager empress who guarded her control jealously and kept a close watch on the policies and activities of the enterprise. Mariya and Timofey had three daughters, Anna, Yulya and Aleksandra, and two sons, Savva and Sergey Timofeyevich. It must have seemed incredible, even unjust, that she and her husband had produced two boys so unlike themselves.

Sergey, the younger, had no interest in business. He married O.V. Krivosheyna, the sister of a prominent statesman,[2] and his energies were absorbed in preserving and restoring the art and handicrafts of the peasants. For this purpose he built and endowed the Moscow Museum of Handicrafts and was generous in his support of village artisans. Once again, the son valued and sought to re-establish what the father had destroyed without a qualm.

Savva Timofeyevich Morozov, Timofey and Mariya's elder son, had been named for his grandfather, and he was surely the most tragic and fascinating figure on the Morozov roster, a nineteenth-century man with the conflicts and values of a later generation. Maxim Gorky, a close friend, described him as 'a solid stocky man with a Tatar's face and sharp, sparkling eyes.'[3] Though he resembled a great shambling muzhik, he was an oddly sensitive and complicated character with a passion for the theatre. Though he was imbued with the intense nationalism which typified so many of the merchant leaders, Savva did not share

the Slavophilism of the majority of his compatriots. He found the mythic idealization of the peasant as the source of Russia's strength to be 'sentimental idiocy'.[4] Perhaps because of his experience as an industrialist, he believed that Russia's salvation lay with the workers – the urban proletariat – rather than the 'anarchic peasantry'.[5] Gorky remembered that the first time he had seen Morozov at a meeting of tradesmen and industrialists, Savva had publicly dictated a telegram to Witte, the powerful Minister of Finance, 'using harsh and impassioned language'.[6] His imperious manner and economic views did not endear him to many of his conservative friends; he had little success in his family life, and to add to his feeling of isolation, he was terrified that he might be going mad.[7]

Savva had been deeply unhappy with what he regarded as his father's brutal tyranny. When he inherited Timofey's authority he abolished the hated work fines and provided decent living quarters, hygienic working conditions, medical care, a hospital, even a theatre for the workers.[8] He was simultaneously ahead of his time and too late.

It has been said that Savva 'understood the power of capitalism on a broad national scale',[9] and his social responsibility did not prevent him from following the sumptuous Moscow tradition. He built a palace in the city designed by Fyodor Shekhtel, the architect famous for the Yaroslavl railway station and Stepan Ryabushinsky's Art Nouveau house among others, and the result was worthy of the Medici, a great structure with a shining gold roof and stained glass windows.[10] The windows contained scenes of battle and returning warriors, and when he was asked whether he liked combat, he replied with a smile, 'I like victory.'[11] The interior was equally extravagant. The door was answered by 'a big mustachioed man with a Circassian dagger in his belt', the hall of rose marble contained a sparkling fountain, and the salons were filled with Russian works of art, including three spectacular panels, *Morning*, *Noon* and *Evening* which he had commissioned from Vrubel. In contrast, his study was 'modest and simple', with Antokolsky's bronze head of Ivan the Terrible as the only ornament. His adjoining bedroom had the same air of austerity, and the two rooms reminded Gorky of 'bachelor's quarters'.[12]

Savva's sensitivity in the presence of talent led him to underwrite a new wave in the Russian theatre. The relationship between commerce and culture had not always been so close. At the beginning of its ascendancy, the Moscow bourgeoisie had been divided into mutually hostile segments: the businessman and the artist-intellectual. Values and goals were different; the artists regarded the merchants as crass, pushy moneygrubbers, and in turn, the business community despised the intellectuals as poseurs, ineffectual dilettantes and idlers. In addition, the intellectuals were for the most part hostile to the unrestricted power of the monarchy; the merchants' stake was in stability and order. For

years there was a minimum of communication between the two camps. However, as the businessmen accumulated wealth and leisure, there was time for the next generation to pause and reassess; a collaboration developed between the two communities and the merchant-patron emerged as a force in the arts.

The theatre of realism was born with the Moscow Art Company in 1898 when Stanislavsky and Vladimir Nemirovich-Danchenko formed their alliance. Though it presented productions of Shakespeare, Molière, Ibsen and Maeterlinck, it seemed created to interpret the subtleties of Chekhov and the proletarian agonies of Gorky; the audience would know not only a character's deepest pain and pleasure, but sense the minutest details of his experience: the heat or cold, the fly on his cheek or the paper lining his boots.

Aleksey Tolstoy's historical pageant *Tsar Fyodor*, which had been banned by the censor for thirty years, was the first presentation of the new company. The play was the second part of a trilogy, the first being *The Death of Ivan the Terrible*, and the third *Boris Godunov*. Morozov had a genuine love of Russian drama and it was this production that activated his interest. Ultimately he became the sole backer of the Moscow Art Theatre.

With his support a new theatre interior was built for 300,000 rubles. Somewhat ascetic for a Russian house, it was simple and unfrivolous, without the customary rococo embellishments. Nemirovich-Danchenko observed that Morozov 'knew the taste and value of simplicity which is more precious than opulence.'[13] The house set a mood in which all emphasis was on the play. The audience was seated in a softly lit, comfortable auditorium with plain, off-white walls. The unpretentiousness was balanced by the technical sophistication of a giant revolving stage. This innovation was rare, even among the most avant-garde Western European companies. The actors, accustomed to changing backstage in tiny crowded spaces next to the frozen pipes, were amazed by the planning given to the dressing rooms. Stanislavsky remarked later, 'All for art and the actor, that was the motto that controlled his actions.'[14] In the 'House of Chekhov' the single decorative touch was the sea-gull emblazoned on the curtain.

The Lower Depths opened in this theatre in 1902, and deepened the relationship between Morozov and Gorky. They had met six years earlier, and initially Gorky had mistrusted this wealthy businessman with his learned discourses on the proletariat. Morozov had given hundreds of thousands of rubles to the Social Democratic Party and contributed twenty-four thousand rubles a year to the party's paper, *Iskra* (*Spark*), which was published abroad. He had started as a progressive, an evolutionary democrat, but he had come to realize that Russia's problems were too extreme to be solved by moderate means. In 1903 he supported the Bolsheviks in their split with the Social Democrats, for he believed that Lenin's faction saw the situation clearly and was capable of the

drastic measures necessary to cure the Russian dilemma. When Gorky helped to finance Lenin's journal *Vperyod* (*Forward*) it was assumed that most of the funds came from Morozov.

Ultimately Savva's artistic interests were overshadowed by his political involvement. It was said that Savva Timofeyevich was like a lover; to each new enthusiasm he brought total devotion. With the approach of the 1905 débâcle, he became caught up in political activism.[15] 'He gave a lot of money to the political Red Cross for building escape routes from places of exile',[16] according to Gorky, and at personal risk carried type to clandestine presses and forbidden books to the workers. It was rumoured that the house with the golden roof provided a sanctuary for revolutionaries who were being sought by the Tsar's police. N.E. Bauman, a Bolshevik who was wanted for questioning, spent a night sleeping on Savva's billiard table, and subsequently was given shelter at his country estate.[17] Morozov was seen less frequently backstage at the theatre, and in 1904 his participation ceased. However, he left his capital invested in an effort to assure the continuity of the venture.

When Gorky was arrested in Riga for sedition in 1905, Morozov paid 10,000 rubles to bail him out, and the cost of this gesture was fatal. In this year of the abortive revolution, Mariya Fyodorovna Morozova was totally out of sympathy with her son's political attitudes, his efforts to ameliorate the lives of the workers, and above all, with his friendship for Gorky. She was still the major stockholder, and when Savva suggested that Morozov industries could safely share a portion of the profits with its employees, she exploded at his 'stupidity'. Despite the swollen earnings, she removed her son from control of the company.

After this confrontation, Savva left for the south of France where, a month later, he shot himself. A member of the industrial aristocracy, he had recognized that Russia's social structure could not endure in its present form and the change which he foresaw would necessitate the destruction of all that he represented. He was as much a victim of the social upheaval as if he had been killed at the barricades.[18]

The years were closing in. Savva Timofeyevich left two sons and two daughters, but none of them made an impact similar to that of their father. The Morozovs of the fourth generation were represented in the arts by a parallel family line. The original Savva who sought his fortune in the city in 1812 had left four sons. After his death in 1860, the holdings of the house of Morozov were divided between them. It was the descendants of the second son, Abram, who now made their appearance. Abram's son, Abram Abramovich, Savva's grandson, had become the head of the industrial complex located at Tver, and it was this branch, known as the Tverskys, which produced the most culturally progressive and intellectually active members of the clan.

Abram had died at an early age and his sons Mikhail, Ivan and Arseny had

been raised by their mother, Varvara Alekseyevna Morozova, née Khludova. Unable to remarry without losing her inheritance, she had been left with the responsibility for three young boys and one of the great fortunes in Russia. A beautiful woman, Varvara might have drifted through life as effortlessly as a frond in a pool, but as a member of the Khludov family, she had matured in an environment which stressed social activism and support of the arts. The Khludovs had been involved in the establishment and maintenance of schools, hospitals, hostels for the destitute, and old people's homes. Pre-revolutionary Moscow was not a centre of women's liberation, but Varvara supported equal education for women, and had she been a man, would have been as renowned and powerful an industrialist as any of her masculine contemporaries. As it was, she took over the management of the business and founded a series of trade schools for the workers which served as a blueprint for other industries. Strong-willed and independent, she shaped her life without regard for the prevailing Victorian views of a woman's role in society.

With this grounding, plus her own drive and instinct for what was important, Varvara Morozova endowed the first public library in Moscow, the Turgenev Library, and her comfortable old mansion in the city soon became the scene of a brilliant salon which provided a rostrum for the leading artists, writers and polemicists of the day. Among the guests were Leo Tolstoy, Chekhov and Vasily Sobolevsky, lawyer, economist, writer, and distinguished member of the editorial board of *Russkiye Vedomosti* (*Russian News*), a publication backed by Varvara Morozova which advocated social change and political reform.

Sobolevsky's liaison with Varvara Morozova was an established and accepted fact of life in Moscow, and in time there were two children from the union. In her personal independence, liberalism and emphasis on the Slavic renaissance, Varvara resembled Savva Timofeyevich, her husband's cousin who died so tragically in 1905.[19]

Her children were raised in an atmosphere of intellectual inquiry and privilege, and as always, the results were varied and unpredictable. The fate of her youngest son is an example. Arseny Morozov was one of Moscow's weary young princelings. When Ambroise Vollard, the Paris art dealer, wrote of 'the morbid impulse natural to the Russian temperament',[20] he cited Arseny as an example. Vollard tells of Arseny visiting the home of his brother Ivan in 1909. The two men were awaiting the arrival of the artist Maurice Denis, who was to supervise the hanging of his works in Ivan's music room. Arseny had spoken often of the pleasure he would have in meeting the painter, but now in the midst of the conversation, the young man idly touched a revolver which was lying on the table and suddenly remarked, 'Tiens, si je me tuais!' and bringing the weapon up to his head, as Vollard testifies, 'il se fit sauter la cervelle.'[21] It is bizarre for a young man to 'blow out his brains' suddenly without warning, but it

illustrates the strange ennui which afflicted the younger generation, and which rose to the surface unexpectedly amid the opulence.

Such a death was doubly shocking in light of Arseny's life-style and the intensity with which he had pursued pleasure. He lived in a remarkable Moorish castle which he had commissioned to be built by Shekhtel, who had designed Savva Morozov's mansion. It was an exact copy of a castle he had seen while travelling abroad. One evening he entertained an entire Guards regiment in his home, and one of the features was a great stuffed bear in the salon which held a giant silver tray piled high with caviare. His extravagance was unbounded. It was said that when Shekhtel asked him in what style he would like his house, Arseny replied, 'In all styles, I have the money.'[22]

Serov painted Varvara's other two sons, Mikhail and Ivan. Today the Serov portraits are a part of the Tretyakov collection, where they are a reminder of a vanished species. The effect of the two paintings when seen together is uncanny. The artworks in the background indicate a shared interest. The physical resemblance is marked: the same ovoid outlines for each figure, the meticulous tailoring, perfectly trimmed beards and soft hands are identical, but it is the contrast that fascinates. It is as if the artist had painted a single figure with a dual personality – a diptych of Jekyll and Hyde. Mikhail, the older by one year, is seen in a full-length portrait (1902). The stance is aggressive, feet apart like a challenger before a fight, an animated, sensuous man with mocking slanted eyes. Serov saw a rogue, assertive and clever.

His brother Ivan, painted in 1910, has the same corpulence, but there is a softness to the bulk of the seated figure, the gaze is gentle and reflective, the hands rest easily on the table in front of him. The authority is implied rather than stated.

Ivan was trained at the Zurich Polytechnic, and after graduation returned to the company town of Tver where he assumed an active role in Morozov enterprises. In contrast, Mikhail adamantly refused to involve himself in any commercial activities whatsoever. His mercurial personality and diversity of interests made him difficult to classify. A respected historian and lecturer at Moscow University, a writer who had scored a modest success under the pseudonym M. Yuriyev, Mikhail Abramovich was also a bon-vivant. Tales of his escapades served up regularly in the gossip columns enlivened the breakfast of many of the city's respectable matrons. In one of his more memorable exploits, he lost over a million rubles to a tobacco manufacturer in a single evening of gambling at the English Club. He was the inspiration for a popular play, *The Gentleman*, which ran for several years at the Maly Theatre, and the nickname stuck. This combination of gambler, sybarite, intellectual and art patron enhanced the Morozov legend in Moscow.

Mikhail was fortunate (or perceptive) in his choice of a wife. Margarita

Kirillovna Morozova was remarkably similar to her mother-in-law, Varvara. One of the liberated Morozov women, attractive and with a bright, inquiring mind, she was a talented pianist and a pupil of Skryabin.

Margarita did not share her husband's taste for personal extravagance. She founded a religious and philosophical society which explored the arcane labyrinths of Slavic tradition and the Orthodox Church. There was some scepticism and sniping among her friends who felt that because of a lack of formal education she could not be expected to follow the complexities of scholarly discussion. Nemirovich-Danchenko publicly caricatured her role as femme-savante in a play, *The Price of Life*, but Margarita was more than a parvenue. Vladimir Solovyov, the eminent philosopher, poet and Neoplatonist, was a collaborator and frequent guest, as were Sergey Bulgakov and the brilliantly acerbic Andrey Bely. In the turbulent year of 1905, Pavel Nikolay-evich Milyukov, political revisionist, economist, liberal author who became Foreign Minister in the provisional Kerensky government during the war, gave several lectures in the Morozov home at her invitation. The degree of non-conformism in these gatherings is evident when one remembers that Milyukov helped to draft the Vyborg Manifesto which declared the signatories ready to follow the people in resisting the Tsar's arbitrary rule. Another visitor, the philosopher Nikolay Berdyayev, spoke of a world in which the artist would enjoy complete freedom from economic and official censorship.

Mikhail had started to assemble his collection of art when he was only twenty. He began with the Barbizon painters, a common point of departure for many Muscovites who had grown up with the Wanderers. The unaffected simplicity, scenes of woods, lakes and countryside made Rousseau and Daubigny familiar and assimilable to the Russians. However, his selections indicated a certain flexibility. They included Degas's brothel scenes and an original drawing for *Elles*, Toulouse-Lautrec's album of lithographs on that subject.

The Morozov home, an immense, square mansion in the Empire style which still stands a short distance away from the present American Embassy, was filled with modern art. Mikhail was one of the earliest Russians to collect contemporary French masterpieces. Though his political orientation was conservative, his artistic tendencies were radical for the period. He had selected two Tahitian landscapes by Gauguin at a time when Moscow had barely accepted Corot. *The Canoe*, also known as *Tahitian Family* (*Te Vaa*), painted in 1896, was an exotic, languid exploration of a tropical culture. Father, mother and son, bathed in an orange sunset, the sea a shimmering, molten mass of green flecks and reflected crimson, project a sense of heat and radiance far removed from Moscow's pale light. The diagonal crescent of the craft at the centre of the canvas anchors the scene, and in the distance a purple volcanic mass emphasizes a feeling of timelessness. *Landscape with Two Goats* (*Farari maruru*), painted a year

later, is saturated in the deep blues of a humid summer night, the azure stillness broken by a mass of scarlet blooms and the shadowy outlines of the animals. Mikhail's audacity as a collector stands out against the two prevailing Russian modes, St Petersburg's linear formality and the fervid works of the Wanderers.

His other French paintings were equally impressive. An early Pierre Bonnard, *Woman Behind a Railing* (1895), is solid and compact, with overtones of Vuillard. The bare, twisted trunks of the trees, the dark lattice fence, convey a sense of wintry grey and accentuate the solitude of the figure behind the barrier. Degas's pastel *After the Bath* (1884) confirmed Morozov's growing interest in Impressionism, and with Monet's dazzling *Poppy Field* (1887) which he bought in 1902 at the sale of the Georges Feydeau collection, he moved into the mainstream of the movement.

There was a hint of academic formality in Renoir's full-length *Portrait of Jeanne Samary* (1878). The work was executed with an eye on the Paris Salon exhibition of 1879, and this may explain a certain lack of freedom, the uncharacteristically detailed background and the corseted stiffness of the figure. Nevertheless, it was a discerning choice for a Moscow merchant in 1901.

Manet's *Le Bouchon* (1878), variously known as *The Pub* or *Parisian Café*, has the freshness of a watercolour, totally at variance with the photographic exactitude of the Wanderers. All the details of a French café are present: a fleeting impression of wine bottles, open or carefully corked, jewelled remnants of wine in the glasses, the ruminating seaman with his black cap and sputtering pipe – these are glimpsed rather than studied, as if the artist had passed by quickly and retained the fragments of a sketch.

Another exceptional painting in Mikhail's collection was a seascape by Van Gogh, *The Sea at Les Saintes Maries*, painted in 1888. Van Gogh seldom painted the sea, and the turbulence of sky and water on a blustery day is conveyed by glistening, iridescent levels of colour. The first small, sturdy sailboat coming into shore is echoed by a second, then a third – and a fourth; the eye follows the rhythm of the wind and billowing sails to the last small dot on the horizon.

It is possible that, with his great wealth, intuition and catholicity, Mikhail might eventually have approached Shchukin's accomplishment. He made a precocious start, but his activities were circumscribed by time. He died in 1904 at the age of thirty-four. In 1910, Margarita Morozova gave a number of his paintings to the Tretyakov Gallery. They have been apportioned since then to other museums. The Pushkin Museum now holds the drawing by Lautrec and the Van Gogh seascape; the pair of Gauguins, the early Bonnard, the pastel by Degas, Monet's field of poppies, Renoir's full-length portrait and Manet's Parisian café hang in the Hermitage. Each work is a reminder of the adventurousness and presence of Mikhail Morozov.

<center>* * *</center>

Mikhail's younger brother has been described as resembling a proper Victorian banker. His reserved, rather haughty manner, impeccable tailoring and discreetly patterned cravat punctuated by a pearl stick pin, reinforced the impression. Ivan had taken over the management of the Tver plant from his mother Varvara, and the time he spent in that business-orientated community strengthened his conservative attitudes. Unlike Mikhail, he had little interest in provoking the establishment – he *was* the establishment. However, despite his sober aspect, Ivan was no plodder. Because of his superb collection of French art, Ivan Abramovich is the Morozov best known in the West.

He began with Russian painting, an interest which continued throughout his life. In 1913 Ivan's collection contained four hundred and thirty Russian works. Years earlier Varvara Morozova had chosen Korovin, then a promising but unknown painter, to act as art instructor to her sons. Only ten years older than his charges, romantic and headstrong, with a talent for communication, he had none of the deadening didacticism common to the St Petersburg faculty. Art was an adventure and he was exploring the diversity, the sheer joy of colour and 'pure painting'. He provided an exciting introduction to Russian and Western art for the young Morozovs, and under his guidance Ivan developed a modest talent for landscape painting. Korovin's views of the Russian countryside were among the earliest of Ivan's acquisitions; from there it was a natural progression to the lakes and forests of Levitan. Where Mikhail was impulsive and intuitive as a collector, Ivan was deliberate. To Korovin's paintings and theatrical sketches, he added a mise-en-scène for Wedekind's *Dance of Death* by Sapunov and sketches for *Little Eyolf* by Golovin. As his sophistication increased, Ivan purchased paintings by Vrubel, Larionov and Goncharova, and the fantasies of an unknown artist from Vitebsk, Marc Chagall – he was one of Chagall's first admirers. His choices were culled mainly from the works of Russian artists, as if he were consciously leaving the field of Western art to Mikhail. After Ivan moved to Moscow from Tver in 1900, he continued to collect principally Russian paintings until Mikhail's death in 1904. At that point he took over where his brother had stopped so suddenly, and Mikhail's influence was evident in the rich assortment of Renoirs, Van Goghs, Gauguins and Bonnards which began to arrive at the house on Prechistenka Street.

There were thirteen works by Bonnard in Ivan's collection. He was the major patron of this artist in Russia; Shchukin never bought any of his paintings. Two of the finest acquired from Bernheim-Jeune in 1912 were *Morning in Paris* and *Evening in Paris*, a pair of captivating, animated impressions of the city. The first encapsulates the movement of pedestrians, flower vendors, children and cabs. It is full of the motion and impulse of an early morning street scene. The twin is a more deliberate evocation. The tempo is leisurely. Here the figures are dispersing, moving slowly out of the canvas at the end of the day, and the soft

blues and greys contrast with the brilliance and freshness of the morning view.

Ivan had the Russian taste for commissioning decorative panels for his home, and the staircase in his Moscow town house featured a triptych by Bonnard, three shimmering variations on a theme, *The Mediterranean* (1911). The main panel contains an enormous garden; on either side the tranquil figures of women and children, besotted with the afternoon sun, decorate the landscape. The garden is an oasis of flowering, stylized trees; in the background the golden, carefully cultivated countryside ultimately blends with the blue sparkle of the sea.

However, the ability to command a work of art can result in unexpected hazards. The patron, having placed himself between the artist and the finished painting, has become a third element, a potential danger to the integrity of the work. Four years earlier, Ivan's enthusiasm had resulted in a rare aberration. Maurice Denis was a respected painter and critic whose technical mastery, sense of refinement and spirituality had earned him a following in Russia. Morozov had bought *Sacred Spring in Guidel* (1905) from the Salon des Indépendants where it had been shown in 1906, and in the summer of that same year, he had acquired *Bacchus and Ariadne* (1906–07) from the artist before it was finished. His admiration for Denis's work had obviously been building, and in 1907, to adorn the walls of his music room, he ordered the series of thirteen decorative panels, *The Story of Psyche*, already mentioned in connection with the death of his brother Arseny. In 1909, Denis arrived in Moscow to oversee the installation, and thereby illustrated the perils of art as decoration. The elegant salon was transformed into a panorama of nymphs and cherubs, Cupids, Greek columns and winged angels. Recumbent, cloud-borne Psyche and a somewhat vapid Eros were delineated in a cloying blend of academicism and banality. After the dissolution of the Nabis group in 1897, Denis's work had lost some of its freshness and originality; it had grown heavier and more literal. But in the Russian setting, the lapses were magnified, the artist lost the sense of scale and discretion that had characterized his previous work. Suddenly it seemed over-extended and pretentious. Perhaps, unlike Bonnard and Matisse, when confronted with a uniquely extravagant patron, he could not fill the space.

Several factors may have influenced Ivan Morozov's choice of this artist. Both he and his brother Mikhail were attracted to the Nabis – Bonnard and Vuillard were represented in both collections. Mikhail had owned Denis's *Mother and Child* (1890s) and *Encounter* (undated) which Margarita Morozova donated to the Tretyakov Gallery in 1910. The painter's early work had been fanciful and misty, yet despite overtones of Puvis de Chavannes, it was recognizable as a distinctive and important oeuvre. Denis had decorated the ceiling in the house of the composer Chausson in 1894, and in 1897 the French collector Cochin had commissioned him to paint a series of panels on the Legend of St Hubert. Now

his popularity as a muralist was at its height. Above all, Denis, one of the most articulate and persuasive contemporary theorists on the problems of modern art, was Ivan Morozov's friend and adviser, and the collector was receptive to expert opinion.

Whatever the reason, when compared to the surrounding galleries, Morozov's music room was an anomaly. What makes the incident so remarkable is the timing. For the past two years, he had been buying some of the most powerful pictures in his collection. In 1907, during a visit to Paris, he had purchased three Gauguins from Vollard: *Conversation: Parau Parau* (1891), *Landscape with Peacocks* (1892) and *Delicious Water* or *Sacred Spring: Nave Nave Moe* (1894). *Delicious Water* had been painted in Paris, a golden idealized memory of Tahiti in which the landscape twists in concentric circles and becomes a widening arabesque of radiant colours. In contrast, the figures of the two women in the foreground are totally still, enclosed in reverie, limpid and unmoving. The exoticism of the work is emphasized by the single exaggerated growth of twining lilies in the foreground, and the nimbus framing the head of one woman. In that same year Ivan purchased Monet's *Landscape with Haystacks* (1899) from Durand-Ruel, Renoir's *Under the Arbour at the Moulin de la Galette* (1875), Cézanne's *Still Life with Drapery* (1899), *Overture to Tannhäuser* (1867–69), and *Mount Ste Victoire* (1900). Other acquisitions from 1907 were Henri Edmond Cross's pointillist *Landscape with a Large Tree* (undated), and two works by Louis Valtat, *The Farm* (undated) and *Landscape at Banyuls sur Mer* (1899). For the works by Valtat, Morozov paid only one thousand francs each, and after every trip to Paris he returned to Moscow laden with paintings as if they were trinkets.

In 1908 he acquired a major ornament for his collection. From Vollard, he bought *Café at Arles* for 8,000 francs. Painted in 1888, it is Morozov's earliest Gauguin, a souvenir of the turbulent summer the artist spent with Van Gogh at Arles. 'Mme Ginoux, Mme Ginoux, some day your portrait will hang in the Louvre' – the amused detachment with which the wife of the proprietor greeted Gauguin's promise is apparent in this painting. For the artist, the interior of the Café de la Gare was transformed into a deliberate, rich, carefully constructed series of forms. The brilliance of the colours, the glowing red walls, the smooth green baize surface of the billiard table broken by three balls, all are defined within precisely delineated areas, a complete rejection of the vagaries of Impressionism.

Simultaneously with his acquisition of Gauguins, Morozov was purchasing a series of Van Goghs. In 1908 he loaned to Ryabushinsky's exhibition the companion piece to Gauguin's *Café at Arles* – Van Gogh's corruscating translation of the same scene, *Night Café*, which he had just purchased for 7,500 francs.[23] This swirling, glaucomatous version was an extraordinary counterpoint

to Gauguin's intense stillness. In 1909 the merchant purchased *Red Vineyard* (1888) from the Druet Gallery for 10,000 francs.

In the summer of 1909, during Morozov's visit to Paris, the city was teeming with Russians. The growing awareness in the West of a sumptuous Russian artistic tradition had exploded with the opening of the Ballets Russes, and Diaghilev's company had created 'Les Ferventes des Russes', Benois's term for the French audience which applauded all things Russian. The restaurant Larue had become a favourite rendezvous for the visitors, an extension of the Yar. Shchukin and Matisse met here; Bakst, Benois, Diaghilev, Ivan Morozov and Serov were patrons.

One afternoon after lunch when Morozov and Serov visited the Druet Gallery, the owner showed the two callers an unusual Van Gogh which Ivan inexplicably bought. Druet was one of the Paris dealers with whom the Russian businessmen were continually involved. He had just sold Van Gogh's *Portrait of Dr Rey* to Shchukin; Morozov had already bought this painter's *Red Vineyard*, and now, almost as an afterthought, Druet displayed Van Gogh's *Prisoners' Round* to him and Serov. This canvas, painted in 1889–90, when the artist was in hospital, had none of the brilliant decorative colour which had proved so alluring to Druet's Moscow clients. Trapped within the asylum, Van Gogh had used as his inspiration a woodcut by Gustave Doré which Doré had created for a book, *London – A Pilgrimage*. A testimony to the deadening effects of confinement, it is a claustrophobic, hopeless work, an unrelentingly monotonous scene of grey-greens and cold blues. The prisoners, trudging in an aimless circle, are enclosed in a world of stone in which there is no hint of sky or grass. The painting is out of tune with Morozov's usual choices. One wonders if Serov was influential in its purchase. As Repin's pupil, the Russian artist was no stranger to this bleak type of theme, and the mood is reminiscent of Repin's *Volga Boatmen*.

From the despair of St Rémy to the last days at Auvers was a brief span for Van Gogh, but during the last two months of his life at Auvers he painted seventy pictures. Morozov purchased two particularly lovely examples from this period. In 1908 at an auction in the Hôtel Drouot, Druet had bid 5,865 francs on behalf of Morozov for *Cottage at Auvers* (1890). The second picture, *Auvers Landscape in the Rain* (1890), is permeated with the charm and tranquillity of an ordered world. The satin ribbon of a road unwinds through the centre of the canvas; on either side, the fields are carefully laid out with the deliberation of generations. The houses are secure and straight, the white walls surmounted by red roofs. A horse and cart in the distance makes its journey through a fresh, rain-washed landscape. From the frenzied hallucinatory scenes at Arles through the despair of St Rémy to the occasional serenity at Auvers, Morozov's pictures trace Van Gogh's path through the last years.

Shchukin's collection of Renoirs was first-rate, but it was Morozov who owned the great masterpieces of this artist, and his selections seemed carefully designed to cover every phase of Renoir's work. *La Grenouillère* (1868–69) is one of the artist's early paintings. The 'frog pond' was a popular bathing spot on the Seine opposite the island of Croissy. When Renoir visited the scene with Monet he was an impoverished, irrepressibly optimistic young painter of twenty-eight. The recurring touches of silvery-black in the ruffled bathing costumes, in a velvet sash or the hats of the men, reflect Courbet's influence. The charm of the colours, a blue parasol, the flash of scarlet ribbons, identify the artist, but there is a delicacy to the foliage, a springtime freshness which has not yet ripened into the golden haze of Impressionism.

In 1907 at the Viau auction in Paris, Durand-Ruel bid 25,000 francs on behalf of his Russian client for Renoir's *Under the Arbour at the Moulin de la Galette* (1875). Like Morozov's portrait of Jeanne Samary, it is an Impressionist touchstone. The swirl of sun-dappled leaves provides an uncertain shade for the group of friends at the table. Monet is seated on the left, his straw boater pushed to the back of his head. The familiar figure of the model, Nini, standing in the foreground is a confection of sashed and ruffled silk set off by a bright blaze of red hair. The painting, large but intimate, fragrant with the smell of wine, grass and flowers, has a historic interest. The group is caught for a brief moment, like rays reflected from a prism, and the fascination is in the perfection with which the figures have been recorded by the theories and principles of their own devising.

Mikhail Morozov's *Portrait of Mlle Samary* (1878) by Renoir was unusually rigid and conventional, but the version owned by Ivan, *Reverie* (1877), reveals the artist's delight in his subject and his own virtuosity. As a rule, Renoir did not probe deeply into the psychology of his subjects, but here the sense of intelligence is striking. The openness of the gaze is an invitation to pause and listen for the words which will surely come.

In 1910 Ivan Morozov persuaded Paul Durand-Ruel to part with a major painting from his private collection. For 25,000 francs he acquired Renoir's *Woman with a Fan* (1881). It was an interesting companion piece to *Reverie*. The tremulous brush-work of the earlier picture has given way to a harder, more precise depiction. Here the black-haired girl does not merge with her background; set against the bright, warm yellows and reds, her face glows with the faceted clarity and brilliance of a diamond.

Child with a Whip (1885) arrived in Moscow in 1913. Renoir's price had escalated. Ivan paid Vollard 42,000 francs for this painting. The work is a conjunction of styles. The naïve rigidity of the child's pose reveals Renoir's concentration on form at that time, but the riotous foliage proves that the artist was incapable of subordinating totally his brush to his intellect. 'For me a

painting must be something winning, joyous and pretty. Yes, pretty.' Renoir
might have been expressing Morozov's view.

There was no hint of rivalry between Shchukin and Morozov, yet as each
made his choice from the same pool, the contrasts were revealing. Shchukin
owned the only portrait by Van Gogh in Russia, but an objective assessment
would show that in the works of Van Gogh and Renoir, the scales tip toward
Morozov. Shchukin owned no Bonnards, but his appetite for Monet seemed
insatiable. He bought thirteen Monets to Morozov's five. Manet is missing and
this absence from Morozov's collection is particularly surprising. André Malraux
has described the artist's 'great innovation' as 'Tradition reunited with the
pleasure of painting', a description which applies to Morozov's group of pictures.
But from the sequence of their purchases, it appears clear that both Shchukin
and Morozov were absorbed in the art of the present. Neither looked back, even
at so great a painter as Manet. He belonged to a past generation, and they were
becoming prophets of the future. Each merchant owned a pride of Gauguins. It
is neither possible nor desirable to measure Morozov's *Café at Arles* against
Shchukin's *What, Are You Jealous?* but after the latter returned from Paris with
the bulk of the Gustave Fayet collection, his accumulation became the richer
and more extensive.

In Russian portraits of the nineteenth century, likenesses of the nobles had
been surrounded by painted evidence of their wealth and prominence,
indications of their primary interests. Serov had the acuity of a court painter,
and when he painted Ivan Morozov in 1910, he placed in the background an
enormous still-life in the manner of Cézanne. The choice may reflect Serov's
own interest in the artist, but it is also a tribute to his client's judgment. Before
1914, Morozov was to own thirteen superb Cézannes which were the glory of his
collection. The two patrons were closest in the case of Cézanne: this master
encompassed the divergent tastes of both. The duplications are noticeable
immediately. Over the years each acquired a *Self-Portrait*, a *Mont Ste Victoire*, a
Smoker and an exceptional *Flowers in a Vase*. Morozov owned the discreet and
classic portrait *Mme Cézanne in the Conservatory* (1891),[24] while Shchukin's
choice within this genre was the bitter-sweet *Lady in Blue* (1900–04). Morozov's
Smoker is a solid, massive presence, rich in golden colour. In Shchukin's
version, *Man with a Pipe*, the figure is attenuated, the diagonal lines
emphasized, and the effect is stylized and remote.[25] Morozov's self-portrait by
Cézanne, *Portrait of the Artist in a Cap* (1873–75), is unusual for its almost
Impressionist bravura, whereas Shchukin's *Self-Portrait* (1880), built up
carefully with a dry brush, is a more objective, intellectualized self-appraisal.

In 1907–08, Morozov purchased from Vollard Cézanne's *Overture to
Tannhäuser* (1867–69). For all its thematic formality, this strange early painting
is an outline, a beginning. In the decorative whorls and patterns of wall

Above left: Valentin Serov: *Portrait of Mariya Fyodorovna Morozova*, 1887. State Russian Museum, Leningrad

Above right: Savva Timofeyevich Morozov

Left: Valentin Serov: *Portrait of Mikhail Morozov*, 1902. Tretyakov Gallery, Moscow

Below: Valentin Serov: *Portrait of Ivan Morozov*, 1910. Tretyakov Gallery, Moscow

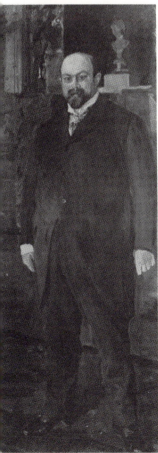

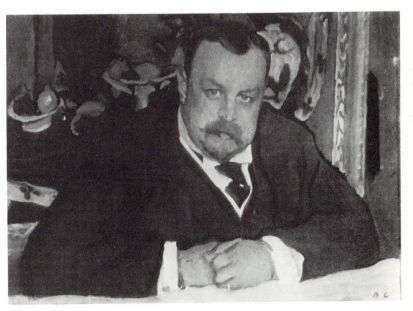

The Triptych, Ivan Morozov's most important
purchase of Matisse's work

Henri Matisse:
Above from left to right: Window at Tangier, 1912;
Zorah on the Terrace, 1912–13;
Entrance to the Casbah, 1912.
The Hermitage, Leningrad

Pablo Picasso: *Acrobat on a Ball*, 1905.
Pushkin Museum, Moscow. This classic of 1905,
purchased from the Gertrude and Leo Stein collection,
was more reflective of Ivan Morozov's taste
than was the splintered likeness of Vollard

Pablo Picasso: *Portrait of Ambroise Vollard,* 1910.
Pushkin Museum, Moscow. The only Cubist Picasso
in Ivan Morozov's collection

Where Morozov's selections were frequently more emotionally beguiling, Shchukin's tended to be angular, remote and intellectual

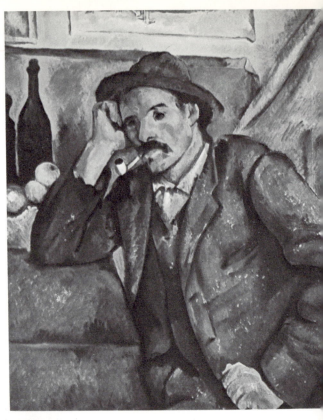

Above: Paul Cézanne: *The Smoker*, 1896–98.
The Hermitage, Leningrad.
(Formerly Morozov collection)

Left: Paul Cézanne: *Man with a Pipe*, 1896.
Pushkin Museum, Moscow.
(Formerly Shchukin collection)

and chair, Cézanne has posed a theorem; employed purely ornamental designs in an effort to develop a logical configuration. The *Mardi Gras* (1888) in Shchukin's collection is the resolution of the problem. A study in suspended animation, it is a vignette in which the billowing draperies, the black and red diamond pattern of Harlequin and the stiff, gathered ruff of Pierrot are transmuted into an intricate scaffolding – a diagram and a solution.

Morozov's collection of Cézanne's landscapes included some of the most beautiful of the painter's works. One Russian critic wrote of 'the blue which lets you feel the air'.[26] Morozov had never lost his affinity for landscape. *Banks of the Marne* (1888) is a cool, pellucid echo of an Impressionist theme. Where Monet's shimmering reflections at Vetheuil were sensed rather than seen, Cézanne's house and trees are mirrored; a still, nether world, not merely indicated, but structured and complete. One feels that if this canvas were turned upside down, the painted reflection in the water would be as solid as the reality on the bank. Morozov continued to buy Cézannes until the outbreak of World War I and for years kept a place vacant on his wall for a particular late painting. *Blue Landscape* (1900–04), which he finally obtained from Vollard in 1912, was given the place of honour.

It was Shchukin who introduced Morozov to Matisse and Picasso. Though Ivan's collection was unusually daring for the time and place, his enthusiasm for these artists never approached that of his friend. In 1908 Shchukin persuaded the younger man to accompany him to Matisse's studio. The painter's daughter remembers Ivan Abramovich as 'bluff, genial and kindly – rather like an explosive child.'[27] At that time Morozov owned one or two of the artist's early still lifes, and Shchukin wished to persuade him of the value of the recent, more controversial works. Morozov remained unconvinced for some time, preferring to search for the gentler, more palatable periods. For example, as late as 1910, he bought Matisse's tranquil *Still Life with Fruit and Coffee Pot*, painted in 1899, from Druet for 700 francs, and in 1911 he purchased *Bottle of Schiedam* (1899) from Bernheim-Jeune for 1,500 francs.[28] These were lovely, early examples; however, at that point, Matisse had passed through his Fauve period and completed the *Dance* and *Music* panels for Shchukin.

Morozov always approached Matisse cautiously. In the case of this artist, he was unable to move with the certainty which he displayed with the Cézannes and Van Goghs. After it was shown at the Salon d'Automne in 1910, he purchased *Still Life with the Dance* (1909). When the painter was working on *Dance* for Shchukin he would turn from the scale and complexities of the enormous project to the creation of smaller works. In *Still Life with the Dance* he reproduced his whirling figures in miniature in the background. When Morozov bought this picture, it was a measure of Shchukin's influence.

In 1911 Ivan Abramovich commissioned two landscapes from Matisse. The

artist's growing reputation and the demands on his time necessitated several postponements, and in 1912 the collector received a letter of explanation.

> Sir, it is extremely awkward for me to write to you about this, but I have not been able to do for you the two landscapes I had promised, and consequently they will not be shown in the Salon, as I had written to you; but tomorrow I am heading for Morocco where I intend to work on them. . . .[29]

Out of the North African visits in 1912 came the most important works by Matisse in Morozov's collection, the Moroccan triptych: *Window at Tangier*, *Zorah on the Terrace* and *Entrance to the Casbah*. Though originally he had ordered a pair of landscapes, Morozov found Matisse's new arrangement irresistible. He could as easily absorb three paintings as two, particularly when the result was as stunning as this latest acquisition. The merchant's capacity, like that of Shchukin, was formidable. Indeed, his flexibility in this instance is reminiscent of Shchukin's reaction three years earlier to Matisse's *Harmony in Red* (see Chapter 7, page 183).

On April 19, 1913, Matisse informed Morozov in a letter that the three paintings had been exhibited at Bernheim-Jeune: 'They have enjoyed great success and I am sure you will be satisfied, though you had to wait so long.' In the same letter Matisse assured him: 'These three pictures were painted with the idea that they would hang together and in a definite order, to wit: the view from the window must be on the left, the entrance to the Casbah on the right and the terrace in the middle, as the enclosed drawing shows.'[30]

Despite Matisse's words, it is possible that these works were not conceived originally as a unit. Alfred Barr states unequivocally that 'the pictures were not intended as a triptych', and indeed they had been painted during two separate journeys to Tangier. Two years had elapsed since Morozov had commissioned the landscapes; Matisse was undoubtedly beginning to feel the pressure, and it is possible that he solved the dilemma with this inspired grouping. However, Barr notes that when the paintings were combined, 'the effect seems to have been both harmonious and magnificent'.[31] Morozov paid 8,000 francs for each of the three canvases.

Shchukin wrote to Matisse in October 1913: 'Mr Morozov is ravished by your Moroccan pictures. I've seen them, and I understand his admiration. All three are magnificent. Now he is thinking of ordering from you three big panels for one of his living rooms. He is returning to Paris the 20th of October, and will speak to you about it.'[32] From the Moroccan period, Shchukin had acquired two large flower paintings. The artist had measured sections of Trubetskoy wall space during his Moscow visit in 1911, and the unusual dimensions indicate that he may have had specific areas in mind when these decorative works were

painted. *Zorah*, which became a part of Morozov's triptych, was repeated in Shchukin's standing version painted in 1912. Shchukin also chose a striking half-figure, *Riffian* (1912–13). Above all, there was *Arab Café* (1912–13).[33] The miracle of Shchukin was that he could always spot the great works. *Arab Café* has an atmosphere of Nirvanic tranquillity, the vivid animated patterns so prevalent in other works have been clarified to a point of abstraction. All extraneous details have been eliminated, yet as the critic Marcel Sembat observed, 'All of Matisse is here.'[34]

Morozov found most of Picasso's work difficult and indigestible. He owned three paintings by this artist; Shchukin owned fifty. Ivan's *Harlequin and his Companion* (1901) is a richly hued, mannered work in which the areas of brilliant colour are defined by thin, black painted cloisons. The controlled balance between colour and form are reminiscent of Gauguin's *Café at Arles* in the same collection.

In 1913, when Leo and Gertrude Stein parted in Paris, they sold many of their greatest paintings. At that time Shchukin purchased the difficult and challenging *Nude with Drapery* (1907) and *Three Women* (1908) (see Chapter 7, page 207). Morozov bought Picasso's classical *Acrobat on a Ball* (1905).

Morozov, like Leo Stein and Ambroise Vollard, never understood Cubism. It is startling, therefore, to encounter Picasso's *Portrait of Ambroise Vollard* (1910) in this luxuriant assemblage. Few statesmen or actors have had their likeness reproduced more times than Vollard, yet one is inclined to agree with Picasso's estimate: 'My Cubist portrait of him is the best one of them all.' An intricate pyramid of angles and planes in shades of grey and brown, it is a pile of shards from which emerges an accurate likeness of the dealer. As with Picasso's *Queen Isabeau* (1909) in Shchukin's collection, the eyes are closed, but the shrewdness, the bristling muscular energy of the man are apparent; he is feigning sleep. Several reasoned essays have been written on the qualities of the Vollard portrait assuming that it was owned by Shchukin, and analyzing the characteristics which he would have found attractive, but the work actually belonged to Morozov. It was acquired in 1913 from Vollard, and while no complete explanation for the transaction is possible, it is helpful to remember the circumstances of that period. In 1912, Morozov had paid the dealer 35,000 francs for Cézanne's *Blue Landscape*, and in 1913 Vollard received from his client the same amount for *Woman in a Crinoline*, in addition to 42,000 francs for Renoir's *Child with a Whip*. The dealer was a patient, wily man who, when he chose, could wait for years for his price. That he shared Morozov's doubts about Cubism seems evident when one discovers that he sold his own Cubist portrait to the Russian for a mere 3,000 francs. It was as if he had included it as a bonus. The gesture would not have been unprecedented, for in 1908 he had made a gift of a Fauve Vlaminck, *View of the Seine* (1905–06), to Morozov.

It is admittedly an arbitrary exercise to compare Morozov's collection with that of Shchukin. What they chose and what they left is a commentary on the character of each, and provides some insight into the intricacies of shaping an artistic entity. Shchukin's audacity and flexibility made him receptive to the most controversial work of his time. Ultimately his home became the Museum of Matisse and Picasso. Morozov's priorities were different; there is something hedonic in the sheer sumptuousness of his selections. Matisse, who occasionally accompanied his clients to the dealers, regarded Morozov as 'a cautious man' who respected 'safe values'. (In Matisse's view, Cézanne was 'safe' by 1906.) The painter summed up the contrast in their tastes when he observed that Morozov was simpler, less complicated, 'plein de force', whereas Shchukin in comparison was 'plus aigu'.[35]

In studying the works once owned by these two men, one becomes aware of a unique aspect of the collection of modern art now in Russia. Today many museums display an assortment of individual masterpieces, but the Russian possessions are distinguished not only by the quality of the works, but by their relationship to one another, the variations on a single theme. The same figures and symbols appear and reappear in the Shchukin and Morozov pictures. Morozov's Gauguin, *Delicious Waters*, contains in the background the same seated nude which is the central figure in Shchukin's *What! Are You Jealous?* Gauguin's *Tahitian Woman with Flowers* from the Shchukin collection is one of *Three Tahitian Women Against a Yellow Background* (of the same year, 1899), which belonged to Morozov. Monet's gardens, haystacks, fields and scenes of London, and of course the Cézannes, were acquired by both men. Shchukin's *Smoker* has a fragment of what appears to be Morozov's *Mme Cézanne in the Conservatory* in the background. This interlocking is particularly evident in the case of Matisse. If Shchukin owned *Dance*, Morozov owned *Still Life with the Dance*, and Shchukin in turn ordered *Nasturtiums and the Dance*. The collectors' personal contribution lies in the density and interaction of the Russian paintings, the intimate exploration of the artists' development which becomes a record of the period. One senses the constant presence of the patron. As a result, this crucial era in French art is represented more completely in Russian museums than anywhere in the West.

Both Shchukin and Morozov were members of a recently established Russian élite, but they moved with assurance, ardour and dedication. To see the total aggregation of early modern Western masterpieces now in Moscow and Leningrad is to encounter a phenomenal accomplishment; to remember when it was assembled and in what space of time is to understand that these two merchants did not merely collect pictures. Out of foresight, total certainty and the will to continue against all opposition, they created a force which changed the face of Russian art.

5

THE SHCHUKINS

In our unstable and reassessing days only a maniac, a speculator
or an amateur whose aesthetic awareness is higher than the
everyday can collect the art of our contemporaries.

Yakov Tugendkhold

In the history of the world what remains are the names of those
who had the courage to go against the taste of their times.

Sergey Diaghilev

In his autobiography Fyodor Shalyapin traced the ascent of the Russian
merchants. He could have had an early Shchukin or Morozov in mind when he
wrote:

He is paralyzed with cold, but is always light-hearted; he never grumbles, but
builds all his hopes on the future. It is no odds to him what wares he peddles –
today they are icons, tomorrow stockings, the day after, yellow amber or
pamphlets of some kind or other. Gradually he accumulates a few rubles and
becomes a 'capitalist'. Next he installs himself as a proprietor of a small shop or
store. Then he establishes himself as a merchant of the first Guild. Wait a little –
behold his eldest son purchases the first Picasso and the first Gauguin, and brings
the first Matisse to Moscow. . . .[1]

When Matisse referred to his patron Sergey Ivanovich Shchukin as 'shrewd,
subtle and serious'[2] in matters of art, he was not speaking of an enlightened art
historian, a dealer as wise and sophisticated as Kahnweiler or an avant-garde
American like Leo Stein. He was acknowledging a phenomenon which evolved
out of a brief moment in Russian history.

To most foreigners, life in pre-revolutionary Moscow was compounded of an
exploited and lethargic peasantry, Gogol's bureaucracy, a core of political

agitators and an effete and uncaring aristocracy. This view ignored the creative presence of the merchants. Maurice Baring, after travelling in Russia, wrote in 1905:

> People are in the habit of saying that in Russia there is no middle class. . . . It exists nonetheless, and it includes the professional class, the world of doctors, lawyers, professors, teachers, artists, the higher and middle merchant class. . . . It not only exists, but it is enormously important, since it calls itself the 'intelligentsia' and does in fact number among its constituents nearly all the 'intellectuals' of Russia.[3]

Shchukin's antecedents place him squarely within the merchant class. As the merchants evaluated their genealogy, the Shchukins were an old-established family in Moscow. The earliest members of the clan on record had been traders in the village of Borovsk in Kaluga province. 'The family had been in textiles longer than anyone can remember.'[4] Never serfs, they were sturdy and independent members of the Old Believers, a rigorous, schismatic, fundamentalist sect which had been originally a part of the Orthodox Church.

In the latter half of the eighteenth century, during the reign of Catherine the Great, Pyotr, the first Shchukin on record, broke away from the security of familiar surroundings and travelled with his son Vasily to Moscow. It was a journey of only forty miles, but it was light-years from everything Pyotr Shchukin had known. In this 'city of the hallowed past',[5] he followed the pattern of Shalyapin's prototype and slowly began to prosper. The family name appeared in the Moscow land register as early as 1787.

When Moscow was burned during the siege of 1812, the small wooden shops and houses were the first to be engulfed. The Shchukins saw the hard-won gains of a generation disappear, but when the French invasion receded there was a small bit of property and a reputation for integrity which remained. With this inheritance, Pyotr's son Vasily began to rebuild and when he died in 1836, his son Ivan Vasilevich took over the Shchukin textile business.

Ivan, the father of Sergey Ivanovich, was one of the early giants of nineteenth-century Moscow; an assertive, individualistic, bombastic businessman, bluff and outgoing with an eye for his standing in the community and a talent for salesmanship. A religious man and a political conservative, he had grown up during the regressive reign of Nicholas I. That monarch had strictly limited the scholastic opportunities for the children of the bourgeoisie, and Ivan had received scant formal education. His will to succeed superseded all other goals, and under his aegis, the firm of I.V. Shchukin and Sons had attained a respectable net worth of four million gold rubles. He enjoyed an extravagant lifestyle and much of what he made, he spent. His appetite for good food, sweet red wine and cigars was legendary, and he was not inhibited by social niceties. The

anteroom next to his box at the Bolshoy was equipped with a couch, and though he enjoyed the florid melodies and dramatic sweep of an Italian opera, he would usually disappear during the performance for an after-dinner nap. His self-indulgence did not extend to others. Even in minor matters he was a martinet; those who worked for him in the shop were forbidden to smoke and the edict included his brother Pavel who was one of his employees. His speech was blunt and aphoristic as when he estimated that a shaggy colleague 'had enough hair for three fights'.[6]

Shchukin's wealth alone was not responsible for his eminence in the community. He had, in addition, a particularly gritty, hard-nosed sense of identity, and was respected for his zeal in advancing the cause of the merchant class. Like Pavel Ryabushinsky and Savva Morozov, Ivan had a fierce pride in his origins and felt that he and his colleagues contributed more to the country than the titled exquisites of St Petersburg. Many lucrative areas of industry, run by the crown and members of the nobility, were notorious for inefficiency, corruption and inferior products. Above all, the merchants scorned the ineptitude of the aristocracy in matters of commerce.

Ivan had married the daughter of Pyotr Kononovich Botkin, a prominent tea merchant and founder of the firm whose caravans had travelled between Russia and China since 1801. The family owned forty depots across the country and a branch of Botkin and Sons was opened in London in 1852. The Botkins were among the most prominent families in Russia, respected not only for their wealth but for their intellectual and cultural attainments. Among their ranks they numbered doctors, diplomats, scientists, artists and businessmen. Documents from the early sixteenth century mention their forebears as *posadniki* or governors of an early city-state. The contrast between the two families extended even to physical characteristics: the Shchukins were short, stocky and dynamic, their conversation tending to be earthy, while the Botkins were taller, more elegant and reserved, and vitally interested in art. Ivan's wife, Yekaterina, was the sister of the literary and social critic, 'the philosophical tea-merchant',[7] Vasily Botkin. An adherent of the liberal movement of the 1840s, influenced by Hegel and by Western political thought, Botkin was an associate of the social reformers and philosophers Herzen, Belinsky and Granovsky. A friend of Turgenev and Tolstoy, a lover of art for art's sake, he was one of the 'civilized and fastidious men of letters'[8] who articulated and analyzed the social issues of the period. Without foreseeing the result, men like Botkin helped to create a climate of restlessness and inquiry which ultimately made the Revolution possible.[9]

Through the Botkins, the Shchukins developed a measure of artistic sensitivity. Vasily Botkin and his brothers Dmitry and Mikhail had accumulated a vast cache of art, both Russian and Western. Though he collected only European paintings, Dmitry aided Pavel Tretyakov in his research on the

history of Russian art and gave numerous Western canvases to the Tretyakov Museum.[10] Mikhail, an artist and academician who had lived in Italy for several years, filled his house in St Petersburg with one of the historic Russian collections, a massive assortment 'in the Moscow manner', expensive, varied, impulsively assembled, a tribute to appetite as well as taste. It ranged from Aleksandr Ivanov's *Water and Rocks at Palazzuola*, a Russian classic of the early 1850s, to rooms full of art from the Italian Renaissance. His biography of Ivanov was published in St Petersburg in 1880, and a comprehensive volume on the subject of his collection, personally written and researched, appeared in 1911. Vasily, in addition to his writing, was a knowledgeable collector of the artefacts of ancient civilizations. A greater contrast to Shchukin could not be imagined, for Ivan was essentially a Russian Babbitt, a booster, who 'never bought a painting in his life.'[11] Discussions of line and form bored him and the elegance of a Greek vase left him unmoved. His idea of an evening well spent was to gather with his friends for a generous feast, a bottle of Georgian wine and game of cards or billiards at the English Club where the air was thick with news of business mergers, scandal and cigar smoke. Richard Cobden, the well-known British Member of Parliament who was a guest of the club at this time, was surprised by the absence of substantive conversation and noted that there was 'no intellectual society, and no topic of general interest was discussed.'[12]

However, the Botkins were related by marriage to the Tretyakovs and soon Shchukin was drawn into a small, intimate group of dynasties, a benevolent cartel, which because of its wealth and prominence helped to subsidize and shape the Russian taste in art. Until Ivan's marriage, none of the Shchukins had shown any interest in this area, and it is reasonable to suppose that the activities of the next generation could be ascribed in part to the influence of Yekaterina Petrovna Botkina and her family.

Ivan and Yekaterina had eleven children, five girls and six boys. It was the custom among the merchants of the time to train their sons rigorously to take over the business; Nikolay, Pyotr, Sergey, Dmitry, Ivan and Vladimir, born in that order, were expected to participate in the firm. The Moscow grade schools were usually the first step; however, Ivan had personally experienced the narrowness of this educational system and was resolved that his heirs would be better equipped to handle any aspect of the family enterprise. As a nineteenth-century merchant he had lived with the barely concealed contempt of the nobility, he had watched while the aristocracy slowly became more impoverished and the influence of the mercantile class had spread throughout Russia. Now he was determined that his sons should excel, and in time they became conversant with mathematics, chemistry, physics, French and German.

It was necessary that the boys be hardy and self-reliant, and after a great deal of searching he finally decided to send them north to a school in Finland. He had

discovered the Bemsky German School at Vyborg near the Gulf run by a Lutheran pastor who emphasized 'discipline, character building and physical training.'[13] Most of Ivan's sons were subjected to this brisk authoritarianism at an early age. After Vyborg, several of the boys were sent to a *pension*, a German preparatory school, Girst, in St Petersburg. As a final step the young Shchukins were expected to serve an apprenticeship at the best known textile factories in France and Germany.

Despite his conservatism, Ivan could be an unexpectedly permissive father. As long as their work was satisfactory, his sons were free to travel as far as their ingenuity and a limited allowance would carry them. At one time they were dotted throughout Europe like pins on a map. As sometimes happens, the education and travel that Ivan so favoured enlarged the mental horizons of his children and diluted the single-minded drive for advancement. Out of severe training and a common heritage, he had anticipated a standardized result, but his plans were thwarted by the mercurial individuality of his offspring. Rather than a series of interchangeable cogs, each of the brothers was a distinct personality, cast from a different mould.

It soon became apparent that the oldest, Nikolay, had little interest in commerce. A civilized and amiable man, he was more like a British country squire than a member of the intense Russian merchant society. He married a widow of one of the Botkins and settled easily into the active social routine of Moscow. There were no children from this union and he spent much of his leisure time playing cards at the English Club and adding to an extensive collection of English silver. Though he had a place in the firm, all of his father's training had not instilled the single-minded ruthlessness necessary for leadership.

In 1867, the second son, Pyotr, entered the *pension* of Girst in St Petersburg, and it was here that he began to deviate almost imperceptibly from Ivan's wishes. More than anything else, he coveted a formal education and it was his ambition to attend the University of Moscow. He would have been the first Shchukin to do so. After leaving Girst he persuaded his father to arrange a consultation with 'the famous educator, Stoyunin',[14] but after several examinations he was told that he was 'insufficiently prepared for entrance into any institution of higher learning', and advised 'to study the sciences at home'. He worked desperately for a year with several respected professors in Moscow, but there was too little time. His father watched the effort with some tolerance, but this form of remedial training could not be allowed to interfere with more practical matters.

The aberration would pass. Pyotr's studies were interrupted when Ivan took him abroad in 1872 to be apprenticed to a textile firm in Berlin. For a young man of eighteen on his first journey, eager to appear a seasoned voyager, Ivan could

be a trying companion. His explosive personality and loud voice were conspicuous, and Pyotr noticed that when they were in Paris, people in the streets and restaurants turned around to look. Pyotr remained in the West for the next few years, working first in Berlin, then in Lyons. It was in Lyons that he acquired a few rare books and engravings; during his side-trips to Paris and Leipzig, he added prints and drawings. Finally he returned to Moscow to enter I.V. Shchukin and Sons.

Ivan soon discovered that increasingly his son's interests lay outside the firm. During a business trip he would travel for hours out of his way, beyond Kazan, to visit the sprawling half-Oriental, half-Russian exhibition at Nizhny-Novgorod on the Volga. This was no rustic country fair; the government had built miles of wooden booths for the display of goods which had been brought to the city by ships and barges, or overland by horses and camels: filmy silks from the Orient, cloth of gold for clerical vestments, works of art, teas from China and India, unfamiliar objects from forgotten cultures, as well as items of little value. Richard Cobden, an advocate of free trade, was impressed by the scope and energy of the scene: 'At one time there were forty to fifty thousand horses waiting to transport goods changing hands in the city.'[15] When Pyotr saw the walls and towers of the city, he escaped into the past and lost himself in the history and souvenirs of another age. After each journey, he would return to Moscow loaded down with objets d'art.

At first Pyotr's collecting was not taken seriously by the experts; he was merely a wealthy man's son who bought indiscriminately and in bulk. But he was also studious and bright and his taste was sharpening. An early concentration on Persian art was extended to works from China, India and Japan. In the 1880s he began to trace the influence of the Orient on Russian culture, and this led him finally to the acquisition of Russian antiquities. To his delight, Pyotr's apartment was becoming a mine for scholars, a jumble of treasures impossible to catalogue. He was spending an increasing amount of time in an effort to keep track of the items, but whenever success appeared near, there would be a visit from an antique dealer or a cartload of merchandise would arrive from the Sukharevka, the flea market of Moscow.

Finally it became too difficult for the visitor to pick his way through the maze and in 1892, with typical Muscovite extravagance, at the age of thirty-nine, Pyotr proceeded to build himself a museum. Ten years earlier Savva Mamontov's small church at Abramtsevo had stimulated popular interest in early architecture and Pyotr decided that his building, the Old Museum, should be in the Russian style of the seventeenth century. To guarantee authenticity, he and his architect, Boris Friedenburg, travelled to the old city of Yaroslavl where they studied the designs and construction of the past. All the dynamism that Ivan had discerned years before was devoted to this project, and within one year there

appeared on Malaya Gruzinskaya Street in the centre of Moscow a fantastic structure of towers and spires which served as a fitting showcase for the expanding collection of ancient objects. In 1895, the museum was opened to the public and proved to be a case of Parkinson's Law. In 1897–98, a second building, the New Museum, was erected nearby to house the overflow, and the two elaborate edifices plus a special annex for the archives were joined by a wide underground passage. The two buildings were based on the old wooden architectural style, modelled after the Kolomenskoye Palace which had been built in the environs of Moscow by successive grand dukes and tsars and completed at the close of the seventeenth century by the father and brother of Peter the Great.[16]

Much of the interior decoration had been inspired by Pyotr's collection of historical documents. The hall was decorated with an exact replica of the ornamentation of an eighteenth-century charter sent by Peter the Great to Yakov Bryus. Vaulted ceilings, carved and gilded pillars, broad aisles and glass cases lent space and perspective to the display. Boxes of eighteenth-century Kalyandan faience were combined with old Russian works; rare illuminated parchments and simple early icons contrasted with gleaming gold vestments; ornate silver from the West, carved bronze crosses and heavy gold seals complemented antique silk Persian carpets. Carvings and intricately embroidered fabrics revealed the extravagance of the early boyars.

The picture gallery was devoted to Russian paintings of the eighteenth and nineteenth centuries, and in the midst of this formal splendour, among the somewhat waxen portraits of officials and ambassadors, was a rare example of French Impressionism: Monet's *Woman in a Garden* (1867), glowing like a polished jewel in a mine. It was a deviation, but collections are interesting for the light they shed on the personal responses of the collectors: Pyotr had admired *Lilacs of Argenteuil* (1873), a Monet owned by his younger brother Sergey, and in Paris in 1899, in addition to a carved Japanese screen which he found at the Paris Exhibition, he bought *Woman in a Garden* from Durand-Ruel. Another unexpected discovery in these surroundings was Renoir's opulent nude, *Anna* (1876). It had been donated to the museum in a spirit of irreverence by another brother, Ivan Ivanovich, who was living in Paris. Ivan found Pyotr's interest in the Russian past incomprehensible, and the galaxy of portraits stultifying. It was his intention to add a touch of Gallic flavour to the sober atmosphere. Though Pyotr thought the picture unseemly for public display, he kept it on view in his private quarters, and in 1912 it passed to Sergey.[17]

Pyotr's reputation for personal eccentricity increased as the years passed. Lidiya Grigorevna, Sergey's wife, a beautiful, imperious woman, flatly refused to visit him. She had aroused his hostility one day when she had observed that his house was dusty and he needed a wife.[18] Pyotr promptly suggested that she stand behind his chair so that he would not have to look at her.

He was always a misogynist. The collection seemed his only passion. There was a great deal of surprise and speculation in Moscow therefore, when in his late fifties, he suddenly married a widow and adopted her two children. The move may have been prompted by the feeling that he was growing older and more crotchety, and he wished to surround himself with the semblance of a family relationship. However, the union was not permitted to change his way of life; if anything he became more absorbed in his work, and the Muscovites continued to refer to his museum as 'his child'.

In 1905 he decided to give his buildings, the land on which they stood, and the contents, to the State. Eleven years earlier, Tretyakov had made his gift of national art to the municipal government, and originally Pyotr had intended to follow this course. He had made his will, but when the city decided to tax his donation, Ivan's son, in his own words, 'thumbed my nose at the City Collector'.[19] Perhaps more importantly, the State could confer a title, and Pyotr Ivanovich had yearned for this acknowledgment for many years.[20] Unlike his father, he was known to be something of a snob. It pleased him to be called 'Your Excellency' and for those who had respected Ivan for his fierce independence and lack of affectation, his son was occasionally difficult to take. As a quid pro quo it was decided in St Petersburg to make him a 'General'. The office carried no authority, but Pyotr was permitted to wear the uniform of a high-ranking official in the Ministry of Education. For this privilege he defrayed all the museum's expenses, added to the collection as before and acted as curator. It was one of his greatest pleasures to guide his visitors throughout the buildings wearing his new professional mantle.

A year after the donation he was photographed full of dignity and honours in his double-breasted white uniform with the gold buttons, four impressive insignia on his collar, and a monocle hanging from a cord around his neck. It is a recognizable portrait of human vanity, and one smiles, but despite a lifetime of eccentricities and pretensions, this man had the wit to know what was important, to use his wealth constructively and with imagination. When Pyotr died on October 12, 1912, he was working on his eleventh book, a history of the Shchukin family.

It may seem that a disproportionate amount of space has been devoted to Pyotr Shchukin in a chapter primarily dedicated to Sergey Ivanovich, but the elder brother was significant in his own right, a man who typified the peculiarities, the emphasis on scholarly achievement and the insecurities that characterized so many members of the Russian bourgeoisie. He was, incidentally, one of the few merchants to be mentioned politely in the *Great Soviet Encyclopaedia*. On January 1, 1913, his obituary noted his contributions to the State: 'Such civil feats are not frequent, one must be proud of them and the name of P.I. Shchukin will henceforth figure in the pages of the history of

Russian enlightenment.' He had fashioned an entity which was finally acknowl-
edged by the academic establishment, and for a moment he attained the
recognition he coveted.

<center>* * *</center>

Sergey Ivanovich was next in the line of descent; a year younger than Pyotr, a
small child, delicate and pale, physically unlike his robust father, his seeming
vulnerability enhanced by an uncontrollable stutter. The speech defect made it
difficult for Ivan to talk to the boy, and because of his frailty he did not envisage
a large role for him in I.V. Shchukin and Sons. His hopes were centred on
Nikolay and Pyotr, and when it was time for Sergey to leave for school, Ivan
yielded to Yekaterina's suggestion that the child be spared the stringencies of a
formal education and be tutored privately.

To be kept at home with his sisters was a misery and an affront for a young
boy, and a succession of governesses and tutors, some friendly, others impatient
and demanding, did not help. Yekaterina had succumbed to the Moscow vogue
for spiritualism and there were frequent visits by a medium whom all the
children disliked. 'A terrible old Frenchwoman, Mariya Ivanovna Kandriyan.
. . . We were very much afraid of her. She practised fortune telling, spiritism and
levitation of tables and when it was time for one of the séances, we were asked to
leave the room.'[21] Sergey's later espousal of free thought may have been in
answer to his mother's spiritualism and his father's formal religiosity.

It was a lonely time for the boy, and as a form of diversion, he was permitted
occasionally to visit the home of his uncle Mikhail Botkin in St Petersburg,
where he wandered for hours through rooms crowded with majolica, rare
marbles and priceless paintings – scenes of combat, religious intensity,
landscapes, warriors, lovers and saints. A childhood refuge exerts a powerful
pull and leaves a permanent mark; this hoard of treasures with its intimations of
past history and civilizations was a compelling introduction to Western art.

Sergey was three years old when Dmitry was born, and this younger brother
was unquestionably his father's favourite. Ivan always kept him close and took
him on business trips; perhaps as a result, Dmitry never lost the shyness and
reserve more often found in an only child. The last sons, Ivan and Vladimir,
were separated from their brothers by more than a decade. Though they were
totally dissimilar in temperament, there was a bond of affection between the
two, the consequence of a shared childhood. Ivan was a poised, articulate, pre-
cocious boy with a love of books; Vladimir was hump-backed, gentle and
affectionate. He was also ailing for most of his short life. The two youngest sons were
the first Shchukins to attend Moscow University. Ivan was an unusually bright
student of philosophy and political science. Vladimir's subject was medicine.

To his father's surprise Sergey was becoming unexpectedly assertive and

difficult to handle. With the persistence of a small terrier, he fought to escape his mother's cosseting and the dull security of familiar surroundings. Finally, Ivan shipped him off to a school in Saxony where, unexpectedly, the boy flourished. The physical discipline hardened his small frame and the challenge of a new situation sharpened his wits. Not a memorably brilliant student, he was remarkable mainly for his curiosity, independence and the ingenuity he displayed in escaping the confines of the school and travelling to the nearby towns with very little money in his pocket. When he graduated, however, he spoke French and German almost perfectly and his drive and determination were becoming noticeable.

In 1873, Sergey and his father visited a doctor in Germany near Münster in an effort to cure his speech impediment, but the effort was only partially successful. Sergey stammered intermittently for the rest of his life, but it did not diminish his activities. He was neither introspective nor self-indulgent; people had lived with worse handicaps, and he was always impatient with self-pity.

Despite the political instability in Russia, the years between 1873 and 1914 were a period of unfettered economic growth and laissez-faire capitalism. During this time, iron production increased twelve times, and coal thirty times. Private merchant banks were opening all over Moscow, and the stock exchange was booming. It was a mouthwatering time for Ivan who loved the challenge of the game as much as the rewards. As the autocratic and indispensable head of I.V. Shchukin and Sons, he had planned a niche for each of his sons but he was always probing for the man best qualified to take over his own essential role. At first it had appeared that there would be a rich and varied crop, but the choices were narrowing. Nikolay's complacency had become noticeable, and increasingly Pyotr was lost in his evocation of the Russian past. Dmitry was too introverted and Vladimir too fragile. Ivan Ivanovich, the most scholastically promising of his children, found business intrusive and life in Moscow backward. Their father's frustrations increased. He could read the basic economic indices, but he was growing older, and was in the disconcerting position of an eager investor with no funds, watching the market rise.

When Sergey entered I.V. Shchukin and Sons in 1878 at the age of twenty-four, Ivan soon recognized his natural successor. The once sickly child, his mother's pet, reacted to the commercial scene with the single-minded determination of the first Pyotr at the Spassky Gate. This small man with the large head and bright Tatar eyes soon became the dynamo of the family business. For the next twenty years Sergey's priorities were fixed and he surpassed his father in shrewdness and ambition. His brothers welcomed his skill in business matters, for it left them free to indulge their own inclinations. Eventually they became silent partners in the company, took their portion of income or capital, and followed a variety of life-styles.

There was a deep vein of speculation running through Moscow's financial community, and Sergey was noted for the hazard of some of his enterprises. By the time he was named to the board of the Merchants' Bank, his associates had dubbed him 'the porcupine' because of his toughness and the prickly cast of his mind. It was rumoured that he used his stutter deliberately during business negotiations to unsettle his opponents and gain himself time to think. He had become a steely, audacious gambler. The wager which secured his reputation occurred in 1905, the year of general uprising, of six days and nights of shooting in the streets of Moscow. Curfew was imposed, violators were imprisoned, barricades were erected in the streets, and each householder was held responsible for sniping from his windows. At this point, Shchukin wagered the revolt would fail and bought up all available textiles, in effect cornering the market. When the rebellion was finally put down, prices skyrocketed and he made a fortune. (He was not omniscient, however, for in 1917 he was to repeat the move, and the textiles would rot in his warehouses.)

In 1883, at the age of twenty-nine, Sergey married Lidiya Grigorevna Koreneva, a ravishing imperious woman, daughter of a family of industrialists whose fortune had come from the coal mines in the Donets area. They had four children: Ivan Sergeyevich was born in a large flat in Moscow in 1885, then Grigory in 1887, Sergey Sergeyevich in 1888, and the only daughter, Yekaterina, in 1890.

It would seem, at this point, that Shchukin's personal life had reached the apex of success and happiness. Yet the single element that was to make him historically significant was missing. Sergey's brothers shared a single trait: each was an impassioned collector. The early 1890s saw Sergey a father, an industrial magnate, and so far, immune to the collector's fever which swept Moscow. In view of his later history, it can only be assumed that all his formidable energy and concentration were directed toward the growth of the family enterprise. He had inherited from his father a thriving, solid company, but under his leadership it was becoming an empire.

It was in the subsequent period of his life that his artistic proclivities asserted themselves. In 1897 he bought his first Monet. Within the next twelve years he began to amass a collection of Western art: twelve more Monets, Pissarro, Sisley, Renoir, a gathering of Gauguins, followed each other in rapid succession. Major works by Cézanne, Matisse and Picasso enhanced the display. By the time he opened his house to the public in 1909, the foundation of his achievement was in place.

Shortly before his death in 1893, his father, the Shchukin patriarch, bought the Trubetskoy Palace from the Princess Trubetskaya and presented it, the future site of the Shchukin collection, to Sergey. It was a belated wedding gift, and an unspoken recognition of an early miscalculation. The great mansion

stood in the middle of Moscow and the splendour of the structure was a measure of the Shchukins' progress. Like the Morozov houses, Pyotr Shchukin's museum or Nikolay Ryabushinsky's palace, it was a badge, a testimonial to the status of the merchants, one which frequently served to focus their attention on art. Ironically, this monument to the new commerce had been owned by Prince Nikolay Trubetskoy, a leader of the nobility, deeply scornful of the arrivistes, and dedicated to preserving the old social distinctions. Because of the profligacy of his sons, the estate had dwindled, and finally the family had been forced to sell the house which had been built for them in the eighteenth century. 'It was said in Moscow that if the old Prince had known that a merchant was its new owner, he would have turned over in his grave.'[22] Yet everything within the palace remained intact, even 'the Trubetskoy coat of arms was left on the walls of the great reception hall.'[23] With a single exception, the original elegance was unmarred by the dreaded commercial invasion. The exception: Sergey found it necessary to build warehouses for the storage of textiles on the grounds. They were placed discreetly out of sight at the back, but it was an indication of change.

There was a strange, artificial, hothouse atmosphere in Russia at the turn of the century, a sense of forced growth and impending metamorphosis. The pervasive political turbulence, the rapid expansion of industry and commerce, with the concurrent emergence of a new power élite, had resulted in the destruction of the old norms. It was a single leap from feudalism to the industrialism of the twentieth century, and the process was jarring, unsettling the traditions of centuries of isolation and undermining a rigidly stratified social structure. The uprising of 1905 had resulted in a society at once revolutionary and orthodox, in which was combined great vigour and early decadence. Outwardly the lives of the merchants reflected very little awareness of this upheaval. The great houses had passed like a sceptre from the nobility to the bourgeoisie, from the Potyomkins to the Morozovs, from the Trubetskoys to the Shchukins, and the newly powerful had continued the prodigal tradition of the old order as did Sergey in his own fashion.[24] The merchants enjoyed their dachas, private clubs, intellectual salons and foreign travel, and they accumulated innumerable objets d'art. They differed from their predecessors in their vigorous contribution to the economic expansion of the country and in the extensive benefactions, endowments and charities which indicated some awareness of those outside their immediate social stratum. Their philanthropies were international. Gennady Vasilevich Yudin made a gift of 80,000 books to the Slavic collection in the Library of Congress in 1907. At the time he stated, 'I do not know a more honoured place for it than the American National Collection.' As with many of the merchant philanthropists, Yudin's activities had unexpected ramifications. From his exile in Siberia, Lenin wrote to his mother: 'Yesterday [March 9, 1897] I went to the local and famous library belonging to

Yudin who welcomed me and showed me his book treasures – I shall be able to use them for the references necessary to my work.'[25] Perhaps there was an atavistic memory of struggle; several prominent members of this circle were only two generations removed from serfdom. Politically, however, there seems to have been no sense of an impending irreversible turn in their fortunes. The prevailing unrest may have become a staple, a part of life like the icy winters, and the merchants adjusted to the discomfort.

Number Eight, Bolshoy Znamensky Pereulok was a mansion of vast proportions. One entered from the street through two elaborate gateways guarded by liveried doormen. On a spring evening, the sound of voices and music, the glimmer of lamps on the grounds, the lights blazing from the windows, created a festive nimbus. Between the gates was an arbour, then a curved, asphalted area surrounding the building. To the right and left were two large gardens containing superb linden trees and sweet-smelling lilac. Inside the house the broad oak stairway led up to the dining room and salon and to the various apartments. The high French ceilings were carved and painted, the windows hung in silk with elaborately draped valances, the furnishings covered in damask. Oriental rugs covered the parquet floors, and a private chapel had been inherited from the previous owner.

Sergey's eldest son remembered that when his family moved into the Trubetskoy Palace, the walls were heavy with the works of the Wanderers and their successors. Surikov was the most popular artist in Moscow at that time and numerous studies for his masterpiece *The Boyarina Morozova* (1887) were scattered throughout the house. Surikov's undiluted sense of drama, brilliant palette of primary colours and ability to portray the fears and emotions of his subjects, made him a favourite with those Muscovites who enjoyed narrative impact in their art.[26] It is not clear whether Ivan purchased these pictures to enhance his gift, or if they were a holdover from the previous owner. What soon became apparent, according to Ivan Sergeyevich's testimony, is that his father could not bear to live with them.

In terms of Sergey's taste, it is instructive that these are the only paintings he ever sold. The first disappeared quietly, without comment from the family, and soon after, Shchukin's first independent aesthetic self-expression appeared. A small picture by Fritz Thaulow, the Norwegian Impressionist, was hung in its place in the drawing room. A snow scene, quietly competent, unremarkable even for conservative Moscow, this first purchase is interesting mainly because it reveals Shchukin's initial caution and his preference for Western art. Sergey's son Ivan found Thaulow's work boring: 'Those Norwegian houses covered with snow were always the same.' Thaulow's *Icy River* was followed by a view of the Madeleine and a corner of Venice. The painter remained largely unknown in Russia until 1897, the year of Diaghilev's exhibition of Scandinavian painting in

St Petersburg. Thaulow's canvases were also a feature of the more conservative French salons and it is probable that Shchukin discovered his landscape during a visit to Paris. It was an inconspicuous beginning for a process that accelerated the pace and altered the course of Russian painting.

Moscow's social life and Shchukin's involvement with its artists and intellectuals heightened his artistic interest. For the Shchukins and their friends, the Moscow season was a glittering round of parties and balls. The glittering formality of the charity galas held a special appeal for Lidiya; Sergey Ivanovich found them a little starchy and boring. But as a decorative and wealthy woman his wife was very much in demand. She appeared at theatres and operas and the charity festivals organized by the Grand Duchess Elizabeth. A popular divertissement at these affairs was an elaborate tableau vivant, and Lidiya was frequently at the centre, a Junoesque Helen or Marie-Antoinette. In her spectacular furs and gowns from Moscow's Lamanova or from Worth in Paris, she was an adornment to Sergey her husband, and the early years of their marriage were full of promise.

With their acquisition of the Trubetskoy Palace, the Shchukins soon became known for their lavish dinner parties and private concerts. Despite the round of social activities, Sergey's preferences remained basically simple. Though the merchant indulged his wife's tastes, he was not preoccupied with fashion or elegance. He would order from the best tailors, then forget what he was wearing. Despite Lidiya's protests, he would occasionally use a clip-on bow tie to save time and his socks did not always match. Moscow was full of extravagant dandies; Nikolay Ryabushinsky was famous for his immaculate tailoring and Mikhail Morozov sent his shirts to London to be specially laundered, but Shchukin had a lack of pretension that belonged to a more Spartan era. In the biting cold of an early winter morning, the servants going to wake him would find all the windows open and snow would have to be brushed from his bed. Everyone in the city who could afford it had his own carriage, yet Sergey would answer the call of 'six rubles the ride', and hire a shabby cab to take him home from the office in the evening, climbing into it with a dozen newspapers under his arm.

His diet was equally austere. The best food and wine were served at his table, but he was a vegetarian. During his elaborate dinner parties he insisted on a special menu: a vegetable broth to which the frustrated cook secretly added chicken stock 'for flavour', young potatoes with dill sprinkled over them, and a favourite dessert, *prasta kvasha*, a Russian yoghurt seasoned with breadcrumbs, sugar and nutmeg. Occasionally he permitted himself a bourgeois indulgence and spread caviare on his new potatoes. An odd figure in a sybaritic society, he was forgiven his whims, for I.V. Shchukin and Sons was rapidly becoming one of the most famous mercantile dynasties in Russia, and by 1900 Sergey was the controlling force.

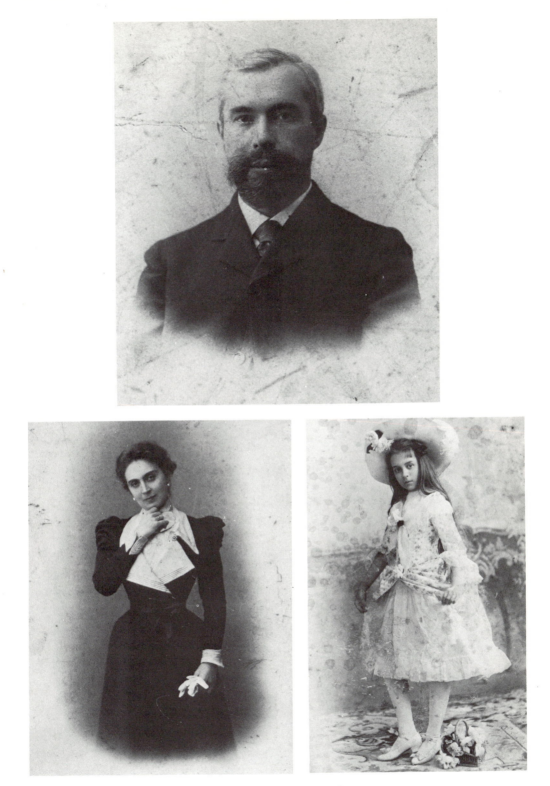

Top: Sergey Ivanovich Shchukin, Moscow, 1900

Above left: Lidiya Shchukina, Sergey Shchukin's first wife

Above right: Yekaterina Sergeyevna Shchukina, daughter of Lidiya and Sergey

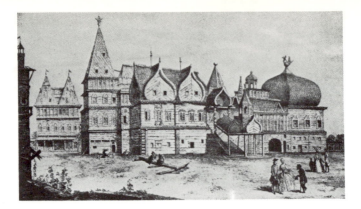

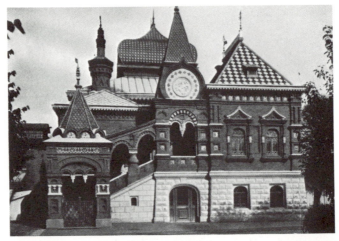

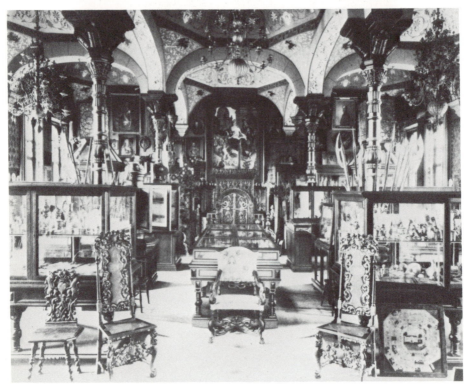

Above: The Shchukins in India, 1895–96
Top: Private church overlooking the Black Sea, built for the Moscow tea merchant Aleksandr Kuznetsov in the late nineteenth century

Opposite top: Kolomenskoye Palace, completed at the end of the seventeenth century. Eighteenth-century engraving

Opposite middle: Pyotr Shchukin Museum, Moscow. The design was strongly influenced by the Kolomenskoye Palace

Opposite below: Interior of one of the rooms of the Pyotr Shchukin Museum, c.1895

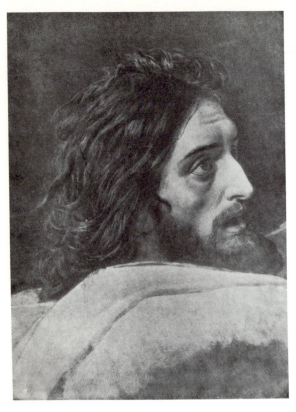

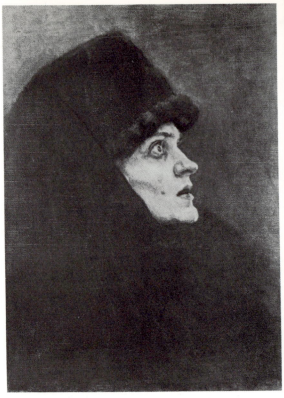

Above left: Aleksandr Ivanov: *Head of John the Baptist.*
Tretyakov Gallery, Moscow

Above right: Vasily Surikov: A study for *The
Boyarina Morozova*, 1886. Tretyakov Gallery, Moscow.
Surikov's studies for his major work
The Boyarina Morozova were the only paintings
that Shchukin ever sold. Their intense
emotionalism, which Shchukin found discomfiting,
is reminiscent of Aleksandr Ivanov whose work
exerted a profound influence on the Wanderers

Left: Fernand Maglin: *Townscape with a Cathedral*,
1899. The Hermitage, Leningrad. An early Shchukin
acquisition

Below left: Fritz Thaulow: *Winter Landscape*.
Thaulow was the first Western artist whose work was
purchased by Shchukin. This landscape was shown in
the *Mir iskusstva* exhibition of 1899

An invitation to a gala evening at the Trubetskoy Palace in Moscow was a coveted token at the turn of the century. In a city known for its prodigal entertainments, these occasions offered an extra element of colour and artistic controversy. The divisions which had existed between the bourgeoisie and the nobility were blurred after 1900 by the vast wealth and the flourishing intellectual life within the merchant community. There was usually a diverse and provocative mix of guests: notables from the world of theatre, art, politics, diplomats, stalwarts of the business community and members of the aristocracy. Circulating in the salon were small fragments of history: the old Prince Yusupov, whose son later assassinated Rasputin, the Morozov brothers Mikhail and Ivan, and the tall, gregarious Dr Botkin, balletomane, art collector, friend and supporter of Diaghilev, Shalyapin, Bakst and Serov. The son of a prominent Russian physician, Sergey Botkin, with his charm, gaiety and breadth of interests, had become an integral part of Moscow as well as St Petersburg society. Though he was something of a liberal and not slavishly devoted to the royal family, he was inordinately proud of his brother Yevgeny, who was the court physician to the Tsar and Tsarina. It was Yevgeny Botkin who, in 1918, chose to accompany the deposed rulers into exile and died with them at Yekaterinburg. For the moment, though, there was no intimation of tragedy.

Each winter the rooms of the Trubetskoy Palace were decorated with red roses and filled with the music of Bach, Beethoven and Mozart. These were the concerts which eventually inspired Shchukin to commission *Dance* and *Music*, the two great Matisse panels. Mamontov was no longer present after the tragedy of 1900, but there were reminders of the merchant patron and life at Abramtsevo in the persons of Serov and his ebullient friend Shalyapin. After 1898, Shalyapin, who according to his own account had become 'the most popular artist in Moscow',[27] was a welcome guest at the Shchukins'. His success in Mamontov's production of Rimsky-Korsakov's *Maid of Pskov* and Mussorgsky's *Boris Godunov* had given fresh impetus to Moscow's sponsorship of Russian opera. He had expressed reservations about the suitability of great music being performed in private homes, but occasionally Rakhmaninov was present ('When he is at the piano, I am not singing alone – we are *both* singing'),[28] and the sounds of Russian music would echo throughout the palace and bring the children with their governess to the top of the stairs to listen and watch.

Anatoly Lunacharsky, a quietly persuasive articulator of the radical viewpoint, who became Commissar for Education after the Revolution, was usually the centre of a knot of animated visitors. On these occasions Diaghilev was charming and adaptable. Mme Lunacharsky once remarked that after hearing him talk to her husband, 'one would have thought Diaghilev a revolutionary.'[29] Despite the intellectual and artistic interests of many of the guests, these

gatherings were in no way solemn or portentous. The Turkish ambassador, who occasionally had difficulty holding his wine, had been known to add excitement to an evening by tumbling down an entire length of the stairs without injury.[30]

Despite the exotic surroundings, the world of Shchukin and his friends retained an intensely personal flavour, almost provincial, incestuous in its fascination with the peculiarities of its members. Gossip was a local industry, and in a corner one might find Prince Sergey Shcherbatov, the sharp, acidulous observer of the foibles and absurdities of his contemporaries, in conversation with Nikolay Ryabushinsky, whom Shcherbatov later described as 'frizzled, with fluffy curls and a well-groomed beard, plump with swollen, buttery eyes and rosy cheeks.'[31] Shcherbatov's preoccupation with personal detail was endless: he could never make up his mind whether or not the young Diaghilev painted that distinctive white streak in his hair. Stanislavsky, fresh from his triumph at the Moscow Art Theatre, was an occasional visitor, as was Benois. Decorating the drawing room were the ladies of Moscow, Bely's 'jeweled constellation', resembling a clutch of full-blown anemones in their vivid silks, velvets and diamonds.

Young and old, critics, poets, army officers, intellectuals and philosophers, they meshed and differed, bowed and passed on. The unexpected ingredient which made these evenings unique was the constantly growing collection of modern French art which blazed from every wall, challenging, infuriating and hypnotizing the guests.

Once Shchukin had moved on to the important phase of his collection, the enormous dining room on the second floor with its tier upon tier of Gauguins up to the carved ceiling was a blazing blend of rococo, Russian and Polynesian. Lidiya Grigorevna, tall, cool and elegant, presided over the domestic aspects of the Shchukin gatherings. The table laden with flowers and the heavy silver candelabra, the solicitous servants in their white gloves, the menus of caviare and pheasant with vintage wines, these were her province. The close proximity of Gauguin's relaxed and pliant maidens was extremely discomfiting to her, and she had no love for this particular feast. At the other end of the crowded table was Sergey, small, bearded and observant, whose drive and individuality were responsible for the spectacular pictures, as alien as moon rocks, which hung everywhere in this mansion, enclosing the guests in an unsettling and claustrophobic ambience. From where he sat, Shchukin could see, beyond the flickering candles, sixteen of Gauguin's most monumental paintings which had been hung according to his instructions. The primitive sumptuousness of these works, clustered so closely together, seemed to create a pervasive languor and humidity in this northern setting.

Art in Russia was an emotional issue, encompassing as it did so much of politics, history and religion. The arguments which exploded regularly were not

always polite. As the glasses were replenished, the voices grew louder and the opinions more contentious. Benois always marvelled at Shchukin's ability to maintain his good humour in the face of impassioned criticism from 'the aesthetic big shots of Moscow'. The merchant's normal reserve fell away as he became involved in the discussions and his smile became more evident. If, as Benois noted, 'on occasion his glance revealed a spark of sarcasm', he nonetheless emerged from these encounters refreshed, 'inspired with renewed power, ready for new daring'.[32] Shchukin obviously found the arguments stimulating for he consistently surrounded himself with opinionated guests, most of whom hated his paintings and felt free to say so.

Prince Shcherbatov was one of these. Though his views were expressed in amiable terms, he was diametrically opposed to his host on every level. Unlike Shchukin, he disliked Paris and found it 'spiritually alien . . . there is something depressing and cheerless about it, and along with its bustling, grey international population of dubious composition, there is something eerie and evil. . . .' He was particularly disturbed by the city's art exhibitions after 1904: '. . . the nature of painting in Paris began to disturb and distress me more and more. I sensed the approach of something evil, terrifying, "unholy" and alien to the noble character of the best works of the French masters'.[33] He specifically exempted Bonnard and Utrillo from his indictment. Shchukin owned neither. Bonnard was too soft, and Utrillo, who might have appealed to Shchukin in the earlier stages of his collecting, did not show at the Salon d'Automne until after 1909, by which time Sergey was absorbed in *Dance* and *Music*, Matisse and Picasso. The nobleman admired Surikov whose works Shchukin had sold, and deplored the Russian tendency to dismiss national accomplishments and to elevate everything foreign. For Shchukin, artistic leadership came from the West. Shcherbatov responded emotionally to the old Russian values: as much as Stasov and the early Wanderers, he sought for an expression of spiritual dedication in art, of nobility, a sense of exaltation and an awareness of the national heritage – in sum, a divine commitment. It is easy from today's vantage-point to deplore Shcherbatov's scorn for the moderns, until one remembers that the French critics, for their own reasons, were even more merciless.

Many of his associates doubted Shchukin's motives and the sincerity of his dedication to modern art. It was noted that until he was over forty he had shown little interest in painting. The purchase of the first Monet in 1897 was usually regarded as the beginning of his metamorphosis. However, before that there had been many elements that combined to create in him an understanding of an art which appeared grotesque to most of his contemporaries. Of these influences, the Botkins were important; Sergey had been exposed to his uncle Mikhail's collection as a child, and to the Oriental art acquired by his mother's family during their trading forays into China. He had accompanied Pyotr on his

expeditions to Nizhny-Novgorod and observed his brother's absorption in
ancient fragments which seemed to him strange and bizarre. Though he had
made not a single purchase for himself, he had noted and learned and his eye had
become accustomed to rare and striking objects.

One of the earliest and most important factors in shaping his taste was the
journey he had made as a young man prior to his marriage, when he had been
sent to Egypt on business for his father. The stylization of that country's art had
stunned him. The Valley of the Kings, that cluster of matchless, carved and
painted tombs like cathedrals, held the remnants of a familiar deep blue touched
with gold stars, the richness of colour and delicacy of concept still miraculously
preserved. For the Russian visitor there was an intimacy with the flatness of the
figures and the divinity of god-kings. A man raised with icons may feel a sense of
identification as he stands in the necropolis of the Pharaohs. For years after this
first journey to the Nile, whenever he was in Paris, Shchukin haunted the
Egyptian section of the Louvre, drawn to the exoticism and hieratic aspects of
this art. The linear elegance of the limestone figures, with intricately carved
wigs and draperies, their unseeing, ornamental eyes of lapis, ebony and quartz,
were a continuing revelation. This encounter with Egyptian art was an im-
portant step in his later understanding of modern Western painting, of the
austere structures of Cézanne and Picasso, the extravagant imagery of Matisse –
and of Gauguin.

If one understands the impact of the experience on Shchukin, then his mass of
Gauguins becomes comprehensible. In his dining room there was a *Scene from
Tahitian Life* (1896). The parade of solemn villagers, the simplified forms and
large, clear areas of colour, evoke memories of Thebes. On the wall of a tomb
near the Nile there is a similar progression which portrays the king's accountant
as he records the tribute brought to the royal granary. Like this wall painting,
Shchukin's Tahitian scene combines the mystery of a remote art with the
commonplace routine of everyday life. Gradually he began to comprehend
Gauguin's dictum: 'Without transformation there is no art.'[34]

Shchukin's restlessness and curiosity had always drawn him to unfamiliar
lands and cultures. The yearly trips to Paris, the Riviera, Munich or the German
spas, which were routine for many of his contemporaries, left him unsatisfied. In
1895–96 he had taken Lidiya on a voyage to India. He organized this trip with
his customary efficiency; it included the Red Fort of Delhi, the elephants and
pink palaces of Jaipur and Shah Jahan's marble monument. Strangely, he never
visited the caves of Ajanta and Ellora, though he loved exotic art and was a
friend of Viktor Golonbev who was among the first to publish photographs of
these remarkable sanctuaries.

In a picture taken of the Shchukins during this visit, there is an element of
British reserve, ceremony and Empire; a reminder of colonial formality in

Sergey's pith helmet, jacket, tie and furled umbrella. On this same journey the Shchukins had explored the great Blue Mosque of Istanbul, and after Turkey they visited Greece. In 1905 Sergey returned to Egypt. This was the year of his spectacular financial coup, and the merchant planned to celebrate with a royal tour. He arranged with his friend the Turkish ambassador to hire twenty Turkish soldiers for what he described darkly to Ivan Sergeyevich as 'the dangerous journey from Suez to Sinai', and this cumbersome caravan wound through the desert guided by the expertise of Cook's Tours. Ivan remembered it as his father's effort to re-create for his family an unforgettable moment of his youth.

In addition to Lidiya, his daughter Yekaterina and sons, Ivan and Grigory, made up the party. Grigory had been completely deaf from birth, and Sergey was determined that his second son should have this visual experience. For reasons which are not clear Sergey Sergeyevich, the youngest boy, remained at home.

On this occasion, according to his son Ivan, Shchukin 'purchased a lot of nice things in Egypt'. He knew the risk of fakes, and wanted nothing from the public dealers. His caution took him to the Cairo Museum, and those items reserved for purchase by foreign governments became his source. From this group he chose 'statuettes of God figures' to be shipped back to Moscow, in which improbable setting they would enhance his growing modern French collection.

The importance to Shchukin of this trip is illustrated by the fact that for the first time in his life he kept a diary. Unlike many of his contemporaries such as Benois, Shcherbatov or his brother Pyotr, Sergey Ivanovich was neither literary nor introspective. There seems to have been no impulse to record his impressions for posterity. It is doubly sad, therefore, that this slim record has disappeared. Ivan Sergeyevich recalls only that his father spoke of the period as 'one of the most memorable and pleasurable experiences of my life'. This was the last moment of complete happiness that Sergey was to enjoy with his family. Of all the Shchukin brothers, Sergey, with his pragmatism and commercial orientation, would have seemed the least likely to experience successive emotional traumas. Yet despite the seeming invulnerability of his life, the period from 1905 to 1908 was a time of concentrated personal anguish for him. The scars of the Russo-Japanese war were still visible within the country during these years. Over a quarter of the Russian forces had been killed or wounded in that conflict, and it was against this background that Shchukin's family suddenly began to suffer recurrent loss and bereavement.

Shortly after the Shchukins returned from Egypt in 1905, the youngest son, Sergey Sergeyevich, threw himself into the River Moscow and was drowned. Only seventeen years old, he had become increasingly morose and rebellious over the past year. The 'romantic love of death' was a recurring phenomenon, a

part of the Russian psyche which surfaced during periods of political upheaval. During the seventeenth century the defeat of the religious insurrection and the persecution of the schismatics had led to self-immolation among the Old Believers, some of whom retreated to the wilderness, put on fresh robes and lay down in their coffins waiting for the Apocalypse – 'disintegration, despair, a longing for miracles, a desire to escape mankind. . . .'[35] After the failure of the 1905 uprising, liberal activists like Savva Morozov killed themselves out of despair for the future, others turned to spiritualism and obscure religious cults, some lost themselves in gambling and debauchery. Among the wealthy and the intellectuals one frequently found an innate weariness, a blend of mysticism and anomie. Self-destruction was 'a solution for those who could find no place',[36] and the children of the privileged – one thinks of Arseny Morozov – were frequently infected by an illusory nihilism. Shchukin had seen in the rebellion of 1905 only an opportunity to make a fortune. Young Sergey's death was in some measure a reaction against his father and a gesture of protest against the values which he represented. In 1909, when he wrote the Futurist Manifesto before visiting Russia, Filippo Marinetti expressed the mood: 'What do the victims matter if the gesture be beautiful?'

In 1925 Nikolay Bukharin, one of the leading figures of the Revolution, looked back on this manifestation and found a sociological cause. He likened the suicides to those which occurred during the decay of the Roman Empire. For Bukharin they were a by-product of parasitism and class psychology, a 'psychology of repletion, satiety, of disgust with life',[37] inevitable in a society which did nothing but consume.

In 1907, two years after the death of young Sergey, Lidiya died after a week's illness. The cause was said to be 'a woman's disease', a non-committal term used in Russian society to avoid specific discussion. Whatever the diagnosis, it is possible that her vitality and will to live had been muted by the death of her youngest child.

Shchukin was left with an unaccustomed sense of mortality. His life had always been compact, subject to discipline and order; now suddenly, he was unaccountably bereft. By 1908 his remaining children were absorbed in their own lives: his only daughter Yekaterina had left home to marry, and was expecting a child. Ivan Sergeyevich was caught up in his own circle of friends and spent an increasing amount of time with Ryabushinsky, Bely or Grabar. Grigory existed in a soundless world of his own.

Shchukin's friendship with Ivan Morozov was based on their shared response to art; the small revelations and confidences which constitute a deeper relationship were difficult for him – he could not reveal his innermost feelings to the younger man. Nor could Sergey turn to his brothers for comfort, for they had never been truly intimate. Each had built a life around his particular

interest; they had spread out over the landscape of Moscow in their individual fortresses without every really forming a family unit. There was sympathy but no consolation.

A few months after Lidiya's death, Shchukin retired to the ancient monastery of St Catherine's at Wadi el Der in the Sinai. It was an uncharacteristic move, for he was not a meditative man, and though he was morose and self-absorbed he soon grew restless.

One afternoon, as he was exploring the priory, he came upon the cell of a young monk. Pinned to the wall of the tiny cubicle, like a small icon, was a reproduction of a work by Matisse, an unexpectedly vivid reminder of the outside world. The incongruity of the surroundings aroused the visitor's curiosity. It was the first time he had been interested in anything since his arrival, and Shchukin soon discovered that the friar was trying to paint in the Fauve style with primitive tools and colours which he had fashioned himself. The will to create which endured under these lonely circumstances was impressive, and the two men spent many hours together. They were completely dissimilar: Shchukin, older, worldly, dynamic and aggressive, a freethinker and lifelong believer in his ability to control his own destiny, and the young recluse, contemplative, content in his cloister, yet spellbound by his guest's tales of the artists of Paris and Moscow. It was a helpful meeting for Shchukin; it took his mind off himself, healed his isolation, and to some degree, alleviated the disorientation he had felt since leaving Russia. He recounted the experience to Matisse when he returned to Paris and sent a bountiful supply of paints and brushes to the abbey immediately.[38]

It was during this visit to the monastery that Shchukin first gave serious consideration to opening his house and sharing the treasures he had accumulated. For several years he had been a friend and informal adviser to the younger generation of artists in Moscow, and the role had been stimulating. Now the prospect of settling into a premature old age as a fixture of the haute bourgeoisie was depressing. Art was the only field which promised an outlet for his vigour and special talents.

A lesser event during this time was the contretemps which involved his brother Dmitry. Ivan Sergeyevich remembered the incident.[39] With the expanding market for art, forgeries and misattributions were becoming increasingly common in Moscow. Even the Shchukins were not immune. The reclusive Dmitry, Sergey's younger brother, had bought a small, old-style house in Moscow and filled it with the works of Memling, Watteau, Boucher, Fragonard and the Dutch masters. His particular prize was Rembrandt's *Tobias Bringing the Goat*.

Unlike Sergey, Dmitry was somewhat capricious in his choices. An avid reader, he studied art catalogues and books, and made his selections from these,

remaining largely unfamiliar with the museums of Western Europe. On one of his infrequent journeys, he bought from a German dealer an allegorical canvas, 'a woman sitting on a globe', which was signed Caspar Netscher. This seventeenth-century painter, a member of the Dutch school and a pupil of Gerard Ter Borch, was 'fashionable' in Russia at that time and Dmitry, pleased with his purchase, decided to have the picture restored by Hauser in Berlin and then sent on to Moscow. He was crestfallen when after it arrived, he could not find a single friend who admired his prize, and within a year he himself began to dislike it intensely. Finally he took it back to Berlin where the same dealer gave him a small profit on his original investment. It was a rare financial success for Dmitry and he was delighted with the transaction.

However, a short time later when he was leafing through a newly arrived art journal, he read that Bredius, the director of the Hague Museum, had purchased a picture purporting to be by Caspar Netscher from the same dealer. Upon examination, beneath the false signature, there appeared the name Vermeer Van Delft. The painting, which was currently being displayed in the Museum, was valued at 400,000 marks. Apart from the financial consideration, Dmitry had lost his opportunity to be recorded as the owner of one of the forty known paintings of this master, and the only Vermeer in Russia. The episode was unsettling to Moscow's cultural leaders, and Grabar considered it to be an illustration of the shallowness of the merchant-collectors and an inevitable outgrowth of their preoccupation with Western 'names' and price.[40]

It would have been a more amusing story for the Muscovites if it had happened to Sergey, the mad Russian with his unshakable assurance and crazy pictures, but as he observed to his son Ivan, artistic misrepresentation had never been a problem for him. There was no point in altering a Matisse or a Picasso at that time, so few were interested.

In 1907 Sergey's relationship with his younger brother Ivan had begun to sour. The most polished and intellectual of the Shchukins, he had always considered Moscow primitive and boring, and as soon as it had been decently possible after the death of their father, Ivan Ivanovich had moved with his brother Vladimir to Paris, to lead the life of an independent scholar – in grand style. He chose to become a 'sleeping partner' and sold his shares in Shchukin and Sons to Sergey. The generosity of the settlement was attested by the house he purchased in the Avenue Wagram and the number of El Grecos assembled in the main salons. But Ivan's appetite for luxury, travel, love affairs and old masters had been costly, and now the extravagances were becoming impossible to support. He had managed in the course of thirteen years to squander his entire capital on a style of life which could be sustained only by someone like Sergey who generated income.

During his many business trips to Paris, Sergey had visited Ivan regularly and noted his scale of living with some concern, but his occasional warnings had received little response, and on the surface, Ivan's affairs appeared to be in order. However, in Moscow over the last two years Sergey had received a flood of importunate telegrams and had helped his brother financially several times. On each occasion he had elicited a pledge from Ivan to curb his expenditures and live within his means, but after a few months there would be a new masterpiece or a fresh liaison, and the crisis was repeated. In his marriage Sergey had been something of a Victorian, faithful, indulgent, if somewhat abstracted; the paintings he had chosen were comparatively inexpensive, and basically he was without understanding of Ivan's dilemma. He perceived in his brother a gifted, learned libertine who never had to earn a ruble.

Ivan in turn had come to regard Sergey as a man of limited imagination and taste, a driving kulak and a money machine. At another time the differences might have been smoothed over, but the death of his wife and son had shredded Sergey's sympathy. A practical merchant, he was fundamentally hostile toward the financial problems of a man with a houseful of El Grecos, Goyas, and a reputation for profligacy which impressed even the Muscovites. Finally, in exasperation, he refused further assistance and suggested that Ivan sell his paintings.

Convinced at last that he would receive no further help from Moscow, Ivan decided to take his brother's advice and market the collection. When the appraisers completed their work, he was informed that most of his pictures, so painstakingly assembled in Spain under the guidance of Ignacio Zuloaga, were forgeries. Desperate, harassed by creditors, Ivan Ivanovich poisoned himself in the study of his Paris home, surrounded by his books and painted facsimiles. When the last telegram was delivered in Moscow, Sergey assumed that it was another appeal, but it contained the news of his brother's suicide.

A memento of Ivan's death in 1908 is the auction catalogue of the Shchukin sale in Paris: a pauper's list of 'Tableaux Anciens', offering, among numerous other items, five El Grecos (genuine). They were sufficient to pay a fraction of his debts.[41]

Ivan was buried in a small cemetery in Montmartre, and when Sergey returned to Moscow after the funeral he felt that the events of the past three years had inured him to further disaster. But in Moscow the final tragedy was waiting. A few months later, his second son Grigory, imprisoned in silence, killed himself at the age of twenty-one.

It was after Grigory's death in 1908 that Shchukin turned compulsively toward the paintings which absorbed an increasing amount of his time, and seemed to afford some measure of solace. This was the year he met

Picasso and began to amass what Alfred Barr has called 'the greatest collection of Picassos before 1914'.[42] At first glance, the collection and Shchukin's private life, like parallel lines on a graph, never seemed to touch, and yet one could place the line of the collection, like a tracing, over the personal line, and a relationship becomes evident. With each crisis his acquisitions increased, as if, in his own words, 'living in a picture' provided consolation and an escape from reality.

6

THE PARIS SCENE

And so life in Paris began and as all roads lead to Paris, all of us are now there, and I can begin to tell what happened when I was of it.

Gertrude Stein

After the unremittingly sombre events of the years between 1905 and 1908, Shchukin found himself drawn more frequently to Paris. His emotional, economic and cultural base was Moscow, and unlike Ivan, he would never have chosen to live anywhere else, but Paris had a special aura for him. His visits to the city, his friendship with Matisse and Picasso, and in particular, his entry into the circle presided over by Leo and Gertrude Stein combined to make him more than a wealthy businessman. It was Paris which provided the final impetus to his emergence as an international figure in the field of art.

In his youth, when he had been dispatched from Moscow to Lyons for training, he had found himself in a familiar setting, surrounded by commercial contacts, the bankers, merchants and manufacturers who made up his life in Russia. Lyons was a business capital – Moscow without snow. But in Paris there were glimpses of an unfamiliar world, tantalizing and unconventional, which he was eager to explore.

After his father's death in 1894, as he assumed control of Shchukin and Sons, he travelled regularly to the French capital on business and soon became a familiar figure in the galleries and museums of that city. His entry into the inner realm of the Paris art community had begun with his brother Ivan. In his luxurious home with Vladimir, crowded with rare furnishings and paintings, a precious library of Russian books and the fawn and silver pug dogs which he loved, Ivan had created a new life for himself after the death of his father. Because of his extravagant hospitality and genuine brilliance, he moved easily within the French intellectual community; his erudition had been deepened and formalized by the years at Moscow University. Before long he was invited to

speak regularly at scholarly symposia and his lectures on eastern philosophy and religion were praised by academic audiences.

As with his brothers, Ivan had succumbed to the collector's virus, but he was determined that his pictures, like his life, should bear no resemblance to theirs. Spanish art would form the main body of his collection, and he had travelled across Spain with his close friend Ignacio Zuloaga,[1] the Basque artist, and Auguste Rodin, on his first search for important works. It was the beginning of a course which would ultimately destroy him, and the presence of this knowledgeable company was not enough to avert the disaster which occurred in 1908. Now, however, his prodigal style and perpetual open house attracted a diverse stream of guests: Degas – who had become somewhat secretive and withdrawn – Renoir, Rodin, and the important French dealer, Paul Durand-Ruel. A mass of Russian visitors represented all political colourations: the respected lawyer Maksim Kovalevsky, a member of the august Russian State Council; Konstantin Skalkovsky, Paris correspondent and critic for the most splenetic and reactionary newspaper in St Petersburg, *Novoye vremya* (*New Times*); and Vladimir Ilich Ulyanov, who had taken the pseudonym of Lenin. It was Lenin's habit to keep in touch with the Russian exiles who frequented Ivan's home, and to absorb the latest rumours which floated like spores throughout the colony. Ivan's heterogeneous guest list gave him a great deal of trouble whenever he wished to return to Moscow to visit his family. The Russian government was kept informed of the activities of its citizens living abroad, and Ivan's familiarity with Russian dissidents and revolutionaries brought him into disfavour in his own country. At times, to his surprise, he was refused entry.

Upon occasion he claimed to be an anarchist, but this was merely a theatrical exercise. To a man of his exquisite sensibilities, violence and disorder were anathema. Basically he was a pretender and something of a snob, whose wish above all was to be welcomed into the French haut monde. If he was mistaken at times for a member of the Russian nobility, he did not hasten to correct the impression. As a result he has been referred to in several books and articles as 'Count Shchukin'.

Though Lidiya accompanied Sergey on many of his visits to Paris, she did not involve herself in his artistic interests. After they checked into the Grand Hotel, she would depart for a fitting or a luncheon, leaving her husband free to finish his business affairs and to join the guests at Ivan's home. Ivan encouraged his brother's nascent interest in art. It amused him to have an area in their relationship wherein he was the expert. As always, Sergey started cautiously, and his first purchase gave little indication of what was to come. Having decided that the Wanderers' works were too declamatory for his taste, he began with a Western artist. After acquiring his three canvases by Thaulow, he continued his

conservative approach with the addition of *Enchanted Castle* by the Scot James
Patterson and a *Forest Scene* by Macauley Stevenson. Dmitry and Ivan owned
several Zuloagas, and in a rare moment of aesthetic accord, Sergey purchased
Spanish Women on a Balcony and *The Hermit* by this painter, as well as a
tapestry, *The Adoration of the Magi*, created by Burne-Jones. Benois charac-
terized this last work as Shchukin's 'sin of youth'.[2]

Then, tentatively, he began to expand. James McNeill Whistler was a
favourite of *Mir iskusstva* at the time, and three paintings by that artist were
added: *Marine. Arrangement in Grey and Black*, *Marine. Arrangement in Blue
and Black* and *Woman Selling Oranges*. Two works by Puvis de Chavannes,
The Poor Fisherman and *Pity*, once again seemed to echo the taste of *Mir
iskusstva*. A thatched *Swiss Chalet* (1874) by Courbet and a delicately coloured
Signac, *The Port of Hue* (1890), bought from a Moscow collector, signalled a
further stage in his development. Though he was moving more surely now, his
eclecticism indicates that he had not yet found his footing.

During this early period, he bought a Tahitian landscape by Gauguin, but
seemed uncertain of his taste, for he hung this painting inconspicuously in his
house and would show it to friends only after much persuasion. His confidence
grew rapidly, however, so that a few years later, in one afternoon he could
purchase eleven of the artist's most important works from the collection of
Gustave Fayet, a vineyardist from Béziers and one of Gauguin's most dedicated
admirers. He also acquired from the estate of Victor Chocquet a rare Cézanne,
Flowers in a Vase (1873–75), of which Lidiya approved for it matched her wall-
paper, and which she promptly appropriated for her bedroom.

Paris also had its melancholy interludes for Shchukin. In 1895 he had been
summoned to the city on a dismal mission. When Ivan left Russia, he had
persuaded Vladimir, the youngest brother, to join him abroad. Always delicate,
Vladimir had become more of an invalid over the years, but Ivan was his closest
friend and confidant and he decided to make the journey. For a few months
Vladimir seemed to improve, but suddenly in 1895, in the south of France,
he died at the age of twenty-seven. Sergey had a peasant's fatalism; he believed
that people died at their appointed time, that there was a 'season' to life.
Ivan's loss was touched with guilt for he had persuaded Vladimir to accom-
pany him to France and the younger man had died far away from everything
that was familiar and reassuring. Sergey came to arrange for his brother's
burial in Moscow, and Vladimir's old nurse accompanied the body back to
Russia.

Though Ivan encouraged Sergey's purchases, it was another member of the
family who drew him into a deeper involvement with the art of the Paris avant-
garde: Fyodor Vladimirovich Botkin, a well-known Russian expatriate, then
living in Paris, one of those whom Diaghilev wished to involve in his plans to

introduce Russian art to the West.³ One evening in 1897 in Ivan's home, after listening to Sergey Ivanovich expounding his views on art, Botkin suggested that Shchukin accompany him to Paul Durand-Ruel's gallery the following day. It was Botkin who introduced the merchant to Impressionism and encouraged him to purchase his first Monet, *Lilacs of Argenteuil* painted in 1873. It was the painting that impressed his brother Pyotr so greatly, the first Monet in Russia. He had made his first step from the status of a buyer of conventional salon art to that of a connoisseur collector.

It was fitting that Durand-Ruel was the man to make this sale to the Russian. He had been a supporter of Monet and the Impressionists since their first showing in 1874. A brilliant and courageous dealer, he had bought a number of these works and recommended them to friends and clients. When they did not sell, he had been forced to close his London galleries in 1875 because of financial difficulties. His conviction had been shared by the French Shchukins of an earlier era: Victor Chocquet and Gustave Caillebotte. Chocquet, a French customs inspector, had encountered Impressionism for the first time at an auction at the Hotel Drouot, and like Shchukin, bought one of Monet's Argenteuil paintings. Caillebotte, when he was only twenty-seven, had made a will leaving all his Impressionist canvases to the State with the proviso that ultimately they would be hung in the Louvre. This was in 1876, and given the angry rejection of Impressionism in those early years, the absolute faith inherent in the gesture is remarkable. In 1897, the year in which Shchukin bought his first Monet, the French government grudgingly accepted a portion of the Caillebotte bequest for the Luxembourg Museum, but refused to receive eight Monets, eleven Pissarros, two Cézannes and a Manet. The Russian never forgot the incident; it confirmed his mistrust of governmental bureaucracy and prompted his later legal attempts to protect his collection and ensure its proper disposition.

It is doubtful whether Shchukin visualized at the outset the scope of his ultimate achievement. He never wished to assemble a complete survey of the unappreciated masters of the epoch. Seurat was absent. The methodology and static serenity of this painter's work was a quality largely missing from his collection. His taste was intensely subjective; he began by choosing a painter whose work he found rewarding, and stayed with him through every phase of his development.

In 1898 he returned to Durand-Ruel to purchase Sisley's *Village on the Banks of the Seine* (1872), Pissarro's *Place du Théâtre Français* (1898) and Monet's *Rocky Coast at Etretat* (1886). In 1902 he acquired Monet's *Town of Vetheuil* (1901) from the same dealer. Eventually Shchukin owned thirteen Monets, including two versions of the *Cathedral at Rouen* (1894), one at noon, one in the evening, the great six-foot oil study for *Luncheon on the Grass* (*Déjeuner sur*

l'Herbe) painted in 1866, and three Renoirs: the appealing young Parisiennes, *Two Girls in Black* (1881), the imposing *Woman in Black* (1876) and *Anna* (1876), a silky, glowing, voluptuous nude which he purchased from Pyotr. This last work, typical of the artist, was daring for conservative Moscow at that time. It was as if he had ended an apprenticeship in 1897, and in the next seventeen years he shaped the monumental collection which would include thirty-seven Matisses, sixteen Gauguins, five Degas, sixteen of the finest Derains, nine Marquets, four Van Goghs, eight Cézannes and fifty Picassos. He may have been the only man who ever, at any time, owned more Picassos than Picasso. Tugendkhold later wrote that 'Shchukin moved on in full awareness of his established goal.'[4] However, like most collectors, he was subject to impulse and an occasional lapse. His was not an undeviating progress toward the modern classics. Even after 1900 there was a colourful, immoderately sentimental oil by Charles Guérin, *Lady with a Rose* (1901), one of the few 'pretty' pictures that Shchukin ever acquired. When one looks at the pink roses and ruffles that fill the painting, it is difficult to believe that within eight years, he would purchase Picasso's Cubist precursor *Woman with a Fan*.

The ability of this Russian businessman to discern the worth of the Impressionists is a continuing puzzle. The hours he spent studying a picture, analyzing the artist's methods and rationalizing the initial impact, was a source of much amusement and scepticism among his friends. There is a clue in a remark he made to his daughter Yekaterina: 'If a picture gives you a psychological shock, buy it. It's a good one.' Yet for Shchukin the artistic ideal remained the lions of Mycenae, which had guarded the gates of the Greek citadel in the fourteenth century BC. He considered them 'the incontestable masterpieces of all art.'[5] Shock alone therefore was not enough. To balance the innovation, he demanded weight, a knowledge of tradition, what has been called 'the curiosity of the historian'.[6] He insisted on artists who had mastered a graphic discipline. He considered them 'artists with a past', and for the work of these men he developed an insatiable appetite.

Soon his attention was drawn to an artist whose work embodied the qualities of creativity and integrity, the 'shock' that he looked for. The chronicle of Matisse's early struggles follows a pattern so familiar that it seems preordained, like a child's fable: poverty, experimentation, rejection, discouragement and finally, success. In 1896, a year before Shchukin's purchase of the Monet, Matisse had submitted four paintings to the Société Nationale des Beaux-Arts (Salon du Champ-de-Mars), a comparatively progressive institution, whose president was Puvis de Chavannes. The reception had been favourable; one picture had been sold to a private buyer, another, a small, dark-toned *Woman Reading*, had been purchased by the State. The artist was then only twenty-six years of age, and here was an encouraging success for a young painter. Despite

this official recognition, Shchukin remained unaware of Matisse at the time and it was ten years before they met.

Following the 1896 exhibition, Matisse was sufficiently heartened to attempt his first major work, *The Dinner Table*, which he sent to the Nationale in 1897. It had been painted in the Impressionist manner, and because of this, according to Alfred Barr, despite the professed liberality of the Salon it was coldly received by members and public. In 1901, when Matisse showed a cross-section of his paintings at the small Berthe Weill Gallery, not one canvas was sold. In 1903 the artist's works were displayed at the newly-opened Salon d'Automne. Shchukin frequented the Salons when he was in Paris, and his son believed that it was here that he bought his first Matisse, but the painter's work was still not yet important to him.

It was in 1904 that Matisse with his family spent the summer at St Tropez in the company of Paul Signac and Henri-Edmond Cross, two leaders of the Neo-Impressionist movement which had gained a measure of acceptance in Paris. Matisse had experimented briefly in 1899 with Neo-Impressionism after reading Signac's article 'From Delacroix to Neo-Impressionism', which had been published in *La Revue Blanche*. Somehow, his friends' experiments, combined with the light and warmth of the countryside, had a noticeable influence on Matisse's work. *Still Life with Decanter I*, from this summer, contains the familiar overtones of Cézanne; the bottles, decanter and cup, even the crumpled cloth, have a palpable weight, and form is dominant. A second version of the same subject, *Still Life with Decanter II*, has been transformed into an airy series of dots, with a concurrent brightening of colours.

Three further works conceived and painted during or immediately after the St Tropez visit afford a further insight into the artist's evolving creative process. Compressed as they are into a brief period, the paintings merge easily from one to the next. The first, *By the Sea*, is an oil, Impressionist in colouring, but somewhat structured, with glistening water, curving coastline and a single tree punctuating the right edge of the canvas. The second is a variant of this same scene, but the lines which imprison the colour in the earlier picture have been shattered into a series of tremulous brush strokes. This last painting was a direct study for the third, *Luxe, calme et volupté* (1904–05), the historic work which Matisse showed at the Salon des Indépendants in the spring of 1905.[7] *Luxe, calme et volupté* had become an atomization of the previous versions, a shimmering maze of dots assembled to portray an idyll of sky, waters, dappled bathers and picnickers with the familiar tree at the right, a remarkable contrast to the 'dark' works which predominated in 1901–04. As always there was adverse comment, but it delighted Signac who saw his own influence reflected in the pointillist technique, and he bought it at the show.

In 1905 Shchukin became vividly aware of Matisse's art. The occasion was the

exhibition at the Salon d'Automne. The artist had spent the summer of 1905 working at Collioure with his young admirers Derain and Vlaminck, and in the autumn he and his friends inflicted their own psychological shock on the Paris art world. As a student, Matisse had diligently copied the masters in the Louvre, and his early works were influenced by artists as diverse as Chardin, Gauguin and above all, Cézanne. Moreau had been his teacher and this painter's exoticism and love of colour left a lasting impression on his pupil. With *Woman with a Hat* and *Open Window*, Matisse created works which were the distillation of all that he had observed, but more importantly, were totally, unmistakably, his own.

The reaction to the Salon d'Automne exhibition matched the fury that had greeted the Impressionists thirty years earlier, and was in effect a replay. Incredibly, nothing had been learned by critics or public, and only the names were changed. This time they were Matisse, Derain, Vlaminck, Rouault, Albert Marquet, Louis Valtat, Henri Manguin, Othon Friesz and Jean Puy. The portrait of his wife, *Woman with a Hat*, which Matisse chose to exhibit has become a part of history, as familiar as the gentle aspect of Saskia, but in the Paris show of 1905 it elicited more hostility than any other work. The choleric viewer was confronted with a face painted in shades of green, with tints of yellow, the hair green and violet. The eyes gazed serenely at the observer, and the whole was surmounted by a riotously colourful hat of the period – a picture marvellously strange and beautiful, but alien to the taste of the time.

When it was hung, the violence of the colours combined with the impromptu sketchiness was considered an affront. There were the usual references to lunatics, monkeys, and to 'the naïve primitive games of a child who has received a painting set for New Year's'.[8] The visitors 'howled and jeered'[9] and according to one account, those who were not furious were 'roaring with laughter at the picture and scratching at it'.[10] The reaction was personal and bitter; critics wrote of 'pictorial aberration, the madness of colours, the incredible fantasies of people who, unless they are practical jokers, should be sent back to school.'[11] Impassioned arguments erupted in front of the paintings. Matisse, shaken and discouraged by the violence of the response, visited the exhibition only once, and according to one version, his wife never ventured in at all.[12]

Not all the comment was scathing. Louis Vauxcelles, who facetiously coined the term 'Fauves', was sympathetic to the innovators; Gide, in the *Gazette des Beaux Arts*, was objective: 'Not madness,' he wrote of Matisse's art, 'but rather the product of theories ... this painting is rational, perhaps too much so.'[13] Maurice Denis, in his capacity as critic for *L'Ermitage*, admired Matisse's work as an act of pure painting dominated completely by reason. Yet he advised a return to tradition, an acceptance of the past, and like Gide, warned against an 'excess of theory'.[14]

The foreign partisans were more fervent. Three years later, Guillaume Apollinaire observed:

It should be admitted that a foreigner, who is outside the Parisian coteries and free of the influence of critics who are often submissive and rarely disinterested, will be naturally drawn to the most important works, works whose beauty appears to him to be the newest and the least debatable. Above all, the foreigner freely seeks out those paintings whose meaning appears to be the most elevated and the most revealing. He seeks out what he does not have in his own country, and reserves his warmest glances for works with originality.[15]

Apollinaire contended that the Russians and the Americans understood French art much better than did the French.

Shchukin was attracted immediately to the excitement and controversy which surrounded this year's showing at the Salon. He had admitted that certain paintings required time and concentration before he could appreciate their worth, but his son Ivan remembers that in this case, his father had no difficulty in recognizing the significance of the exhibition, and he could only wonder at the older man's enthusiasm. Although Sergey owned several of Matisse's early works he had never met the artist and he decided to establish a personal contact. The collector made his usual visits to Durand-Ruel and Vollard at this time, and Ivan believed that it was from Vollard that he obtained Matisse's address.

A year later, in 1906, Shchukin visited Matisse's studio for the first time. When the small, intense Russian entered the neatly kept interior, explained who he was, and expressed his admiration for the painter, the lives of both men were changed; the merchant embarked on the most significant phase of his odyssey, and Matisse acquired a patron who gave him freedom from constant distracting financial worries and who exacted no compromise in return. In answer to the question 'What made Shchukin the ideal client?' Pierre Matisse, the artist's son, answered, 'He never tried to influence the structure of a work.' After a moment's pause he added pragmatically, 'He was good because he always came back.'[16]

Paris in 1905 was attractive in many ways for Shchukin. The city was full of familiar faces: Benois was living there, Korovin had just decorated the Russian Pavilion at the Exposition Universelle with great success and this had attracted many of his countrymen. Korovin was a herald for the Russian advance on the French capital which would begin the following year with Diaghilev's exhibition at the Salon d'Automne. The 'export programme' of Russian art envisioned for so long by Diaghilev and Benois was approaching realization. Shchukin in turn was opening Russian painting to the influence of the Western avant-garde.

For Sergey Ivanovich, the 1905 visit to Paris was also an interlude of personal discovery. It was the beginning of what was, for Shchukin, an unusually close family bond. In Moscow he was usually absorbed in business matters, absent-

mindedly generous, but unable to express himself with his children. He adored Yekaterina and spoiled her, his youngest son and namesake Sergey was difficult and moody, and Grigory's deafness had been an insurmountable handicap from the beginning. But now, during the leisurely days of this journey, Shchukin had found to his surprise that he could communicate easily with his eldest son, Ivan. He discovered that Ivan Sergeyevich was no longer an inarticulate adolescent, but an interesting companion, a young man of twenty who was forming his own ideas and tastes at the Moscow University. Ivan shared many traits with his father, the sturdy build, a determined individuality, stubbornness and independence. As a cautious rapport developed between the two, the merchant learned that they disagreed completely on aesthetic matters; Ivan disliked his father's collection intensely, and was attracted to the subtle formality of Chinese art. After they arrived in Paris, Shchukin accompanied his son to the gallery of André Vignier, where Ivan chose several delicate Chinese paintings which became the foundation of his collection of Eastern works and ultimately of his career; he later became a leading historian of Persian art.

The Shchukins belonged to the first wave of Russian collectors in Paris. The great influx of Russians had not yet begun, they were still rare fauna, regarded by most Parisians as millionaires and possibly a little mad. Initially, Vollard had shared this attitude, but recent experience had shaken his certainties. By nature the dealer was somewhat gruff and testy, but over several visits to his shop Shchukin, unperturbed and unintimidated, had gone through his entire inventory, in the process briskly choosing some of the finest Gauguins. Two of the loveliest, *Maternity, Women by the Sea* and *Tahitian Woman with Flowers: Te Avae No Maria*, both from 1899, were included in the painter's last shipment to Vollard from the Marquesas just before his death in 1903. Vollard discovered that a few Russian merchants were creating their own special art market.

They were not alone. Americans were also buying the latest 'grotesqueries' of French art. Shchukin and Morozov represented the Russian contingent; the most prominent figures in the second group were the Steins, members of an eccentric, somewhat whimsical family, recently settled in Paris.

Gertrude and her brothers Leo and Michael, and Michael's wife Sarah – their lives have been so widely examined and recorded that it would be pointless to pursue them further, if they had not, by their presence in Paris at this time, influenced so many of Shchukin's decisions. These catalytic figures brought together the most important modern painters of the era, mixed them indiscriminately with collectors, writers, critics and politicians, and generated a notable reaction.

Leo and Gertrude shared a seventeenth-century apartment in the Latin Quarter: 27 rue de Fleurus, an address which has come to epitomize an era. After Leo had settled in Paris in 1903, he had discovered that most of the

contemporary French painters did not satisfy him for long. In 1904, at Bernard
Berenson's suggestion, he had visited Vollard's gallery to see the Cézannes. Leo
has cited Mantegna's *Calvary* as his favourite picture in the Louvre, and this
preference for a painting of linear dimension in which the tragedy and
foreboding of the theme is communicated by the soaring vertical lines of the
three crosses, by a surrounding landscape of hills and stones rendered with
archaeological accuracy, and the sculptural depth of the attendant figures, may
explain Leo's immediate reaction to the structural emphasis of Cézanne. A short
time later he purchased the artist's *Landscape with Spring House*. He returned
with Gertrude to the darkness and clutter of Vollard's little shop many times and
together they browsed through the piles of canvases. One day when they found
that they had some extra money, 'a criminal waste', they selected 'two Gauguins,
two Cézanne figure compositions, two Renoirs, and Vollard threw in a Maurice
Denis *Virgin and Child* for good measure.'[17] Frequently they would buy
paintings in pairs, for they were not expensive, and Gertrude would like for
example Gauguin's *Sunflowers*, while Leo would prefer the figures.

The two resolved to 'buy a big Cézanne and then they would stop',[18] but the
resolution was doomed, for in 1904 it was their purchase of Cézanne's portrait of
his wife that marked the beginning of Gertrude's deep personal involvement
with art. She reacted to the painting as literature. 'Cézanne gave me a new
feeling about composition, not solely the realism of the character, but the realism
of the composition was the important thing.'[19] Until that time, she had been
Leo's disciple, the listener and pupil, but she found in Cézanne, and eventually
in Cubism, a visual essay which she could appreciate on her own. Years later she
remembered the portrait: 'It was an important purchase in looking and looking
at this picture, Gertrude Stein wrote *Three Lives*.'[20]

Though the Steins' resources were not nearly as great as Shchukin's, their
collection resembled the Russian's in many ways. Their walls were filled with
the works of Gauguin, Renoir, Vuillard, Denis and Cézanne. Unlike Shchukin,
they owned paintings by Bonnard, a languorous, sprawling nude, *Siesta* (1900),
a tiny jewel of a ball scene by Manet with Forain in the foreground (1873) and a
small, fine Daumier, *Head of an Old Woman* (1856–60). While they were
among the early patrons, they were not the first to recognize these artists. In
Russia at that time, Mikhail Morozov had accumulated works by Gauguin,
Renoir, Bonnard and Manet, and now Shchukin was moving into the field.

Leo's reaction to a painting was akin to Shchukin's. When the Steins
purchased Matisse's *Woman with a Hat* in 1905, he confessed that when he first
saw the work, he felt that it was a 'thing brilliant and powerful, but the nastiest
smear of paint that I had ever seen.'[21] He asked that he be permitted to live with
the portrait for a time to determine why he liked it, and it was hung at the Rue de
Fleurus. Emotional involvement was the prerequisite; understanding came later.

In 1906, Leo and Gertrude acquired *Joy of Life*, a brilliant illumination, sensual and decorative, the clusters of animated nude figures slightly distorted, alive with colour against the grass and curving arch of the trees – a worldly pastorale.

Sarah and Michael bought two studies for *Joy of Life* in the same year and made a major purchase with the superbly innovative *Portrait of Mme Matisse, The Green Line* (1905). The Michael Steins have been somewhat overshadowed by the more flamboyant Gertrude and Leo, but Matisse has remarked that Sarah knew more about his paintings than he himself. Eventually Sarah's devotion to Matisse filled their apartment on the Rue Madame with a dazzling array of paintings which spanned each phase of his early career, starting with *The Open Door, Brittany* (summer 1896); *Ajaccio, Corsica* (1898) and the lovely, dappled *Sideboard and Table* (1899). There was a *Male Nude* and *Still Life with Coffee Pot* (both from 1900), and *Woman with Black Hair* (1902). Several important bronzes included *The Serf* (1900–03) bought jointly by all four Steins, and *Madeleine* (1901). A highlight of the collection was the vital, febrile *Portrait of André Derain* (1905), now in the Tate Gallery.

In 1906 Michael and Sarah Stein reached their peak as collectors. In this one year they assembled a series of the artist's most important works and created a miniature version of Shchukin's Matisse Room in Moscow. In addition to *The Green Line*, they bought the first and more mordant version of the *Young Sailor*, *The Gypsy*, the gay and charming *Pink Onions* and the revealing, almost severely classical *Self Portrait*, in which the artist painted himself in a jersey work shirt without his customary spectacles, divesting himself of his formal shell and providing a rare interior glimpse. All these were painted and purchased in 1906. After this time the Steins' acquisitions diminished somewhat. In 1907 they added two major paintings of that year, *The Hairdresser* and the larger *Blue Still Life*. Matisse's prices were edging higher. Now Michael and Sarah were competing for the works with Shchukin.

* * *

During this period in Paris there was a small band of dealers, diverse in temperament, resources and taste, but sharing a personal relationship with the artists they represented, an insight into their work and an unquenchable optimism about their prospects. Gertrude Stein wrote of them: 'In Paris there are picture dealers like Durand-Ruel who went broke twice supporting the impressionists; Vollard for Cézanne, Sagot for Picasso, and Kahnweiler for all the cubists. They make their money as they can, and they keep on buying something for which there is no present sale, and they do so persistently until they create its public.'[22] In 1905 one of Gertrude's special group, Clovis Sagot, called 'Sagot le frère', owned a tiny gallery on the Rue Lafitte, near the Church of Notre Dame de Lorette. There one could see the work of the

unknown Braque, and lovely mysterious pictures of blue and rose hues –
Apollinaire wrote that Sagot had pawned his watch chain to buy pictures from
Picasso. Apollinaire considered the dealer 'the Père Tanguy of today's young
painters.'[23]

Ambroise Vollard, a more intimidating personality, a constant taciturn
presence in his small gallery on the Rue Lafitte, dealt with some of the most
important collectors of modern art, both Russian and American. Artists such as
Cézanne and Gauguin knew that he would buy or show their works even though
there was no current demand for them, and as a result, out of his unprepossessing
small shop with the simple frame in the window, he could produce a
seemingly endless supply of singularly beautiful paintings. Inevitably he
attracted perceptive clients like the Steins and Shchukin and Morozov who
recognized the quality of his offerings.

Vollard had a young admirer, Daniel-Henry Kahnweiler, who with Durand-
Ruel, Vollard and Sagot completes the legendary quartet of dealers most helpful
to the modern painter in those early, lean years. Kahnweiler arrived in Paris
from Germany in 1907 at the age of twenty-two and rented a small tailor's shop
at 38 Rue Vignon: 'one fine day when everything was ready, I rolled up the iron
screen, I hired a boy named Georges, who was a bit feeble minded, and I
opened my gallery.'[24] Though by his own admission he was too shy to introduce
himself to Vollard, he made a point of meeting the artists he admired, and his
showroom was stocked with pictures by Vlaminck, Van Dongen and the new
Cubist works of Derain.

In 1908 when Braque's Cubist paintings were refused by the Salon
d'Automne, Kahnweiler in effect opened his own Salon des Refusés and
displayed the rejected works. It was the earliest exhibition of this new style. The
only Braque in Shchukin's collection, a powerful Cubist canvas, *The Castle at
La Roche Guyon*, painted in 1909, came from Kahnweiler. It was in his
relationship with this dealer that Shchukin made one of his rare errors of
judgment. Kahnweiler tried to argue the merits of Braque with the Russian,
who however dismissed the artist as 'a mere copyist'.[25] His negative reaction may
have been occasioned by the fact that Picasso and Braque worked together so
intimately in 1908–09, and there were times when a casual viewer could not
distinguish between the works of the two men. Picasso referred to the
collaboration as 'a kind of laboratory research from which every pretension or
individual vanity was excluded'.[26] Now and then Braque has been credited with
inventing Cubism, but in the Russian's view he was a pretender, and
Kahnweiler could never change his mind. For Shchukin, Picasso was Cubism.

The dealers, the artists, the Russian financiers mixed with celebrities,
politicians, foreign visitors and critics in a strange mélange at the Rue de
Fleurus. Saturday evenings at the Steins' have been described as 'very rigolo' –

diverting, amusing and eventually historic. All the future giants were young in years and reputation. Matisse and Picasso, unencumbered by success, were living unknowingly through their own legendary era.

Leo was the intellectual master of ceremonies at these evenings. Slim, bearded and didactic, he dominated the gatherings, explaining, arguing, a self-educated propagandist for modern art, yet he had bought his first Cézanne less than two years earlier. Gertrude was the counterpoise. Always observing and listening, hoarding her impressions, she sat near the pot-bellied iron stove in her high-backed chair, feet not quite touching the floor, breaking her silence with unexpected gusts of laughter.

In 1907, Apollinaire wrote a small ode to the Steins: 'Their bare feet shod in sandals Delphic, they raise toward heaven their brows scientific.'[27] Apollinaire was one of the few French critics to write favourably of Matisse and Picasso. He had met Matisse in Sagot's shop, and like Gertrude, he had recognized that far from being 'extravagant or extremist', Matisse's art was 'eminently reasonable'.[28] Apollinaire's companion at the Rue de Fleurus was the elfin Marie Laurencin, 'living her strange life and making her strange art.'[29] The two had met in 1907, and in 1908 Laurencin painted what has become a memento of these evenings, the famous multiple portrait, a daguerreotype of Apollinaire, who had the head of a 'late Roman Emperor';[30] Picasso and his dog, each in perfect profile, stylized as an ancient frieze; the sloe-eyed Fernande Olivier, Picasso's mistress; and a wonderfully sly version of Marie herself – a picture as funny, telling and innocent as a valentine. It is not surprising that Gertrude found it irresistible and bought it immediately. It was Marie's first sale, and in time she would sell three of her best works to Shchukin. He selected three fantasied studies: *Artemis*, *Bacchante* and *Head of a Woman*, painted before the artist had dissipated her energies and inventiveness in the flood of portraits which she turned out in her later years. *Artemis* (1908), an oil, is a pure unadulterated example of Laurencin's decorative gifts; delicately coloured, composed entirely of curving, sensuous lines, like a series of quarter moons, which delineated the almond eyes, spherical breasts, the roundness of the cheek and the stem of the flowers. Her *Bacchante* (1911) was an elegant and remote votary with a slight edge of self-satisfaction.

Braque, Derain, Vlaminck; the ingredients of the evenings changed constantly. Later, Picasso's friend the poet Jaime Sabartès, Georges Rouault, Elie Nadelman and John Reed were added to the mix. Of Reed, the tall American who would be buried in the Kremlin wall, Picasso decided, 'The same type as Braque, but not as amusing.'[31]

It was Vollard who introduced Shchukin to the Americans.[32] Sergey Ivanovich, dressed as if for a board meeting, raised in a conservative society with an awareness of class and protocol, found the casual acceptance, odd costumes

and American freedom of manner refreshing. Yet it was an improbable encounter involving completely dissimilar personalities, and without a shared passion, the relationship would never have developed. The pattern of the Steins' purchases provides an interesting counterpoint to that of Shchukin's. He enjoyed the intellectual stimulation of Sarah and Michael's gatherings, but it was the theatre of Leo and Gertrude which attracted him. It would be difficult to overestimate the influence of this milieu on the Russian. Many of his important decisions had their origin here. It was in the Steins' studio that he first studied Matisse's *Joy of Life* as well as the oil sketch *Music*. These were the forerunners of the two panels that he would commission from the artist in 1909. *Joy of Life* holds in the centre background a small circle of dancing figures which anticipate *Dance*, and Shchukin's *Music* is a descendant of the Steins' sketch.

The Steins' apartment was a total contrast to the formal grandeur of the Trubetskoy Palace, yet when Shchukin visited this small domain, he felt at home; he was reminded of the early days in Paris when he had sensed that there was an intimate, private universe of which he knew nothing. Lidiya seldom accompanied him to the Rue de Fleurus, for the jumble and disorder were disconcerting, and she had little in common with the guests whom her husband admired. Above all, she disliked many of the pictures which resembled those hanging in her own home. After the death of her son she could summon neither the energy nor the interest for this new scene. It may be for this reason that Sergey spoke so seldom to his family about the interludes at the Steins'. It was as if he compartmentalized the two segments of his life.

When Matisse and Picasso met at the Steins' in 1906, Fernande Olivier was an observer. She noted: 'Very self-controlled, in contrast to Picasso who was always a bit sullen and awkward at such encounters, Matisse shone imposingly.'[33] Theirs was a complex relationship; a compendium of respect and antagonism. When Matisse offered Picasso one of his paintings as a gift, which was the custom among friends and artists, Picasso selected Matisse's *Marguerite* (1906–07), at first glance a seemingly naïve work, tender, almost primitive. It shows a fragile young girl, the painter's daughter, with a black band at her throat, looking directly at the viewer, and in the upper left-hand section of the canvas, the word 'Marguerite' crookedly printed in block letters, as in a school book. It was Gertrude's theory that Picasso selected the weakest painting, the more easily to point out Matisse's shortcomings, but Pierre Matisse commented that neither his father nor Picasso threw open his studio to the other and said, 'Choose.' It was more likely that Matisse himself offered two or three works from which Picasso might select his favourite.[34]

Matisse made a generous contribution to the ronde between Paris and Moscow in 1908 when he took Shchukin to Picasso's studio in the Bateau Lavoir. Kahnweiler has described the surroundings: 'This house hanging on the

side of a hill of Montmartre had its entrance on the top floor, and one walked down to the other floors.' Picasso's door

> was covered with the scrawls of friends making appointments: 'Manolo is at Azon's ... Totote has come ... Derain is coming this afternoon.' ... No one can ever imagine the poverty, the deplorable misery of those studios in the rue Ravignan. ... The wallpaper hung in tatters from the unplastered walls. There was dust on the drawings and rolled-up canvases on the caved-in couch. Beside the stove was a kind of mountain of piled-up lava, which was ashes. It was unspeakable. It was here that he lived with a very beautiful woman, Fernande, and a huge dog named Fricka.[35]

Fernande was also present at the meeting between Shchukin and Picasso:

> One day Matisse brought an important collector from Moscow to see him. Chukin [sic] was a Russian Jew, very rich, and a lover of modern art. He was a small, pale, wan man with an enormous head like the mask of a pig. Afflicted with a horrible stutter, he had great difficulty expressing himself and that embarrassed him and made him look more pathetic than ever. Picasso's technique was a revelation to the Russian. He bought two canvases, paying what were very high prices for the time – one of them was the beautiful *Woman with a Fan*, and from then on he became quite a faithful client.[36]

What matters here is not the brutally unflattering portrait of Shchukin, which reveals more of Olivier than of Sergey, nor the inaccuracies: e.g. Shchukin was not Jewish. What is important is what Fernande says about the Russian as a collector. First, he didn't hesitate; confronted with this challenging art he was decisive and sure of his choice. Second, he paid a generous price – Picasso was still struggling and he did not take advantage of the circumstance. Third, Shchukin was nearly always able to accept painters when their work seemed unfamiliar or bizarre. While *Woman with a Fan* (1908) is truly a beautiful picture, it is difficult and innovative. It was painted at the beginning of the Cubist period, and the angles and planes of hat and fan, the strangely empty eyes must have been startling at the time.

Picasso had seen Matisse's *Joy of Life* at the Steins' in 1906 and Alfred Barr has suggested that this was the spur which prompted the artist to attempt his own major work during that period. The year in which Shchukin met Picasso was the year in which the collector first saw *Demoiselles d'Avignon* (painted 1907). Gertrude Stein wrote of his consternation: 'Shchukin, who was so fond of Picasso's paintings, happening to be at my house, said to me, weeping, "What a loss to French art."'[37]

She may have exaggerated Shchukin's desolation, but there is no doubt that he rejected *Demoiselles* completely at first. Yet a short time later, he bought an

oil study for that work, a nude half-figure, also painted in 1907. In fairness to Shchukin, it must be said his reaction was shared by Picasso's closest friends and colleagues. Totally uncompromising, with no concession to current standards, with a deliberate repudiation of any hint of acceptable beauty, and accomplished with fidelity to a private vision, *Demoiselles d'Avignon* was rejected by many who had known and supported Picasso's earlier work. The only man who understood immediately and found it admirable was Kahnweiler.

Shchukin's adverse reaction to *Demoiselles*, while intense, was short-lived. Soon after, he purchased Picasso's *Dryad* (1908), an equally formidable nude in the Cubist manner. In 1909 the artist's *Young Woman* arrived in Moscow. It was a delicate portrait of Fernande, the face in wedges, small jutting breasts, the beautiful arms, round and graceful, ending in oddly undefined hands. After 1908 Shchukin added to his gallery a series of Picasso's Cubist female portraits, the most awesome pantheon in any collection. He had accepted Cubism and the African influence, but it was not an easy process. Picasso has said: 'While a picture is being done it changes as one's thoughts change. And when it is finished, it still goes on changing, according to the state of mind of whoever is looking at it. . . . This is natural enough as the picture lives only through the man who is looking at it.'[38] Shchukin's habit of spending time with a work, the dogged will in him to understand the artist's 'thought', enabled him to make a breakthrough into the difficult world of Cubism. For this period the Russian was Picasso's financial mainstay. Kahnweiler has described the painter's plight very simply: 'No one else was buying from him any more.'[39]

Though the Americans and the Russians shared an enthusiasm for the new art, there were fundamental differences in the quality of their backing. Shchukin's patronage was objective, basically consistent and unvarying. There was never a close friendship with the artists, but to Matisse and Picasso he offered freedom and an absence of interference. On the rare occasions when his support faltered, it was as a result of his own situation in Moscow, or an instinctive, if temporary, reaction to a painting, never because of the painter's personal traits or circumstances. In contrast, Gertrude's responses were subjective. In addition to the merit of a picture, her reaction was conditioned by an intimate relationship with the artist. She involved herself not only in his work but in his personal life, and saw it as part of her role to analyze his philosophy, to approve or disapprove of his standards and priorities, his liaisons as well as his art.

The writer defended Matisse generously while he was still an object of dispute, and suspected his art when success affected his life-style. As for Picasso, she identified his work with her own. He saw art as a 'subversive' force and believed that once understood and approved it became 'old hat'.[40] This view cemented their friendship, and throughout the formative Paris period Picasso

Left: Henri Matisse: *Study for a Portrait of Sergey Shchukin*, 1912. Collection of Pierre Matisse, New York City. Mme Duthuit (Marguerite Matisse) remembered that Shchukin was sitting for this study in Matisse's studio in Paris in preparation for a portrait, when word arrived from Russia of the death of his brother Pyotr. He left immediately for Moscow and the project was never resumed. The sketch is all that remains

Below: Henri Matisse: *The Fisherman*, 1905, formerly in the Museum of Modern Western Art, Moscow. A memento of the summer at Collioure. Gift of the artist to Shchukin

Two souvenirs of Paris

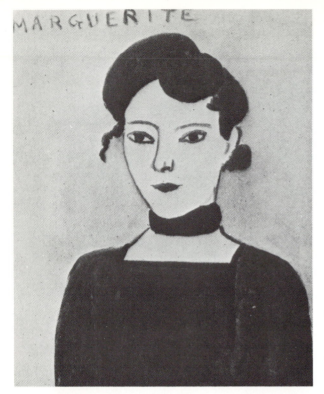

Left: Henri Matisse: *Marguerite*, 1906–07. Picasso Collection, Paris

Below: Marie Laurencin: *Group of Artists*, 1908. The Baltimore Museum of Art, Baltimore, Maryland. Cone Collection

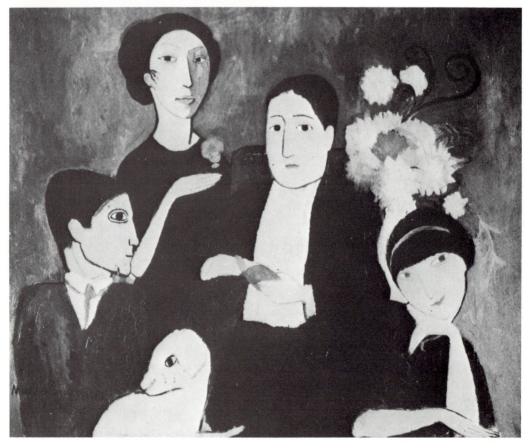

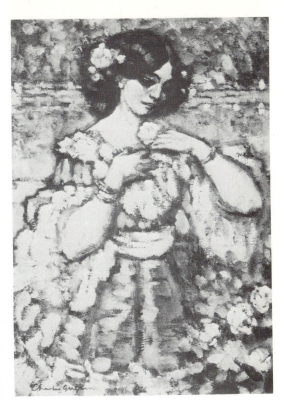

Right: Charles Guérin: *Lady with a Rose*,
1901. The Hermitage, Leningrad

Below: Pablo Picasso: *After the Ball*, 1908.
The Hermitage, Leningrad

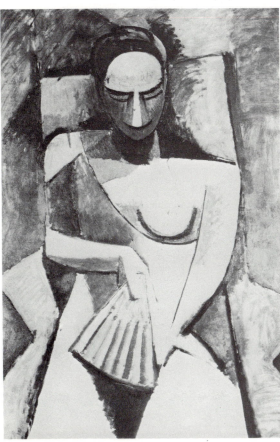

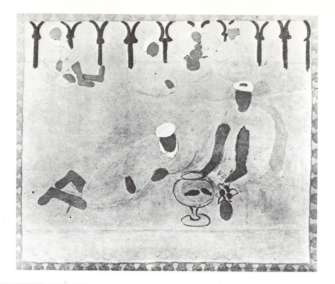

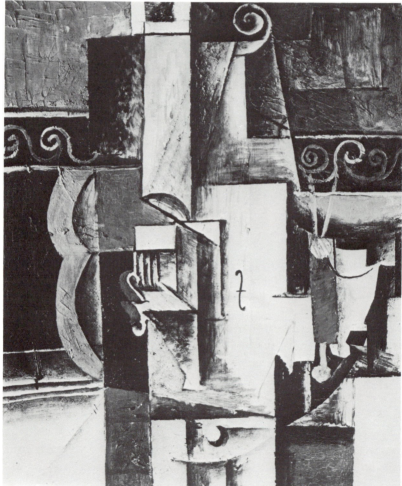

A collector's flexibility

Top: Henri Matisse: *Arab Café*, 1912–13. The Hermitage, Leningrad

Above: Pablo Picasso: *Violin and Guitar*, 1913. The Hermitage, Leningrad

remained sufficiently provocative to merit her admiration. Gertrude believed that there would have been no great contemporary literature without her contribution, and apparently she needed to feel the same way about modern painting.

The relationship between Shchukin and Matisse has been described as 'warm but not intimate'[41] and there were times when it had overtones of a duel. When Shchukin entered Matisse's studio, he unerringly selected the finest and most innovative works. Occasionally they were paintings with which the artist was reluctant to part, and he would try to persuade his client that they were unsuccessful: 'this work hasn't come off ... it's a "daub."' The Russian was unimpressed. 'The trick always failed and Shchukin would finally buy the "daub" that hadn't come off.' His visits were often doubly profitable for he 'would soon be followed at the studio by Morozov, who trusted his rival's taste but preferred to leave the choice of pictures to the painters themselves.'[42] Matisse spoke of this contrast between the two men. 'When Morozov went to Ambroise Vollard, he'd say: "I want to see a very beautiful Cézanne." Shchukin, on the other hand, would ask to see all the Cézannes available and make his own choice among them.'[43] Matisse was present on that afternoon at the Galerie Druet with Sergey, his son Ivan, and Ivan Morozov when Shchukin decided to buy the major portion of the Fayet collection. The wealthy Gustave Fayet had seen his first Gauguin in his dentist's waiting room, and had become the painter's most fervent admirer and client. He had paid more than Vollard; Gauguin had respected him as a 'serious' collector and his collection was remarkable for its variety, depth and quality. (Morozov later bought *Still Life with Parrots* (1902) from the same group of pictures.) Shchukin's purchase was an early intimation of the exceptional capacity of Matisse's new patron, and that evening he described to his family the riches that were to be shipped to Moscow.

Matisse received a similar acknowledgment from the Russian when he completed three of his most beguiling portraits: the wondrously appealing *Girl with Green Eyes* (1909), *Woman in Green* (1909) and *Girl with Tulips* (1910). In March of 1910 the painter sent a single canvas, *Girl with Tulips*, to the Salon des Indépendants. One might have expected the hostility to his work to have abated over the previous five years, and indeed, he had acquired a group of admirers and patrons, but the demure young *Girl* in her soft shirtwaist and bowl of potted tulips, an oddly elliptical composition, managed to provoke the reflexive outrage that Matisse still aroused among his countrymen. Unlike the Russians, the French took an uncomplicated pleasure in their odalisques and nudes; the cool sensuousness of Ingres was an academic ideal, but Matisse could depict a pensive young woman in a simple blouse, and by the manner of his painting, inspire a furious moralistic outburst. A French critic wrote of Matisse in 1910: 'Let us consider ourselves lucky to see nothing but Russians, Poles and

Americans among his ardent admirers and disciples.'[44] Shchukin purchased *Girl with Tulips* as well as *Woman in Green*.

In *L'Intransigeant* on March 18, Apollinaire wrote a rebuttal to the derision that greeted *Young Girl with Tulips* at the Salon des Indépendants. 'Let us first talk about Henri Matisse, one of today's most disparaged painters. No man is a prophet in his own country, and while the foreigners who acclaim him are at the same time acclaiming France, France is getting ready to stone to death one of the most captivating practitioners of the plastic arts today.'[45]

Despite their generosity and superb taste, the Americans were more capricious as collectors than Shchukin. Leo Stein was fully convinced of his ability as an art critic and never hesitated to offer his advice on a work to Matisse or Picasso, and as we have seen, Gertrude's loyalty was uneven, her enthusiasm tinged with partisanship. Though their resources were limited in comparison with Shchukin's, the Steins were clearly of great help to the modern artists of the time. But an intimacy with the painters as well as their own well-defined needs occasionally led them to reactions which were emotional rather than aesthetic. When Matisse had been the target of contumely and insult in 1905, Gertrude had responded to his courage as well as his work and their friendship grew. Later in 1909, when he began to attract some favourable attention, and signed with Bernheim-Jeune, she was wary: 'A very middle-class firm indeed.'[46] When Matisse mentioned that they seemed to be growing apart, she replied that the 'struggle' had gone out of his work: 'there is nothing in you that fights itself, and hitherto you have had the instinct to produce antagonism in others which stimulated you to attack. But now they follow.'[47]

Gertrude, who valued struggle as a creative necessity, appeared to feel that Matisse would be corrupted by success, lured into compromise by conformity and small comforts. When his prices advanced, she expressed disappointment that he made no financial concession to her as an early supporter; his endless striving became invisible to her, and she referred to his 'brutal egotism'.[48]

Yet money was not the crucial factor in Gertrude's disenchantment with Matisse. Picasso granted no special consideration because of their relationship. In 1912, when she wanted to buy his *Architect's Table* (1912), she could not afford the asking price and ended by paying for it in instalments, but their friendship endured. Gertrude enjoyed the role of early advocate, and remarked later, 'once everybody knows they are good, the adventure is over.'[49] She occasionally forgot that Matisse had endured his period of hardship and deprivation. If he now enjoyed a garden, a house in Clamart or a canter, this country gentleman during the early years had painted all one winter in an icy Paris studio, bundled up 'in an overcoat and gloves'.[50] Like Picasso, he knew the price of coal. Her commitment to Picasso made it difficult for her to acknowledge simultaneously the worth of Matisse's decorative images.

There was no such problem with Shchukin. It was unimportant to him whether an artist was accepted or not, and it never mattered how the painter lived or with whom. The Russian could visit the cluttered atmosphere of Picasso's studio or the immaculate, ordered precision of Matisse's without noticing the difference. His intimacy was with the paintings. For him there was no conflict, it was inconceivable to choose between the two. His devotion to the work of both men was unflagging. In 1913, the year in which he wrote to Matisse of his love for the newly-arrived *Arab Café*, with its sense of shimmering sand and dream-like symbolism, he acquired from Kahnweiler its antithesis, Picasso's cool, precise exercise in synthetic Cubism of the same year, *Violin and Guitar*. This suppleness was responsible for the remarkable breadth of his collection. Assembled in a brief span of seventeen years, it mirrored all the innovations of a historic period, and it is impossible to comprehend the major currents in art at that time without reference to this group of paintings.

For Shchukin, the 'adventure' was never over.

7

SHCHUKIN'S COLLECTION

It is people who make collections.
 Daniel Henry Kahnweiler

And thus before us is opened the first heroic page from the history of modern art – on the walls of a Moscow home, the ... 'outcast' artists were gathered together.
 Yakov Tugendkhold

'One may quarrel with Shchukin's collection – but with head bared, for here is the repository of *labour, continuity* and *culture*.'* With these words Yakov Tugendkhold, the celebrated Russian critic, completed his essay on the collection of Sergey Shchukin. In this same article he wrote, 'on each picture acquired there is the seal of talent,'[1] and thirty-seven years later, Alfred Barr concurred: 'From the beginning there was quality to his selections ... Shchukin bought very few bad pictures.'[2] Though his first choices were traditional, they were seldom trite. This was never a collection of 'all the fine painters of the Salons ... the painters of pink heather.'[3]

The early acquisitions were tentative, carefully considered and basically solid. The main ingredients in these works were a skilled technique, the Moscow preference for colour and a discernible individuality. Empty prettiness was rare, and there was no sense of thoughtless improvisation. Shchukin responded to organization and discipline. From the beginning he was attracted to paintings with a certain edge. He had been credited with 'youthful enthusiasm' by Tugendkhold, and it is the growing sense of an exciting odyssey which becomes most apparent in his activities. After a brief period with painters who belonged to no school – 'the outcasts', Puvis de Chavannes, Whistler and Odilon Redon –

* Tugendkhold's emphasis.

he moved on to Impressionism, then to Post-Impressionism, of which Cézanne and Gauguin were his favourite exponents.

Later came Matisse, and finally Picasso, representing the final, the incomparable part of Shchukin's collection.

The first purchases were a prelude to his main efforts. Charles Cottet's *View of Venice from the Sea* (1896) is reminiscent of Turner. The old city seems to be on fire, enveloped in a sunset haze of warm yellows and greens. The bright orange sails of the small boats are reflected in the glassy stillness of the water. In a second Cottet, *Marine with a View of Venice* (1896), there is the turbulence of a gathering storm, the clouds shade from pink to grey and the distant sky-line is etched in black. *Moonlight Night in Montmorency* (1879) by Charles Guilloux is a dream-like landscape in tones of soft green, lit by a hazy, glowing full moon. However, all was not mystery and colour. *The Market at Brest* by Fernand Piet and *The Boatmen* by Lucien Simon shared a brisk craftsmanship which evoked the wind-swept atmosphere of Brittany. Two pastels by Max Liebermann and a pair of watercolours by Frank William Brangwyn, both of whom were popularized in Russia a short time later by *Mir iskusstva*, were part of Shchukin's exploratory period.

There were metaphysical overtones which linked Shchukin's paintings by Odilon Redon, Eugène Carrière, Gaston de La Touche and Maurice Denis. Moscow was, after all, the centre of Russian mysticism. In Redon's *Woman Lying Under a Tree* the sleeping figure is wrapped in a dream, under a midnight blue sky, enclosed by mysterious symbols and borders. The gnarled form of the tree trunk is the only substantial presence, the dry branches with their scattering of brown leaves are dead and give no shelter. Carrière's *Woman Leaning on a Table*[4] is a less necromantic, more Freudian version of the same theme. *The Transference of Holy Relics* (1899) by La Touche is unusual in Shchukin's collection because of its religious intensity, but the painting is a study in jewel tones. The shape of the reliquary is outlined before a shimmering, green-gold stained glass window, and the supplicants and votaries, their faces translucent in the reflected glow of the candles, the deep red and green of the priestly robes, and the dark blue stained glass window on the left of the canvas, create the heated atmosphere of a Moscow chapel.

Shchukin owned four paintings by Denis, works of the artist's early period: *Portrait of the Artist's Wife* (1893), *The Visitation* (1894), *Christ Visiting Martha and Mary* (1896) and *Sacred Grove* (1897). During his career, this painter decorated the interiors of many important French churches, and his combination of religiosity and stylization made him a favourite of several Moscow patrons. In her *Portrait*, the image of Mme Denis is pressed out and broadened, the contours rounded in a parody of femininity. The figures of the two women in *The Visitation* have the same exaggerated flatness, but the black dresses lend

weight and dimension to the forms. The flowering trellis which frames the figures is subdued in tone, but the background landscape glows with shades of blue, orange, pink and green. *Christ Visiting Martha and Mary* is a serene moment depicted in soft blue-greens, the white robes and linens tinged with cool blue. Again the figures are stretched to paper thinness; only the food, the single glass of wine and the table have depth. The unexpected impact of the sharp citrus-yellow structure which cuts across the upper half of the canvas enhances the tranquil aura of the meeting in the foreground. Denis's placing of placid, uninvolved figures against a vivid background heightens the sense of unreality and remoteness in the last two works. *Sacred Grove* was acquired by Sergey from his brother Pyotr in 1912, and is similar in theme to Ivan Morozov's murals. However, the treatment is more delicate, and the transparency of line and colour lend subtlety to the landscape and the figures of the three nymphs. There was a mood and lyricism to the painter's early works, reminiscent of Verlaine or Debussy with whom he was associated during his lifetime; but as the years passed and success grew, his output became somewhat pallid and saccharine. All his paintings in Shchukin's collection are suffused with the spiritual intuition and other-worldliness which appealed to a Russian audience.

Two particularly outstanding early purchases were *Swiss Chalet* (1874) by Courbet, the closest Shchukin ever came to the Wanderers' genre, and *Bathers* by Fantin-Latour. However, it was as if he had been marking time until his visit to Durand-Ruel. After that date his walls reflected each innovation in modern French painting almost as soon as it occurred. Unlike many of his contemporaries he never became angry with what he did not understand. Kahnweiler once stated, 'In art there is always something after',[5] and Shchukin's ability to perceive the continuity, and to recognize that the newest manifestation owes a debt to what has gone before, made him a distinguished and broad-minded patron.

Shchukin's capacity to disregard popular prejudice was unusual. Over the years he learned to appreciate the entire spectrum of modern art. His understanding was not automatic and never came easily. He would spend up to two hours at a time in front of a new painting, trying as he said, 'to conquer it', to comprehend its meaning with an intensity and thoroughness which might have surprised the artist. It was a habit he never outgrew. As late as October 1913, in a letter to Matisse, he wrote, '*Arab Café* arrived in good condition and I have placed it in my dressing room. It is the picture which I love now more than all the rest, and I look at it every day for at least an hour.' The latest acquisition was usually his greatest love, and love was a word he used frequently with regard to his pictures.

<p style="text-align:center">* * *</p>

After the first visit to Durand-Ruel, Shchukin revealed the design he was to follow. Once committed to an artist, he would buy on a grand scale at an accelerated pace. His first Monet, *Lilacs of Argenteuil*, was an opening into Impressionism. Though there are still whispers of Courbet, the scene shimmers with the heat of a French summer day, the lilacs and the figures of the women are an idealized fantasy. The German art historian Julius Meier-Graefe, with whom Shchukin became so unexpectedly involved during the war years, has commented that in certain paintings the objects were transformed into the ideal 'originally desired by the Creator'.[6] His words apply to this picture, and it is amazing that a work so appealing could have remained unsold for more than two decades.

Over the years, the first Monet was followed by twelve more. The thirteenth, *Woman in a Garden* (1867), was inherited upon Pyotr's death. Shchukin's collection of Monets shows his early desire for a full representation of an artist's work. If he owned *Cathedral at Rouen* painted at noon, then indeed, he must have the same cathedral painted in the evening, not because his taste was narrow or repetitive, but because the juxtaposition of the two canvases revealed to him something of the artist's intentions and theories. He was forever trying to fathom the secrets of his own collection.

Pissarro and Sisley were also represented in the early portion of his collection. Impressionism's movement and play of light were particularly well suited to city scenes, and *Place du Théâtre Français* (1898), an animated view of Paris as seen from Pissarro's window, is a kaleidoscope of blooming trees, boulevards, carriages and scurrying Parisians. Then there was Sisley's sun-drenched *Village on the Banks of the Seine* (Villeneuve-la-Garenne), which Durand-Ruel had bought from the artist in the year in which it was painted (1872), and finally sold to Shchukin in 1898. It was followed by four Van Goghs.

The blazing *Bushes* had been painted at Saint-Rémy in the spring of 1889. With its riotous foliage heavy with white lilac, it complemented the silvery Impressionism of the Sisley. This work may have occasioned Gauguin's remark that Van Gogh was 'floundering' in Neo-Impressionism. The two artists spent the summer of 1888 together, and the nostalgic, winding *Promenade at Arles (Memory of the Garden at Etten)* comes from this time. The painting conveys Van Gogh's dream-like recollection of a Dutch garden; by some extraordinary effort of will, the dizzying whirl of colours is contained within separate areas like a piece of cloisonné. There is an indication of Gauguin's presence in the uncharacteristic stillness of the two women, but the tragedy and foreboding of the faces is the artist's own. Shchukin was particularly fond of the Arles period from which three of the works in his collection date. Before 1905 he had bought Van Gogh's *Arena at Arles* (1888), a picture of marvellous immediacy with its brilliant golden arena at the upper right of the canvas, the animated throng in

tones of blue, sweeping and spinning toward the viewer. The work has the movement and perspective of a Japanese print, and the influence is confirmed by the Oriental demeanour of the two women under a Japanese parasol in the foreground. In 1909 Shchukin added *Portrait of Dr Rey* (1889), the only portrait by Van Gogh to reach Russia.

The three Renoirs are of particular interest; two of them represent the artist's response to the challenge of black, a hue which did not exist in the Impressionists' view. Renoir has overcome the problem by painting the dresses of *Woman in Black* (1876) and *Two Girls in Black* (1881) with so many undertones of repressed colour and light that they glisten with opulent texture and sheen. No one could paint women as tenderly as this artist, and Shchukin's enchanting nude *Anna* (1876) revels in her femininity. She gazes at the observer, wholly serene and confident, the pearly, translucent tones of the body set off by the blue-black hair and ripe, red mouth. The formality of her coiffure and a single earring add a provocative, knowing touch. *Anna* and *Woman in Black* are two versions of the same model. Pyotr had made a major contribution to Shchukin's collection of Renoirs by relinquishing *Anna*. After he had married for the first time in his fifties, Pyotr's newly acquired wife was inflexible in the matter of this lustrous nude. In desperation, Pyotr offered it to Sergey 'at a fair price between brothers',[7] i.e. what he had paid for it. The transaction resulted in a measure of domestic tranquillity, and at last *Anna* was among her peers. Shchukin's son Ivan remembered that she became a major attraction, and sixty years later, if he had been given his choice, he would have selected this painting for himself.

Of the five Degas, one, *Woman Combing Her Hair* (1885–86), was also from the collection of Pyotr who had purchased it in 1898 from Durand-Ruel. It passed to Sergey in 1912, the year of Pyotr's death. Also a nude, it is an interesting contrast to Renoir's *Anna*. A seated figure, her back to the viewer, she is totally without seductiveness or artifice, brushing her hair forward in a prosaic and mindless ritual. Where one feels that *Anna* would lovingly spend hours on herself, Degas's *Woman* gives a vivid sense of the boredom and drudgery inherent in the everlasting pursuit of beauty. Three soft, smoky studies of the artist's ballerinas: *Dancer at the Photographer's Studio*, with the grey roofs of Paris seen through the window – the one oil by Degas in Russia – together with the later pastels *Dancers in Blue* and *Dancers at Rehearsal*, plus a vibrant *Horses at the Racecourse*, complete Shchukin's holdings in the painter's most familiar images.

When one remembers the extent of the hostility of the French officials toward Impressionism at the end of the nineteenth century, the measure of Shchukin's courage and the sureness of his choice are startling. Viewed from today's perspective, the Impressionists have the aura of the museum, gentle, lovely,

familiar, acknowledged masterpieces, certified by time and economics; but these artists were vilified in France for over two generations as leaders of a revolution which violated a deeply ingrained sense of structure and order. Russian taste in painting was even more conservative, reflecting either St Petersburg's derivative classicism or the social consciousness and literary bias of the Wanderers. The latter had used the tools of story-telling, religious themes, familiar scenes and legends to elicit an emotional response, and the message, as we have seen, was usually underscored by a dramatic title. Repin's *Arrest of a Propagandist* and Surikov's *Morning of the Streltsy Execution* were classics of this type. Impressionism was thus doubly alien to a Russian audience. It required sophistication and an effort of understanding from a public accustomed to simpler fare. Yet today the Russian museums are among the world's richest in this art.

Shchukin's dining room contained sixteen Gauguins, together with Matisse's *Harmony in Red* and *Corner of the Studio*. The Gauguins were hung closely, the frames almost touching, starting so low that one could barely put a chair against the wall, and mounting almost to the ceiling. The effect was that of a huge pagan mural, and at the far end of the room was the Burne-Jones tapestry representing the *Adoration of the Magi*. It was a rare juxtaposition, but as he moved on, Shchukin retained a certain fondness for the early acquisitions.

The Gauguins were complemented by another tropical fantasy depicting the dream-like encounters of animals in a jungle. Rousseau's *In a Tropical Forest. Battle Between the Tiger and the Bull* (1908) creates a hot-house wilderness festooned with gobbets of yellow fruit and pink flowers, at the centre a compliant victim and a flash of orange cat. It was purchased by Shchukin in 1912. Another tableau, a mythical unicorn-horse assaulted by a jaguar, *Horse Attacked by a Jaguar*, painted in 1910, has the naïveté and charm of Russian folk art. Shchukin was the first owner of these works, reminiscent in some ways of the Russian popular prints known as *lubki*, and they were the favourites of every child who entered the house. He loved Henri Rousseau; he owned seven canvases by 'Le Douanier', which has been called 'a piece of eminent audacity for a collector in the first years of the century.'[8]

Over the years Shchukin acquired eight Cézannes, a small number in light of Ivan Morozov's group of eighteen. Like Morozov's, Shchukin's collection had been purchased mainly from Vollard. His Cézannes included a late version of the *Mont Ste Victoire*, painted in 1905, a year before the artist's death. The painting is unusual in that the solidity does not derive from a formal, organized scaffolding, but rather emerges out of an arrangement of subtly assembled brush strokes, broad wedges of green, yellow and silvery-blue, which in their density and contrast construct a massive, weighty vision of the countryside at Aix solely out of the contiguity of colours. In comparison, the

serene monumentality of *Lady in Blue*, painted six years earlier, flows from a harmonious series of lines. The figure dominates the canvas, an organic structure which moves inevitably from the contour of the arm to the table on which it rests. The diamond shape of the deep blue hat is echoed by the pattern of the richly-hued cloth on the table. There is a poignant complexity and remoteness to the woman which is emphasized by the unrelieved, cool, sad blue of her costume and her eyes.

Shchukin's taste was growing more sophisticated. The pleasure he took in colour remained, but now an increasing concern with form was becoming evident. Despite the diversity of the paintings, this accumulation of individual works gradually assumed an outline and took on a collective identity. His preference for impact and 'big pictures'[9] was creating an entity stamped with his own imprimatur.

There were nine Marquets, serene and lyrical, scattered throughout the house. Alfred Barr has called this artist 'a Fauve seen through dark glasses', and the scenes of Paris or Naples, the glimmering, pink coastline of *Saint-Jean-de-Luz* (1907), a view of the *Port of Hamburg* on a winter day (1909), are like pages from a traveller's journal. The single interior by Marquet in Shchukin's collection was an early work, *The Milliners* (1901), which in its warm security is reminiscent of Vuillard.

The ability to appreciate the flow and change in an artist's work is illustrated in Shchukin's collection of thirty-eight paintings by Matisse. The earliest examples, *Still Life with Tureen* (1900) and *Still Life: Dishes and Fruits* (1901), anticipate the colour which erupted a few years later. In the first, the solid, blocky forms owe a debt to Cézanne, but the blue cup tilting precariously in the pink saucer, the orange and yellow tablecloth, a pink tureen cover topping the blue and yellow vase, the luminous silver coffee-pot reflecting all these hues – these are pure Matisse. In *Still Life: Dishes and Fruits*, colours spill forth from the fruits and pottery, this time lightened more liberally with white. The floral pattern on the blue and white china echoes the bright orange of the pitcher and the scarlet and yellow of the scattered fruit.

The two landscapes from the same period, *The Luxembourg Gardens* (1901–02) and *The Bois de Boulogne* (1902), reveal the painter's constant exploration. The shady side of the Luxembourg trees are deep, undefined patches of dark purples and greens, but where the sun touches, there are sudden explosions of warm, bright yellows, oranges, scarlet and emerald green. *The Bois de Boulogne*, an infinitely more restrained work, is full of silvery purples and greys. The curving forms of the tree are outlined in black, and it reflects more completely than the other three works just mentioned the legacy of an earlier tradition. It is as if the artist had drawn back briefly from the temptations of colour.

Shchukin's pattern of acquisitions in 1908 is illuminating. The tragedies

which had afflicted him, the deaths of four members of his immediate family, had culminated that year in the suicide of his son Grigory. It is a bizarre circumstance, therefore, that this was also the year in which he outstripped even Michael and Sarah Stein in his purchases of the works of Matisse. It is possible to exaggerate the significance, but it reveals the growing psychological indispensability to him of his collection, the importance it had attained as a force in his life. The scale of his activities increased dramatically at this time, and if art was an obsession, it was one which saved him from a destructive contemplation of his loss. In this one year he purchased three of Matisse's best known and most powerful works as soon as they were completed: *Game of Bowls* (1908), *Still Life in Venetian Red* (1908) and *Harmony in Red* (1908). From then on there was no hesitation, and the opulent paintings flowed into Znamensky Pereulok.

Game of Bowls is an ascetic exercise, an effort by Matisse to pare away the decorative aspects of Fauvism. The colours are primal, a wide straight swath of emerald lawn occupies the lower two-thirds of the canvas, and above this, a ribbon of bright blue which merely indicates water, is topped in turn by a strip of cobalt sky. The three pink figures are crude and heavily outlined, as with a child's crayon, the arbitrary slanting wedge of colour on the figure at the left enhances the effect of flatness and power, and the black roundness of the three heads is echoed by the black balls on the ground. The force is in the rigour and sophisticated primitivism of the work.

Harmony in Blue had been purchased by Shchukin from Matisse's studio. This was its second incarnation. According to Alfred Barr, originally it had been entitled *Harmony in Green*, but Matisse was dissatisfied with the effect, and by the time Shchukin acquired the work it had been reborn as *Harmony in Blue*. Before sending it to Moscow, Matisse loaned it to the Galerie Druet where it was shown as '*Decorative Panel for a Dining Room* (belonging to Mr. Shch.)'. Matisse always said that he learned from exhibiting, and after the showing the artist decided to make further alterations. The patterns and designs of the tablecloth and wallpaper remained essentially unchanged, the posture and visage of the woman at the table were subtly altered, but the season of the landscape as seen from the window passed from spring to winter. Instead of white blossoms, the trees now held great cotton balls of snow. Most notably, once again the entire work had been overpainted, the cool blues which predominated in the earlier version had been covered, and it was *Harmony in Red* which arrived in Moscow in 1909. Shchukin accepted delivery of a radically altered work, a giant canvas over six by eight feet, immersed in a vibrant cherry red, and dramatically changed from that which he had anticipated.

The episode is well known and would not be worth repeating except as it bears on the Russian's character and function as a patron. He was not a man to cavil; the new work was welcomed and hung in his dining room without protest. With

this flexible attitude, he encouraged the artists of his choice, particularly Matisse, and later Picasso, to paint as they wished, to pursue their experiments with some economic freedom, in the expectation that they would receive his support. The poet Aurier said of Gauguin, 'des murs, des murs, donnez-lui des murs.'[10] In Shchukin, Matisse had a patron who encouraged him to create the great paintings of this period with the knowledge that they would be understood and hung. The artist could work with the assurance that, unlike Monet, he would not have to roll up a masterpiece and leave it to crack and disintegrate.

The Russian selection of Matisse's work at this time ranged from the raw, unfinished effect of *Game of Bowls* to the magical decorative arabesque of *Coffee Pot, Carafe and Fruit Dish* (1909). For the latter, the artist had used the same piece of fabric, a *toile de Jouy*, which animated the background of *Harmony in Red*. Here the familiar whorls and spiralling designs surround and threaten to overwhelm the solid forms settled at the centre. In 1909 a companion piece to *Game of Bowls* was hung at the Trubetskoy Palace, a slightly smaller picture. The austerity of *Nymph and Satyr* (1909) links it to the earlier painting. Without shadow, the scene is enacted against a stark landscape of bitter green divided by a horizontal wedge of blue water, with glimpses of pink sky. This is no Bouguereau nymph; a thick, red line delineates the single arc of the figure and follows the exhausted curve of the arms. The satyr is a less amiable version of Cézanne's *Bathers* and the heightened red of his body, the enlarged, grasping, brutish hands, give the work an unexpectedly dramatic quality, unusual for Matisse.

The richness of Shchukin's collection was revealed in 1911 when the painter visited Moscow at his patron's invitation to supervise the hanging of his pictures. When he finished, the Matisse Room held twenty-one major works beginning in 1901, with the years between 1908 and 1911 strongly represented. Side by side and one above the other were *Game of Bowls*, *Nymph and Satyr*, *Spanish Still Life* and its pendant, *Still Life, Seville*, *Spanish Dancer*, *Pink Statuette and Pitcher on a Red Chest of Drawers*, *Girl with Tulips*, and so on, around the room in incredible profusion, all glowing under the huge chandelier, and hung so closely that they formed an exotic iconostasis. In addition to the individual glory of his canvases, the artist produced for the Russian a total environment. When a guest stepped into the Matisse Room, he entered a fantasy: pale green wallpaper, a pink ceiling, cherry carpet and the joyous works of Matisse, the emerald greens, bright lemon yellows and pure reds. Tugendkhold felt that no depression was possible in this setting. 'One cannot fall into a Chekhovian mood.'[11]

Thirteen other works by the artist were scattered throughout the house, four in the dressing room, including the stained glass polychrome of *Family Portrait*, and later, *Arab Café*. Outside the Matisse Room, in the dark oak stairwell, there hung two great panels, *Dance* and *Music*.

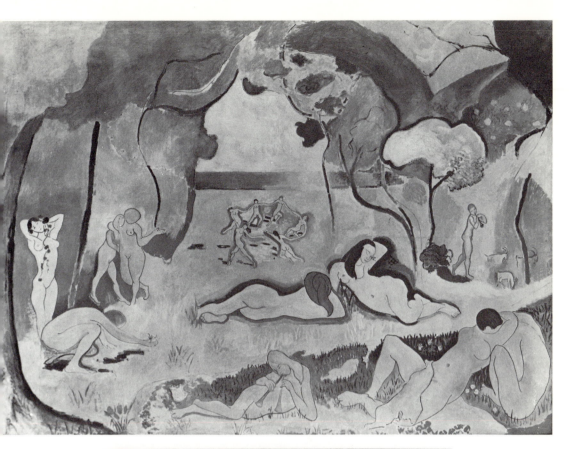

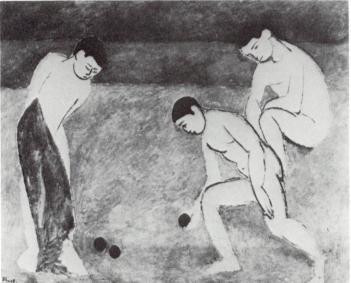

Top: Henri Matisse: *Joy of Life*, 1905–06. The Barnes Foundation, Merion, Pennsylvania.
In the background, the beginning of *Dance*. *Joy of Life* hinted at a new direction
in Matisse's work, a steady progression with increasing emphasis on form and
structure, which reached its climax with *Dance* and *Music*

Above: Henri Matisse: *Game of Bowls*, 1908. The Hermitage, Leningrad

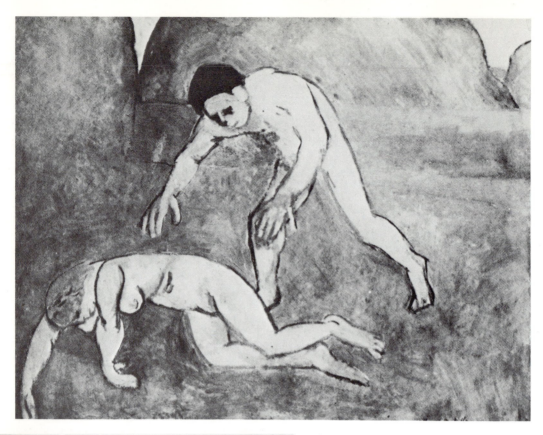

Above: Henri Matisse: *Nymph and Satyr*, 1909. The Hermitage, Leningrad.

Left: Henri Matisse: *Bather*, 1909. Collection The Museum of Modern Art, New York. Gift of Abby Aldrich Rockefeller

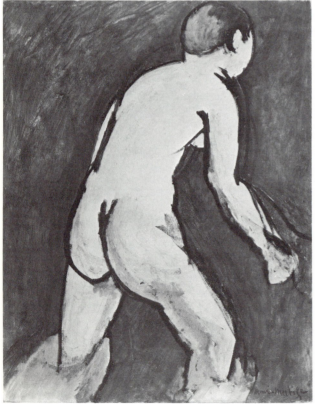

Opposite above: Henri Matisse: *D* (Composition No. I) (watercolour), I Pushkin Museum, Moscow. This study for *D* was Shchukin's gift t friend Ilya Ostru

Right: Henri Matisse: *Dance* (first vers (oil), early 1909. Collection, The Museum of Mo Art, New York. Gift of Nelson A. Rockef in honour of Alfred H. Bar

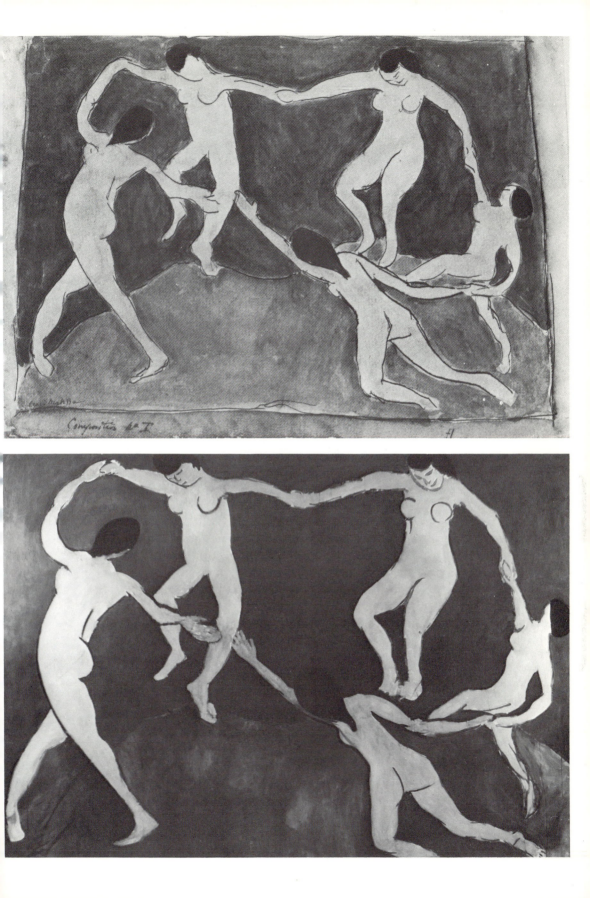

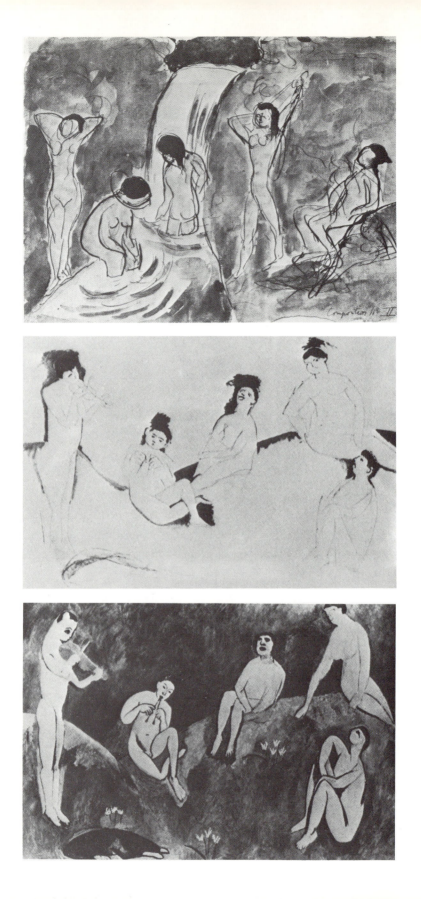

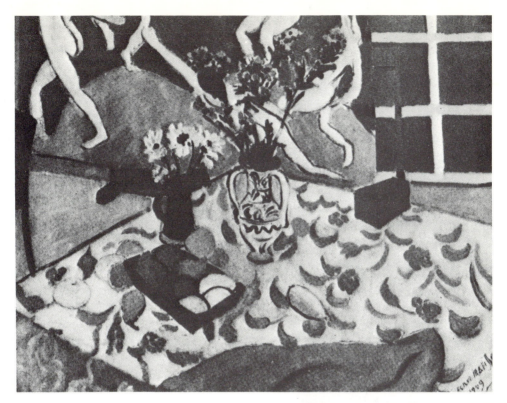

Above: Henri Matisse: *Still Life with the Dance*, 1909. The Hermitage, Leningrad. Part of Ivan Morozov's collection

Right: Henri Matisse: *Nasturtiums and the Dance*, 1912. The Hermitage, Leningrad. Part of Sergey Shchukin's collection

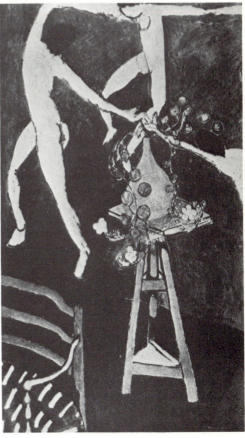

Opposite top: Henri Matisse: *Dance* (Composition No. II) (watercolour), 1909. Pushkin Museum, Moscow. Matisse suggested this theme as a companion-piece for *Dance*, but Shchukin preferred the *Music* sketch of 1907 (see the illustration in Chapter 1) which he had seen in the Steins' apartment in the Rue de Fleurus

Opposite middle: Henri Matisse: *Music* (early sketch), 1910. Pushkin Museum, Moscow

Opposite below: Henri Matisse: *Music* (second study), 1910. Pushkin Museum, Moscow

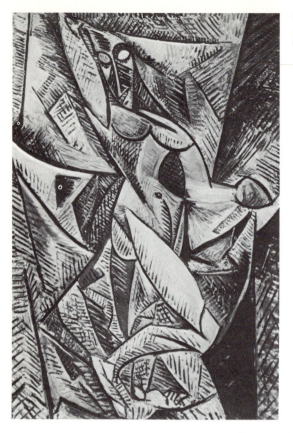

Pablo Picasso: *Nude with Drapery*
(Dance of the Veils), 1907.
The Hermitage, Leningrad

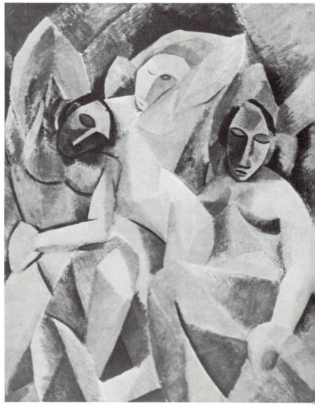

Pablo Picasso: *Three Women*, 1908.
The Hermitage, Leningrad.
When the Steins separated,
Shchukin bought *Nude with Drapery*
and *Three Women* from
their collection

Interior of the Trubetskoy Palace. Visible at the right is a fragment
of Degas' *Dancer at the Photographer's*. Mme Miasnovo, 'sister-in-law of a
brother-in-law', was placed in charge of the two war orphans
adopted by Shchukin

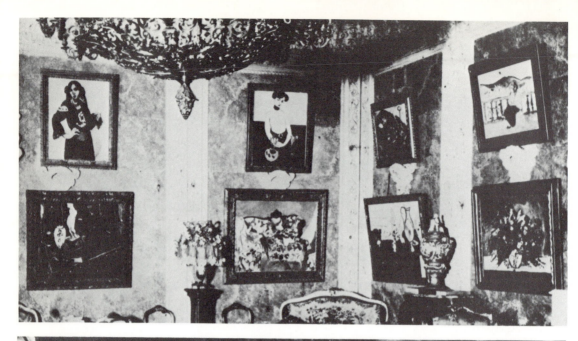

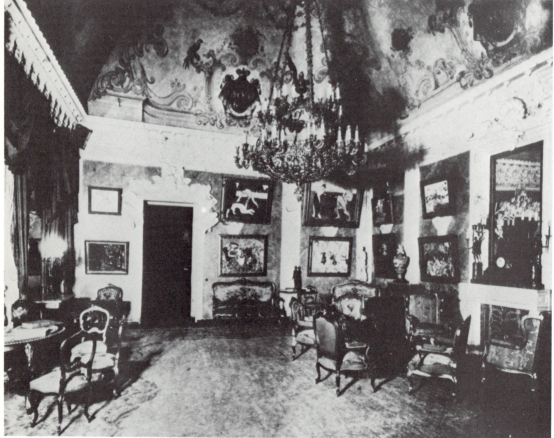

Top: Matisse Room at the Trubetskoy Palace

Above: Matisse Room at the Trubetskoy Palace, second view.
'I did not know Matisse until I saw Shchukin's house.'—Yakov Tugendkhold

It has been suggested in connection with *Dance* and *Music* that Shchukin was a vacillating and uncertain patron. This charge has been made also in relation to his initial rejection of Picasso's *Demoiselles d'Avignon*. But the latter incident was so fleeting as to be almost meaningless, and it at no time disturbed Shchukin's relationship with Picasso or interfered with the rhythm of his acquisitions. The circumstances surrounding the commissioning of *Dance* and *Music* were more revelatory of the pressures on the Russian at the moment. They invite an exploration. Shchukin played the role of midwife in the genesis of these paintings; his function was to collaborate in the theme, provide financial support and an area in which the enormous canvases could be housed. They were intended for a special niche in Moscow, and Matisse would not have attempted works of such physical dimension at that point without a specific commission from the Russian. He was beginning to prosper, but his resources were not great, and the expenditure of money, in addition to time and energy, would not have been feasible. When asked if his father would have painted the panels on such a scale without Shchukin, Pierre Matisse answered, 'Why – for whom?' Thus it is ironic that with these works in which he participated so actively, Shchukin opened himself to charges of timidity and indecisiveness, and endangered his valued friendship with Matisse.

It was in 1906 at the Salon des Indépendants that the merchant first saw *Joy of Life* (*Joie de vivre*, 1905–06), with its tiny bacchanalian ring of dancers in the background. His eldest son Ivan was with him on this occasion and remembers that his father was drawn to the distant farandole – to the innovation and colour. Subsequent visits to the Steins provided Shchukin with an opportunity to study the picture, together with the oil sketch *Music*, which the artist had completed and shown at the Salon d'Automne in 1907. *Music* was an unusual concept for Matisse at that moment, the antithesis of *Joy of Life*, an indication that he had moved beyond Fauvism and would not be restricted to the decorative aspects of that style. The tones are subdued: a soft blue for the sky, green for the grass; the bodies a pale earth tone, carved out with thick black lines. The scene contains four figures; the ingenuous, standing nude violinist on the left, two dancers in the background, and a round, embryonic, faceless figure, a cluster of ovals seated on the grass in the right foreground. It is a restrained work, simple and unassuming, but from this origin there flowed a series of distinctive canvases wherein the emphasis is on structure, and colour is relegated momentarily to a secondary role. This group, which included *Nymph and Satyr* and *Game of Bowls*, would reach its zenith with *Dance* and *Music*.

In the early months of 1909, Shchukin visited Paris and discussed with Matisse the possibility of a great panel which would hang either in the music room or on the huge stairwell in the Trubetskoy Palace. It was not the merchant's custom to commission an artist to decorate his home; he usually

preferred to hang the completed works, but when he had first come to Paris on a commercial errand he had been struck by an enormous Cézanne in the home of the banker Auguste Pellerin; now he wished to order a painting from Matisse on that scale. It was agreed that the theme might be based on the small whirling figures in the distance in *Joy of Life*. Shchukin had admired the Steins' *Music* study and the large *Bathers with a Turtle* which had been acquired by Karl Osthaus for his private Folkwang Museum in Hagen. The Russian had purchased *Game of Bowls* the previous year and now when Matisse showed him a 'full scale preliminary sketch' of *Dance* in March 1909, he was impressed by the treatment.

It was at this time that the two explored the possibility of a second piece, a companion painting, and Matisse submitted a sketch, *Dance II* – five bathers under a rushing waterfall. It would have been an unusually animated decoration for the stairwell, but Shchukin had been intrigued by the stillness of the Steins' *Music* and finally after many conferences and several additional sketches, the motif was decided. It was typical of the Russian that he would not wait to see one work completed before ordering another.

Upon his return to Moscow, Shchukin studied the areas in which he might wish to place the new acquisitions. Ivan Morozov had just commissioned the series of panels from Denis for his music room. These works, telling the *Story of Psyche*, with their nymphs and cherubs, were traditional and somehow assimilable in a formal setting, whereas the Matisse panels, because of their size and forcefulness, could not be enclosed. They required distance and perspective. Shchukin decided against the music room, for as he remarked to his son, 'No one would hear the music.'

At the end of March Shchukin wrote to Matisse confirming his commitment:

Moscow, 31 March 1909

Dear Sir:

I find your panel 'The Dance' of such nobility that I have resolved to defy our bourgeois opinion and to place on my staircase a subject with NUDES. At the same time it will be necessary to have a second panel of which the subject might very well be music.

I was very pleased to have your answer: accept a firm order for the panel 'Dance' at fifteen thousand francs and the panel 'Music' at twelve thousand, price confidential. I thank you very much and I hope soon to have the sketch for the second panel.

In my house we have a great deal of music. Each winter there are some ten classical concerts (Bach, Beethoven, Mozart). The panel 'Music' must indicate a bit of the character of the house.

I have full confidence in you and I am sure that 'Music' will be as successful as 'Dance'.

I beg you to give me news of your work.

All my reservations in my two preceding letters are annulled by my telegram of last Sunday. Now you have my definite order for the two panels.

My compliments to Mme Matisse.

Awaiting your news, I remain

your very devoted

Serge Stchoukine*

In this letter, Shchukin twice underlined the words 'le nu', indicating that he gave great importance to this aspect of his decision.

When he referred to Russian society's aversion to nudity, he acknowledged a deeply felt attitude, and this factor played a role in the events which followed. It is revealing to note how few Russian artists attempted the subject. Mikhail Larionov was an exception in 1903 and 1904 with his *Bathers* and *Blue Nude* and the *Prostitute* series; the Shchukin and Morozov brothers flouted the tradition to some degree, but basically the prudery was cultural and extensive. Vollard, who had several Russian clients, gave an illustration of this trait in his memoirs:

> One day there came to my gallery a chasseur d'hôtel. He wished to tell me of a client who was searching for paintings 'like that' and he pointed out the nudes of Cézanne which were in the window. The next day he returned, accompanied by a Russian, a certain Count Snasine who, standing in front of the Cézanne, shook his head. 'It is painted too grossly, too vulgarly. I prefer the paintings of nudes to be very well drawn, the filth very delicate.'

Vollard wrote that 'among Oriental people [sic] all representation of nudity is regarded as an indecency', and while Shchukin had none of this prurience, he was aware of the taboos. In addition, while his wealth and eminence provided insulation from community pressures, he knew that there existed a strong residue of resentment and contempt for the merchant class among many members of the nobility. Vollard had noted this phenomenon in passing during his encounter with Snasine. When he mentioned that he had several Russian merchants among his clients, that connoisseur of 'cochonneries très fines' had replied: 'Mais, je ne suis pas marchand. Je suis noble.'[12]

After receiving the merchant's letter with his assurance of financial backing, Matisse built a huge barn on his property at Clamart to accommodate the panels. As news of the commission spread, there was intense speculation about the theme and size. Totally freed from the usual economic restrictions, what would Matisse devise? A steady trickle of friends came day after day to sit on the ladders and stools, to observe and comment: Edward Steichen preserved a

* See Appendix 2, 'The Mysterious Letters'.

moment on film, Pierre Bonnard and Hans Purrmann were callers. Purrmann, a painter, collector and devoted admirer of Matisse, had helped to organize the artist's school of painting in 1908. Leo Stein came by to question or to offer advice, and whenever he was in Paris Shchukin visited the studio to watch the evolution of his latest acquisition.

Before shipping the two panels to Moscow upon their completion in 1910, Matisse sent them to the Salon d'Automne exhibition which opened on October 1. They were the only pieces he submitted, and one can understand why. They tended to dwarf everything around them, not only in size but in treatment. The theme of *Dance* had been based, as agreed, on *Joy of Life*, and the style had been foretold by the *Music* study. Now, however, the colours were no longer subdued. *Dance* was drenched in the brilliant deep blue of the sky, the earth was emerald, and against this primal background there was the pull and vitality of the brilliant circle of five red, nude figures, so compelling in their energy that the surface on which they dance is contoured to their feet. The tug between them is of such tension that when one notices that the hands of the two in the foreground do not quite touch, the fear is that they will fly apart.

By contrast, the tranquillity of the second panel is startling. Here, in a strange eclogue, five figures are entirely isolated from one another. The familiar standing violinist, retained from the 1907 sketch, the flautist, and the three singers are soloists, each wrapped in his own environment. They face outward, and in the ingenuousness and gravity of their gaze, the observer finds himself observed. One remembers the church frescoes of ancient Kiev, and understands that the Russian heritage is not necessarily an impediment to the appreciation of modern art. In no true sense 'panneaux décoratifs', they were the culmination of a series of bathers, musicians, bowls-players and nymphs created in this unique style, a strain powerful and rudimentary, yet always charged with the worldliness and Gallicism of Matisse.

Alfred Barr has noted that when these works were placed at the Salon they were 'hung high'. It was this perspective that Shchukin had devised for the panels on his staircase and it added to their impact. Today at the Hermitage, *Dance* is still at the top of the stairs.

Gertrude Stein, whose tastes had been growing away from Matisse over the past two years, reacted to these paintings in a manner which may constitute her greatest lapse in judgment. She wrote:

> I am quite sure that it is true of Matisse that he cannot do pure decoration because he has to have the practical realism of his group as his point de depart always. He must paint after nature, his in-between decorative period was and is a failure, it is only carried by his beautiful colours and his power in drawing, but they have no real existence. He has always failed in such flat painting, he then of course not

understanding his own failure cannot understand Pablo who succeeds in just this. . . .

It is very interesting that the dramatic independent dependents [i.e. Matisse's type] have no lyric or decorative sense.[13]

'Beautiful colours' and 'power in drawing' would seem to deserve more than commiseration, but Gertrude's dedication to Picasso and Cubism lessened her impartiality and narrowed her view. Judging by the comparison she made with Picasso, it had become necessary for her to choose. Even so, as one of Matisse's first supporters, her publicly stated opinion carried an apparent objectivity and authority.

The overpowering images aroused a howl of protest at the Salon, and the repercussions of this new Paris contretemps were felt in Moscow immediately. For the first time, Shchukin reacted to outside criteria. He wrote to Matisse withdrawing the original commission, and asking if the artist would create two smaller versions of the panels to be hung in his bedroom. For these he was willing to pay the amount agreed upon for the larger works. Despite this financial concession, it was impossible for Matisse to conceive of *Dance* and *Music* scaled down, and he refused. Shchukin's reluctance to relinquish the original panels was indicated by a suggestion which he made to the artist in the same letter. Perhaps if Matisse would consent to retouch the figure of the flute player in *Music* to tone down the frontal nudity, it might be possible to adhere to the agreement? It is true that Shchukin owned several nudes at this time: the Gauguins, Matisse's *Nude, Black and Gold*,[14] *Nymph and Satyr* and *Game of Bowls*. But after its arrival in 1908, *Nude, Black and Gold*, an extremely sensuous picture, had hung for a time in a private room, *Nymph and Satyr* while erotic in theme was not particularly explicit, and *Game of Bowls* was ascetic in concept. Moreover, all of these were of a more traditional size than the projected panels. For example, *Game of Bowls* measured approximately 46 by 57 inches, *Nymph and Satyr* 35 by 46 inches, and *Nude* was less than one-third the size of *Dance*. Still, the Russian had seen *Dance* and *Music* in progress at Clamart several times and there had never been a sense of reserve or a word of caution. He had demonstrated his adaptability only recently when he had accepted the altered *Harmony in Red* without a murmur, and this new uncertainty seemed to be completely uncharacteristic. Matisse declined to make the modification, and the result was an impasse.

Shortly after, Shchukin left Moscow for Paris. For a man who prided himself on his decisiveness, he was caught in an embarrassing situation, and was anxious to settle the affair quickly and avoid a permanent rift with the artist. Bernheim-Jeune was Matisse's dealer at that time, and Shchukin and the painter met at the gallery on the Avenue Matignon. It was a stiff confrontation and during the

encounter Sergey Ivanovich compounded the confusion when apparently he was attracted to an enormous allegorical work by Puvis de Chavannes, *The Genius Instructing the Muses*. Years previously, he had purchased two paintings by this excellent artist, *Pity* and *The Poor Fisherman* (the latter a variation on the painting by the same name in the Luxembourg Museum), and they had occupied a valid place in the early stages of his collection. Now, however, it would be difficult to imagine anything more at variance with his recent acquisitions. Approximately fifteen by sixty feet, it was a giant study which Puvis had made for the mural in the Boston Library. With its gentle classicism and muted hues, it was more Morozov than Shchukin, and in fact there was a slight thematic resemblance to the recently installed Denis murals. The overpowering size of the Puvis was undoubtedly a consideration, for it was large enough to fill the empty stairwell at the Trubetskoy Palace and blot out the immediate problem. In a moment of artistic recidivism Shchukin was considering buying a painting by the yard. Matisse was frustrated and angered by this erratic behaviour; the lapse in judgment puzzled him, and he simply could not believe that his patron could go back in time to such a degree. Every painting the Russian had acquired from him over the years had been leading to the climax of *Dance* and *Music*.

Shchukin wished to study the Puvis work at greater length and finally Matisse offered to have it installed in his studio in Clamart. It was a surprising move under the circumstances, but Bernheim-Jeune quite naturally wished to retain the good will of such an extravagant client and they may have persuaded Matisse to consent. If it had been a ploy it could not have been more successful. With its evocation of *Dance* and *Music*, there was no setting more calculated to fluster the Russian. Marguerite Duthuit, the artist's daughter, remembers that the barn was cleared and the huge canvas was set up. There were serious discussions of how the work could be divided for the stairwell. Marguerite was only a child at the time, and as she notes, 'my memories are sentimental and are not supported on every point', but she recalls 'the incident of the Puvis', because the 'muted, sad, dismal colours' were so strange to a child of the Fauve period.[15] The subdued tones of this immense painting impressed her as contrary to everything she had known. The study belonged to the estate of Puvis's widow, and Bernheim-Jeune was asking 15,000 francs – exactly the price of *Dance*. On November 4, 1910, four days before the closing of the Salon d'Automne, at which time *Dance* and *Music* had originally been scheduled to be shipped to Moscow, Shchukin finally said he would take it. Apparently he was still ambivalent, for the sale was conditional: if, after the work was delivered, it was not 'suitable', Shchukin could return the mural. According to M. Jean Dauberville, 'that is exactly what happened.'[16] It arrived in Moscow, Shchukin shipped it back to Paris, and Bernheim-Jeune refunded his money. Considering

the size of the canvas and the length of the journey, the clause had been an unusual concession, but in 1909 alone, Shchukin had bought *Nymph and Satyr*, *View of Collioure*, and two paintings completed that year, *Spanish Dancer* and *Woman in Green*, from the dealers and they were willing to accede to his request.

Matisse's role in this affair is interesting; it would have been natural if he had expressed his anger and disappointment instead of permitting his studio to be used as a showcase. Possibly he suspected from the outset that this was a phase, a mood which would pass; the hours that the two men had spent together in the galleries had given the painter a special insight into Shchukin's aesthetic needs. He may simply have decided to wait for the merchant to recover his equilibrium. It did not take long. During the long journey to Moscow, Sergey Ivanovich changed his mind for the last time, and wrote to Matisse, asking him to ship *Dance* and *Music* after all.

According to Russian records, the two panels became a part of the Shchukin collection on December 4, 1910.[17] It had been a brief episode; the wonder is not that the merchant faltered, but that he dared to hang them at all. The reasons for his hesitation go beyond the public reaction to the panels at the Salon d'Automne.

Shchukin's personal situation in Russia at that time enhanced his sensitivity to the Paris uproar. One reason for his indecision was that in 1909 he opened his house and collection to the public, a circumstance that will be described later. He still had painful memories of a guest who, several years previously, had marked a Monet with a pencil as a protest against radical art. Now a broad section of the Moscow community was to be admitted, and when a visitor entered his house, he would be faced, at the top of that monumental oak stairway, by a flying circle of nude figures which would explode from a panel over twelve feet high, which size would be matched to the inch by its companion piece. Shchukin's customary imperviousness to his critics could have been breached temporarily by his anticipation of the public disapproval which was expressed subsequently by Pyotr Pertsov, a well-known writer and critic. 'A Russian viewer will usually be scared away by the "insane" figures of the bright orange dancers who form in their furious whirling, some kind of wild *grande ronde*.'[17A]

There was another, more private element. When he wrote to Matisse withdrawing the commission, Shchukin explained that he had recently adopted two small girls, and feared that they might find the works disturbing. In the aftermath of the Russo-Japanese war in 1905, many families were left destitute, and Sergey had impulsively decided to adopt Anna and Varvara (Anya and Varya), not sisters, orphans of sailors of the Baltic fleet. They were installed in his house under the tutelage of a widow, Mme Myasnovo, 'a sister-in-law of a

brother-in-law'.[18] Grigory, Shchukin's second son to commit suicide, had been dead for less than a year, and according to Ivan Sergeyevich, his father had resolved that this time he would be more responsive to the needs and problems of the children in his care. Though he was sincere when he made this excuse to Matisse, his resolution, out of all proportion and based on guilt, began to wane almost immediately. His collection had never been influenced by family considerations. Lidiya, his wife, strong-willed and assertive, had 'loathed' the works of Matisse and Picasso, but in this one area, Shchukin had not pampered her. From the first the paintings were shipped from Paris without interruption. Now, at fifty-five, he could not re-order his priorities. It was only a matter of time before he would rationalize the effect of the panels on the young people and revert to his former pattern. It must be admitted however that he was sufficiently concerned to have *Music* retouched. Once the paintings were installed, no harm seems to have been done. Memories have blurred over the years, but Ivan Shchukin recalled that far from being corrupted or intimidated, the children made the stairwell and its looming inhabitants a pleasurably scary part of their lives.

The arrival of *Dance* and *Music* in Moscow was to reinforce the connection between the names of Matisse and Shchukin. In 1914, in *Apollon*, Tugendkhold commented: 'One may study and understand Matisse only in Shchukin's collection. No matter how many times I have seen his exhibitions in Paris, or his works in his own studio, I did not know Matisse until I saw Shchukin's house.'[19]

It has been said that from the beginning of Russian art 'the colours had to be bright in order to show up in the dark labyrinths of the cloisters or in the half-light of the space in front of the icon screens.'[20] Undoubtedly Shchukin's initial empathy with the works of Matisse sprang from the glory of the colours. In the icy climate of Russia colour is an ingredient of life. The glowing decorations of the church interiors, objects of lapis lazuli and malachite, and Byzantine painting, conditioned his reaction. Also the excursions to Nizhny-Novgorod had exposed Shchukin to exotic examples of ancient art, Oriental as well as Russian. In their strangeness and unfamiliarity, like images seen faintly through a distorted lens, these souvenirs of antiquity gradually acquired a logic and an aesthetic of their own. After the first encounter and the second, he began to appreciate the tradition of altered reality – of the artist's 'right to lie'. Above all, there were the icons. The stylization and flat surfaces in many of Matisse's paintings have been compared to these works. Frequently his portraits have a two-dimensional effect; the likeness of *Marguerite*, for instance, which Picasso selected for his own collection, is without physical depth or inner volume. The young girl rests delicately on the surface. Shchukin's *Conversation* (1909), which has been called 'the pyjama icon', gives the effect of two paper profiles suspended in an eternal dialogue. Matisse has written that he found in Byzantine

art a reaffirmation of his own theories. 'It is so much easier to apply yourself when you see your efforts confirmed in such an ancient tradition. It helps you take the plunge.'[21]

* * *

Where Matisse was considered controversial, Picasso was regarded as blasphemous. After their meeting in 1908, the Russian began to gather up the paintings which few others could accept. He had placed the Rousseaus outside the Picasso Room, and one critic had thanked his host for permitting him to rest his eyes.[22] It was impossible at one sitting to absorb even a small portion of what this room had to offer.

The earliest work by Picasso in the Shchukin collection was *The Embrace* (Rendez-vous), a small, detailed, richly hued painting of a meeting in a shabby room, the starkness of the setting, the low ceiling, one straight chair and a bed, relieved only by the curving forms of the entwined lovers, intensified by the strong arch of the man's neck. The pliant body of the woman with its red skirt and white shift are part of the enveloping male figure. This was painted in 1899 when Picasso was nineteen and from that point on, Shchukin's walls held every important stage of the artist's work until 1914.

There were several paintings from the Blue Period, notably *The Old Jew and the Boy* (1903), in which the pervasive hue has an icy comfortless quality, emphasizing the despair of the two figures huddled together, skeletal forms draped in the monochrome of the blue robes, their gaze heavy and sad, contemplating hunger and an indifferent world. It was not a picture calculated to appeal to a wealthy businessman, but this one was difficult to stereotype. Another brooding presence was the melancholy likeness of the poet and Picasso's close friend, *Portrait of Jaime Sabartès (Le Bock)*, painted in 1901. The face is pale and bloodless, the blue tones equally sombre, but unlike that in the later work the despondency is romantic and theatrical. The disproportionately large hand curving around a decorated stein has an air of Mannerism.

When he bought Picasso's *Two Sisters* (1902) Shchukin may have been reminded of one of his early purchases – Puvis de Chavannes's second version of *The Poor Fisherman*. There is a similarity in the themes, a shared classicism, the figures are frozen and desolate. The studies for Picasso's work had been made at the Saint Lazare Hospital in Paris, but his painting of the nun and the sick woman is unmistakably a Spanish tragedy.

In 1903 Picasso painted the portrait of his tailor and friend Francisco Soler, a distinguished-looking and elegant man, whose presence in the Blue Period earned him a place in the Trubetskoy gallery. Against a deep blue background, with his white linen and brooding eyes, he is as Byronic a figure as Sabartès.

Toulouse-Lautrec's influence was evident in many of the works of 1901;

Shchukin's example of this period was not acquired until 1911 from Kahnweiler. *Absinthe Drinker* (L'Apéritif) is a subject Toulouse-Lautrec painted many times, but here she is without animation, wrapped in her own arms, contemplating her glass and her addiction. The work is superficially decorative, the blues relieved by yellows and ochres, the forms delineated with a heavy black line, but again the mood is one of hopelessness.

In 1905 Leo Stein bought his first Picasso from Clovis Sagot and Vollard commissioned the series of Saltimbanques etchings from the painter. In addition, Apollinaire wrote of Picasso's work in *La Revue immoraliste* in April, 'Everything enchants him, and his incontestable talent seems to me to be at the service of a fantasy that justly blends the delightful with the horrible, the abject with the refined.'[23] The Fauve exhibition, steeped in colour, had opened at the Salon d'Automne, and perhaps as a result of all these events, a sudden lightening of mood and hues was apparent in the works of 1905. This was the year in which Picasso painted two of the most beguiling pictures in the Shchukin collection. In *Majorcan Woman* there is a sense of refinement, even fashion. The slender woman depicted in soft blue and terracotta is far removed from the hapless figures of his earlier works. Her robe is not merely a covering, but an adornment, she glows with a Mediterranean light, and the delicate pagoda of the Phoenician hat, veil falling to her shoulders, emphasizes her loveliness. *The Naked Youth*, composed in tones of rose and ochre, is remote from anxiety, classical as an ancient Greek statue, a timeless dream of adolescence.

Despite the unfamiliarity of his images, Kahnweiler has said that Picasso was beginning to sell relatively well at this time. The parade of acrobats, slender youths, harlequins, loving families and beasts of infinite humanity, created a world in which, for all its strangeness, the viewer could feel secure, even happy. While these canvases never offered the riotous hues that Shchukin so obviously loved, they conveyed a pleasurable and lovely vision. He was never permitted to grow comfortable with Picasso for long, however. In May 1905 Apollinaire had written, 'More than all the poets, sculptors and other painters, this Spaniard stings us like a sudden chill.'[24]

Of the artists in the Russian's collection, Picasso most consistently embodied the principle of 'psychological shock', and in 1906 the painter's work took a new direction. During this period he visited Andorra and was struck by the ancient Iberian sculpture. His figures lost their softness and began to assume a strange angularity. In addition, as Kahnweiler remarked, 'there is one art they [the painters] all collect, and this is negro art',[25] and it was at this time, according to Gertrude Stein, that Matisse drew Picasso's attention to African carvings. His ensuing fascination with the artefacts of the French Congo and Ivory Coast intensified the distortion of form which marked the beginning of a phase in which he was truly isolated.

1907 was the year of *Demoiselles d'Avignon*, and financial support for this period was practically non-existent. Picasso had relinquished a style which was beginning to bring him a measure of money and renown and turned toward a vision that was shocking and perverse to even the most enlightened and sympathetic observer. Vollard temporarily discontinued his purchase of the artist's paintings, and Leo Stein could not follow Picasso into Cubism. The American came to think of it as 'cubico-futuristic tommyrotting' and an 'exploitation of ingenuity'.[26] Only two years earlier he had written to a friend of 'a young Spaniard named Picasso whom I consider a genius of a very considerable magnitude and one of the most notable draughtsmen living.'[27] He had prided himself on his discovery, and had taken particular pleasure in the works of this classical Harlequin period which he and Gertrude had acquired, among them *Girl with a Basket of Flowers* (1905), *Acrobat's Family with Monkey* (1905), *Head of a Boy* (1905), and particularly, *Boy Leading a Horse* (1905–06), which he felt to be a masterpiece. For him, Picasso was in the tradition of Goya and Ingres, and he had become the artist's patron and most fervent advocate because of these qualities. He had disliked Gertrude's portrait with its arbitrary mask, finding it 'incoherent', and this reaction marked the beginning of his eventual disenchantment with the painter. Leo believed that Picasso was influenced too much by Cézanne and had become an experimentalist in form, a development which he considered alien to the Spaniard's true talent.

Though Shchukin shared Stein's admiration for the earlier period, he was able once again to take the next step. Kahnweiler remembers that there was no competition for Picasso's pictures in 1908, but it was in that year that the great Afro-Cubist works began to appear on Shchukin's walls, and these pictures were the confirmation of his genius as a collector. In a city far from the ateliers of Paris, in a year in which this artist's rejection was almost total, Shchukin could say of Picasso, 'This is the future.'[28] With the advent of Cubism, he confirmed not only his courage but his insight. Kahnweiler maintains that in the crucial early years of Cubism, 'Shchukin was almost the only important collector of avant-garde art.'[29] This dealer who sold him many of his Picassos has stated that 'starting with the Impressionists, the general public could no longer read the works of real painters.' Kahnweiler felt that there were certain men who were the 'locksmiths of painting', and Shchukin's ability to fathom these pictures was a miracle. One critic has written that collectors are of interest only because of the mistakes they make, the humanizing errors that give them their fascination, but they are lost amid the masterpieces they assemble.[30] Perhaps so, but in Shchukin's case he assembled an entity so provocative and formidable, so far ahead of its time and alien to its place, that the collection does make a very real statement about the man.

After 1908, many important examples of Picasso's Negro and Cubist period

were seen for the first time in Moscow. Leo Stein has noted that Picasso always exhibited alone and Shchukin recognized the necessity. Matisse's works could hang with those of other artists, be reflected in the Fauve Derains, hold their own with the dazzling works of Vlaminck, share a room with Gauguin, but Picasso in Moscow, as in Paris, was isolated. 'The secluded Picasso Room' belonged to that artist and no other.

Shchukin had placed a few pieces of African sculpture in the room. He had done something similar with the Gauguins, using Maori carvings, but these additions were always an extension of the display, never an intrusion. The ornate décor, typical of the rest of the house, did not extend to this chamber. The furnishings were severe and minimal: straight-backed chairs against plain light-coloured walls, a parquet floor undecorated by the usual Oriental rugs, the ceiling without ornament or carving. Nothing was allowed to intrude or divert. Unlike the Matisse Room, or the dining room with its luxuriant Gauguins, Picasso's compartment was not a place for living. The Russian had created a museum to be visited, and the setting was appropriate. It took time and concentration to understand these works, and their collector always felt that the final revelation was just ahead. He once told a visitor, 'Each time I enter, it is like putting my foot in a bucket of broken glass.'[31] It is remarkable that he felt compelled to submit himself to a discipline at this period of his life. He was fifty-four years old when he visited Picasso's atelier, an age when many men turn from innovation toward the familiar and comfortable. Yet here he was in this shabby Paris studio doggedly scratching hard ground.

Shchukin owned four of Picasso's *Still Lifes* from 1908, as exquisite as a series of mathematical formulations, one leading inescapably to the next. These experiments had a double attraction for their owner: their intellectual appeal, the careful construction and exploration of form, was reinforced by the unexpected mystery and beauty of commonplace objects. *Still Life (Pot, Wine-glass and Book)* (1908), shows the solid rounded image of a vase, one side suddenly swollen, seen through the prism of a wine glass; the book, carefully placed on the right, is a counterweight, solid and three-dimensional. Not a view of reality, but a fantasy of abstract shapes interacting, reflecting, the work has the symmetry and order of a Chardin. Despite the innocuous subject-matter, the strangeness of these works evoked a deep antagonism, almost a sense of apprehension from the Russian critics. For one, these still lifes were 'black icons … reminiscent of Egyptian idols in their power and mystical terror.'[32] Pyotr Pertsov wrote:

> It is theoretically inconceivable that a simple *Still Life*, a bottle, a vase with fruits, a pharmaceutical vessel—could be saturated with a feeling of world denial and immeasurable hopelessness. But go into the Picasso Room and you will see this

miracle, there you will find a whole series of canvases that depict only these harmless objects and that breathe through their outlines such an unbearable depression, such a 'grief of the last days' that you will be seized with involuntary horror.[33]

Pertsov was an early Jungian, a man who held the view that Picasso was a metaphysical painter, whose Spanish heritage was responsible for his apocalyptic vision of the world, that he painted out of 'the religious fanaticism of his distant ancestors who lit the real purple flame of their Inquisition bonfires.' He wondered: 'Will he be able to overcome the might of demoniacal disintegration that has bewitched him ... or will the power of blood be insurmountable? ...'[34] For Shchukin, Picasso's Spanish heritage owed more to El Greco than to the grey images of the Inquisition.[35] Yet it is remarkable how many Russian intellectuals attacked the painter on theological rather than artistic grounds as a creator of 'heretical chimeras' whose demons could be exorcized only by means of 'absolute faith' – 'Picasso is terrifying because he is demonically real.'[36]

For many Russian viewers, caught between the folkloric memories of an ancient past and dread of a chaotic and impenetrable future, Picasso's images were both enticing and malignant. Above all, they were terrifyingly familiar, the dark side of the Russian fairy tale. In 1915 Bulgakov stated: 'When you enter the Picasso Room you are surrounded by a night filled with mute, evil spectres.'[37] The painter's apparitions were the creatures of legend, yet there was a disturbing contemporaneity in his vision, a prophecy. 'There is something that makes it modern and corresponding to our spiritual age, for it excites us so, produces such anxiety. Affliction becomes once again a wide-spread phenomenon ... I thought of Gogol ... and I thought of Dostoyevsky even more.' The most striking element in the reams of criticism which greeted Picasso's work is this odd note of intimacy, a sense of recognition, as if he came not as a stranger, but as part of a familiar nightmare. Bulgakov, one of his most obsessive adversaries, understood this: 'When I looked at the works of Picasso – this part Spaniard, part Moor, part Parisian, purely Russian thoughts and feelings sounded forth in my soul.'[38]

All the acquisitions of the Blue Period were hung in one section of the room. After *The Embrace*, through the increasingly sombre colours and intimations of blue which marked the *Absinthe Drinker*, the visitor was drawn into a lunar dream world, a chilly landscape which held *The Old Jew and the Boy*, the portraits of Soler and Sabartès and *Two Sisters*. Though the dark rose scarf of *Woman with a Kerchief* (1903) violated the monochromatic discipline, the harshness and despondency of the image placed it in this company. These did not escape Pertsov's censure: 'A black precursor of future

horror. The whole world is flooded with this black blue of a dawnless night.'³⁹

In 1908 Shchukin purchased *House in a Garden*, a compact, uncharacteristically subdued work. Picasso frequently worked in different styles during the same period, and in a year which yielded some of his most grotesque figures he chose a subject of utmost peacefulness, which in his hands became a rigid experiment whose main characteristic is a total preoccupation with diagrammatically intersecting lines.

Landscapes are rare in this artist's work, and this example had been constructed with the concentration and deliberation of a chess problem. There is no sense of dramatic impact or the 'big picture' which Kahnweiler noted usually appealed to Shchukin; the small flat house is a partial hexagon, windowless and stony, half hidden by the forbidding line of the fence. In the foreground, the straight thrust of the tree trunks and the curve of the ground confirm the complete absorption with structure. Even the colours are muted: sandy yellows, purples, murky greens and blues; yet, for all its restraint, this painting is a landmark on the way to cubism.

In the following summer of 1909, Picasso returned to Horta, San Juan, today called Horta de Ebro. He had spent an idyllic summer there in 1898; the strong, bright, unshadowed colours of the Spanish terrain, the inhabitants' harsh, daily struggle to survive, and above all the cubed shapes of the small houses, piled together in the sunny countryside, had left an ineradicable imprint on his mind. Later he said, 'Everything that I knew, I learned at Horta de San Juan.' When he returned to Paris from Horta, he brought with him three landscapes which were an exercise in pure Cubism, pared down and shorn of African influence. These were works in which Picasso had harnessed his romantic imagination and produced three essays, as clear and logical as a Cartesian formula. Gertrude Stein wrote of these works, 'This then, was really the beginning of cubism.'⁴⁰ Two of these scenes were bought by Gertrude.

The third painting from this summer, *Factory at Horta*, was purchased by Shchukin. Here Picasso realized a rigorous work in which the cubes and rectangles interact, blend and merge into the sharp facets of the sky. The only relief from this insistent exercise is supplied by the curving lines of the palms in the background. Tugendkhold saw '. . . no horizon . . . no optic of the human eye . . . no beginning or end . . . here there is cold and the madness of absolute distance . . . an enchanted labyrinth of mirrors, a flood of madness.'⁴¹

Shchukin was perceptive enough to know that *Demoiselles d'Avignon* had marked a departure. His initial rejection of that work, expressed to Gertrude Stein, had been emotional, and it is as if he set out to make amends. His series of Picasso's female portraits from this time was the most controversial element in his collection. There were fourteen in all; the first to arrive was *Woman with a Fan* (1908). She was strange enough, with the rigid arc of her hat shading

remote eyes, the razor edge of a fan contrasting with fluted fingers and the sharp ruching of a white jabot, but there was a stylishness about her, an identifiable femininity. Tugendkhold conceded her elegance.

Shortly after, Shchukin added *The Farmer's Wife* and *Dryad*, both from 1908. *The Farmer's Wife* was a monolith, an earth-mother, indestructible and inhuman, a series of blocks painted in tones of deepest blue, unchanging and unconquerable, drawing her strength from the land on which she stood. Her round, upturned flat face, like a small disc, the clenched hands, indicated a total defiance and immutability. The *Dryad*, a great hulking nude set in a dark forest, was so powerful and three-dimensional that she seemed to spring from the wall, more sculpture than painting, her energy and sexuality expressed in aggressive rectilinear planes. It was only a year since Shchukin had turned away from the innovations of *Demoiselles*, but these pictures, painted at the same time, were equally difficult to accept. Where *Demoiselles* had been painted flesh, these figures were hewn out of rock. There was not a single concession to beauty or decoration. The works were a statement wrung out of complete artistic solitude, a declaration, militant and uncompromising. Unless the viewer could adjust to this fact and 'read' the work, he would feel cheated and snubbed. When Picasso shattered and reassembled his world at this time, he did not endeavour to pacify; even his colours were stark. His friend the artist Robert Delaunay called these muted tones 'painting with spiderwebs'.[42] Sergey's grandson, Herman de Keller, says of this period, 'As a boy I remember certain angular pictures of a drab coloration', and this child's reaction was kinder than most. In his appraisal of this segment of Picasso's work, Bulgakov wrote: 'Picasso with his brush insults the Eternal Feminine. ... Womanness ... appears in Picasso's work in unspeakable desecration, as an ugly, heavy, broken-down body, more precisely, as the corpse of beauty.'[43] Another critic, Georgy Chulkov, summed up the prevailing attitude: 'The forms have no corresponding influence outside of hell.'[44]

Two of the most important works of this genre were not available immediately to Shchukin. *Nude with Drapery* (1907) and *Three Women* (1908) were in the collection of Gertrude and Leo Stein, and it was not until the Americans separated in 1913 that the paintings were shipped to Moscow. *Three Women* was closest in theme to *Demoiselles*; perhaps that was a factor in the Russian's continuing desire for the picture. For years he had had to be content with a study for the work, but when it was placed on the market, he put in a bid with Kahnweiler right away. Shchukin had always been a tenacious man. Gertrude Stein has described her initial reaction to *Three Women*: 'Against the wall was an enormous picture of light and dark colours, that is all I can say, a group, an enormous group, and next to it another in a sort of red-brown of three women square and posturing all of it rather frightening.'[45]

Nude with Drapery was a startling, innovative swirl of motion, an exercise in movement and angular construction. It was 1907; again the African face, but here the mask was alive and animated. The Steins owned five studies for this painting, each a speculation, a question, a determination. All the divergent attitudes in these experiments are blended into the rhythm of the ultimate work.

'... and so cubism came little by little, but it came,' wrote Gertrude Stein.[46] When Shchukin opened his house, it was introduced into Russia. With a single act he exposed the cultural activists of Moscow to a series of influences from abroad which outraged his contemporaries, revolutionized current aesthetic norms and resulted in a wildly creative surge of artistic activity. It was Picasso who would have the most lasting effect on the Russian avant-garde, and it was only in Shchukin's home that one could trace the artist's complete development up to 1914.

Not everyone was hostile. From the outset, the young artists of the city were among Picasso's most vociferous supporters. Impatient with doubts and forebodings, the liturgical cadence of the critiques, they understood, in Kahnweiler's words, that 'People missed the real meaning of cubism, which was a form of writing that was intended to be severe, consistent and precise. ...'[47]

Cubism reflected the Revolution in that it broke all ties with the past, rejected all accepted values, beauty, form, the comfort and reassurance of familiar images, and presented in their place chaos and fragmentation. It was a dividing line and once it had been crossed, it was impossible to return to the old order. Cubism placed a weapon in the hands of the revolutionary artists of Russia. They went on to Rayonnism, Futurism, Suprematism, Constructivism, and for a time, in their daring and energy they outpaced the political radicals. Most of the leading modernists left Russia; some, like Tatlin, stayed and were destroyed. Years later when the few remaining artists of the revolutionary period attempted to work in the realistic idiom, the results were sad, contrived echoes of their youth. They laboured to create a new world in which they would become the prophets and propagandists, only to discover when it arrived that there was no place for them.

* * *

The art that Shchukin collected so avidly was derided by the Russian hierarchy; men as diverse as Stasov, Shcherbatov, Repin, Serov, Mamontov and Benois evaluated these pictures as insignificant, provocative or decadent. There was no Duveen to sanctify Matisse or Picasso in the first decade of this century, to guarantee the immortality of the artist, and by extension, the collector. To the academicians in Russia as in France, these paintings were transitory phenomena, graffiti, which in time would be washed away. There was more than a touch of egocentricity in Shchukin's urbane and good-humoured acceptance of violent

criticism, but as a result of his independence, the group of works in his collection has the individuality of a thumbprint. It becomes apparent that the merchant was completely self-reliant, shaping his environment to suit his needs without regard to popular opinion or cultural authority.

To his artistic activities, Shchukin brought the same qualities of discipline and organization as marked his financial career. The painstaking exploration of modern art, the period of observation and research, the early refusal to buy, were consistent with the deliberate pattern of the businessman. He studied, investigated and learned to recognize an artist who built on tradition, who did not depend on random impulse. It was because he heard the basic melody so clearly that he could appreciate the variations. When he finally found the area in which he wished to invest not only his money – for to him that was a comparatively minuscule amount – but more importantly, his energy, his time and reputation, he committed himself absolutely. 'Before I come to a conclusion about a picture it has to hang in my house for a year. I must get used to it and understand it.'[48] Yet once he made up his mind about an artist, it was a verdict without qualifications.

Though he accumulated a vast number of pictures, the result was never an unclassifiable, sprawling mass of works. Each canvas, as it was hung in Shchukin's home, like the piece of a puzzle put in place, provided a further insight into the overall picture of modern art as it was unfolding in Paris. Despite his close relationship with many of his country's painters, Sergey Ivanovich did not own a single Russian work of art. He admired Vrubel and Goncharova but he never deviated from his belief that leadership of the new movement rested in the West.

Adventurousness is not a characteristic usually associated with bankers or tycoons, and important collectors are not always ahead of their time. Frequently they view the art world as an area of commerce and evaluate their pictures with the same tools that have proven useful in other fields. In an investment, one looks for reputation, past performance and a high degree of security. For this reason many great collectors have found themselves more comfortable with the old masters. Museums are filled, wings are built and the public benefits. By these standards, Shchukin's choices were highly idiosyncratic.

If he had been interested in public acclaim or social advantage, Sergey Ivanovich was wealthy enough to have commissioned a dealer to procure the Rembrandts or Watteaus for him as they became available throughout Europe. Matisse said of him, 'He loved the profound and tranquil pleasures.'[49] Yet he was also a non-conformist and a gambler. He did not stock his home with the riches of the past, he never bought a painting because it was safe. Instead, against all odds, he made a giant continuing wager – and won.

He reacted to a painting on several levels: the warmth and beauty of Matisse

and Gauguin filled a cultural and emotional need. The distance between the ancient icons and Matisse's *Family Portrait*, between the old Russian embroideries and the artist's familiar toile de Jouy which appeared in so many of his paintings, was not unbridgeable. Just as Matisse reacted to the icons of Moscow, so Shchukin recognized the familiar art of Matisse. The open-mindedness which distinguished his activities and linked him to those much younger than himself led him to explore uncharted territory. He found the challenge of Cézanne and Picasso, the manipulation and reordering of form, intellectually stimulating, and in time he became as sophisticated as Kahnweiler or Vollard in assessing their worth.

There was another aspect to his judgment. Like many Russians, Shchukin remained close to his roots; there was nothing effete or decadent in his nature. Despite his wealth and a veneer of worldliness, these works moved him on a primal level. Bulgakov touched on this when he wrote: 'It was not in vain or by chance that Russia – by means of Sergey Shchukin – took Picasso's work away from the French, if not for Russia's own delight or consolation then as raw material for the tormenting religious work for which the Russian soul is renowned.'[50] Though he did not share this spiritual fervour, it is true that Shchukin gave a peasant's uncomplicated, superstitious response to the best and strongest of his paintings. In Picasso's women, the merchant recognized an indomitability which recalled 'the music of the countryside and the songs of the harvesters'. He realized that the dynamics of this art were peculiarly appropriate to his country during this period, and insisted, 'Don't you see? It *is* Russia.'[51]

The artist may not always realize the extent and implications of his creation. Picasso in Paris, exploring a new perspective, could not have anticipated that his works would be perceived in Moscow as supernatural, theologically subversive or as portents of a cosmic disaster. But the collector brings to his paintings the sum of his history and experience. Shchukin was the product of a society both ancient and modern, and the resultant ambivalence created the ideal patron for twentieth-century art, receptive to its innovations, to its mystery and symbolism. He had become a master of oneirocriticism, a diviner and interpreter of the dreams of the greatest artists of his time.

8

OPEN HOUSE

Youths stood with mouth agape before the canvases of artists of
the most extreme tendencies, like Eskimos listening to a
gramophone.

Prince Sergey Shcherbatov

The Cubists, thanks to the pulverization of the object, left the
field of objectivity, and this moment marked the beginning of
pure painterly culture.

Kazimir Malevich

The doors of the house in Znamenka Lane were opened to the public for the first
time in the spring of 1909, and here in this baroque palace near the Church of
the Annunciation to the Blessed Virgin Mary, the young artists of Moscow were
exposed to a complete survey of the most revolutionary art of the twentieth
century. Every Sunday morning at ten, the gates were pulled back by two
attendants and the visitors spilled into the fragrant gardens, crossed the circular
driveway and entered the coolness of the great hall. It was only a step from the
spires and domes of ancient Moscow to the bohemianism of the School of Paris,
but for some the journey produced a disorientating time lag.

It was understood that the merchant had assembled an unparalleled
representation of Matisse's paintings. In addition, there were rumours that he
had begun to collect the demonic works of an unknown Spanish artist. In the
Zolotoye runo exhibition a year earlier there had been not a single Picasso. Like
previews of a coming attraction these reports had created great anticipation.

The visitors to the Trubetskoy Palace, the Russian intelligentsia, a hetero-
geneous mingling of students from the Moscow School of Painting, Sculpture
and Architecture, writers, professors, critics, poets and painters, were usually
greeted in the hall or main salon by Sergey Ivanovich. They included Aristarkh

Lentulov, who a year later, with Mikhail Larionov, was to form the Knave of
Diamonds group, and the poet-critic Ivan Aksyonov who became its spokes-
man; Aleksandr Kuprin, admirer of Van Gogh and Cézanne; Olga Rozanova,
one of the most gifted and poetic of the new painters; and Ilya Mashkov, a close
friend of Shchukin's whose brilliant colour and linear discipline showed the
combined impact of Cézanne and Matisse. The Russian Symbolists were
represented: Pavel Kuznetsov, Kuzma Petrov-Vodkin and the writer Vladimir
Markov, who believed that while the influence of French painters was
indisputable, the Russian artist ultimately must find his own path. Even those
who disagreed most violently with Shchukin's choice of art could not afford to
miss these occasions, for they were a vital part of the eternal Russian dialectic.
As one observer wrote, 'a thesis is too vital and has too great an influence on
those who aim at deposing it.'[1]

Matisse had not yet arrived in Moscow to claim the salon for his own, and it
still held the porcelain midinettes of Renoir, a *Bathers* by Fantin-Latour and
two of Degas's dancers. Not satisfied to open his home and withdraw to a private
apartment, Shchukin moved quickly through the throng of visitors which was
drawn to his collection by curiosity or conviction. Originally he had planned to
limit each 'tour' to fifty guests. However, he could seldom refuse a request and
after a time the restriction became a formality. He relished the role of guide and
interpreter, and was to be found at the centre of the crowd whenever he was in
Moscow.

On these Sunday mornings, fortified by absolute conviction, Sergey
Ivanovich forgot his stutter, took his guests by the hand and led them through
the maze of modern Western art. His early purchases were still on view,
mementoes of another time. A visitor might encounter a mustering of discreet
landscapes by Fernand Maglin from the late 1890s, a secure and sturdy
Townscape with a Cathedral, or a view of an isolated *Hamlet*, the colour of an
autumn leaf. In a small enclave one could find a nest of three works by Maurice
Lobre painted at the beginning of this century, interiors of the Palace of
Versailles, which in their technical proficiency, charm and evocation of period
might have been watercolours painted by the young Benois. There were other
early remnants: a small, mysterious *House in a Garden* (1905), a 'minute
observation' by Charles Lacoste, and *The Port* (1896) by Henri Moret, a richly
coloured chameleonic view of the sea-coast at Brittany which seemed to change
with the light. A few years previously they would have attracted attention, but
now the crowd passed them by unseeingly and moved quickly to the main body
of the collection.

The audience was fluid, with the usual stragglers free to linger in front of a
favourite canvas, but by an unspoken consensus, the small Courbet, *Swiss
Chalet* (1874), with its silvery mountain peaks, became the curtain-raiser to the

tour. In a moment of hubris, at a public exhibition, Courbet had written under one of his paintings, 'It is I, Courbet, shepherd of the flock.'[2] His prominent position in the first room was fitting. From this comparatively dark beginning, there was a steady progression toward light and colour.

The collection of Monets was the first stage in this sequence. Ivan Sergeyevich remembered that the Monets were 'beautifully exposed in the salon des danses'. The moment one entered this gilded setting, the eye was drawn to the great study for *Luncheon on the Grass* (1866). The vast canvas transformed six feet of Russian wall space into the forest of Fontainebleau, cool and dark, for this was still Monet's Pre-Impressionist period. Even die-hard admirers of the Wanderers' realism and narrative style found little fault with this work. The light, glancing through the leaves, reflected in the sheen of the dresses, is sternly controlled; the solidity of the figures, the blue-black of the men's jackets, the white of the linen, is elegant and classical in feeling. The repast spread over a white cloth on the thick grass is an irresistible invitation. Many Russian guests who encountered the work for the first time noted that the birch tree on the right had been marked with an initial and a flèche d'amour carved into the trunk. It was an effective introduction to the Impressionist section, for in addition to unassailable stature and magnificence, it possessed a popular appeal. The Moscow audience found it completely French and totally beguiling. Shchukin had purchased this work for 10,000 marks[3] from the Berlin dealer Paul Cassirer, and it remained one of his favourites.

Of his thirteen Monets, the first acquisition, *Lilacs of Argenteuil*, was also in this salon, as were two seascapes of 1886, the crashing, turbulent *Rocks of Belle-Île* and the limpid *Rocky Coast at Etretat*. The ornate room held all the facets of Monet's obsession: the cool shimmer of waterlilies, a mid-day haze of meadow and haystacks, and the tremulous outlines of the Cathedral at Rouen in the heat and dust of noon, and again in the soft blues of evening.

In the library over the mantel, Shchukin had placed *The Seagulls* (1904). The final Monet acquired by the Russian, it depicted a misty view of the Thames with a dim outline of the Houses of Parliament barely visible, a drift of birds like commas punctuating the blue-grey fog. A diminuendo, a soft, hushed painting, it was an effective coda.

The dining room, with its profusion of Gauguins, has been compared to a Gothic temple. 'You see only the sumptuous colours, you hear only the fitting and triumphant music – the hymn of the leisurely life.'[4] It is somehow fitting that, with his great capacity, Shchukin owned the largest and most monumental of Gauguin's paintings: *The Gathering of the Fruit: Rupe Rupe*, painted in 1899. The stillness of the three women at the centre of the picture, the heavy fruit and blossoms, the drooping line of horse and rider, make this a golden, autumnal work.

From this molten centre, fifteen Gauguins spread like a radial frieze throughout the room. Above and to the right of this canvas, Shchukin placed a related painting from the same year. In *Tahitian Woman with Flowers: Te Avae No Maria*, Gauguin had plucked the most idealized and dream-like figure of the three women from the larger picture, and in their subtle variations, the two mirror images supplemented each other like two of Monet's *Haystacks*. Directly above the centre canvas was a Tahitian Virgin and Child, enshrined in the *Nativity* (1896). More human than divine, this work holds all the elements of Christian tradition: mother and infant, the stable, lambs and straw, all suffused with a rich, glowing light. Yet the relationship is less to the crèche than to the stone *Blue Idol: Rave te hiti Aamu* (1898) on the same wall a few feet away.[5]

The most opulent creations from the Tahitian period were in this salon. *Woman with Mangoes: Te Arii, Wahine* (1896), a languorous Polynesian Olympia, and the two mysterious elemental sisters of *What! Are You Jealous? Aha Oe Feii?* (1892) formed an impressive trinity on one wall. Despite the sensuous appeal of bronze forms on pink sand, these are mythical women, as unreachable and unknowable as any of Picasso's stone figures. In the midst of these luminous, richly painted images, Gauguin's rough, tormented *Self-Portrait* of c. 1890 seemed out of place; the eyes burn, and the coarse canvas has absorbed the paint until finally it forms the texture of the skin and of the work itself. In these untroubled surroundings, it is the face of an alien. Shchukin owned none of Gauguin's early paintings, but after 1907 he had appropriated eleven of the best and most mature of the Fayet collection.

Then came Matisse and a crescendo of colour. 'Sergey Ivanovich attracted everyone with his fiery temperament'[6] as he guided his visitors through a new landscape, explaining, propounding, reflecting. Occasionally he would preface his remarks with a description of the contrasting ateliers of Matisse and Picasso, and the conditions under which they worked. For those who had not travelled to Paris, he provided a glimpse into an unfamiliar milieu. Art dealers were a rarity in Moscow and he could entertain his guests with stories of the treasures he had found in Vollard's shop and his meetings with Kahnweiler.

On the way to Matisse, there was André Derain. Over the years the Russian acquired all the important phases of his work, ranging from the dazzling early Fauve period to the careful experiments in Cubism. With Matisse, Derain had been a prominent target of the critics at the Salon d'Automne in 1905. One of Shchukin's first purchases of this artist's work was from Kahnweiler, the glistening *Port at Le Havre* of 1905–06, a scene of radiant colour in the Fauve manner. One critic wrote of Derain in this period: 'The easy juxtaposition of his complementary colours will seem to some no more than puerile. His paintings of ships would do well as decorations for a nursery.'[7] There were sixteen Derains in the Russian nursery. After 1907, Derain's preoccupation with Cubism in-

creased; he worked closely with Braque in the summer of 1909, and Shchukin's collection reflects Derain's metamorphoses. Montreuil on the Sea (Harbour) of 1910 is a geometric progression of structures in tones of sand and deep grey-greens; the equation on the shore is reflected in the glassy, still water. The sharp vertical trunks of the two trees on the right of the canvas plumb exactly the lines of the buildings. A still life, *Earthenware Jug, White Serviette and Fruit* (1912) is a composition in earth tones, silver-grey and white. It is the apex of Cubism for Derain. Shortly after this, the power of his concentration seems to have been deflected. Shchukin's *Harbour in Provence (Martigues)* (1913) is the beginning of Sienese primitivism. The deliberate Gothic realism of the two identically titled works: *Portrait of a Girl in a Black Dress*, both of 1914, is a striking change, and finally, *Portrait of an Unknown Man with a Newspaper (Chevalier X)* of the same year is a witty caricature. All of Shchukin's Derains were purchased from Kahnweiler.

Until Picasso superseded him, Matisse was the undisputed favourite among the modern painters. Mashkov, Malevich and Larionov had all been influenced by exposure to his work at the Trubetskoy, and in this city of declarations and manifestos, the clarity of the artist's ideas and the precise manner in which they were articulated were greatly admired.

In 1909 and 1910 Matisse's popularity was at its height in Russia. But although a year later the Russian avant-garde had begun to prefer Picasso, Matisse was welcomed as a hero and 'grand master' when he made his triumphal visit to Moscow in the autumn of 1911.[8] The newspapers carried his biography complete with photographs and reproductions of his work, cited the Russian students who had been in his school in Paris, and mentioned the 'Banker Stein' as his chief supporter in France.

On Matisse's arrival the Trubetskoy Palace had been opened to the public and *Dance* and *Music*, clearly remembered by Ivan in 1974, were displayed prominently on the stairwell.[9] Of the two panels, *Music* was considered by the Muscovites to be the more offensive. It was argued that *Dance* might have classical antecedents, could be related in theme to the figures on a Greek vase, but *Music* seemed to have been born without a pedigree, and with its peculiar innocence, it infuriated many visitors. Shchukin was not easily intimidated; over the years his friends had been outspoken in their criticism and he had become accustomed to adverse comment. But with a wider audience a new element had been introduced. He had become a target of ridicule, and one privately printed pamphlet by Mme Nordman-Severova, a supporter of the Wanderers and of Russian art in general, had been particularly painful and upsetting to his family. The degree of animosity can be gauged by the fact that the collector had yielded to pressure and finally consented to the modification, by a local artist, of the flute player, without informing Matisse of his decision. Shchukin had been genuinely

upset by his first quarrel with the painter. Now their relationship had been repaired and he wanted no new rift. His son Ivan was waiting in the hall when Matisse arrived at Znamensky Pereulok. He recalled the occasion clearly sixty-three years later, because it was the only time he had ever seen his father embarrassed or apprehensive. Increasingly, Sergey had been concerned that the freshly added tones were deeper than the original and the alteration was blatant. He was right, the effort is still discernible today. After the greetings, when the visitor turned to his two panels in the hall, there was an endless silent moment. Finally, he shrugged, 'It doesn't change anything.' It was his only comment and the incident was closed.[10]

Despite the size of the Shchukin home, Ivan was temporarily displaced and the guest was given his apartment. When the artist asked what he might do to compensate for the inconvenience, the young man requested a small sketch of a nude, which Matisse presented before his departure. This memento was lost during the upheaval of 1917, but years later Sergey's son still remembered the loss of his 'personal Matisse' with regret.

The painter had made the long journey at Shchukin's invitation to discuss future projects with his patron, see his paintings in their Russian setting and offer his suggestions for their placement. The merchant was particularly eager for Matisse to study the soaring space available for his work and to plan accordingly. Matisse drew a sharp distinction between 'architectural' and easel painting and Ivan Sergeyevich remembered the snowy mornings when the visitor would put great sheets of paper on the wall and make sketches for those areas that seemed most promising.

Shchukin, with his vitality and enthusiasm, was an ideal host, and he was determined that his friend should miss nothing of interest during this interlude. His ties to Moscow's haut monde ensured the artist's access to every important work of art in the city. As a director of the Tretyakov Museum, a relative of the Botkins and the Tretyakovs, he was able to expose Matisse to the Russian mania for art and to the extensive, if occasionally disorganized collections of Moscow.

Matisse was familiar by hearsay with the extent of Ivan Morozov's fabled collection. In the house on Prechistenka Street the salons had been stripped of all decoration in order to display the works more effectively. The newly arrived *Mediterranean* triptych of Bonnard was on the staircase, the Denis murals, the Cézannes and Renoirs, all were complemented by a remarkable assortment of Russian art – Chagall, Goncharova, Korovin, Larionov – a survey of the artistic parallels and divergencies of East and West.

Mikhail Ryabushinsky, a banker and Nikolay's elder brother, entertained Matisse in his home, the mansion with the golden roof which Savva Morozov had built for himself before his death. It was, according to Prince Shcherbatov,

'absurdly ostentatious', but for a newcomer, there could not have been a more effective introduction to the extravagant taste of some of the merchants and Old Believers than this fantastic structure. Ryabushinsky's preference was for Vrubel and the French Impressionists, and in the midst of all this shimmer was Pissarro's familiar *Boulevard Montmartre* (1897). There is a remarkable sense of space and organization in this work; the straight vertical line of the lamp-post in the foreground is a focus beyond which the stream of pedestrians and carriages, the old buildings which rise on either side of the broad avenue, are orchestrated. Every gradation of the golden afternoon light is explored. It is a more ordered work than Shchukin's *Place du Théâtre Français*, painted a year later. The manner in which the Impressionists were scattered throughout Moscow's most noteworthy collections was striking. They appeared unexpectedly among the Russian moderns, old masters and icons, in the homes and private museums of the city.

Ilya Semyonovich Ostrukhov, a friend of Shchukin's and a fellow-merchant, had established a Museum of Painting and Icon Painting in Moscow which held one of the finest and most extensive collections of icons in Russia. Shchukin realized that these rare items would interest his guest, but he warned Matisse that his compatriot collected 'magnificent icons and bad paintings'. It was not an entirely fair appraisal, for the Museum held several works by Puvis de Chavannes, a fine Degas pastel, *Woman at her Toilette* (1899), dishevelled and contemporary amid the rigidly venerable images, and Renoir's delicate *Lady with a Muff*, a china ink, pen, brush and watercolour drawing. In an effort to broaden his friend's appreciation of Matisse's work, Shchukin had presented him with a preliminary sketch of *Dance* which he had received from the artist, but Ostrukhov's enthusiasm for modern art had been dampened temporarily. He was still smarting in the aftermath of a recent embarrassment. The work of Ignacio Zuloaga was popular in Moscow at this time and Ilya Semyonovich had acquired many of his canvases. Recently, a friend, Yevgeny Zubov, who had studied painting in Germany had detected several forgeries among them and brought the matter to the collector's attention. Perhaps he had expected some expression of gratitude, but Ostrukhov was furious. For a man of his reputation to have been defrauded in an artistic transaction was humiliating. It was months before he spoke to Zubov again. When the relationship was finally re-established, it was with an unspoken understanding: the incident was never mentioned and the Zuloagas remained. The episode bore some similarity to Ivan Shchukin's experience three years earlier. Apparently there was a thriving market in forged Zuloagas at the time, but in Ostrukhov's case the loss of money was unimportant; what counted was the loss of face. Matisse was informed of the incident before his meeting with Ostrukhov.

Ivan Shchukin was a member of the party during this visit, and in his own

words he noted 'the relationship between Matisse and the icons'. The painter
had been greatly impressed by his visit to the exhibition of Persian art in Munich
a year earlier, and the icons were an important sequel. His newly activated
interest in Eastern art made this immersion in a Byzantine city particularly well
timed. The memory was still fresh years later when Matisse wrote of the
'revelation which came from the Orient' and his understanding of Byzantine art
which began 'while looking at the icons in Moscow'.[11]

In 1912, after his return from Russia, Matisse sent a token of his apprecia-
tion to Ostrukhov: *Nude* (1908), an oil study for *Nude, Black and Gold* which
was in the Shchukin collection. The canvas was signed and inscribed on the
lower left side: 'A Monsieur I. Ostrooukoff, hommage respectueux, Henri
Matisse' and on the subframe: 'Etude faite en 1908'. *Nude, Black and Gold* was
well represented in Moscow. Ivan Morozov owned the related *Woman Seated*
from the same year. He had purchased it from the Salon d'Automne show in
1908.

One morning when Sergey Ivanovich and Matisse arrived at the Old
Shchukin Museum, Pyotr, resplendent in his official attire, was waiting to greet
them. From among the myriad textiles, embroideries, carvings, antiques,
parchments and assorted works of art, Pyotr at Sergey's suggestion first showed
the guest ten watercolours from the sixteenth-century manuscript of Baher-
nemeh, Monet's familiar *Woman in a Garden* and two Indo-Persian water-
colours of jewelled maidens who in their vanity and femininity might have
stepped off the walls of the Ajanta caves.

Since his arrival, Matisse had grown accustomed to returning to the old house
in the afternoon to find a scattering of young painters in the formal salons, their
easels set up in front of a Monet or a Matisse, diligently copying these works, as
he had copied Poussin or Chardin in the Louvre less than two decades
previously. In Paris he was still a progressive force; in Moscow he was rapidly
becoming an old master.

Matisse was an interested observer at Shchukin's Sunday morning gatherings.
He shared his host's affinity for the new generation of artists, and in turn the
news of his presence attracted an eager audience of students, who became his
special constituency. The welcome accorded him by the artists of Russia was
overwhelming. From the moment he arrived, Goncharova, Larionov, Kuznet-
sov, Mashkov and their friends took every opportunity to show their respect and
admiration. Before he left, the entire artists' colony joined to give the painter a
great boisterous farewell party. On this occasion he was presented with a portrait
of a plaster bust of himself, signed by all present, and inscribed 'To the glory of
the great Henri'.

During his visit Matisse, with Shchukin, supervised the hanging of his own
works in the grand salon. Tugendkhold summed up the result:

> Some pictures, after all, need a corresponding external environment, like hothouse flowers; its absence is the evil of museums and the advantage of the private collection. And so Shchukin's house is the apotheosis of Matisse's paintings ... composed one with another in concordant proximity. ... And when one enters Shchukin's living room decorated by Matisse, one senses this painter's happiness – rarely is one accorded during one's lifetime the happiness of such a successful practical application of one's labour.[12]

Where before Matisse's paintings had been dispersed throughout the house, now the bulk of his work was assembled in a single area. Shchukin's family noted that the painter 'chose the best and greatest room for himself'[13] and when he finished there was never another to match it. In a postcard to Michael Stein from Moscow, Matisse pronounced himself 'well satisfied' with his visit.

There was exhilaration for the Russian artists in the realization that Matisse's innovations held relevance for their own work. Shchukin had opened a door. The personal contact and interaction with a major Western figure lessened the sense of remoteness, of working in a vacuum which had plagued many Muscovites. The visitor recognized Byzantine art as foreign yet innate and in turn, these young painters related to the art of Matisse as a 'new confirmation'.

Picasso's acceptance took longer. In Moscow as in Paris, he was a stranger, uncommunicative and uncompromising. A member of no club, totally uninterested in teaching, he did not verbalize. Painting was his language, and Shchukin was an effective translator.

Inside the Trubetskoy Museum, his paintings were the last stop. In Picasso's redoubt, Russian artists were caught up in an unfamiliar world, unlike anything they had experienced previously. On one wall Shchukin had assembled a cluster of Picasso's granite Medusas from 1908. *Dryad* was placed high, just under the ceiling, and on the same lofty level to the right was another singular work from this year. Entitled either *After the Ball*, or *Seated Woman – Buste*, this is a malevolent block of a woman, seated, wearing an evening gown like a sheath of white armour plating, one breast bared, holding a half-opened fan. The face is a mask, seductive and repellent. A hypnotic painting, the 'written' eyes seem to open and fasten on the viewer. One massive shoulder higher than the other, the splayed fan incongruous in the wedge-shaped hands, she is as primordial and tangible a presence as any pre-Columbian idol. It is a marvel of construction, but no matter how worldly the observer, the initial reaction is emotional, irrational. The critic Pertsov found that in this 'group of devilishly gloating, blasphemous female figures ... the dead flesh, the lie of artificial life, is wrapped or tries to be wrapped in the most captivating veil – in the smile and caress of gender.'[14]

On the same wall Shchukin had hung a bust of *Farmer's Wife*, scarcely less awesome than the full-length version nearby. When, after several years, he

finally managed to acquire *Three Women* from the Stein sale ('three terrible friends in an infernal fire') he placed it carefully between *Dryad* ('the most diabolical of all') and *After the Ball*. For Pertsov these 'large, grating canvases' were 'the ultimate abuse which can not be forgiven.'[15]

The wall to the left was also dominated by the works of 1908: the impregnable armature of *Woman Seated* and *Friendship*. In the latter, Picasso synthesized his twin preoccupations of the period: the structural concepts of Cézanne and the influence of African art; a blend of primitivism and a sophisticated concern with form. The basic geometrical shapes and components of this picture evolve rhythmically into the final configuration as surely as atoms in a molecule. Shchukin, always fascinated by the means by which an artist arrived at a particular goal, owned two gouache studies for this painting.

The crucial *House in a Garden* (1908) hung below these two massive canvases, next to the charming and refreshing *Queen Isabeau* (1909). The feathery delicacy and lightness of this girl, with her closed eyes and listening air, was in contrast to the brooding, weighty classicism of the neighbouring *Still Life with a Bowl of Fruit* from the same year. Another presence was *Still Life with Skull*, Picasso's *memento mori* of 1907. There was a Fauve gaiety to the colours, a verve and dash to the brush strokes which many visitors found inappropriate to the theme.

Russian painters were well served by Shchukin's impatience to expand his collection. After his meeting with the artist, he purchased from Kahnweiler an average of ten Picassos a year, some of them almost before the familiar line had been stroked under the signature. In 1909, the same year in which Picasso painted in Horta, his *Factory at Horta* was available to students in Moscow. Kahnweiler, 'one of the great uncomplicators'[16] who did not romanticize, remembers simply that Picasso would give him pictures three or four times a year, and immediately he would wire Shchukin who would arrive shortly thereafter from Moscow. The dealer made no effort to screen the works or to anticipate the preferences of his client. When the Russian appeared at his gallery, 'I showed him the Picassos and he frequently bought three or four pictures at one time.'[17]

Ivan Shchukin, a young man during this period, years later well remembered the sense of occasion as the enormous crates arrived from France, and his father's raptness as they were unpacked. The overpowering works were hung immediately in the Picasso Room under Sergey's supervision, and his son recalled that as they accumulated over the years, 'the Picassos seemed too big for the room.'

Even the most urbane of Shchukin's friends were uneasy in 'Picasso's cave'. Benois's assessment was typical: 'Picasso's monsters resemble the religious art of savages'.[18] Some were moved to speak out of their deepest philosophical beliefs:

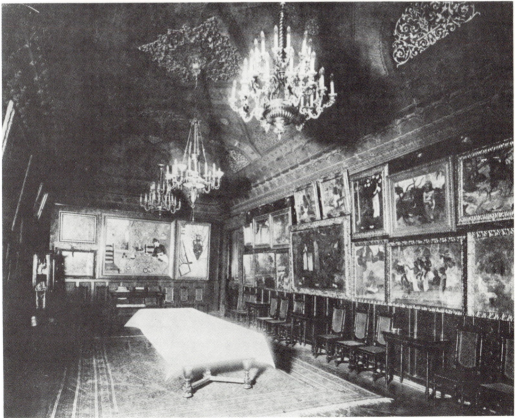

Top: Courtyard of the Trubetskoy Palace. Sergey Shchukin is standing in the doorway (right)

Above: The Trubetskoy dining room

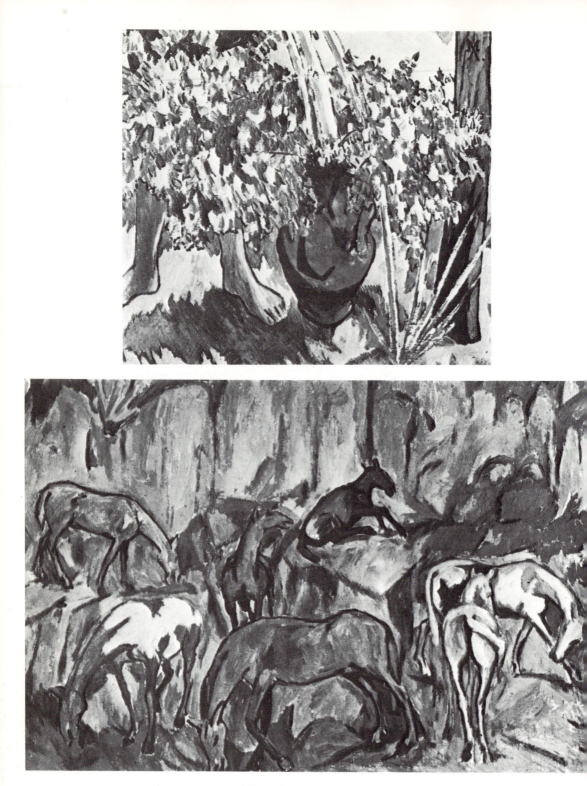

The influence of Gauguin

Top: Mikhail Larionov: *Bare Feet and Foliage*, 1905.
Private collection, Paris

Above: Mikhail Larionov: *Horses on a Hill*, 1907. Private collection, Paris

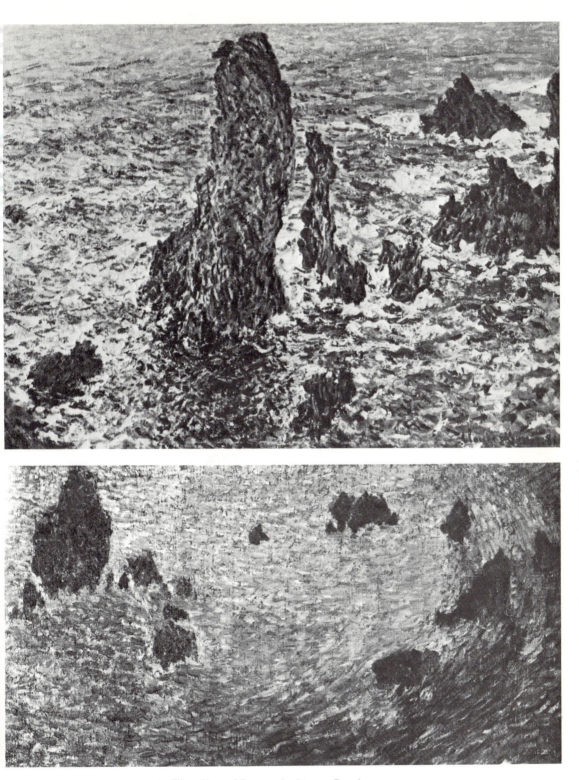

The effect of Impressionism on Russian art

Top: Claude Monet: *Rocks of Belle-Île*, 1886. The Hermitage, Leningrad

Above: Mikhail Larionov: *Sunset on the Black Sea*, 1902.
The Hermitage, Leningrad

Анри Матисъ.
(Henry Matisse).

Одно изъ именъ, наиболѣе часто упоминаемыхъ при разговорѣ о новѣйшей живописи, — Анри Матисъ.

Сравнительно въ короткій срокъ Матисъ заставилъ о себѣ говорить, какъ о смѣломъ новаторѣ въ области живописи, нашелъ себѣ подражателей и сталъ, такимъ образомъ, во главѣ опредѣленнаго теченія.

Онъ родился въ 1869 году. Окончивъ École des beaux Arts въ Парижѣ и не мало поработавъ самостоятельно, Матисъ не сразу пріобрѣлъ извѣстность. Учителемъ его (такъ же, какъ и Марке, одного изъ самыхъ обѣщающихъ современныхъ французскихъ художниковъ) былъ Густавъ Моро, чрезвычайно бережно относившійся къ индивидуальности своихъ учениковъ. Владѣя недюжиннымъ рисункомъ, Матисъ, тѣмъ не менѣе, не могъ овладѣть вниманіемъ общества.

Не примыкая къ импрессіонистамъ, онъ искалъ свои пути въ передачѣ художественныхъ представленій. Въ своихъ краскахъ онъ преслѣдовалъ до извѣстной степени восточные мотивы, и увлекся въ направленіи орнаментаціи картинъ, приближаясь къ плакату.

Его опыты въ этомъ направленіи обратили на него вниманіе молодыхъ художниковъ. Упрощая свой рисунокъ, и переходя отъ сложныхъ къ болѣе простымъ тонамъ, Матисъ постепенно нашелъ «себя».

Онъ сталъ во главѣ извѣстной группы молодыхъ, которыхъ общество окрестило полунасмѣшливо кличкою «fauves». Имя Матиса звучало все громче. Въ Парижѣ нашелся банкиръ Штейнъ, горячій

А. МАТИСЪ, Автопортретъ (1906 г.). Вверху и внизу— снимки съ А. Матиса въ домѣ С. И. Щукина: 1) у портрета его работы, 2) съ внукомъ С. И. Щукина.

сторонникъ новаго искусства. Онъ сталъ главнымъ заказчикомъ Матиса, и тѣмъ сдѣлалъ свой салонъ моднымъ въ извѣстныхъ кругахъ.

Коллекціонировать Матиса сталъ почти одновременно московскій меценатъ С. И. Щукинъ.

Матисъ сталъ появляться на самыхъ передовыхъ выставкахъ Европы, въ «Салонѣ независимыхъ» въ Парижѣ, въ берлинскомъ «Secession». Въ музеи его

*) Переводъ: Количество положенной краски и ея относительная цѣнность составляютъ качество колорита.
Интенсивность цвѣта— ничто.
Одно повышеніе голоса — не убѣждаетъ.
АНРИ МАТИСЪ.
Москва, 28 окт., 1911 г.

картины входа не имѣютъ, они расходятся по рукамъ немногихъ частныхъ коллекціонеровъ.

Матису стали подражать, причемъ наибольшее количество послѣдователей его объявилось въ Россіи, Америкѣ и Венгріи.

Увлеченный на путь новаторства, Матисъ открылъ свою школу-ателье во Франціи. Его имя привлекло къ нему немалое количество учениковъ (болѣе 150), среди которыхъ было нѣсколько русскихъ.

Но черезъ два года Матисъ закрылъ школу. Профессура, по его словамъ, мѣшала его творчеству. Злые языки утверждаютъ, что школа закрылась въ

Right: First page of a letter from Shchukin to
Matisse, August 22, 1912, in which he mentions
four paintings: *Nasturtiums and the Dance,
The Moroccan-Amido, Goldfish* and (obliquely)
Conversation. The English text is reproduced
in full in Appendix 2.

Below: The Trubetskoy dining room,
with *Harmony in Red*

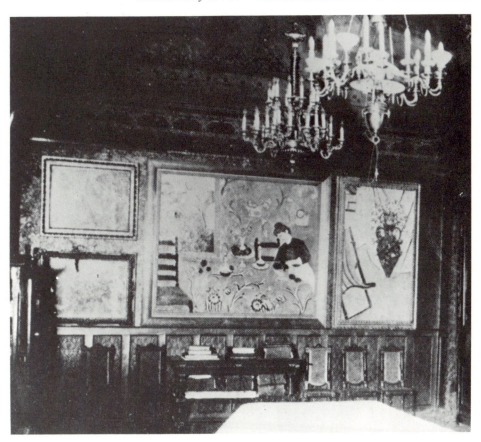

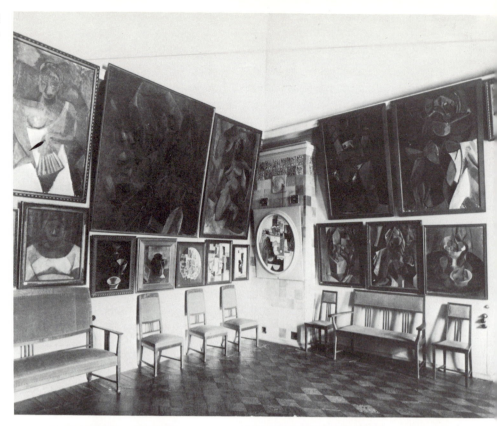

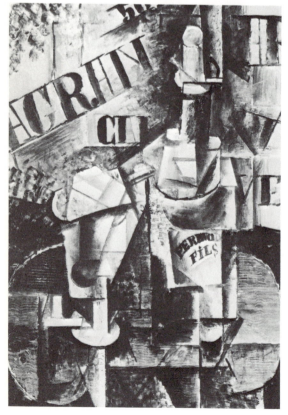

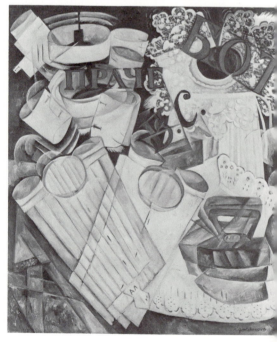

Above: Natalya Goncharova: *The Laundry*, 1912.
The Tate Gallery, London

Left: Pablo Picasso: *Bottle of Pernod*, 1912.
The Hermitage, Leningrad

the response to Cubism was pervasive and long-lasting

below: Marc Chagall: *Nude Outside the House*, 1911

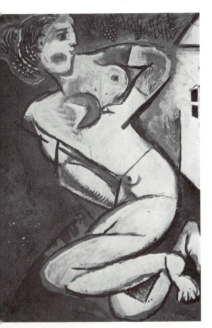

Mikhail Larionov: *Self-Portrait*, 1912. Private collection, New York. A humorous response

Picasso.

Far left:· Ivan Puni: *Chair and Hatbox*, 1917–19. The George Costakis Collection, Athens

Left: Ivan Klyun: *Copy after Pablo Picasso*, mid-1920s. The George Costakis Collection, Athens

Shchukin ordered both of these paintings
from Matisse. *Woman on a High Stool* was never
delivered because of the outbreak of war.
Portrait of Mme Matisse was the final work
by the artist to arrive in Moscow

Above: Henri Matisse:
Portrait of Mme Matisse, 1913.
The Hermitage, Leningrad

Left: Henri Matisse:
Woman on a High Stool, 1913–14.
Private collection, New York

the writer and mystic Sergey Bulgakov found the 'cubist weight' too heavy: 'This ice in the heart, this non-love for Divine creation is strangely the pathos of his work. ...'[19] Pertsov referred to Dostoyevsky's 'cramped hut filled with spiders' and noted, 'Indeed this room is something like that hut, and spider-like impressions are created by these sinister canvases.'[20]

For many, Shchukin's collection was a disjointed, outrageous assortment, without guidelines or philosophy. When asked if there was a pattern, a sequence to his selections, the Russian replied: 'To understand, look at the first painting, look at it very, very carefully. Absorb it. Realize you would have done the same thing.' Shchukin repeatedly stressed the continuity of his collection. For him, it had grown from a series of individual masterpieces to a complex entity with the form, energy and logical progression of a fugue.

He would stand in front of a favourite picture, his hands in the pockets of his rumpled suit, rocking back on his heels, as he endeavoured to justify his involvement with these works – his basic message: 'Ex Occidente Lux'.[21] Occasionally, because of his stammer, words would not keep up with ideas, but he had become a convincing and informed advocate. The years of scepticism and derision had sharpened his insights without embittering his disposition.

Years before, the first Gauguin had been hung circumspectly in his dressing room, hidden from all but his closest friends. Now he took pleasure in circulating among his guests where he could hear the exasperated comments of conservative critics.

Shchukin was able to restrain his zeal when there was no possibility of conversion, but if a question was probing, an objection serious, or debate truly impassioned, his words could be heard above all the rest. He loved the stimulation and excitement of these moments, and for this reason his special audience was the intense, responsive band of artists which appeared regularly week after week: Mikhail Larionov, unfailingly curious and assertive, with whom he had developed a close friendship; Natalya Goncharova, Vladimir Tatlin, Ivan Klyun and his friend Kazimir Malevich. A touchy mixture of arrogance, aggressiveness and creativity, they were young, poor, frequently at odds with each other, but for the moment, united in their fascination with the new pictures. For Shchukin, their spontaneity provided a stimulating contrast to the years of hostility and polite reserve to which he had become accustomed.

In contrast, the businessmen and members of the aristocracy who came to these Sunday gatherings were often condescending or abrasive. Occasionally the great hall, presided over by the giant unconcerned denizens of *Dance* and *Music*, became an arena for debate. Prince Shcherbatov, as always, was one of Shchukin's most prominent adversaries. As a personal guest over the years he had become familiar with the paintings, but he was attracted to the public sessions by the opportunity to observe their effect on the young Moscow art

world. He recognized the dimension of the merchant's accomplishments, but was outspoken in his opinion that poor Sergey Ivanovich, the 'conspicuous money bags from Moscow', had been plundered by a group of rapacious art dealers. In his view, Shchukin neither understood nor enjoyed the art he assembled, but was motivated by a desire to establish himself in the Paris art world and to emerge on the Moscow social scene as a leader of the avant-garde. His analysis of his friend's motives was ambivalent. He conceded the effectiveness of his role in the Sunday forums: 'Then Sergey Ivanovich relinquished his role as host and became a lecturer and a mentor, clarifying, leading and enlightening Moscow – he became an expert, a propagandist.'[22] At another time Shchukin became 'a dodgy merchant publicist'[23] pursuing the role of innovator and forward-looking collector.

Shcherbatov's suspicion that Shchukin was attempting to advance his reputation and standing in the community seems ill-founded in light of the widespread consistent opposition he received from his peers. Shcherbatov regarded Moscow with a touch of St Petersburg hauteur, and Shchukin can scarcely have enjoyed the regional condescension implicit in his guest's comment that while he was not devoid of flair, he revealed all of his 'provincialism' in trying to win the 'admiration of the "backward" Muscovites'.[24] Shcherbatov, who considered Matisse 'a talented but inconsistent and mischievous artist', found *Dance* 'unbearable in its insolence'. 'Tell me, Sergey Ivanovich, why did you buy this – forgive me – bad Matisse? And at such a price – 45,000 francs!' It was at this time that Shcherbatov noted with surprise that his host 'was proud and did not appreciate criticism of the things he had bought.'[25]

Shchukin did not pretend to any divine insights, confessing that he often bought a painting without understanding it, moved by an impulse that he could not explain. His struggle to understand the 'hidden charms' of his collection struck Shcherbatov as 'touching and comical'. Shchukin impulsively unburdened himself one day after the arrival of a picture by Matisse: 'You know, I privately hate this picture myself, have been fighting with it for weeks, curse myself and almost cry that I bought it. But lately I feel that it has begun to overpower me.'[26] Shchukin spoke of this conflict to Shcherbatov and others many times, and it is probable that he felt threatened periodically by the increasing scale and audacity of his project. Matisse later remembered this attitude:

> One day he [Shchukin] dropped by at the Quai St Michel to see my pictures. He noticed a still-life hanging on the wall and said 'I like it, but I'll have to keep it at home for several days, and if I can bear it, and keep interested in it, I'll keep it.' I was lucky enough that he was able to bear this first ordeal easily, and that my still-life didn't fatigue him too much. So he came back and commissioned a series of

large paintings to decorate the living room of his Moscow house. ... After this he asked me to do two decorations for the palace staircase, and it was then I painted *Music* and the *Dance*.[27]

Shcherbatov observed that 'he went through the same thing with many canvases by Picasso, paying a great deal and suffering in the depths of his soul – forcing himself to admire them.'[28] Yet when the merchant led his guests into the Picasso Room, he could say of the painter: 'Of course he is right, not I.'[29]

In addition to the radicals, Shchukin's visitors comprised members of traditional art circles. His audience included the most disparate and contrasting personalities in the Russian art world. On a single Sunday, the group in Picasso's 'museum of the stone age'[30] might include those painters and poets who, like the Burlyuks, found in Picasso's shattering of form an affirmation and mirror of the times, and Benois, pursuer of harmony and line, lover of Fragonard and the painted delicacy of eighteenth-century laces and silks.

Korovin and Serov were two of Shchukin's most eminent and respected opponents in the matter of his later acquisitions; both of them now successful artists and members of the faculty at the Moscow School of Painting, Sculpture and Architecture. Korovin had encountered Impressionism during his first visit to Paris in 1885, and though he was technically associated with the Wanderers, he had been impressed by the freedom and colour of the Impressionists' landscapes and had incorporated some of their theories into his own work. The series of glowing canvases which followed his visit abroad had earned him the title of 'the Russian Impressionist'. In 1901 he was appointed to the Moscow College where he taught many of the most promising members of the new wave. In addition to Larionov and Goncharova, he worked with the Symbolist Kuznetsov, with Kuprin and Mashkov, Malevich and Tatlin. He had received his training under Polenov who had brought him to Abramtsevo, and with Polenov he shared an openness to new trends in painting.

At the time Korovin visited Shchukin's open house, he had decorated the Russian Pavilion in Paris in 1905–06, was a member of *Mir iskusstva*, and had created the scenic designs for Diaghilev's production of *Le Festin* in the first Paris season of the Ballets Russes in 1909. With these international credentials, it can be assumed that his opposition to Shchukin's Cubist works was not rooted in rabid nationalism or reaction. Bearded and informal, something of a gypsy, he had been a progressive influence at the Moscow School of Painting, Sculpture and Architecture from the beginning of his tenure. His popularity with the students was the result of a 'frank and open manner' and an ability to 'reach at once an intimate footing with everyone'.[31] However, now in his students' reaction to the work of Cézanne, and particularly to Picasso, he perceived a baneful effect, and he was disturbed to find himself among the conservatives.

His colleague Serov, who had become Russia's foremost portrait painter, lived across the street from Shchukin, and as a personal friend he had watched the growth of this disturbing collection with fascination and apprehension. Serov's first violent rejection of his neighbour's Cézannes had been followed by regular visits to the house; his obsession with *Mardi Gras* in particular had increased until he finally admitted: 'They are always on my mind.'[32]

Benois considered Serov 'the strongest bulwark in Russia of pure, free realism'[33] and in the summer of 1909 he had accompanied Diaghilev, Benois and Korovin to Paris, lending his support to the historic season of opera and ballet which opened at the Théâtre du Châtelet. He was no longer deeply involved in scenic design now that portraits took most of his time, and his participation in the Paris première had been limited. However, he had seen the posters advertising the opening, based on his famous drawing of Anna Pavlova, plastered all over the kiosks of that city, and his father's opera *Judith*, for which he had designed the scenery, had been presented during the season. Now, on his return to Moscow, he was drawn to the excitement at the Trubetskoy Palace.

As with Korovin, it was in his role as a teacher that Serov was most voluble in his opposition to Shchukin's collection. The artist felt threatened by the effect of these paintings on the young. He feared that the collective impact would distract the neophyte from a necessary discipline and evolution. Serov knew from experience the restlessness of the new breed of Russian artist; he had taught the Burlyuks, Goncharova, the revolutionary poet Vladimir Mayakovsky, and Mashkov, and found in each an eagerness for change and a strange vulnerability. His own success had been based on what Benois referred to as the 'steady quiet development' of his work.

Now he was dealing with young people who believed with David Burlyuk that 'Art is a distortion of reality and not a copy of it.'[34] In an emotional discussion he confided to Shcherbatov his 'horror at the influence the paintings imported from Paris were having on his students.'[35] For a professor it was difficult to maintain a rational conversation with a student who insisted upon submitting his own dark and subjective version of reality. The ensuing dialogue usually followed a pattern: 'Can you not see the subject is blonde?' 'Yes, but this is how I see her.' (Pause) 'Have you been to Shchukin's?' After the merchant's exotic offering, student artists were increasingly reluctant to return to the orderly regimen of the college; the sessions seemed mundane and dreary. Finally Serov observed despairingly, 'Everyone is seething in his own way; they want to catch up with Paris and they don't want to study. After all this hot pepper, school fare is not to their liking, they want to get rid of teaching and listen to nothing further. Enough! It's all a lot of nonsense.'[36] In 1909, two years before his death, Serov resigned from the College.

When Shcherbatov accused the merchant of injecting 'a dangerous poison

which contaminated youths during their formative years in school', he saw this decadent art 'giving rise to a hurried, fanatical imitation, uncontrollable, senseless and pitiful.'[37] The rhetoric sounds too strident for the circumstances, but in a time of mounting crisis, art in Russia was subject to extraordinary pressures, not all of them aesthetic. For the 'nationalists', Russian Realism exemplified historical continuity and spiritual strength as opposed to the disintegration and apparent nihilism of the latest forms of Western art. The impulse to turn inward was felt not only by the Wanderers and their followers, but occasionally by the radicals, torn between the iconography and primitivism of their own heritage and the sharp explosion which splintered reality and represented an unknowable future. Shchukin refused to believe that exposure to the best that the West had to offer could do other than strengthen the Russian painter's resources and place in his hand the tool with which he might carve out his own path.

Shchukin realized that many of his merchant colleagues were uneasy with his collection for a different reason. They despised the pictures, but in spite of their distaste they retained a great respect for his financial acumen. For these men, the unsettling suspicion remained that a great opportunity to turn a profit was being overlooked. Sergey Ivanovich did nothing to lessen their uncertainty with his constant reminders of how valuable they were destined to become. He was known at the Stock Exchange as a hard-headed businessman, and the fact that he was pursuing this bizarre art with a singular fixity was disconcerting.

But what was folly to the merchants was virtue to the artists, and Shchukin was exempted by them from the usual criticism they applied to his associates. Collectors were not always admired by the painters they subsidized. Bely wrote scathingly of the pretensions and condescensions of certain merchants and the tendency to exploit their protégés: 'Would-be Savva Mamontovs suddenly descended upon us trying to get something from us with the persistence of goats.'[38] Bely's resentment stemmed from the merchants' use of art as a social ploy. This antagonism was echoed in the mocking words of David Burlyuk: 'Complacent bourgeois, your faces shine with the joy of understanding. You have fathomed the profound meaning of the pictures.'[39]

In the labyrinth that was the world of Russian art, the most violent arguments were not those between the old guard and the young rebels; these were the inevitable consequence of change, passionate but predictable. The divisions were deepest within the ranks of the modern artists. Differences were papered over endlessly, only to split open more widely than before. Vladimir Tatlin and Kazimir Malevich were an example. In Picasso's room they were roped together like two hostile mountaineers on a peak. Each man, subjected to the same stimulus, drew from the experience a different revelation. The burly, leonine Malevich with his Slav face and dark gaze, bulky frame balanced dangerously on

one of Shchukin's spindly straight-backed chairs, was a fixture. Unlike Bulgakov or Pertsov, he saw no demons here, no threat of madness or disintegration: 'The new Cubist body that has been built up is not opposed to life; it is a new conclusion drawn from the previous ones on the formation of painterly movement, and has nothing national, geographic, patriotic or narrowly popular about it.'[40] In Shchukin's home he noted that Cubism revealed not only the visible, but the remembered, the intuited aspect of the object. He saw evolution, in which the weight of Cézanne's forms was shattered by Cubism and animated by the dynamism of Van Gogh. Later he wrote of Cubism-Futurism-Suprematism as a single indivisible process. 'Cubism is freeing the artist from the dependence on the creative forms of nature and technology that surround him.'[41] Shchukin had provided an introduction to 'the world of his intuitions'.

From time to time Tatlin joined him in the Picasso Room. In his rough clothes, wheaten hair carefully brushed, Tatlin was obviously poor. The strange, intent light eyes gave him an ascetic air, and like Malevich he was an incongruous figure in these sumptuous surroundings. He was less articulate than Malevich, but it was only a short time later that he set out for Paris where he met Picasso.

In one sense Shchukin's critics were right; his collection was a radicalizing force. They erred in assuming that the result would be a series of sterile copies, that the search for new forms would stop with Cubism. 'Forms move and are born and we are forever making new discoveries,' wrote Malevich,[42] and he translated the broken rhythms into his own metaphysical terms, always 'seeking to bring from what already exists the basis for new phenomena.'[43] His exposure to Cubism was evident immediately in his work. In 1911 he began to move from the blocky figures of his primitive phase into the more intricate geometrics of *Morning in the Country After the Rain* (1912), and from there to the skilful interplay of forms apparent in his portrait of Mikhail Matyushin, the Futurist artist, painted in 1913. The Picasso Room was a revolutionary blueprint of the stages through which an artist might pass in the course of a mere fifteen years. 'Hurry! For tomorrow you will not recognize us.'[44] When in 1913 Malevich conceived of Suprematism, it was a constantly evolving system, 'a system constructed in time and space, independent of all aesthetic beauties, experiences, moods'.[45] He 'found the face of a new art', moved through the mathematics of Cubism and Futurism and carried the square and the rectangle into the realm of non-objective art.

Tatlin in contrast was a utilitarian, an engineer who viewed art as a sociological tool. He found in the structures of Cézanne and Picasso not cosmic dreams, but the scaffolding of Constructivism. The importance of this discovery was implicit in the journey he made to Paris in 1913. He was eager to meet Picasso, to observe him at work and listen to his theories. In Russia, debate was

Pablo Picasso:
Woman with a Fan, 1908.
Pushkin Museum, Moscow.
Shchukin's first Picasso.
'From that time on, the Russian
was a partisan of Picasso.'
—Fernande Olivier

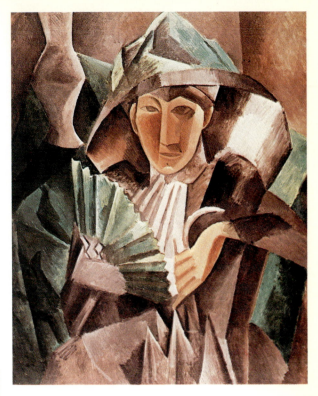

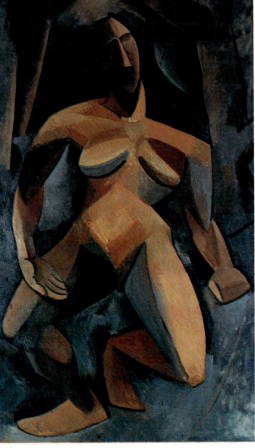

Pablo Picasso: *The Dryad*, 1908.
The Hermitage, Leningrad.
Russian critics were particularly
incensed by this addition
to the Shchukin collection

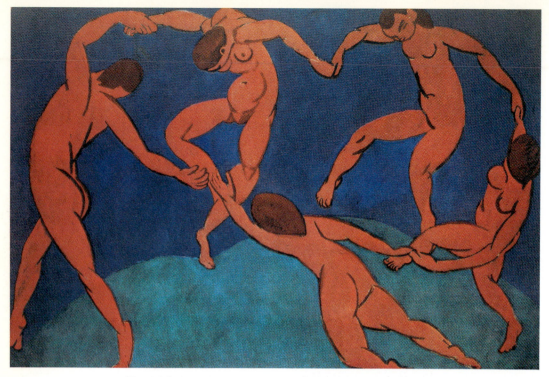

Henri Matisse: *Dance*, 1909-10. The Hermitage, Leningrad

Henri Matisse: *Music*, 1910. The Hermitage, Leningrad
A contemporary Russian critic said of these works, among the most controversial in
Shchukin's collection, each measuring nearly 13 feet across: 'A Russian viewer will usually be
scared away by the insane figures . . . who form . . . some kind of wild *grande ronde*'

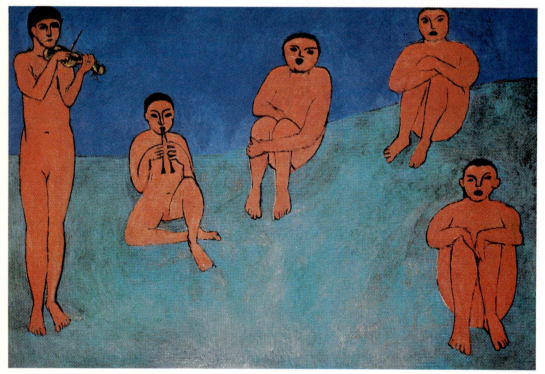

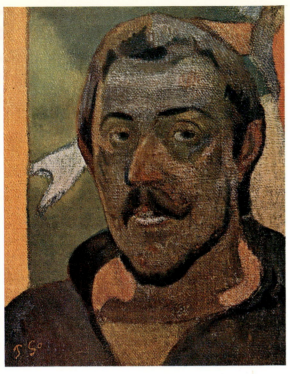

Paul Gauguin: *Self-Portrait*, 1890.
The Hermitage, Leningrad

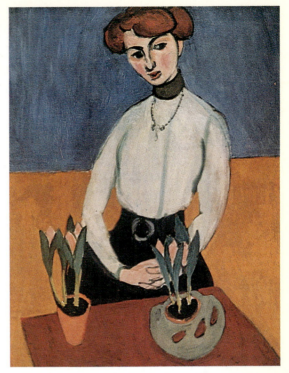

Henri Matisse: *Girl with Tulips*, 1910.
The Hermitage, Leningrad. The stylization and brilliant
colours of Matisse, the emotional intensity of Gauguin,
as revealed in Shchukin's collection, were reflected
in the work of Malevich at this time

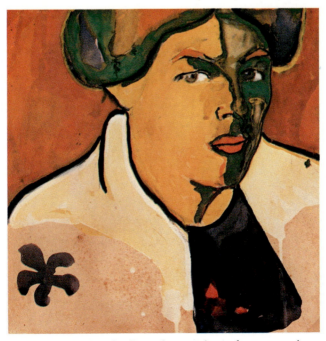

Kazimir Malevich: *Portrait*, 1910 (gouache on paper).
The George Costakis Collection, Athens

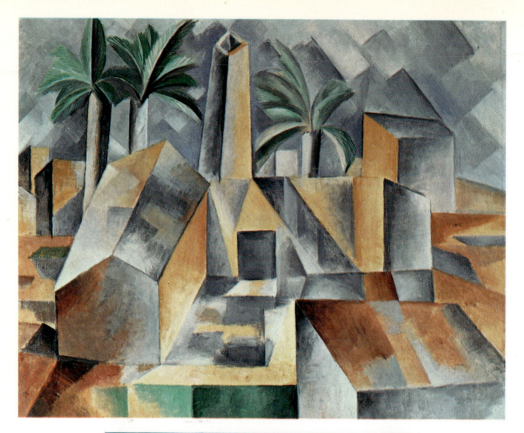

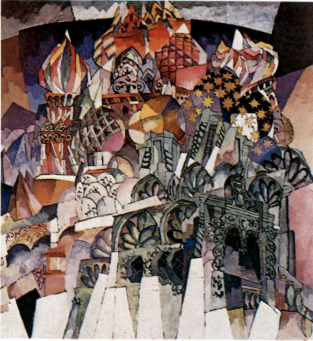

Top Pablo Picasso: *Factory at Horta*, 1909. The Hermitage, Leningrad

Above Aristarkh Lentulov:
St Basil's Cathedral, Red Square, 1913. Tretyakov Gallery, Moscow.
Lentulov here presents a Russian variation
on the Cubist theme

an organic part of the creative process, but Tatlin soon discovered that Picasso was no theologian. Impatient with 'bistro arguments' which interrupted his work, he cut off all questions: 'Do not talk to the driver.' Kahnweiler wrote that there was no formal Cubist doctrine. 'No one really formulated it for the simple reason that there was no theory. Picasso carefully avoided all theory in what he said.'[46]

If Tatlin's pilgrimage yielded no verbal insights, his timing was flawless. His most imaginative concepts were reinforced by Picasso's current work. In 1912, the Spaniard had begun to experiment with three-dimensional structures. One of the earliest, *Guitar* (1912), an arrangement on coloured paper, folded and glued, added a third element to the familiar papiers collés of the period. A pen and ink *Study for a Construction* (1912) anticipated Tatlin's later Constructivist creations. In 1913 Picasso had begun to work on a wooden Cubist structure which was a direct progenitor of Constructivism.

In 1915 in Petrograd, Tatlin participated in '0.10. The Last Futurist Exhibition' (December 19, 1915 – January 19, 1916) which had been organized by his friend and admirer the painter Ivan Puni. The exhibition featured work by Puni's wife Kseniya Boguslavskaya, Ivan Klyun, Mikhail Menkov, Olga Rozanova[47] and Malevich. Within this group, the words 'intuition' and 'dynamism' helped to define a method by which new forms of construction could be attained. A blend of geometrical calculation and metaphysics, it was a philosophy opposed to the more rational calculations of the Knave of Diamonds and the utilitarianism of Tatlin. A confrère and collaborator with Malevich, Puni also rejected 'the tyranny of the object', and in this spirit he exhibited a board which had been painted green. On this occasion, Malevich introduced Suprematism to the Russian public in *Black Square on a White Background*, complete with manifesto. Tatlin issued his own declaration at the opening, but his theories were lost amid the dramatic impact of the Suprematist idea. It was one thing to distort reality, but to deny it altogether as did Malevich and Puni, or like Rozanova reduce it to its basic components, was infuriating to the critics. The exhibition aroused Benois's wrath and prompted his violent tirade against the 'buffoons' who proclaimed their new art in such a 'horrible, tearing, hoarse voice.'[48] The tensions and rivalries were so strong that Tatlin's endless differences with Malevich erupted into a serio-comic fist fight. The two men and their followers fell to pummelling each other until they were prised apart. Finally it was agreed that the rivals could not exhibit side by side, and Tatlin with his admirers moved to another area. They had the last word, however, when over their section a sign was erected: 'Exhibition of Professional Painters'. Despite the humour of the incident, it was another illustration of the turmoil on the Russian art scene. Buried under the mass of esoteric pamphlets and proclamations which flooded Petrograd and Moscow were fundamental disagree-

ments as to the nature, future and purpose of art in a deteriorating society.

Tatlin and Malevich would become the two giants of the post-revolutionary period. Their philosophies were dissimilar, but in Shchukin's house they had shared an experience which liberated their imagination and provided new insights.

Another Sunday visitor, Mikhail Larionov, was among the most eclectic of the younger painters. Because of his artistic curiosity and facile brush, his work, like a piece of litmus paper, is particularly revealing when it comes to assessing the influence of Western art on the emerging generation in Moscow. Larionov's first efforts, like those of many of his contemporaries, had been reflections of his love of the Russian countryside, particularly the radiant summer scenes at Tiraspol where he was born.

In 1900 Larionov was a student of Levitan and Serov at the Moscow Academy where he painted a landscape from his childhood, sparkling and delicate, full of colour and warm sun, which was closer to Monet and Pissarro than to his Russian professors. Restless and ambitious, Larionov was eager to establish his credentials in Moscow as a leader of the most progressive trends. By 1902, at the age of twenty-one, he had moved into his Impressionist period. *Sunset on the Black Sea* had its origins in Étretat or Belle-Île. In 1903 he expanded his exploration, and the rosy contours of a Bonnard nude alternated with the shimmer of Russian fields. As early as 1905, the influence of Gauguin was apparent in *Luxuriant Landscape* and *Bare Feet and Foliage*; the tropical greenery and golden sunset hues were unmistakable.

In 1906 Diaghilev invited the young man to show his canvases with those of his friends Natalya Goncharova and Kuznetsov at the Russian exhibition of the Salon d'Automne. With Kuznetsov he had made his first trip to Paris for the occasion. From his small hotel near the Madeleine, Larionov could wander through the streets of Paris and lose himself in a rich and random display of contemporary masterpieces. The Salon des Indépendants was showing Matisse's *Joy of Life* together with an extensive selection of Gauguins, and in the year of Cézanne's death, numerous exhibitions of his work were suddenly available.

According to Shcherbatov, Larionov was 'stupefied' by the 'Paris innovations in art', and he became an observer and reporter for his friends in Moscow. His enthusiastic communiqués contained photographs of the most avant-garde paintings the city had to offer, accompanied by descriptions of the colours and structures, as well as minute analyses of the problems and methods which he discerned. 'The letters were read with rapt attention and reverence as items of news and indications from the city of light.'[49] But despite the richness of the exhibitions, nothing in Paris could equal the examples of modern art which would suddenly become available in Moscow after 1909: the dense cluster of

Gauguins; the *Dance* and *Music* of Matisse, the assortment of Cubist masterpieces which had not yet been envisioned.

A few months later, after his return to Moscow, Larionov's work reflected the influence of Cézanne and Matisse.[50] Yet he was not merely a copyist, for despite the ease with which he absorbed the theories of others, his pictures retained an individuality. After each encounter, he stitched the strands of Bonnard, Gauguin, Matisse and Cézanne into his work; occasionally the results were raw, but gradually as the new influences were assimilated, the threads dissolved and his own tapestry became visible.

Periodically Larionov returned to his heritage for inspiration; during a stint in the army he produced a series of Russian soldiers, barbers, bakers and sailors which are among the most individualistic and vital of his works. Portrayed with a particular electricity, these kinetic figures possess the sharpness of woodcuts or the old Russian *lubki*.

By 1912 Larionov had originated Rayonism, a study of spatial relationships and the effect of light rays on objects. Three years earlier he had painted *The Baker*, a work in which the man's figure is enveloped in the red glow of the oven fire in the background. Over the next few years his subjects became increasingly obscure; merely devices by which he could explore the results of illumination on a surface. As it grew less visible, form was sensed as a presence against which the rays rebounded in a brilliant pattern of reflections. Finally, when reality had been absorbed completely, all that remained were the intersecting shafts of light which were the essence of Rayonism. Like Malevich and Tatlin, Larionov arrived at abstraction by his own road.

Despite the intensity with which Larionov pursued Western trends, he was subject to an intermittent disenchantment. In 1913 in the Rayonist-Futurist declaration of principles, he turned to the art of the East: 'We are against the West which is vulgarizing our Oriental and Eastern forms and rendering everything valueless.'[51] Yet he always returned to his obsessive analyses of Cubism, Futurism, Orphism – of Cézanne and Picasso.

Larionov's relationship with Natalya Goncharova was remarkable for its closeness and longevity. Born in the same year, 1881, they met at the Moscow College in 1900, and until Goncharova's death in 1962, they shared their personal and professional lives. The two seemed to balance each other; Larionov, gregarious, burly and overwhelmingly energetic, Goncharova with an aura of remoteness and fragility. Tall and slender, with intense dark eyes, her delicate appearance was deceptive; she conformed to none of the clichés about female artists. There was no powdery prettiness in her work; it was as strong and inventive as that of any of her associates. As a girl she had been eager to study architecture. When finally she was convinced that her chances in that masculine preserve were slim, Goncharova turned to the plastic arts. Prince Pavel

Trubetskoy, rare aristocrat in the arts and a pupil of Rodin, whom Apollinaire called 'the Michelangelo of miniatures', was her teacher, and in 1902 under his tutelage she won the Gold Medal at the Moscow School of Painting, Sculpture and Architecture. However, two years earlier she had met Larionov, and increasingly her interest was caught up in painting.

An extremely skilful artist, she could have settled for the easy popularity of decorative and charming works. There is the imprint of Impressionism on the hazy, intimate clutter of *Still Life with Shoe and a Mirror* (1906), and in *Winter Night* (1904) she created a promenade, light and magical: two bundled and befurred ladies, barely articulated, with their whimsical sketch of a dog; the theme saved from triteness by the remarkable beauty of the setting. It contains the mystery and hush of a snowy Russian night; a symphony of blues, from the puffs of snow in the silvery birches to the mauves and deep midnight hues of the streaky sky. The wall, with its solid sculptured patterns, which bisects the canvas, is a reminder of Bonnard and lends weight to the work. The assurance is unusual in one so young. In 1906 Goncharova sent four pastels to Diaghilev's Russian exhibition at the Salon d'Automne and this international exposure enhanced her reputation at home. Ivan Morozov bought her painting *Young Men Skating* and her canvases began to appear in important Moscow collections.

Goncharova's journey through the succeeding stages of Western art was less systematic than Larionov's. In 1906 a Slavic Neo-Primitivism began to emerge in her work. Mingled with the French-inspired paintings were scenes of Russian peasants, saints, whirling skaters and village life. The eternal Russian legacy is apparent in this aspect of Goncharova's art. Her group of prophets, madonnas and archangels is related to fourteenth-century spirituality and the icons of Rublyov. She was a finer draughtsman than Larionov; her initial interest in sculpture and architecture may have been responsible, and she moved into an area which Larionov touched only peripherally.

Gradually Goncharova began to reflect her exposure to the work of Picasso. Her *Fertility Goddess* (1909) was a response to Negro art. A tentative, diffuse effort with little feeling for the idiom, it was grotesquerie without power. A more sophisticated foray was the dashing *Portrait of Larionov* (1911) in which the fragmentation of surface reality was skilfully treated. Her *Factory* of 1912 bore the impress of Horta, and with *The Laundry* of that same year she handled the ingredients of Cubico-Futurism with flair. Benois was 'deeply infatuated' with the work of Goncharova. He deplored her Cubist and Futurist efforts, but her Russian decorative genius for the theatre delighted him. In 1914 when she created the brilliant décors for Diaghilev's production of *Le Coq d'or*, he wrote, 'Goncharova conquered Paris.'[52]

These were only a few of Shchukin's visitors: sceptics, acolytes, converts, rebels, who were affected by his collection. The sudden revelation of his

paintings accelerated the ferment which was always present. The Cézannists and Cubists who comprised the Knave of Diamonds group – Falk, Lentulov, Kuprin, Mashkov – became increasingly involved with the lapidary rearrangement and cohesion of form. Larionov and Goncharova, always restless and experimental, found the structural emphasis, the constant theorizing, static and mathematically deliberate. In 1911 they denounced the influence of the West and left the Knave of Diamonds to form the Donkey's Tail, during which time their work was characterized by a vivid Russian Neo-Primitivism. Though they claimed to find their inspiration solely in Eastern art, Goncharova's primitivism was touched with Gauguin's decorative Symbolism and the fantasy of Rousseau. Both she and Larionov were attracted to the rhythms and constant motion of Futurism, the art of the machine, which was, after all, a form of kinetic Cubism.

These painters devoured the art to which they were so suddenly exposed, and tore through Impressionism, Fauvism and Cubism in less than a decade. In this brief span they sought to digest a banquet which had taken fifty years to prepare. The isolation and insularity in which they had matured resulted in an insatiable desire for outside stimulation and a headlong rush to catch up with Paris. The year 1909 was the beginning of a period which saw a torrent of Russian paintings in the manner of Gauguin and Matisse, and later, of Cézanne and Picasso. For all the feuds, the incestuous in-fighting which erupted sporadically, it is inescapable that out of this obsession with the West came an art that was violent, peculiarly Russian and born out of social upheaval.

The painter and critic Vladimir Markov wrote: 'Chance opens up whole worlds and begets wonders.'[53] Only in Shchukin's home could these artists perceive the entire progression of modern Western art, and their subsequent efforts revealed the emancipation of the experience.

Though he had never bought one of their canvases, there was no animus toward Shchukin. Ivan Sergeyevich remarked, 'I usually shared my friends with my father'; and indeed, Sergey had an exceptionally strong rapport with bright, creative young people. The students 'adored him',[54] flocked to his house and valued what he had to offer. Most of the artists were radicals, whole-hearted supporters of social change: Malevich, Tatlin, the Burlyuk brothers, the painter-writers Grabar and Bely, yet they all became involved with him in varying degrees. As a pillar of the establishment, he observed their political orientation with detachment, but in the area of art he met them as equals, and his openness and enthusiasm combined to obliterate the differences in age and points of view.

Ivan Sergeyevich had memories of coming home and finding his father absorbed in conversation with David and Vladimir Burlyuk. David believed that 'modern art rests on three principles: disharmony, dissymmetry and disconstruction. Disconstruction is illustrated by the distortion of lines, planes and colours.'[55] Shchukin's latest Picassos validated his thesis. The brothers 'would

come and ask to come again' and Shchukin, pleased with his success among the most intractable of the moderns, would offer the guest book for their signatures: 'For this week and for next week too.'

Grabar was particularly perceptive in his analysis of Shchukin's appeal to a later generation. He recognized two indispensable qualities: irreverence and a sense of adventure. He observed, 'Shchukin was by nature and by temperament a collector of a lively art, the art of today, or more correctly of tomorrow. He was comforted by the thought that the pictures he bought were not to be found in museums, and therefore cost relatively little. This view was dictated not by niggardliness but by the sporting turn of mind of a man eager to make a mock of the thick-headed rich men who did not know how to look at things.'[56]

For a full understanding of the instantaneous impact of Shchukin's collection on the Moscow art world, it is essential to remember the social framework which surrounded it. Suddenly the old norms were shattered; yesterday's tenet was today's cliché, and the search for new values was a part of every level of contemporary culture. For the Muscovite painter, physical and cultural remoteness had been a way of life until the close of the previous century. He had been raised in the shadow of the Wanderers, and the rigidity with which the influential old guard viewed foreign influence and experimentation made the city a cloister for the emerging generation. To be an artist in Moscow was to be a Slav.

This artistic quarantine was reinforced by economics. The students of the city were for the most part extremely poor, and the opportunity to visit the West, to familiarize themselves with the newest developments, was seldom open to them. They were dependent upon the bourgeoisie for their livelihood, and the taste of this segment was, with few exceptions, conservative, conditioned by the standards of Repin, Stasov, Makovsky and Surikov. Benois has written that as late as the 1890s 'all of Moscow idolized Surikov. ...'[57] For the work of a newcomer to be shown in the important exhibitions of the city it had been necessary to follow the path of the Wanderers, a situation which led to a form of self-censorship. It was not until 1898, when Diaghilev broke this monopoly with his joint showing of the art of Moscow and St Petersburg, that aesthetic distinctions between the two cities began to blur.

Finally, at the beginning of a new epoch, it was no longer possible for a young painter to continue to produce indefinitely the familiar landscapes and portraits, the distraught renderings of social injustice and persecution. A new force was trying to free itself, and in the process there emerged a highly stylized art, led by the Vasnetsov brothers, Roerich and Surikov, which drew on religious themes, Russian folklore, bogatyrs and scenes of medieval Moscow: a colourful and decorative manifestation, but somewhat iconic and inner-directed.

The relative swiftness with which Impressionism and subsequent movements

from abroad were welcomed and absorbed by the Moscow painters reflects not only their rebellion against the isolationism which surrounded them, but also the importance of timing. Impressionism appeared in Moscow at a moment when the original energy of the Wanderers had become paralyzed by success. Foreign books and periodicals were the main source of information. Choice was limited and reproductions were frequently inferior, but these publications were coveted, passed around and studied eagerly.

This reaction was in contrast to that of St Petersburg. Moscow's sequestration from the West was a crucial element in her artists' ready acceptance of new techniques. Many St Petersburg students had been influenced by their European training, reacting to Impressionism with the caution and inhibition of the French salons.

The Moscow artists were less concerned with the formalities of Western classicism. Their first response, uncomplicated and basic, was to colour rather than to form. No cerebral preference for formal line separated the Muscovite painter from the glimmering, sensuous, spontaneous world of the Impressionists and their successors. In this city the artist was surrounded by the vivid undiluted hues of Old Russia and the fairy-tale improbabilities of Orientalism. Impressionism was a wedge, and the new art took hold here because it was superimposed upon an emotional and aesthetic sensibility with which it had much in common. A sense of experimentalism, of infinite possibilities was instilled. Mayakovsky expressed the mood when he defined Larionov's Rayonism as a Cubist interpretation of Impressionism. All this could have happened without Shchukin; but his collection played its part in the existing cultural ferment as a catalyst which coloured Russian art until the onset of Socialist Realism in 1932.

In the years between 1909 and 1914, Shchukin's gallery continued to attract Western critics, writers, museum directors and serious collectors of modern art. The Russian had assembled the early landmarks of the period, and even in 1910 it was impossible to claim a complete knowledge of Matisse or Picasso without reference to this remote collection. In 1913 Shchukin wrote to Matisse about the influx of visitors:

Moscow, 10 October 1913

Cher Monsieur:
It is two weeks since my return to Moscow and during that time I've had the pleasure of a visit from Mr Osthaus, founder of the museum at Hagen, and again the visit of many museum directors (Dr Peter Tessen of Berlin, Dr H. von Trenkmold of Frankfurt, Dr Hampe of Nuremberg, Dr Polaczek of Strassburg, Dr Sauerman of Flensburg, Dr Stettiner of Hamburg, Dr Back of Darmstadt, Max Sauerlandt of Halle and Jens Thiis of Christiana). All these gentlemen looked at your pictures with the greatest attention and everybody called you a great master

('ein grosser Meister'). Mr Osthaus has come here twice (once for luncheon and once for dinner). I observed that your pictures made a deep impression on him. I spoke of your blue still life which you had done for him. What a beautiful picture I found it, and what a great development I found in your later works (Arab Café, blue still life, Mr Morozov's Fatima). Jens Thiis, director of the Museum of Fine Arts at Christiana (in Norway) spent two days in my house studying principally your pictures (the second day he stayed from ten o'clock in the morning until six in the evening). He is so taken that he hopes to buy a picture for his museum. The other gentlemen also asked where one could buy your pictures and I replied at Bernheim's in Paris or directly from you. Mr Osthaus will write you of his own impressions regarding your works. . . .[58]

Shchukin's eagerness and impetuosity are implicit in every word of this letter. He refers, as always, to his next acquisition: 'I hope that your portrait of Mme Matisse also will be a very important work.' The hastily scribbled PS is typically anticipatory. 'When will the Salon d'Automne open? Will you exhibit?' His habit of purchasing the 'important' and difficult works never abated. As time passed, the overflow from the Matisse Room was spectacular.

In a single setting, the Russian placed the joyous *Harmony in Red* together with *Family Portrait*. This last work was painted in the living room of the artist's home at Issy-les-Molineaux in the spring of 1911, before his Moscow visit. Matisse has decorated almost every inch of this large canvas with an explosion of patterns and floral motifs, and yet the dazzling designs of carpets, checkerboard, walls and sofas are as disciplined as a mosaic. In this intimate, cloistered setting, the familiar family figures are without interaction or mutual recognition – four strangers in a dream. The effect is totally exotic, as if a Persian miniature had been magnified a thousandfold.

Prince Shcherbatov was present when Shchukin 'joyfully displayed' this painting upon its arrival in Moscow after Matisse's visit. He remembers that Shchukin considered the work 'very significant' because it revealed 'the reverse influence of the Russian on the French'.[59] It is a puzzling, if minor reversal of the actual sequence, however, for Shchukin must have known that the painting had been completed before Matisse's journey to Moscow, and the style could not have been affected by the painter's encounter with Russian icons.

Shchukin delighted in contrast, as when he juxtaposed Marquet's pristine greys with Matisse's vivid *Lady on a Terrace* (1905). In the same spirit he hung the riotous *Nasturtiums and the Dance* together with *Conversation*, a mingling of decorative extravagance and restraint. He bought *Conversation* in 1912, three years after it had been completed. It was not his habit to wait for several years before ordering a picture; his impatience was a factor in the continuing vitality of the collection. However, 1909 had been the year of *Dance* and *Music*, of the richly patterned *Coffee Pot, Carafe and Fruit Dish* and the solid impact of

Nymph and Satyr. Conversation was a complete contrast to these styles. It had neither the vivid ornamentation of the one nor the dramatic immediacy of the other. The cerebration, the sense of psychological distance between the two figures which marked *Conversation,* was a departure from the more familiar canvases of 1909. For Shchukin, initially, this work seems to have been lost amid the assertive and resplendent pictures of that year. Yet after he had lived with it for a time, he wrote to Matisse: 'I find it like a Byzantine enamel because of the richness and depth of the colour. It is one of the most beautiful paintings in my memory.' Alfred Barr considered it one of the artist's most monumental canvases.

In 1913, the recently completed *Portrait of Mme Matisse* arrived at the Trubetskoy Palace. Withdrawn, flat as a prehistoric cave painting, it recreated the remoteness of *Conversation*. It bore a resemblance to Shchukin's first Picasso, *Woman with a Fan* (1908): the mysterious unseeing eyes, the elegance and control, the strange distortion and subdued colours. Shortly after the *Portrait* was received Shchukin reserved *Woman on a High Stool*, a work in the same ascetic style, and *View of the Seine*. However, these were never delivered. *Portrait of Mme Matisse* was the final painting by the artist to arrive in Russia.

Matisse requested permission to exhibit *Woman on a High Stool* in New York before shipping it to Moscow. Shchukin consented in a telegram dated November 21, 1914 which arrived at Collioure at nine-thirty in the evening:

> Content exposer New York
> Amitiés
> Stschoukine.[60]

Three months earlier, Germany had declared war on Russia. This telegram was Shchukin's last message to Matisse from Moscow.

9

WAR AND POST-REVOLUTIONARY RUSSIA

The first impact of the storm came in 1905. The next begins to grow before our eyes.

Lenin (1912)

... and so developed in Russia in the midst of a foreign war the Social Revolution on top of the Political Revolution culminating in the triumph of Bolshevism.

John Reed

Our debates are now in the streets.

Leon Trotsky (October 11, 1917)

This is a class war.

Lenin (November 23, 1917)

In 1914, with the outbreak of war, the drive toward revolution was halted by an upsurge of Slavic patriotism; briefly and for the last time, the Tsar became the symbol of Russia. On a pilgrimage to the old capital he tapped the source of ancient pride and memory, and in the oppressive heat of a Moscow August over a million Muscovites lined the streets and hung from windows to cheer as he passed. All the classic paraphernalia of a nation at war was unfolded with the Russian genius for pageantry and religious fervour.

During this period the cathedrals were crowded. In the dark interiors, the single gathering place where all Russian classes met, the bearded, sumptuously

robed priests bestowed their traditional blessings. The glorious icons, jewelled crosses and mitres, the rhythmic chants, created a golden haze of incense, patriotism and piety. Kerensky said of that moment, 'War was declared and all at once not a trace was left of the revolutionary movement'.[1] This intense exaltation could not be sustained. Within a few weeks the mood of invincibility was shattered abruptly by the demoralizing defeat at Tannenberg. A quarter of a million men were lost in a few days in the forests of East Prussia and suddenly the banners vanished, replaced by the unrelenting lists of wounded and dead which papered all the walls and shop windows of the cities. The summer of 1915 saw the agonizing retreat from Galicia – 1,500,000 casualties could not be concealed or justified. Yesterday's ceremonies seemed bitter and far away.

Unlike St Petersburg, Moscow had been affected only recently by the traditions of internationalism, and here in the Slav heartland the rage was primal and atavistic. Mobs rioted in front of the Kremlin; shops and businesses with German connections were destroyed. A colleague of the Shchukins and Morozovs, a Russian-German textile magnate with the untimely name of Ludwig Knop, was a target. His country home was sacked and burned, and according to the British consul, R.H. Bruce Lockhart, who was an observer, 'the police could or would do nothing'.[2] Knop was one of the most powerful figures in Russian financial circles. Not merely a wealthy businessman, he had played a major role in the development of the country's nascent textile industry. With his international contacts and vast resources, he had aided the Morozovs in importing industrial machinery from Britain, and thus had broken Russia's reliance on foreign manufacturers. A few years previously an attack on his property would have been inconceivable; the Cossacks would have been called out to put down any disturbance. The approaching anarchy was clear to see.

The first explosions of public bitterness were directed at the Germans, but soon all the old anger and frustration returned, the class hatreds, temporarily forgotten, split open like infected wounds. Within two years the crusade to defend Russia would be denounced as an imperialist war and the people's rage and disillusion turned against the establishment and its dominant classes.

In 1915 Shchukin was a conspicuous member of an endangered caste. After Pyotr's death in 1912, his was the sole responsibility for I.V. Shchukin and Sons. Now, restless and trapped by historic events over which he had no control, he spent his days contending with war-time shortages and an endless flow of bureaucratic directives. Although he was active in the affairs of the Institute of Psychology which he had endowed as a memorial to his wife Lidiya, and as a member of the board of the Tretyakov Museum, he was nonetheless uneasily aware that he was hardening into the prototype of the conservative Moscow businessman. The role of aesthetic rebel had added a necessary

dimension to his life; he now missed the challenge of the Paris ateliers, the sessions with Vollard and Matisse.

In a moment of mingled boredom and nostalgia, he decided to become a painter himself; he set up his easel in the main salon at the Trubetskoy Palace where, surrounded by masterpieces of the twentieth century, he attempted to emulate the paintings which he could no longer acquire. He was depressed to find that he produced 'only banalities'.

Shchukin made some other uncharacteristic mistakes at this time. Shortly before the Tsar's abdication, in an effort to re-create the old excitement, he attempted to repeat his spectacular financial coup of 1905. Again he set out to corner the textile market, wagering that the domestic chaos would subside once more. He had always been a cool gambler, respected for the skill and timing of his wagers, but this was an abysmal manoeuvre which finally cost him over a million rubles. It was a frustrating time; the customary outlets for his energy and creativity were sealed off. Crucial economic decisions were made by statesmen and generals, dictated by the exigencies of an international alliance and the needs of a huge anachronistic military machine which had stalled at Tannenberg and disintegrated in Carpathia.

Despite the social tensions, the old customs persisted; the merchants still tended to intermarry with biologic intensity; community alliances were arranged with care and deliberation. After Lidiya's death Shchukin had found himself paired with a series of carefully screened prospects. These attempts to order his life had met with little response and gradually they were abandoned. A widower for seven years and a grandfather, his personal pattern seemed settled, but he had not lost his flair for the unexpected. In 1911, at a concert in Moscow, he had been introduced to the wife of Lev Konus, a well-known pianist and a professor of music at the Moscow Conservatory. Nadezhda was a small, vivid, brown-haired woman in her thirties, with dark eyes and a mixture of independence, warmth and animation which Shchukin found appealing. He had never been a dashing, romantic figure, and the fact that she was half his age, married and the mother of a small daughter, Natasha, presented a substantial obstacle, both psychological and social. Their liaison was discreet and long-lasting but finally loneliness, war and an uncertain future made up his mind. Nadezhda obtained a quiet divorce, and in 1915 Shchukin was married for the second time. In the midst of a turbulent city, the wedding was simple: a few family members, Yekaterina, Ivan Sergeyevich, Anya and Varya, the bride's sister Vera, and several close friends. At the end of a year a daughter, Irina, was born to the Shchukins.

Nadezhda Afanasevna Shchukina was neither as elegant nor as classically beautiful as Lidiya Grigorevna; she did not have the aura of great wealth which had distinguished her predecessor, but she managed to revitalize a life which was

becoming too orderly and predictable. Brisk and practical, she had little interest in modern art, but after a few months she exercised a bride's prerogative and, like Lidiya, filled her room with a bouquet of Impressionist works by Monet, Pissarro and Sisley. The unaccustomed grandeur of her surroundings was not intimidating. She was a deeply religious woman, and the Trubetskoy chapel gave her great pleasure; the Picasso Room was her cross. Sergey's new wife was not particularly intellectual, not interested in forming her own salon, but she was an excellent hostess, warm and spontaneous, and she surrounded him with people who stimulated and diverted him.

There were no more great balls and musicales in Moscow in the winter of 1915; the yearly concerts, the houseful of red roses, had vanished from Shchukin's life. That year, in a fever of nationalism, Petrograd[3] had banned German music – Bach, Beethoven and Brahms were *verboten* in the Russian capital. The wealthy were learning that it was dangerous to flout the public mood, jewels and gowns were subdued for the duration, conspicuous consumption was risky, and the gatherings in the enormous mansions were comparatively discreet and low key. Politicians, statesmen, writers, bankers, industrialists and textile magnates still gathered with their wives at the Shchukin home amid the glorious exuberance of Matisse's works. In the muted wartime elegance of the Trubetskoy Palace, foreign diplomats attached to the embassies were always welcome, and this exotic meeting place was an ideal listening post. The Matisse Room provided an illusion of security and permanence; the terrors of war, cold, hunger, fear of death, had not penetrated this luxurious enclave. The flamboyant Trubetskoy escutcheon emblazoned at both ends of the high, curved ceiling, framed by painted birds and carved garlands, enclosed a world of continuity in which it was still possible to perceive the future.

After dinner, the conversation turned to the current obsessions: war and internal unrest. What would be the shape of Russian society in the years to come? Now political arguments superseded artistic controversies. All shades of opinion were expressed. Adaptable people like Ivan Morozov would argue that the business community could live with and adjust to a modification of the social system under a new political order. He believed that if the Social Democrats came to power, the Menshevik doctrine of evolutionary socialism would still provide room for negotiation. Ivan Abramovich was not frightened by the term 'liberal'. There had been progressives in his family and among his friends, such as Savva Morozov and Inessa Armand,[4] and his mother's home had been the scene of political discussions on social issues, debates which had included many reformists.

One might have expected cultural interests to have been suspended during this period; however, as always in Russia, the arts responded to the political situation. Just as the interior paintings of the bourgeoisie had supplanted the

religious and royal art of a feudal and monarchist Russia, so revolutionary art was encroaching on the private, individual preserve of the merchants. In a period of social evolution '[artists] are not isolated men'.[5] Despite the grim circumstances of war and revolution, the Russian art world had never been more creative. As if a dam had given way, there was a torrent of theatre, ballet, music, literature and painting. The artistic axis of the country had shifted from the epicureanism of St Petersburg and *Mir iskusstva* to the vital, energetic, at times vulgar climate of Moscow.

No matter how many theories of painting evolved in Russia after 1909, Cubism remained the touchstone. One of the outgrowths of the Russian encounter with Cubism was Futurism. The Futurist Manifesto had been published in Russia in 1909, and the movement, born in Italy, had made a strong impression on many of the country's radical painters and writers. Filippo Marinetti visited Russia in 1915 at the invitation of Nikolay Kulbin, an artist who believed in an 'intuitive' principle which would liberate art from the forms of the past: an atonal, spiritual painting symbolized by Kandinsky, allied with the music of Skryabin and Schoenberg. In contrast, the Constructivists were drawn to the Futurists' idealization of the machine and industry which seemed to augur a new era and a rejection of outmoded standards and artistic shibboleths. The Futurist philosophy was sufficiently violent and anarchic to satisfy, for the moment, all currents of contemporary avant-garde opinion. Diaghilev commented on the eagerness with which the Russians embraced each new movement: 'Twenty new schools of art are born within a month. Futurism, Cubism, they are already pre-history. ... Mototism overcomes Automatism which yields to Trepidism and Vibrism. ... Exhibitions are arranged in palaces and hovels. In garrets lit by three candles princesses grow ecstatic over paintings by masters of Neoairism.'[6]

Shchukin mistrusted the overtones of mysticism which clouded Russian Futurism. He considered it merely part of an evolutionary process. With its emphasis on rhythm and speed, it was a natural supplement to the broken images of Cubism. The splintered, impulsive Futurist poems of Mayakovsky and Khlebnikov, the jagged strokes of Burlyuk, Annenkov and Rodchenko, embodied these principles. In Russia, Futurism was not restricted to the formal Italian precepts, rather it became a generic term which covered a broad range of modern poetry and painting notable for its vitality, irreverence and lack of syntax. Shchukin analyzed the forms and endeavoured, as always, to understand what the artists were trying to express. The fact that many Futurists considered themselves heralds of the Revolution did not lessen his interest.

Benois, the sophisticated critic and social observer, placed Futurism and its successors within the current Russian framework and found a deeper significance. In 1915, after the opening of '0.10. The Last Futurist Exhibition' in

Petrograd, he expressed his foreboding in uncharacteristically metaphysical terms. It was a review remarkable for its emotion and the tone of despair which permeated every paragraph: 'Why is it so cold at the art fair? What kind of catastrophe threatens everyone? ...'[7] Benois found his answer in Malevich's tract on Suprematism which was distributed at the exhibition and in which the artist proclaimed 'the nullity of forms ... objects have disappeared like smoke before the new culture of art, and art is approaching creation as an end in itself, dominating the forms of nature.'[8]

The St Petersburg critic found the new art dehumanizing, the visible omen of impending chaos, a 'very powerful philosophy that is tearing sons away from their mothers and turning them into "fighting material".' In sum, for Benois, Malevich with his Suprematist 'icon' represented disorder and destruction; his manifesto was an 'affirmation of the cult of emptiness, gloom, "nothing", a black square on a white background ... Nirvana, frost, zero'.[9] In relating Suprematism to the political situation, Benois recognized Malevich's intent. Several years later, the painter confirmed his critic's instincts when he wrote: 'Cubism and futurism were revolutionary movements in art, anticipating the revolution in economic and political life of 1917.'[10]

Benois dismissed Tatlin's constructions: 'Some are busy with scrap iron and other types of hodge-podge.'[11] Yet Tatlin's efforts were as revolutionary and 'destructive' as those of Malevich. Earlier in the year, the 'Tramway V' show had formalized the rivalry between the artists. 'Tramway V' had been classified as a 'nursery school for adults' and there was a furore when it was rumoured that the Shchukin Museum was about to change its policy and acquire a painting by Tatlin. It would have been a coup for a Russian artist; the gossip may have stemmed from Shchukin's fondness for Cubism and Tatlin's artistic debt to Picasso. However it originated, the rumour was false, and the Tatlin was never bought by Sergey Ivanovich.

Shchukin, who seldom missed an exhibition, noted that each new show revealed innovative experiments with form and space. The authority with which Robert Falk handled Cubism, Larionov's Rayonism, Goncharova's Futurist-Cubist portrait of Larionov which she had shown in Moscow in 1914, were continuing evidence of the vitality which the merchant considered indispensable to the growth of an artist. Futurism in all its aspects was intriguing to many members of the artists' community, and their enthusiasm occasionally produced unexpected results. In 1914, Larionov and Goncharova, with the Burlyuks and Mayakovsky, completed a 'Futurist' motion picture, *Drama in Cabaret Number Thirteen*, which depicted a day in the life of the Futurist artists. Though explicitly labelled 'Futurist', the style was notable for its early sense of Expressionism, and the stills reveal a remarkable similarity to the German Expressionist film classic *The Cabinet of Dr Caligari* which was produced in

Berlin six years later. In another gesture, more Surreal than Futurist, the artists
had drawn attention to their effort by appearing in the city's restaurants and
night clubs with flowers and decorative designs drawn on their faces and bodies.
It was Benois's opinion that Larionov was a showman, 'a very gifted artist', but
one in whom he detected a 'strange sterility'. But he admired Goncharova, and
though he deplored her 'rather absurd experiments of a modernist kind', he
found her feeling for imagery and icon painting 'admirable'.

David Burlyuk was another example of unpredictability. The young man who
had passionately argued the merits of Cubism had abandoned painting tempor-
arily to become a Futurist writer and pamphleteer. In 1913 he had been expelled
from college with Mayakovsky, and the two rebels had embarked on a Futurist
tour of Russian cities. When the artist painted 'I am Burlyuk' on his forehead,
it was an echo of Courbet's 'C'est moi'. The bizarre actions were a bid for atten-
tion on the part of a group which felt itself useless and peripheral to society.

Amid the current turmoil of the wartime art world, Shchukin's collection was
uncharacteristically static. The two final purchases from Kahnweiler had
entered his collection in 1914: Picasso's *Fruit Vase and Bunch of Grapes*,
painted in the spring of that year, is an austere, intellectual work, a collage in
pale tones of beige, blue and white; a construction of paper forms arranged with
care and precision, unexpectedly stippled in tiny spots of colour with a
concentration worthy of Seurat. Cool, smooth and analytical, the only touch of
reality and immediacy is in the gritty texture of the sawdust arranged
deliberately in a pattern near the lower right hand side of the canvas, and a small
card tucked between the layers of paper which reads 'Picasso'. The second, a
smaller picture, *Composition. Bowl of Fruit and Sliced Pear*, painted in April
1914, is in the same spirit: wallpaper, gouache and plumbago on cardboard, the
graphite precisely outlines juts, angles and planes of rust and beige sprinkled
with the same confetti dots.

Occasionally, Ivan Morozov tried to persuade Shchukin to widen his selection
with the works of Russian artists. Less of a purist than his friend, Morozov had
always mixed Russian canvases with his Cézannes and Van Goghs. Now with his
French contacts cut off, Ivan had turned to the variety of his own country. At
the moment, it seemed to him that there was in Russia the perfect bridge
between Paris and Moscow. 'Cossacks Christ the sun in dissolution roofs
noctambulist goats ...'[12] In Morozov's opinion all the elements that Shchukin
found irresistible in a picture had been translated into a completely original body
of work.

After four years in Paris, Chagall had returned to Russia for a visit and had
been trapped by the war. Morozov had been collecting this artist's paintings for
some time, attracted by the brilliant colour and the Russian sense of fantasy.
Noting Shchukin's preference for Cubism over Symbolism, however, Morozov

reminded his friend that in 1911–12 Chagall had produced a series of paintings in which his sensuous imaginings and the folkloric imagery of the *shtetl* were subjected to the discipline of Cubism. The nude 'portraits' of 1911–12 with their convoluted limbs and ardent profiles were suggestive of Picasso's females. The intricate, carefully assembled structure of *Adam and Eve* (1912) was akin to the single Cubist picture in the Morozov collection: Picasso's *Portrait of Ambroise Vollard*. But for all his eloquence, Morozov could never convince Shchukin that Chagall belonged even momentarily in the Cubist category. Yet Morozov was close to the truth; Chagall brought a marvellous flexibility and resourcefulness to the Cubist idiom.

During these interludes when Shchukin contemplated the painted galaxy that he had assembled, he was struck by its vulnerability. A few years previously he had worried that conservative officials within the government might break up the collection after his death. Now he feared a mindless rampage and physical destruction. For the first time, the sound of the streets was audible. In the years between 1914 and 1917, the wages of skilled locksmiths increased tenfold; more than for any other segment of labour in Russia.[13] This obscure statistic bears tacit witness to the anxieties of those in Russia with property to conserve.

One of the most intriguing features of Russian night life at this time was the avant-garde cabaret wherein the new breed of poets and painters proclaimed its sympathy with revolutionary ideals to an audience of appreciative and fashionable bourgeois. In Moscow the Café Pittoresque was a popular rendezvous, a bastion of radicalism, heralding change and the new order. A dark, crowded cave, it had been decorated by Tatlin, Yakulov and Rodchenko. Vitality and imagination compensated for a lack of funds. The perpetual motion of Futurist designs animated the walls, and Constructivist sculptures hung like stalactites throughout the smoky, velvet-lined interior.

Intellectuals, bohemians and scions of the merchant families crowded into the dimly lit club to hear the latest epic poems and ballads. Ivan Shchukin and Nikolay Ryabushinsky brought their friends to listen to the impassioned, uncompromising poet of the revolution, Vladimir Mayakovsky. Alone on the stage, his bright yellow silk tunic a single spot of colour against the dim background, he gave voice to his poems:

> No more to beg
> for one day as a dole
> and then to age
> in endless sorrow drowning.
> but to see all the world
> at the first call of 'Comrade'!
> turn in glad response around.[14]

There was something unreal in the scene, with artists as careless of tragedy as children playing soldiers, and an audience, prosperous and complacent, voyeur at its own wake.

In their fascination with the avant-garde, the middle-class intellectuals who frequented the Café Pittoresque contemplated the threat of social change as they would a continuation of Futurism or Cubism; as if revolution were a new art form. However, outside the Café, war and the old order were no longer supportable. On the night of March 15, 1917,[15] Nicholas II finally abdicated, and a day later the first Provisional Government was established.

Shchukin had no fear of the new régime; it was studded with familiar faces. Moreover, he had never been an ardent monarchist. The Tsar had been a totem, however, an unchanging presence, not always congenial but somehow essential, like God to an agnostic, and it was disorientating to witness the collapse of absolute power. Yet in the midst of turbulence, Sergey Ivanovich and his friends were reassured by the knowledge that they were indispensable to the orderly operation of the economy. In a country seventy-five percent illiterate, how could food and coal be distributed without them? Who else would run the railroads and banks, operate the mills and mines in wartime? It was impossible for Shchukin to foresee a complete breakdown of the system. Like Morozov, he was sure that the Bolsheviks would remain a splinter group.

On April 16, Lenin arrived in Petrograd from Switzerland. Kerensky became Minister of War on May 18, and in the same reshuffle, I.M. Tereschenko, a sugar millionaire, received the portfolio of Foreign Minister. Tereschenko's presence provided reassurance in the matter of capitalist continuity, and Kerensky had always been regarded by the merchants as a link between the bourgeoisie and the revolutionaries. But in six months the latter would be gone, and a placard placed on the walls of Petrograd would announce the arrest of the former, whose replacement as Commissar of Foreign Affairs would be Trotsky. Russia had become a vast accelerated time machine; events spewed forth in rapid succession, small shards of history, and there was no time to assemble the pieces or evaluate the overall design.

In August, Lunacharsky was arrested with Trotsky during the government crackdown on the Bolsheviks, and Shchukin found this comparatively minor event unsettling. A few years previously, Lunacharsky had been one of his favourite guests. He had enjoyed the company of this unpretentious young man with the red hair and beard and 'the accent of Odessa'.[16] Lunacharsky was a brilliant, cultured man of many interests: writer, playwright, polemicist, friend of Gorky and Stanislavsky, a colleague of Lenin and Trotsky, his interests ranged from political activism to the Habimah theatre. He had been a revolutionary sympathizer since his student days in 1892. As a guest in Shchukin's home his understanding of art had provided an easy basis for their

relationship: their discussions had encompassed the role of government in art and the effect of Cubism on Tatlin. The son of a prosperous textile merchant, Lunacharsky had shared a common background and tradition with his host. Now he had been jailed with the agitator Trotsky.

A short time later, Shchukin received a similar shock when news arrived that another promising young man, Sergey Nikolayevich Tretyakov, a friend and distant relative, had been arrested by the Germans and shot as a Soviet spy. In 1918, the purge of the Tsar and his small retinue would include Dr Yevgeny Botkin, the brother of his old companion. As always in a civil war, one lost friends to both sides.

Finally Shchukin decided that his wife and young daughter Irina could not remain in Russia. In 1917 it was impossible to leave the country legally, but the upheavals had created a sub-culture, skilled in escape and false passports. For the first time, the merchant dealt with the world of illegal cash, seedy and resourceful entrepreneurs. He had kept money in Germany for years in order to buy paintings, and this comparatively modest amount would enable his wife to live comfortably for a time in a strange country.

Shchukin knew that the journey would be difficult, and he persuaded Nadezhda's sister Vera, to whom she had always been close, to travel with her. They were warned repeatedly that the child Irina would be the greatest danger. A bright prattling two-year-old, she had to be taught to answer to a new name – Zina – and above all, trained not to chatter. For a time the little girl was deprived of her favourite doll, and when it was returned there was an imperceptible line of fresh stitching where the stomach had been fattened with rubles. Sergey still trusted cash.

Finally the conspiracies were finished. One night Nadezhda, her daughter and sister, their identities newly defined by forged papers, entered the ornate Bemsky Station and boarded the train for Weimar. Like all Russians who left, the sisters reassured themselves that their exile was only temporary. Basically Sergey agreed. Though he was anxious to remove his wife and child from a threatening atmosphere, he personally remained convinced that the political situation would stabilize. It was necessary for him to stay behind to protect his holdings.

Other family members had made their choice. Shchukin's oldest daughter Yekaterina, as strong-willed and determined as her mother, had just remarried and was determined to stay in Russia with her husband. Dmitry, his brother, who had become more of a recluse over the years, would not hear of leaving his familiar surroundings and paintings. Sergey's adopted daughters Anya and Varya had never known a life outside their own country, and it was decided that they would continue to live with him.[17]

In 1917 the immediate future of the family had been settled, if not to

Shchukin's satisfaction, then to the extent of his power to affect it. But the collection was becoming an obsession. The single creative achievement for which he would be remembered was a conspicuous museum full of delicate, shimmering treasures more susceptible to assault than if they had been hanging in the poorest slum in Moscow.

The Congress of Soviets convened in Petrograd on the night of November 7, 1917. The following evening at 8.40 p.m., Lenin entered the great hall to address the delegates: 'We shall now proceed to construct the Socialist order.' The few brief hours between these two events held the historic montage of twentieth-century revolution. The classic scenes – *The Cruiser Aurora Shells the Winter Palace*, *Kerensky Leaves the Capital*, *Armed Sailors Block the Nevsky Prospekt*, *Assault on the Winter Palace* – flashed by too rapidly to be comprehended. When the Winter Palace was taken, members of the Kerensky cabinet were arrested and led from the conference room by the Red Guards. War Minister Tereschenko, the last symbol of merchant inviolability, passed from the scene into the recesses of the Peter and Paul Fortress, and all that remained was the tattered public poster proclaiming his arrest.

It might be assumed that from that moment Shchukin lost control over everything he owned, but there was a momentum to the old ways, and life continued in the familiar pattern for a few more months. An odd souvenir of this period of limbo is the small contribution which Shchukin made to Russian war relief. On December 16, 1917, shortly after the Revolution, he donated a pencil, brush and watercolour sketch to be auctioned in Moscow for the benefit of war victims. It was the earliest study by Matisse for *The Red Studio* (1911),[18] inscribed meticulously on the back: 'I hereby confirm that this is Henri Matisse's original drawing. Sergey Shchukin, Moscow, December, 1917.' The sketch brought 500 rubles. This tiny gesture, unimportant, almost invisible in the surrounding tumult, was one of Shchukin's last recorded acts in Russia.

In December 1917, the nationalization of all industries was legalized. At the outset, the edict was applied haphazardly – the size of the task and the inexperience of the new administrators made it necessary to retain some of the original owners and managers in positions of power. Years before, Lenin had recognized that the 'educated middle-class specialist' might be useful in operating the government apparatus. Now the first priority was the distribution of food to the cities, and the continued functioning of railroads and factories was essential to that purpose. Many industrialists and their supporters saw in this crisis an opportunity to cripple the new régime. These businessmen possessed neither the temperament nor the equipment for guerilla war, but sabotage was an effective weapon and there were plant managers and workers who had remained loyal to the old order. When the incidence of slow-downs, stoppages and 'accidents' became apparent, the government cracked down. Several of

Shchukin's friends were suspected of treasonable activities, and though the merchant was not involved, he was caught up in the reaction.

In January 1918 he was arrested and taken to the local headquarters for questioning. Though it soon became clear that he was not actively engaged in promoting subversion, the recent departure of his wife and child became an issue. He had a muzhik's toughness and resilience, however, and when he was informed during an interrogation that his net worth had been assessed at thirty million gold rubles, he had no apologies. His answer, 'I didn't know I was so rich', earned him a few extra days and nights in a jail cell before he was released.

The Anarchists were becoming the true 'superfluous men' of the Revolution. Their leader, Prince Pyotr Kropotkin, had returned to Russia in the wake of the Communist take-over.[19] The Anarchists continued to believe that 'Our ruler is our enemy'[20] and many of them considered Lenin 'insufficiently radical'.[21] They sought the total eradication of all government control and resented the new flood of directives, which in their numbers and thoroughness rivalled the old bureaucratic rulings. Some of the more violent members of the Moscow branch, a band of deserters, malcontents, drunkards and drug addicts, had appropriated the Merchants' Club as their sanctum without interference from the authorities, and their principal activity was occupying the mansions of the city's wealthiest citizens. Ivan Morozov's home, one of the most imposing in Moscow, was a natural target. One night they burst into the darkened premises and took over, spreading into every room like nomads in a tent, sleeping amid the Cézannes and Gauguins, drinking and gambling in the marble salon surrounded by the infatuated nymphs.

Morozov, once so proud and sure of his role, was confronted by a ragged, threatening mob which despised his skills and mocked his accomplishments. That evening he sought refuge with friends for himself and his family. He had not been injured, but he had been dispossessed, severed finally and irrevocably from the private world of privilege and certainty which had shaped his values. Shchukin dated his friend's physical and psychological decline from that moment.

The wariness and introversion which marked Morozov's last years were a sad contrast to his former optimism and self-esteem. The revolutionary government had been slow to move against the Anarchists, but finally it became clear that this disruptive element must be routed. Random hooliganism has always been anathema to Russian officialdom, and Feliks Dzerzhinsky was given the task of smoking out the rebels – the infamous Dzerzhinsky of whom Shalyapin said: 'In the struggle against the enemies of the revolution, he has neither mother, father, son nor Holy Ghost.'[22] When at first the Anarchists refused to leave their sanctuaries, he fought them with tanks, shelling the houses until little was left standing. When it was rumoured that his armour was moving toward

Prechistenka Street and the Morozov home, the occupiers fled without touching or destroying a picture. If they had been permitted to remain in the mansion, the Russian collection of French art might have been greatly diminished.

Considering the violence of the post-revolutionary period, it is amazing how little damage was done to the national treasures. This may be due in part to the fact that Russia, unlike France, was a poor country, and the poor do not casually destroy their patrimony. Equally important, the Russian collection of modern art survived because of the unwitting, unspoken collaboration of three men: Shchukin, the collector, Lunacharsky, the preserver, and Lenin, the pragmatist. In 1917, the role of the collector had ended. Lunacharsky was the lover and protector, issuing proclamations and fervent pleas against looting and excesses, reminding the people of their heritage which could so easily be destroyed. His commitment was so strong that when he heard that the Kremlin had been shelled by his own party forces, he rushed out of a meeting of the People's Commissars. 'I cannot stand it, I cannot bear the monstrous destruction of beauty and traditions. . . .'[23] His letter of resignation was published that day in the government press, and he would not return until the news of the siege was proven false.

Lenin, who seldom visited a museum, was impatient with Lunacharsky's emotionalism. His taste in literature and painting was conservative. He preferred the traditionalists to the revolutionaries: Pushkin to Mayakovsky and Bely, Repin to Tatlin and Lissitsky. He cared little for art and less for the bourgeoisie, but he recognized that these new works were a Russian resource which deserved protection and which would eventually prove valuable.

* * *

For a brief period after his imprisonment, Shchukin lived in a netherworld in which there were no guidelines or certainties. Finally he was informed by a delegation that all artistic works in private collections were to become the property of the State and would be administered by the People's Commissariat for Enlightenment. The Trubetskoy Palace and Ivan Morozov's home were to become two museums of modern Western art and would be opened to the public immediately.

In a single moment Shchukin lost every token of rank and achievement. His only consolation was the knowledge that, with government annexation, the threat of anarchism, looting or malicious destruction had passed. The merchant was certain that as a remnant of the old order he would be dispossessed right away, and it came as a shock a short time later when he was offered the post of guide and curator. He was never completely sure what prompted the proposal; perhaps Lunacharsky was responsible, or it could have been a practical decision to utilize his talents. Whatever the source, Shchukin promptly accepted, for as

he remarked to his son: 'No one is better qualified for the job.' In the past he had enjoyed the role of instructor, but the new circumstances were difficult and treacherous. Always totally in charge of his creation, now he was to be relegated to the role of caretaker, with the decisions being made by others. Any evidence of proprietary enthusiasm would be noted.

Ivan Morozov accepted the same terms. It was a bitter, disillusioning time for him. His certainty that his experience as an industrialist would make him indispensable to a new régime was shattered. With the advent of the Soviet government he realized that the best he could hope for was the humiliating position of People's Custodian of his own property.

There was a difference between Morozov's attitude toward his pictures and that of Shchukin. Morozov thought of his paintings as private property, and though he admitted scholars and prominent figures to his gallery, he was essentially reserved and jealous of his privacy. Shchukin was sociable and welcomed any visitors who were interested enough to come. A young student who in 1913 was a guest in both their homes, years later remembered Morozov as being haughty and 'uninterested in young people', while Shchukin was unassuming, respected their opinions, and escorted them personally through the collection.[24] This contrast was illustrated by an episode which occurred early in 1917, shortly after the February Revolution, when Kerensky had been in office. Two French Socialist deputies, Marius Moutet and Marcel Cachin, had been sent by their government to observe the course of the Revolution. After their arrival in Moscow, a friend of Shchukin's was delegated by the Moscow authorities to accompany the prominent visitors. Later he wrote:

> One of them, Moutet, I think, asked me to arrange for him the opportunity to become acquainted with the Shchukin and Morozov collections. I.A. Morozov refused point-blank saying that his paintings were packed up and that he was planning to remove them from Moscow. But S.I. Shchukin not only agreed but showed his galleries himself; I remember that Moutet said to me after the viewing: 'Here you see, our bourgeoisie let all these treasures go, and is not moved by them, while yours collected them and is being persecuted for it.'[25]

As curator, Shchukin was permitted to stay with his son Ivan in the caretaker's lodge on the grounds; a valuable perquisite, for it enabled him to provide shelter for Yekaterina, her new husband, and Ilya, the son by her first marriage. When they moved into the cottage, Sergey unobtrusively expropriated the servant's room off the kitchen in the main house for himself. Though she was expecting a child, Yekaterina proved to be a surprisingly valuable assistant in the months that followed. According to her brother Ivan, she was considered 'harmless' by the officials and knew the paintings intimately, having watched her father lead his guests through the rooms many times.

During this early phase of the Revolution, the Department of Education and Culture under Lunacharsky was transporting busloads of workers to the museums and theatres in a massive effort to stimulate interest and generate public participation in the arts. One of the first stops was the Trubetskoy Palace, and as the visitors were deposited, Yekaterina would wait in the hall to guide them through a replay of the early Shchukin tours. This was the first exposure to modern Western art for most of the soldiers and workers' delegations, and they usually passed silently, if warily, in front of *Dance* and *Music*, but by the time they filed out of the Picasso room, all decorum had vanished. In the explosion of indignation, the comments were caustic and derisive. . . . 'If we had had things like this in our house we would have known what to do with them.' Yekaterina was able to keep silent, for as she remarked to Ivan one evening, she had heard worse in the old days and now at least no one scratched the canvases.

Shchukin had not seen Dmitry for some time, and he was disturbed by the reports which were beginning to reach him. It was said that his younger brother was systematically hiding his own paintings in an effort to protect them from confiscation by the Soviets. The public mood was volatile, and these tales were dangerously inflammatory. When Sergey finally visited the small house he noted the empty spaces on the walls which had once held the most precious works. There was no sign of the Rembrandt or the Memling. His brother's naïveté depressed Shchukin, for he knew that once it was discovered, there was no activity more calculated to bring down the wrath of the government than 'theft of State property'. For days Shchukin tried to learn if the pictures had been smuggled out of the country or buried, but Dmitry was adamant. With the odd defensive stubbornness of a timid man, he refused to discuss the matter. He persisted in his silence for the rest of his life. A few months after Sergey left Russia, Dmitry's tactics came to the attention of the officials and he was arrested. Despite his Russian connections, Sergey could never find out how long his brother remained in prison or what happened to him. There were reports that finally he went blind. Dmitry Ivanovich died in Russia; according to family legend he kept his secret and the major portion of his collection was never recovered.[26]

In the few months Shchukin remained in Moscow, he saw art move out of the salon into the streets. Lunacharsky was the link between government and the artistic community and under his aegis the artist became a political force for the first and last time in Russia. During the French Revolution, David had epitomized the artist *engagé*; supportive, influential, but never innovative. The Russian painter of the left went beyond; briefly he became a theorist, administrator and participant in social change. The artist as Commissar was a Russian phenomenon.

The idealistic determination of the avant-garde to join with the workers in

building a new society was apparent everywhere. Bristling Constructivist designs dominated the public buildings; stage sets, murals, municipal decorations, all extolled the future, hailed the new Soviet state. Posters and banners by Tatlin, Puni and Altman were spread over the cities in an effort to broaden support and heighten political awareness. As they had done for centuries, the townspeople gathered around the official proclamations pasted on the walls, but often now these edicts were signed by writers and artists such as Mayakovsky or Burlyuk: 'Henceforth, together with the destruction of the Tsarist régime, the keeping of art in those storerooms and warehouses of human genius – viz. palaces, galleries, salons, libraries and theatres is hereby abolished.'[27] The apocalyptic tone reflects the artists' impatience with every vestige of the old society, but despite the extremism of the sentiments the old institutions endured, though in a somewhat altered form.

Shchukin understood the idea of art as a means of social enlightenment; it had been part of the Russian tradition from the time of Chernyshevsky and the early Wanderers, but their paintings had been realistic and evocative, emotionally appealing to an unsophisticated citizenry. The radical development was the use of modern forms as a means of communication: Constructivism, Suprematism, Futurism and Cubism with their thorny obscurities and abstract exhortations. Stamps, revolutionary porcelains from Petrograd, stoves, classes in political education, hygiene or agriculture, all were animated by the dynamics of modern art. Experimental street theatre in which the evils of the old system were dramatized and placed on trial became the Passion Play of the Revolution.

Shchukin, a pre-1917 harbinger of the new wave, who had introduced Cubism into the plush surroundings of the Moscow merchant, had provided a futuristic, international frame of reference against which Russian painters could measure their work. Now these artists were caught up in the challenge of a new society and some were denouncing all that had gone before. Tatlin, who had been influenced so strongly in Shchukin's home by Picasso, proclaimed easel painting obsolete; the decorative art of the easel was appropriate to the 'bourgeois mausoleums' of the past. The art of the future would utilize available industrial materials to construct a society built on the factory and the machine. Yury Annenkov, an admirer of Tatlin, later remembered: 'In our discussions Tatlin loved to say that the modern factory was the highest form of the opera and ballet, that reading a book by Albert Einstein was unquestionably more interesting than some Turgenev novel, and that contemporary art should thus be examined thoroughly.'[28]

For men like Tatlin, the new goal was a heroic art which would infuse every aspect of the environment; blend with the architecture, industrial design, theatre, the machine, to create a new Soviet prospect. If it had been realized, his gigantic *Monument to the Third International*, a coiling tower of iron and glass,

would have been the ultimate construction in this epic mould; a thrusting spiral 1,300 feet high, a new cathedral for Moscow. The Russian artistic radicalism which Shchukin had supported had become for a moment an organic part of the Socialist Revolution.

In May 1918, the shape of the future was made clear. During the first months of 1918, the bourgeoisie had inaugurated its covert resistance to the Soviet takeover. As a result of this effective campaign, trained personnel was scarce, the civil service non-existent and sabotage plagued the industrial plants. The government responded with a series of inexorable proclamations. In May 1918, for the first time an entire Russian industry (sugar) was nationalized; a month later, oil was declared a State monopoly. Finally on June 28 all commercial enterprises of more than one million rubles capital were pronounced the property of the State. These expropriations took place within a few weeks; the pace and totality of the sequence made Shchukin realize at last that the historic process was irreversible – and that if he did not leave soon, he would be trapped.

It was no longer possible to protect Dmitry, but Yekaterina and her family troubled him – if he left, he had to know that they would be reasonably safe. It was at this time that the Pokrovskys returned to Moscow. Many years before, Lidiya's favourite cousin Lyuba had married Professor Pokrovsky, a committed young radical. When the couple had been deported after the 1905 uprising because of Pokrovsky's leftist views and his activism, Shchukin had maintained a correspondence and aided them financially during their exile in Paris. Now the Professor had been assigned to a post in the Department of Education, and from this office, he was able to repay his debt to the Shchukins. After Sergey's departure, Yekaterina was permitted to remain in the cottage. For the next five years she assumed her father's role and guided the visitors through 'The First Museum of Modern Western Art'. This pampered young woman who had swept through the great halls in a black velvet gown carrying her white Persian cat now considered herself fortunate to have food, shelter and a few friends.

When Shchukin left Russia in 1918, according to his son, several members of the new government were disappointed and angry at his departure. In the early stages of the new régime, there was still a sense of flux among the intellectuals; ideology had not hardened to a point where all members of the old establishment were classified automatically as enemies. Shchukin's collection had frequently been described as revolutionary and there were those who felt that this might be an indication of his true nature. His nonconformism had contributed to this misconception. He had endowed the previously mentioned Institute of Psychology as a memorial to Lidiya at a time when this branch of medicine was still a new and radical idea in Russia. His friendships with Lunacharsky and Pokrovsky had been noticed; above all, there was his continuing interest in the young Russian artists, many of whom were revolutionary sympathizers.

These factors contributed to an unrealistic evaluation of Sergey Ivanovich. While he had little of the bile and hatred of the arch-reactionary, he was inescapably a member of the old order whose family had come to affluence and power within the previous two generations. Shchukin had been apolitical for most of his life; even the crucial events of 1905 had not disturbed his pattern, but basically he was wise enough to know that a well-meaning moderate would have no place in the new society. One morning early in August 1918, he and Ivan boarded a train at Bemsky Station, and in the general confusion and disorganization were able to cross the Ukrainian frontier. Sergey Ivanovich was now sixty-three years old.

Shortly after his departure, the fate of the Shchukin collection was confirmed officially. A seal was placed on the door of the Trubetskoy Palace. Dated November 15, 1918, it stated:

> Since the Art Gallery of Sergey Ivanovich Shchukin is an exclusive collection of the great European masters, especially French, of the late nineteenth and early twentieth centuries, and since, because of its great artistic value, it is of great national importance for the people's culture, the Council of People's Commissars have decreed ... that it shall count as the State property of the Russian Soviet Federated Socialist Republic and shall come under the administration of the People's Commissariat for Education. ...

This 'Decree Number 851 (Laws and Decrees of the Workers and Peasants' Government)' was signed by Lenin. On December 19, Ivan Morozov's mansion became 'The Second Museum of Modern Western Art'.

Sergey and Ivan parted in Kiev. The Germans were occupying the Ukraine and the older man was permitted to move on to Germany where Nadezhda was staying. Ivan had decided to pursue his interest in Eastern art, and Lebanon was his ultimate destination. His first concern was to avoid possible conscription into the German army, and after two months in Kiev, he moved south to Odessa. Eleven months later he was on his way to Beirut. Eventually Ivan Sergeyevich was recognized internationally as one of the leading scholars in the field of Persian and Indian art. Several years were to pass before he and his father would meet again in Paris.

<p align="center">* * *</p>

Shchukin, Sergey Ivanovich (born 1854). Now a white emigrant. Collected works of recent French art (Claude Monet, Cézanne, Gauguin, Matisse, Derain, Picasso, and others who had a great effect on the development of recent Russian art). The purely aesthetic 'Shchukin Collection' was nationalized in 1918 and at the present time constitutes a part of the State Museum of New Western Art.

In this brief fashion, Shchukin's entire life was summarized by the *Great Soviet Encyclopaedia*.[29] Subsequent fluctuations in the political line removed all mention of his name. It was not until the 1970s that the names of Shchukin and Morozov began to reappear in a favourable light in Soviet publications.[30]

Shchukin arrived in Weimar on September 19, 1918. The city was a peaceful half-way house on his passage to the West. The home of Goethe, with its ancient churches, narrow twisting streets and medieval character, provided an illusion of serenity and historical continuity in contrast to the upheaval he had left behind. There was little difficulty in locating Nadezhda. After her arrival she had found temporary quarters in the home of a local family for herself, her sister and daughter, and in the interval 'die russische Frau' had become a familiar figure in the town.

Shchukin now discovered an unexpected friend in Germany. During the early years of the war, the well-known German art critic Julius Meier-Graefe had been captured by Russian troops. Having heard of Shchukin and his paintings, he had written to him in Moscow for assistance, and the merchant had sent him money for cigarettes, a razor and whatever small articles might make internment more bearable. In addition he had interceded with the Russian authorities on behalf of the prisoner, appealing for his release. His efforts were successful, and when Shchukin arrived in Weimar, Meier-Graefe was living only a short distance away. This authority on modern art had written extensively about Renoir and Cézanne, and years earlier in his *History of Modern Art* he had complained that one of the most perfect examples of Denis's easel works – *Sacred Grove* – had 'disappeared' into one of the Russian private collections. The picture had belonged to Shchukin. The Russian spent many hours in Meier-Graefe's home, once again surrounded by the paintings which had become a constant element in his life. In twenty years the wheel would make another circle. After Hitler came to power, Meier-Graefe's collection was labelled 'degenerate art' and in turn confiscated.

In 1919, after several months of uncertainty, the Shchukins decided to settle in Paris. The sums of money which the merchant had deposited in the West over a period of years to facilitate the purchase of paintings enabled them to take an apartment at 12 Rue Wilhelm in the 16th Arrondissement. Sergey's grandson, Herman de Keller, remembers him during this period. 'Even in exile the Shchukin quarters were very animated, though naturally on a far more modest scale than before. Out of all this my grandfather emerges as an extremely active, alert, observant personality, curious about things and people, and fond of society, though not what is termed gregarious. His sharp, independent mind had its own philosophy, not without humour'.

Shchukin was more fortunate than many of his countrymen. Paris was now teeming with Russian refugees, aristocrats, officials of the old government,

many destitute and selling off their belongings bit by bit, others learning to conform to a new setting, all hungry for the latest news of families or friends still in Russia. The new wave of immigrants had no wish to be assimilated, they had not come to the West seeking a better life; ejected from their country, they clung to the old ways, as if to assure themselves that their banishment was only temporary. In a gigantic miscalculation, a few sat in the streets of Paris with their suitcases packed, as if in transit, waiting to be summoned home. It was a tightly knit community of the dispossessed, and many members gathered at the Shchukin quarters to exchange bulletins, listen to music and reminisce. The unpretentious flat served as a temporary refuge for friends, a mail drop, and an occasional meeting ground for Russians on both sides of the political boundary.

One of the first visitors was Ivan Morozov, who was now living in Germany. He had been granted permission by the Soviet government to leave Russia. He was of course not permitted to take out any of his paintings. The meeting depressed Shchukin, for it seemed to him that his younger friend had grown strangely waxen and uncertain. His concern was justified, for Morozov died in Carlsbad in 1921 at the age of fifty, shortly after returning from a trip to Paris.

There were happier encounters. The unsinkable Ryabushinsky, who usually managed to land on his feet, had secured for himself the role of art adviser to the new government. During his sojourns in Paris, he enlivened the Shchukin ménage with anecdotes and the latest gossip from home as if he were reporting social notes from Monte Carlo. Predictably he did not remain with the new régime for long, and after a time he settled in Paris and opened a profitable antique shop.

Benois also visited the Shchukins whenever he was in the city. As a consultant to Lunacharsky, he was a cultural bridge between East and West, proof to the outside world that the new Soviet officials were not a collection of barbaric misfits.

Diaghilev's arrival was always a major event. From the moment he appeared, wrapped in a perfectly fitted coat with fur collar, sporting monocle and cane, he exuded success and assurance. Frequently he was accompanied by Sergey Lifar, and Shchukin, who loved theatre and missed the drama and colour of the old days, looked forward to their meetings. Diaghilev's massive figure filled the apartment; the great square face and heavy-lidded eyes, the charge of white hair as exaggerated as the caricatures they inspired.

Amid all his current international success, the pressures of intrigues and financial crises, Diaghilev found time to visit Shchukin because the merchant was able to satisfy his curiosity about artistic developments in the Soviet Union. Over tea and Russian pastries, the impresario talked obsessively of Russia and the new proletarian culture. His questions revealed a range of knowledge surprising in one who had not been home since 1914. He compared Lunachar-

sky with his old patron Prince Volkonsky, and extracted from his host the last scrap of information about street theatre and Tatlin's tectonic art. He was particularly fascinated by reports about Meyerhold's Futurist-Constructivist epics. What was Shchukin's opinion of Aleksandra Ekster's sets and the dynamic space of Georgy Yakulov? How did they translate into theatrical terms? Meyerhold, who had been a successful actor with Stanislavsky's Moscow Art Theatre, had parted company with the theatre of realism and established his own Revolutionary Theatre in Moscow, where he sought to transfer Constructivist principles to the stage. Stanislavsky 'pinned his hopes on the actor', but Meyerhold strove for a stark and stirring revolutionary spectacle in which the performer was merely a single element in the total work. Diaghilev had heard that Meyerhold's productions were innovative and powerful, but if one used the actors as component parts of the scenery, surely the result would be a series of boring, static tableaux? The intensity of his inquiries indicated even then that Diaghilev was considering a collaboration with Soviet artists. Though he was attacked frequently by the French left, and by Louis Aragon in particular, for the 'decadence' of his glittering ballets, Diaghilev's capitalism was not a religious revelation; it was simply the only environment in which he could operate effectively. It was Shchukin's personal opinion that for Diaghilev, art was beyond politics, revolution was theatre and high fashion; he would have worked happily with Meyerhold, Lissitsky, Tatlin or Lenin himself to produce a major work.[31]

Diaghilev pursued his idea of a Soviet ballet for more than five years. Eventually he approached Meyerhold through an intermediary with a proposal that they cooperate on a project, but for all his persuasiveness he could not induce Meyerhold to work with such a conspicuous remnant of the old order. Though he had to compromise with his idea of an all-Soviet ballet, Diaghilev's persistence paid off eventually. In 1927 his 'revolutionary theatre' opened at the Sarah Bernhardt Theatre in Paris with music by Prokofiev, constructions and designs by Yakulov and choreography by Massine. When his wife refused to endure an evening of 'Bolshevik art', Shchukin bought a single ticket to *Le Pas d'Acier*. On his return later that evening he reported that there had been no provocation, no disturbance in the audience, and that Yakulov's mechanistic designs were 'original and charming'.

It is a common belief that all contact between Russian émigrés and the new government was broken, but in fact the gulf was not unbridgeable. In the early stages of Shchukin's exile, figures within the Soviet hierarchy would travel to his apartment in the Rue Wilhelm to discuss the paintings. As if they had been entrusted suddenly with the care of a mythical beast, they were uneasy about the true nature and value of the works. One official with the imposing title of 'Director of Collections' spent an entire afternoon speaking about 'our collection'. There was a certain irony to this occasion, but Shchukin

never refused a request for a meeting, and displayed little overt bitterness, perhaps because he had always intended that the pictures should be left to his country.

In 1908, shortly after Lidiya's death, he had made out a will leaving the collection to the city of Moscow, and had stipulated even then that all the pictures must be kept and shown together within one year after his death. Failing this, they were to go to the children. It was a form of insurance; he used the increasing value of the Monets to protect the later, more controversial canvases, for he realized that there were few in Russia who understood the historic significance of what he had assembled. The merchant deeply mistrusted the bureaucrats and he never forgot that in 1897 a portion of the Caillebotte bequest of Impressionist and Post-Impressionist works had been refused by the French government. He was determined that his legacy should not be split up; the 'thread', so visible to him, which connected the works was not to be broken. By 1908 the collection had assumed an outline; the Monets, Gauguins, Cézannes, Matisses, and now the Picassos were becoming part of a whole, and he told his son, 'I do not wish them hidden away in a cave somewhere and brought out piece by piece or sold.'[32]

While Lunacharsky was in charge, the paintings were comparatively safe, but in the chaos and urgencies of the Revolution, the power of the Commissar was not absolute. Lunacharsky recognized this in his declaration of November 1917, when he pleaded with the new 'young masters' of Russia: 'I beg you, Comrades, to give me your support. Preserve for yourselves and your descendants the beauty of our land.'[33]

Shchukin was aware that this liberal approach to modern art did not represent the majority view. The communist officials were as mistrustful of artistic radicals as were the Tsar's censors. Lunacharsky was influential because of his relationship with Lenin, but when that support faded, the thin veneer of tolerance would shatter and there would be a resurgence of philistinism. Shchukin's understanding of the destructiveness that these works provoked was expressed in his remark to Ivan, 'I don't want the Picassos sold or burned after my death.'[34] In Paris his concern persisted and this may be the reason why he was so willing to keep open the communication between himself and the latest guardians as long as possible. After 1922 the occasional visits from Russian officials ceased completely and it became obvious to the merchant that the last tenuous ties had been broken. In self-preservation he turned away from the past.

It has been said that after Shchukin's arrival in Paris he lost all interest in art, but this is not borne out by his activities in the last years of his life. Certainly he could no longer afford the works he loved most, but among the art dealers in the city he was remembered and respected as a man who almost single-handedly had created a market for the great Cubist paintings when few others were buying.

Many sought his advice; one enterprising gallery-owner proposed that they enter into a partnership: he would make a gift to Shchukin of a number of works in his possession if the Russian would permit his name to be used as a collector of the paintings. Art as a commercial venture had no appeal for Sergey Ivanovich and the offer was refused, but the passion was still alive.

Though money was scarce, there were occasions when he could not resist the impulse to acquire a small picture. One day when he stopped at a country inn with his daughter Irina, he noticed a work by Dufy hanging in the main room. The artist had made a wager with the innkeeper that he could finish a sketch of his host within an hour and the proprietor had been painted watch in hand. Shchukin found the spontaneity attractive and persuaded the owner to part with it. Though Dufy's work was still relatively inexpensive, the purchase involved considerable sacrifice, but over time Shchukin managed to purchase three more of his canvases.

In Russia he had owned a landscape by Henri Le Fauconnier. One day in Paris, almost guiltily, he bought another. Shortly after, the painter called on him; he was eager to buy back the picture, for now he wished to give the work to a Russian museum. After 1920, Le Fauconnier had become something of a recluse owing to the severe mental illness of his wife, and he seldom painted. Fernand Léger had donated several of his own paintings to the Hermitage and Le Fauconnier thought it would be appropriate for him to do the same. Sergey Ivanovich stared at him for a moment, and replied quietly, 'I think I have given enough.'

It is interesting to speculate where Shchukin's taste would have led him over the next decade if he had been able to continue in the old pattern. Undoubtedly he would have persisted in his admiration for Matisse and Picasso, and in 1919 a promising young newcomer had arrived in Paris from Barcelona. Shchukin said many times that of the new artists he admired Joan Miró most of all. When he had first come to Paris Miró had been influenced by Picasso, and it may be for this reason that the Russian found his work so appealing. The artist has been quoted as saying: 'Above and beyond all, it is the visual shock that counts. Afterwards, one wants to know what it [the painting] says, what it represents. But only afterwards.'[35] The words could have been Shchukin's.

Despite his unending appreciation for the work of both Matisse and Picasso, the merchant's subsequent contacts with the two artists were strangely contrasting. The encounters with Matisse had a sour quality, those with Picasso proceeded effortlessly.

The reality of exile and lack of funds complicated Shchukin's relationship with Matisse. After 1906, the artist's presence had wound through his life like a leitmotif. His many letters and telegrams had attested to his devotion to Matisse, and his constant quest for new works: '. . . I beg you to give me news of your

work.'[36] Though the friendship was not intimate, the two were able to communicate on the most important level, and there were few with whom Shchukin could discuss his obsession. They shared an adventure; Matisse summed it up when he said, 'It took sheer nerve to paint in this manner and it took sheer nerve to buy.'[37]

Now five years after the last message from Moscow, the meetings between Shchukin and Matisse were unexpectedly awkward, marred by the merchant's hesitation and by mutual misunderstanding. Their first encounter took place in Nice shortly after Sergey Ivanovich had left Russia. Despite his vitality and determination, the shock of displacement had affected him more than he realized. The numbness was beginning to wear off and each day he was reminded of the extent of his loss. He had heard that Matisse was spending the summer only a short distance away, but he made no move to contact him. The painter had no such reservations; perhaps remembering the day in 1906 when Shchukin had first rung the bell of his studio, he called on his former patron at the hotel. When the door opened, it seemed that no time had passed. The familiar, small figure was still sturdy, the eyes bright, black and alive as he had sketched them in 1912 – and the stutter was noticeable. Perhaps there was a slight reserve in the greeting which he had not encountered before.

Matisse was eager to have the Russian visit his studio; he had always respected Shchukin's views and was sure that he would be interested in the new works from that summer in Nice, paintings with the lavish decorative qualities which had invariably appealed to his old client: *Antoinette* with her white plumed hat, and *Banquet for the Fourteenth of July* in which he had used the same piece of toile de Jouy that he had painted in his patron's *Coffee Pot, Carafe and Fruit Dish* ten years earlier. An identifiable piece of fabric, the outline of a familiar chair, the intimate details which spilled over from one work to another had always pleased Shchukin. Now, when Matisse extended his invitation, there was a stillness which was almost a rebuff. Finally, stiffly, the answer came. 'I am no longer in a position to buy.' For a moment the painter was stunned. The remark was completely out of character for his old friend; surely Sergey Ivanovich must realize that he had no need to sell his work in this manner. Matisse could not know that this meeting was one which the Russian had avoided, the encounter in which he was no longer the generous patron, final proof that their relationship had changed irreversibly. The silence was broken when Shchukin abruptly invited Matisse to tea the next day; an oblique apology which the artist accepted.

The following afternoon when he entered the lobby, Matisse was directed to a salon where a large reunion of Russian émigrés was in progress. At the back of the crowded room a trio of musicians explored the newly popular melodies of Romberg and Kern; along one wall a buffet featured 'enormous pastries with

mounds of icing'[38] which brought back memories of Moscow. The conversation was mostly in Russian, and the guest realized that he had merely been asked to join a gathering of Russian exiles. Later he told his family that he had found Sergey Ivanovich in a corner surrounded by 'a vast number of White Russians', an impenetrable phalanx which made private conversation impossible. In this festive setting Shchukin did not seem impoverished, and Matisse found the previous day's emphasis on money puzzling.

He made one more effort to re-establish the old rapport when he asked Sergey Ivanovich to accompany him on a visit to Renoir, who was ill and living close by at Les Collettes in Cagnes. Shchukin could not resist this excursion into the past, and the two men agreed to meet at the station the following day. Matisse, with a memory of other times, looked for the Russian without success in the plush comfort of first class. Finally he discovered his friend sitting quietly in the second-class section. As if in explanation, Sergey Ivanovich looked up and remarked, 'One must keep in the good graces of the masses.'[39] Whether he spoke ironically or out of trauma was uncertain; whatever the case, during his remaining years in Paris, Shchukin could never bring himself to travel first class.

Renoir died a short time later and Matisse and his former patron seldom met after that day. The artist concluded that their interests no longer coincided and that Sergey Ivanovich had become indifferent to painting. It would have been impossible for Matisse to comprehend Shchukin's rootlessness at that time. The Russian had lost his role, both in his country and in the world of art. Matisse's presence forced him to face that fact. No such dislocation is possible for an artist who has the capacity to define his identity and create his world wherever he goes. The role of the collector is circumscribed by economics, and when his circumstances changed, Shchukin became a proud and difficult man.

Shchukin and Picasso met again in 1920 in the south of France. The Russian had brought his family to Juan-les-Pins for a week and Picasso was spending the summer in the vicinity. Picasso's life too had changed greatly since his first meeting with Shchukin at the Rue Ravignan in 1908. As a foreigner living in France, he had not been subject to the draft, but one by one, his closest companions had faded from his life. This erosion was made more painful when his friend and dealer Kahnweiler was abruptly cut out of his circle. A German citizen, Kahnweiler had been forced to spend the war years in Switzerland, unable to return to France until the peace treaty was signed in 1920. According to the dealer, these were lonely years for Picasso and he was rescued from his 'isolation' by a meeting with Diaghilev in 1916. With this encounter, Picasso entered a small corner of Russia.

Diaghilev was collaborating with Massine, Satie and Cocteau on *Parade* and

was eager to persuade Picasso to design the scenery and costumes. Picasso had always regarded ballet with some wariness as a fashionable entertainment, and since its sensational Paris début in 1909, the Ballets Russes had been synonymous with Russian-Oriental exoticism, scarcely Picasso's milieu. *Schéhérazade*, *Sadko* and *Cléopâtre* had featured the sumptuous, erotic designs of Bakst; Korovin, Roerich and Golovin had reinforced the special aura of Moscow and St Petersburg. Now Diaghilev was turning from the proven success of these ornamental displays to a completely Western, urban ballet. *Parade* opened in Paris in May 1917. It realized Savva Mamontov's ideal of synthesis; the scenery and costumes with their clear, bright colours and diverting geometrical planes presented a form of antic Cubism which was both striking and diverting. But the ballet was something of a disappointment to an audience accustomed to more florid offerings, and the cool dissonances of Satie's music and Massine's angular choreography were overwhelmed by Picasso's décors.

Despite the mixed reception, Picasso's collaboration with Diaghilev continued. He found the intensity and brilliance of the theatrical atmosphere exciting, as if he had returned to the vividness of the Cirque Medrano. In 1918 he married the Russian ballerina Olga Koklova who had been dancing minor roles with the company, and in 1920 when he and Shchukin met, he was designing the production of Stravinsky's *Pulcinella* for Diaghilev.

The artist's association with the Ballets Russes gave Shchukin and Picasso several current mutual friends. One day Sergey Ivanovich brought Nadezhda and his attractive sister-in-law Vera to meet Picasso, and at the end of the visit the artist made a quick sketch of Nadezhda's sister. He gave it to Shchukin as a souvenir, saying, 'These days it is worth money.' Years ago it would have been a pleasant token of a summer afternoon, but Picasso was right. Circumstances had changed. Shortly afterwards, the sketch was sold. The man who had amassed the finest collection of early Picassos in the world could not afford to keep his last Picasso sketch.

Shchukin's later years in Paris were quiet and uneventful. Ivan had come to the Sorbonne to defend his doctoral dissertation on Persian art, Mme Morozova had settled in the city after the death of her husband, and now Shchukin's daughter, Yekaterina de Keller, had been allowed to leave Russia with her family and was living in Paris. Irina was dancing with the Monte Carlo Ballet, and Sergey enjoyed travelling to the south of France with Nadezhda to see the performances. He was a familiar sight during these visits, sitting among the palms of the hotel court in Nice, listening to American jazz in a black cape and large straw hat, a dark figure in a Dufy landscape.

Sergey Ivanovich grew a little smaller with the years and stuttered less. Finally, in 1936 he died. He was buried in Montmartre next to his brother Ivan.

He might have been impatient with the tapers and ceremony of the huge Russian Orthodox funeral, but he would have appreciated the words of Benois, his friend and adversary, who wrote of him after his death:

> One of the wonderful figures of old Moscow is no more. Sergey Ivanovich Shchukin is dead – My God how he was made to suffer for his 'sins' at the hands of those aesthetes among the money bags. His collection was not a whim, but a genuine feat of courage, for in addition to attacks by others he had to fight against his own doubts. He knew that many thought he was a madman, but he never became angry or demoralized by the doubts of others. I cannot think of Sergey without remembering his smile and bright alert eyes. He received his visitors with the unaffected kindness of old Moscow. He collected the modern French painters of the nineteenth and early twentieth century, not only for himself, but for his country. It is a Tsar's gift.[40]

THE LEGACY IN THE
SOVIET ERA

Comrades, wake up
Give us new art
to haul the republic out of the mud
 Vladimir Mayakovsky,
 *Order No. 2 To the Army
 of the Arts*

There must be a star, there must!
 Vladimir Mayakovsky, *Listen!*

For over fifty years, the artists of Russia had been prophets and advocates of social change. Now the old order had fallen and suddenly many were faced with the realization of an ideal, with the opportunity to fill a fresh canvas with new form and structure, without reference to the past. They regarded themselves as members of a new cadre which would sustain the momentum of revolutionary idealism and keep the remnants of the old society at bay. For a fleeting, euphoric moment, the bond between art and politics seemed indissoluble.

Bukharin noted that 'the changed artistic sphere corresponds closely with the changed social sphere'.[1] Modern Russian art, the art of protest, had flourished during an era of rebellion and had served to unify revolutionaries and intellectuals in a common cause. During the early years of the post-revolutionary period, artists were predominant in the field of propaganda and enlightenment. Yet as their individuality manifested itself, it became difficult to integrate and subordinate their separate viewpoints to a common social goal, and the utilization of modern art for State purposes in the late twenties became increasingly unpredictable and hazardous for its creators. At first, the Shchukin and Morozov collections, open to the public, were unaffected. However, as the

factionalism within the leading ranks of Russian artists grew, and as art increasingly was judged for its revolutionary effectiveness, it was merely a matter of time before the merchant collections became the object of political scrutiny. The fate of the modern Western collections and that of the Russian progressive painters were linked, and both reflected the uncertainties and priorities of government policy.

At the beginning the prospects seemed limitless. The Department of Fine Arts was created in 1918, and under Lunacharsky, the Commissar of Education, the Russian avant-garde received full support. 'Our land is being turned into a paradise, and is being made under the dictatorship of a genius. I am certain that the heights that will be achieved in the field of art under socialism will exceed all that has been created on this earth up to this time.'[2] The revolutionary message would be transmitted by the country's greatest talents: Kandinsky, Tatlin, Malevich, Puni, Benois, Rodchenko, Popova, Rozanova, Altman, Annenkov and Chagall. The storms that surrounded and ultimately engulfed these artists are relevant to the State's treatment of the merchants' paintings.

The government was in charge of the acquisition and assignment of all works of art within Russia; as head of the government purchasing commission, Kandinsky supervised the activities of the outlying museums in cities such as Perm and Yekaterinburg, and in the years between 1918 and 1921 he established twenty-two museums in the provinces.

In 1919 he founded the Academy of Pictorial Culture, where with other painters and scholars he explored the possibilities of artistic synthesis; he believed that poetry, drama, music, even science, could be joined to painting, combined in order to heighten aesthetic awareness and elevate standards in every area of national life. His efforts to improve the quality of art, publishing and theatre in Russia were part of this programme. Yet Kandinsky was no proletarian. When he became involved with applied art, he submitted to the former Imperial porcelain factory in Petrograd designs for a dinner service which were covered with graceful symbols, exquisitely esoteric. Primarily, he wished to 'touch the beholder's soul', not add to his physical well-being. In 1920 he established the programme for the Institute of Artistic Culture (Inkhuk), and the following year co-founded the Russian Academy of Artistic Sciences (RAKhN). Now his administrative duties left little time for teaching or creative work and in 1921 he completed only eight pictures. There is no indication that he endured any political harassment or pressures, but the bureaucratic duties, the committee meetings and lectures became burdensome. He was not free to work as he wished, and increasingly in the Soviet Union, art was becoming submerged in political necessity. The politicians and officials had less time and sympathy for the needs of the artists in their midst. In 1921 Kandinsky obtained government consent for a three-month visit to Germany, and in December he

left Russia for Berlin. The permission to travel had been a rare privilege, a reward for services well done; when it became known that he would not return, his departure was regarded as a betrayal and his citizenship was revoked. It is still difficult for a visitor to obtain access to the Kandinsky 'closed file' in Moscow. (However, with the showing of the Moscow–Paris Exhibition in Moscow in 1981, his important works were seen publicly in Russia for the first time since his departure.)

Marc Chagall was another notable figure to be employed at this time by the government in an administrative capacity. He was made Commissar for Art in Vitebsk. Lunacharsky had never been enthusiastic about this painter's work; he preferred the stark arcana of Tatlin, Malevich or Rodchenko. He had met Chagall in 1911–12 when both were living in Paris in the artists' colony of La Ruche. Lunacharsky had been working as a journalist, and after his first encounter with Chagall's pictures he had written an unsympathetic review for a newspaper in Kiev. But despite his personal preferences, Lunacharsky supported Chagall's appointment, for he knew that the painter would be a valuable addition to his programme.

The timing was superb; the first anniversary of the Revolution was to be celebrated throughout Russia, and each major city planned a mammoth festival. Petrograd commemorated the occasion with the first gigantic re-enactment of the 'Storming of the Winter Palace' staged in situ. With décors by Altman and Puni, it was the supreme street theatre. At night the Alexander column was illuminated with brilliant arc lights; the square in front of the palace was decorated with red banners; great canvas murals, two and three storeys high, depicted towering figures of the Revolution, not in the later style of Socialist Realism, but in the dynamic manner of Russia's most experimental artists. The pale, water-green façade of Rastrelli's edifice was transformed by jutting Cubist and pre-Constructivist designs and structures. On the roof behind the balustrade the serene bronze statues with their Classical attitudes seemed like detached observers at a carnival. Diverse elements of East and West were orchestrated into a single exultant pageant.

Vitebsk was not outshone by the spectaculars of Petrograd and Moscow. However, Chagall was no polemicist, and he created a version of the uprising, idiosyncratic, even whimsical, in which the dialectics and historic significance were muted by the sheer joy of the celebration. The figures on his banners flew through the air with no regard for gravity or history. The well-known symbol which he created for the occasion, *War on Palaces*, illustrates the contrast between Petrograd and Vitebsk on that day. Instead of jagged and dynamic workers, his standard carried a single hulking figure, a gentle fairy-tale giant holding aloft a gingerbread palace; ceremonial arches, garlands of flowers and greenery celebrated a revolution without casualties.

In 1919 Chagall became a director of the Art Academy in Vitebsk, and within a short time this peaceful setting became a battleground for the war between him and Malevich. Lazar (El) Lissitsky, then head of the Department of Graphic Arts and Architecture, precipitated the conflict when he suggested that his friend Malevich be invited to join the faculty.[3] The differences between Malevich and Chagall were both personal and artistic. Four years earlier, Malevich had written: 'The artist can be a creator only when the forms in his picture have nothing in common with nature.'[4] He foresaw a 'non-objective, pure' art devoid of the distractions of representational painting, one in which the square would be the 'face' of the future. Suprematism would provide the dynamic for a new world and a new art. Malevich abhorred Chagall's romanticism, colour and sensuousness, and Chagall's reaction to the creator of *White on White* was equally strong; the ardent warmth of one was pitted against the cold, brilliant non-representation of the other. Malevich's brooding, divisive presence filled the corridors and lecture halls; students and faculty became polarized, hecklers interrupted the sessions, making it impossible to teach. Malevich drew tortuous analogies between Suprematism and politics:

> The three squares of Suprematism represent the establishment of definite types of Weltanschauung and world building. The white square is a purely economic movement of the form. ... In the community they have received another significance: the black one as the sign of the economy, the red one as the signal for revolution, and the white one as pure action.[5]

For him, 'little pictures and fragrant roses'[6] had no purpose in a modern world. Malevich was a skilled brawler, incapable of engaging in any activity in which he was not the acknowledged leader. At Vitebsk, he organized Unovis (Uniya novogo iskusstva – Union of the New Art), and the power of his personality and his ideas soon attracted a devoted group of followers. It was a strangely peevish conflict, and the bitterness was captured in one small incident. Chagall's administrative duties frequently took him to Moscow to obtain official support and the money necessary to continue the Academy. He returned one evening after a short trip to find that during his absence the sign over the entrance had been changed from 'Free Academy' to 'Suprematist Academy'.

Though he had many supporters at the school, Chagall finally resigned in May 1920 and moved to Moscow where he became associated with the newly established Kamerny State Jewish Theatre. His theatrical involvement was not new. In 1911 in St Petersburg he had designed the sets and costumes for a play, *Happy to Die*, and while still at the Vitebsk Academy he had created the décor for a production of *The Inspector General* given by the Moscow Theatre of Revolutionary Satire, in which he used weightlessness and fantasy to highlight

the contrast between the new industrial Russia and the provincial land that Gogol knew.

The small auditorium of the Kamerny State Jewish Theatre held an audience of only ninety persons, but Chagall's most important theatrical work was done with this company. The artist was involved in every level of the production; in addition to the stage settings and costumes, he painted the friezes and murals which adorned the house; his fancies animated the plays of Ansky and Sholem Aleichem; he inspired the make-up and ultimately influenced the style of the actors' performances. Their portrayals absorbed the colouration, eccentricities and configurations of his sketches. During this association, Chagall fulfilled Mamontov's idea of the painter's role in the theatre. Today one cannot imagine the plays of Sholem Aleichem without visualizing Chagall's characters.

By 1921 Chagall was living in extreme poverty. The State provided the funds for artists in Russia at that time, and he was no longer an official favourite. The museums had ceased buying his paintings, his repeated applications for grants were reviewed by a committee which included Malevich, Rodchenko and Kandinsky,[7] men whose non-objective precepts were totally at variance with the lively images which inhabited his work. Chagall was placed in the lowest category of artists (Third Class), and the pittance he received was barely enough to sustain him and his family. In the battle between humanism and the machine, the machine had won.

This was the year of the introduction of Lenin's controversial New Economic Policy (NEP), which removed some of the restrictions on the capitalist segment and produced a new élite, the 'nepmen', and once again a small privileged group was buying pictures. The taste of the new bourgeoisie was less sophisticated than that of Shchukin or Morozov. It rejected all forms of modern art and provided a new market for the Wanderers. Thus Chagall was isolated from official support because he was insufficiently avant-garde and scorned by the private sector as too radical. Finally in desperation he appealed to Lunacharsky, with his help obtained a passport, and in 1922 left Russia for Berlin.

Russia was losing many of her greatest artists. Goncharova and Larionov had left the country in 1915 to work with Diaghilev in Paris; David Burlyuk abandoned Moscow in 1918 and after an incredible journey across Siberia, turned up in Japan in 1922. In June 1922, a few months after his arrival in Germany, Kandinsky took up a post at the Bauhaus in Weimar.

The core of genuinely revolutionary artists who chose to remain in Russia fared badly. Before he died in 1935, Malevich returned in part to Realism. Finally, he relinquished painting for textile and porcelain design and spent his last years admonishing the textile workers to study Cubism-Futurism. Yet despite his involvement with politics and applied art, Malevich was fundamentally a cabalist; Suprematism was a mystical formula designed to fascinate the

audience with abstract symbols: 'the purely painterly essence' of non-objective creation. In a final gesture, he chose to be buried in a Suprematist coffin which he had devised. 'I have set up the semaphores of Suprematism.'[8]

The continuing philosophical contrast between him and Tatlin was evident in the area of industrial design. Tatlin, the engineer, was governed by the logic of the machine; a proletarian, he could turn easily from his steel tower to the creation of functional objects: warm clothing, stoves and utensils for the workers. More than any other artist, he embodied the revolutionary ethic, but finally he retreated into a miasma of anxiety and suspicion, a crippling paranoia which made him unable to show his art for fear it would be stolen. His last important effort contained in a single work the conflict which ultimately destroyed him. His fantastic glider, *Letatlin*, was conceived as a functioning machine, a gift which would enable a terrestrial people to soar. When asked about the practical necessity for such an apparatus, he replied, 'Has the proletariat no use for a glider? . . . We have to learn to fly with it in the air, just as we learn to swim in the water. . . .'[9] Earthbound, useless, the model was finally valid only as an aesthetic creation. It stood as a permanent refutation of the Constructivist slogans: 'Long live technology', 'Down with art'.

Lunacharsky remained in office until 1929. His influence dwindled with each succeeding crisis, but he never swerved from his devotion to the ideals of the Revolution. In 1933, the year of his death, he was appointed Soviet ambassador to Spain. He had presided over a historic experiment which originated one of the fleeting myths of the twentieth century: that modern art and revolution are inextricably linked.

* * *

Years after the Revolution, a tribute to Shchukin came from an unexpected source. Yury Annenkov acknowledged the importance of the merchant's achievement. In his youth an artist of unassailable revolutionary sympathies, Annenkov had staged the third spectacular *Storming of the Winter Palace* in 1920 which had involved eight thousand participants and an orchestra of five hundred. This massive testimonial to the new order, his portraits of Malevich, Tatlin, Gorky and various Communist leaders, had brought the painter renown in the Soviet Union, and finally he had been commissioned to paint Trotsky. One day after a meeting at the Military-Revolutionary Council, the two men visited the Shchukin Museum which was nearby. Their discussions frequently turned to literature, poetry and the fine arts, and Annenkov noted that Trotsky was a connoisseur.

> I can attest to the fact that Trotsky's favourite artist was Picasso. In Picasso's formal instability, in his endless quest for new forms, Trotsky saw the embodiment

of 'permanent revolution', the very same 'permanent' quality that brought Picasso fame and wealth and cost Trotsky his life. . . . The Museum had been nationalized and Shchukin himself – who had discovered Picasso, discovered Matisse, who had created a priceless museum of the most contemporary European painting, this most generous of men – had been given a servant's room near the kitchen of his home. Trotsky lingered in front of Picasso's canvases and I did a sketch of him against the background of *L'Arlésienne*.[10]

In 1923 it was decided that though they were housed separately the Shchukin and Morozov collections should be administered by a single committee and the budgets combined. Boris Nikolayevich Ternovets, art historian, critic, and himself an artist, had been appointed director of the Museums after nationalization; his aim was 'to bring art closer to the people' and to gain world recognition for the unique quality of the Russian collection. Ternovets planned to reorganize the displays to show the evolution of art in the West and the manner in which one artist influenced another. This was a valid objective from a pedagogical point of view, but in the process, each of the merchant collections would lose its element of personal taste and individuality. In light of these new long-term goals, Yekaterina Shchukina's special knowledge was of little further use to the government, and in 1923 she and her family were permitted to leave Russia for Paris. In 1925 the paintings which had belonged to Ivan Morozov's brother Mikhail were transferred from the Tretyakov Gallery to the Museum of Modern Western Art.

Despite its limited funds, under Ternovets's dynamic direction the Museum purchased many paintings and drawings from exhibitions held in Moscow: works by Klee, Pechstein, Campendonk came from the Exhibition of German Art in 1924; those by Steinlen and Käthe Kollwitz were shown at the Exhibition of Revolutionary Art in 1926; and from the Exhibition of French Art held in Moscow in 1928, examples by Utrillo, Dufy and Ozenfant were acquired. Italian works by de Chirico and Campigli were exchanged and mingled with the Shchukin and Morozov pictures. The effort to show the continuity of revolutionary art and to 'display the works in accordance with scientific and historic principles'[11] further dimmed the individual contributions of the collectors.

In 1927–28 the merchant collections were brought together in the same gallery. The Shchukin accumulation was moved to the former Morozov town house in Kropotkin Street, once Prechistenka Street, and the building became the sole Museum of Modern Western Art. The Trubetskoy Palace later became the home of the Soviet Academy of Sciences. After 1928 there was an increasing concern with the doctrinal purity of the painter, and the Museum featured many exhibitions of individual modern artists, primarily those who were considered to be sympathetic to the new régime: Lurcat and Minna Harkavy were judged to

be acceptable. Ternovets defined the goals as 'the presentation of contemporary Western bourgeois art, the collection of revolutionary art from capitalist countries, and the formation of an active centre for teaching the revolutionary art of the West'.[12] In 1931 the Exhibition of the John Reed Club opened, and from this display the works of Gropper and Bard were added. André Lhote persuaded a Paris admirer to donate his *Green Landscape* (undated) to the Museum in 1927, and in 1934, Le Fauconnier, after his failure with Shchukin, induced another client in Amsterdam to make a similar gesture with his painting *The Signal* (1915).

In the twenties, the National Museum of Fine Arts (later the Pushkin) was established in Moscow. It held several private Russian collections, a portion of Western European art from the Tretyakov, but few old masters. The Hermitage owned a superb assortment of early Western masterpieces, but these ended abruptly with the Barbizon painters. A major reorganization of three museums was decided upon: the Hermitage sent the Pushkin many old master paintings and the Museum of Modern Western Art parted with some of the twentieth-century works. For the first time, and briefly, a few carefully chosen examples of the moderns were seen in the Hermitage. They included many of Shchukin's early selections: *Hamlet* and *Townscape with Cathedral* (1899) by Fernand Maglin, interiors of Versailles by Maurice Lobre (*The Dauphin's Room*, 1901) and Eugène Carrière's *Woman Leaning on a Table* arrived at the Hermitage in the thirties. In 1930 Matisse's *Conversation* (1909) was sent to the Hermitage, also *Still Life with a Red Commode* (1910) and *Woman in Green* (1909), along with a number of Picassos: *Portrait of Soler* (1903), *Pot, Wine-Glass and Book* (1908) and *Farmer's Wife* (1908) – the half-length version. The following year other important paintings were removed to Leningrad including Picasso's *Boy with a Dog* (1906) and Matisse's *Coffee Pot, Carafe and Fruit Dish* (1909). Even this rough outline of Museum activities makes it clear that the character and unity of Shchukin's collection were becoming invisible and the exhibits no longer reflected his special genius.

In 1922 there had been rumours that the Soviet government was desperately in need of funds. On July 19, 1922, the *New York Times* carried an article 'Bolsheviki Plan Picture Sales at the Hague'. Over the next decade the *Times* published periodic announcements of Russian sales of old masterpieces. The greatest sums were paid for the old masters: between 1929 and 1931, Calouste Gulbenkian made several major purchases, among them five Rembrandts including *Pallas Athene* and *Portrait of Titus*. In 1931 Secretary of the Treasury Andrew Mellon, through M. Knoedler and Company, purchased 6,500,000 dollars worth of paintings from the Hermitage, works by Van Dyck, Titian, Veronese, Rembrandt and Botticelli. The sale included Raphael's *Alba Madonna*, for which Mellon paid over 1,700,000 dollars. In 1933 the Metropolitan Museum in

New York acquired the Van Eyck diptych *The Crucifixion; The Last Judgment*.

R.C. Williams has observed, 'Had there been more of a market for them, the Soviet government might well have sold off the great collection of French moderns created before the revolution by Shchukin and Morozov. . . . In fact, in 1932 and 1933 the Soviet government did put some of the Shchukin and Morozov paintings up for sale, but failed to find a buyer.'[13] 'Soviet Items Bring Low Prices in Berlin' was a *Times* heading in 1932. This was the year in which the Soviet government put Cézanne's *Mardi Gras* from the Shchukin collection on the international market. The asking price was high for that time, approximately 115,000 dollars. Furthermore, because of the unusual circumstance of nationalization (or confiscation), legal titles to the paintings were clouded. There were no purchasers, and as a result the Soviet government 'began dickering to sell works by Degas, Picasso, Toulouse-Lautrec and Van Gogh at more reasonable prices, say $6,500 to $50,000 a piece'.[14] In retrospect, it would seem that what preserved these modern holdings in Russia at that time was the absence of understanding in the West of the true value, both aesthetic and financial, of the Shchukin and Morozov collections which had been assembled over the past thirty-five years.

The flow of hearsay and publicity in the twenties and thirties engendered a spate of lawsuits against the Soviet government by Russians living in exile, attempts by former owners to establish their legal claims to the works. Ultimately their efforts were fruitless, but they led to a great deal of speculation among Shchukin's friends as to his intentions. A companion of his son asked Shchukin if he planned to take legal action. He remembered: 'Sergey Ivanovich grew very upset. He always stuttered, but now he began to stutter even more as he said to me, "You know, P.A., that I collected not only and not so much for myself as for my country and for my people. Whatever is in my land, my collection must stay there".'[15]

Initially the Soviet authorities regarded Shchukin's involuntary bequest with a mixture of respect and mistrust. Even in the transitional period when the Soviet government protected the integrity of the collections, their fate was not entirely secure. Lenin's dislike of modern art and literature added to the uncertainty. For Lenin the authoritarian, Bolshevism would be imposed through Marxist theory and the Party. Art at best was an adjunct to revolution, a side-effect which could prove useful in manipulating public opinion.

Lunacharsky, in contrast, retained the romantic, almost theological conviction of the nineteenth-century Russian radical, that political change would result from a drastically altered culture and art. He believed with Georges Sorel, the French Syndicalist, that a people could be stirred emotionally to revolutionary action by social myth and legend, and his instrument to this end was the Russian avant-garde. His new Minister of Education had not always pleased Lenin, who

once claimed that Lunacharsky should be 'flogged for his futurism'.[16] These divergent attitudes were built into the official handling of the merchant collections.

In the early stages they were displayed internally and advertised abroad as proof of Russian progressiveness and sagacity. A modern Soviet source describes this policy:

> During these years the main task of the new museum was to achieve some kind of unity in its exhibits. In 1925, the collection of Mikhail Morozov, which had been in the Tretyakov gallery since 1910, was moved to the new museum together with a number of interesting works taken from various reserves and other collections. Thus, in these early years, many new paintings were added to the museum, including works by Manet, Renoir, Degas, Pissarro, Jongkind, Van Gogh, Carrière, Vallotton, Denis, Valtat, Toulouse-Lautrec, Forain, Van Dongen, Le Fauconnier, Rouault, Cassatt, Moreau, as well as pieces of sculpture by Rodin and Bourdelle.
>
> The second task was to re-organize the hanging of the pictures. . . . Making a private collection into a national museum does not merely mean opening it to the public: the paintings must be so disposed as to show the development of art during a certain period, the interacting of certain trends, the evolution of different painters. The organizers of the new museum also had to take into account the fact that it was being visited by more and more people who were perhaps inexperienced, but who were moved by the desire to understand art.[17]

Revealing the impact of one movement on another and illustrating the manner in which the artists influenced each other was undoubtedly simplified by the merchants' habit of buying closely related works. Shchukin's comprehensive accumulation of the paintings of Matisse, Derain and Picasso, and the Cézannes which overlapped both collections, are among the most obvious examples. A comparison of Van Gogh's *Night Café* and Gauguin's *Café at Arles* was available for a time before the Van Gogh was sold to a private collector in the United States.

In the early twenties efforts were made internationally to promote Soviet holdings. In addition to his abilities as administrator, painter and sculptor, Ternovets was an enlightened critic. His interest in modern art was evident in the article which he wrote in 1925 for a leading Paris publication, *L'Amour de l'Art*. Entitled 'Le Musée d'Art Moderne de Moscou (Anciennes Collections Stchoukine et Morosoff)',[18] the article enumerated the paintings of the Shchukin and Morozov aggregations and featured sixty-seven illustrations of the most important works by Cézanne, Gauguin, Renoir, Derain and Picasso among others. Ternovets did not focus on Matisse and Picasso, but emphasized the breadth of the assortment. His final sentence paid homage to the accomplishments of both men: 'Rendons justice aux deux collectionneurs.'

The writer predicted that 'in the years to come the museum will be enriched by new acquisitions and the post-war art of France will find itself represented with dignity and glory'. Signed 'Ternoviets. Directeur du Musée d'Art Moderne de Moscou', the article was at once an enthusiastic and subjective appraisal by an important figure in Soviet Russia and a statement approved by the government, designed to remind the West of the rare quality of the Soviet collection. The amount of care lavished on the Museum at this time comes through clearly; also, the respect with which the names of the absent patrons are mentioned is striking. The comprehension and warmth shown in the article were such that Shchukin and his family kept a copy of the magazine for years.[19]

After this high point came a reversal. By 1927, State sponsorship of modern art had begun to wane. The untrammelled explosion of experimentation which erupted after 1917 was subjected increasingly to the rigours of political and economic necessity. 'Art must serve the people and not the cultural élite', wrote Tatlin, but he and his friends had envisaged a society in which there would be complete freedom of artistic expression, by means of which the government and the people would be united in a common purpose. Excited by the challenge of street art, of immense monuments, of the functional creations of which Tatlin's projected steel tower would have been the culmination, Russian artists scorned the museums and the old formal collections. And if, in the light of what has passed, these dreams seem impossibly idealistic, it was a moment seldom equalled in history, in its optimism, desperation and terrible hope. The Revolution had been like a genetic mutation, a biological 'sport', unpredictable, possessed of its own voracious energy. If those who created it were unable to foresee clearly what would come, it is not surprising that artists and poets miscalculated the future.

The year 1930 was a crucial date in the history of art in Russia. In that year a conference of Museum workers was held in Moscow, and a new system of 'scientific research based on Marxian-Leninist theory' was implemented. 'From being a place merely to collect and hoard artistic materials, the Museum became a most important source of political mass enlightenment and cultural education of the visitors.'[20] The purpose: to show the effects of class struggle on the artists of the West, and 'the contradictions within the pessimistic decaying culture of the bourgeoisie and the culture of the proletariat which was flourishing despite all obstacles'.[21] The Marxist rhetoric clothed a reactionary disavowal of artistic values, a return to Stasov's realism and a utilitarian art. Shchukin and Morozov above all had appreciated art for its own sake and it is ironic that their paintings, which formed the basis of the Museum of Modern Western Art, were now the 'artistic documents of this great historical epoch of struggle of the world proletariat and its liberation'.[22]

Even the most enlightened critics reacted to the political pressures, and it is

interesting to note how Ternovets adapted to the change. For several years an awareness of the artist's political colouration had been discernible in his museum activities. His purchases of the works of Yves Alix and Fernand Léger are illustrative. From Alix he commissioned *A Scene at Court* (1928). In the twenties Alix had broken with Cubism and returned to Classicism. This painting, in the manner of Daumier, is a work of social criticism, depicting corrupt judges and venal lawyers of an old system. Léger was sympathetic to the Soviet revolution, and in 1927 his *Composition* (1924) was donated to the Museum by Ternovets. In the same year, Léger gave the Museum two of his sketches, from 1903 and 1905, each entitled *Standing Nude*. In 1929, another nude by Léger was donated by Larionov.

In 1934, the State Publishing House in Moscow issued an analysis by Ternovets of the two merchant collections of French art. His earlier admiring evaluation which had been published in Paris in 1925 was supplanted by many of the attitudes of the Stalinist régime. Ternovets still recognized the comprehensiveness of the works, their historical value and high quality. His appraisal of the differences in taste revealed by the two collectors was acute. He wrote that Shchukin's choices were 'distinguished by the vividness and subjectivism of the art displayed which gave it a flavour of sophisticated aestheticism'. Those of Morozov were assessed as 'well balanced, methodical, and pervaded by a spirit of compromise, eclecticism'.[23]

However, despite this recognition, artistic values were diminished in an effort to utilize the collections in a political statement. Ternovets went on to explain the new function of the Museum after 1930:

> The Marxian theory of Art, which had hitherto exerted a negligible influence on the work of the Museum, became a decisive factor only in the third period of development. A new approach to the problems of museum work was necessitated by the cultural revolution which was taking place throughout the country. From being mere storehouses and collections of art objects, the museums became influential centres for mass political-educational works of vital importance in the political and cultural education of the public. . . . By basing its work on Marxist art theory and the historical conceptions of Lenin (in particular his work on Imperialism), the Museum is developing a new conception of modern Western art which fundamentally differs from the various conceptions of Western art theorists. While these latter see only the development of different formal tendencies in art, the Moscow Museum exposes the class nature of art, and detects the fundamental contradictions of bourgeois society as reflected in its art.
>
> The period reviewed by the Museum is the period of the founding and development of the system of Imperialism, the contradictions of which led to the world war of 1914 and to the post-war crisis of capitalism. The new arrangement of the Museum material follows the basic historical stages of development of

Imperialism. It is not intended to show merely the changes in art styles, such as Realism, Fauvism, Cézannism, Expressionism, but is designed to demonstrate the development of social dynamics in art, to reflect those complexes of social relations which determine the separate stages of development of Imperialism. The Museum is also seriously engaged in the collection and exhibition of the new art of the Western proletariat, and of the radical petit-bourgeois fellow-travellers who, under the influence of the growing power of the proletariat, are drawn into its political struggle, and become the faithful allies of the working class. ... Exhibitions have been arranged of the work of Masereel, Laforge, Vogeler, Ehmsen. Group exhibitions of the Dutch fellow-travellers and of the John Reed Clubs of the United States have been held. ... At the same time, the Museum's excellent collection of works of bourgeois art is a guarantee that their study will be deeply scientific without over-simplification or vulgarization of Marxist principles, and this will permit a correct solution of the problem of our art heritage.[24]

Ternovets attached to his text a separate analysis of the major artists in the Museum, viewed in the light of Marxist principles. Some he discussed at length and some briefly.

Gauguin was denigrated as a mere hedonist who glorified Imperialism by portraying a serene and contented native population and ignoring colonial reality. The decorativeness of his work reduced his art to 'artificiality and pompous rhetoric'.

Cézanne presented a problem for Ternovets, for he had written of the artist as 'one of the greatest masters of the nineteenth century'. Finally, it was easier to attack the capitalist system which destroyed him. In 1933 Ternovets had conceded that this artist was

> greatly influential in the development of Russian painting and one of the central groups of the Moscow Painting Institute was for a long time based on Cézanne and his work. His influence on this group was especially evident following the Revolution. However, a realization of the dangers of Cézanne's formalism, *the inability of the methods of his abstracting art to solve the most important problems of Soviet painting* [emphasis – B.W.K.] caused a sharp criticism of the artist and an elimination of his influence in the art of the USSR.[25]

Matisse had been referred to by Ivan Shchukin as 'the perfect bourgeois', and the Marxists condemned him for his 'epicurean attitude toward life', and the impulse toward 'mere decoration'. Degas, considered a mere recorder of the more trivial pleasures and the ugly features of modern life, was dismissed as a 'blasé hedonist'.

Among the other painters, some were criticized and some were accepted, according to whether or not their work fitted Marxist ideology. Signac's pictures were rejected for 'artificiality and rationality typical of the industrial

bourgeoisie'. Vuillard received some respect for the refined composition, the lightness, airiness and cheerful character of his conceptions. However, his sympathetic treatment of the idle middle class living on unearned increment earned him a rebuke. Van Gogh, a painter of the 'plain people' who was reduced to penury by capitalism, unappreciated by the bourgeoisie, was hence admired in the Soviet Union. 'Van Gogh brings forth all the confusion and broken-up quality of his own life. . . .'

As the trend toward Socialist Realism intensified, Russian painting was reverting to the era of the Wanderers. It became increasingly difficult to reconcile this tendency with the eruption of avant-garde art which had been the banner of the Revolution only a few years earlier. In the German version of Ternovets's work published in 1934, Picasso was not discussed at all. Cubism, the art of the Revolution, was too difficult, too thorny and individualistic to be shaped easily to fit changing values. For a time the most conspicuous section of the foreign collections was ignored. In the earlier Russian edition Ternovets had discussed Cubism. Apparently the deep involvement of the revolutionary painters with Cubist art presented a continuing dialectical problem. It was a difficult fact to erase or discredit entirely and so a line was drawn. Before World War II, Cubism was 'a kind of last gasp of European art', but like all the other 'innovations' it suffered a decline after the war because of the 'exhaustion of Western artistic foundations, and the inability of the bourgeoisie to create anything new'. According to Ternovets, Cubism came to reject the principles which it had once defended, and the innovations which had seemed so active before the war declined sharply. It suffered a permanent crisis, and this very rational style began to move towards mere decorativeness. Cubism was accused of a 'dread of reality' and it succumbed to the 'inherent contradictions of bourgeois art'. Ternovets foresaw a return to realism in Western art, but he made a distinction between 'bourgeois' and 'socialist' realism. Western European art was 'based first of all on the use of colour sensations. Aesthetics and symbols are rolled up into conventionality and falsification. . . . Genuine realism under bourgeois conditions could only be revolutionary, an unmasking, revealing the essence of society's contradictions, leading to recognition and an alteration of reality.' Thus he concluded that if the realist painters in the West gave a true picture of life in a bourgeois society, their art was certain to become a radical force for change. Failing this, they distorted reality as completely as the Cubists. He summed up his critique: '. . . none of these artists can be accepted entirely. The limits and the contradictory nature of their world must be kept in mind.'[26]

This writer's efforts to view the entire spectrum of modern Western art as an exercise in dialectics seems sad and outmoded today, but Ternovets is an interesting study, his thinking revealing the effort of a critic, curator and scholar to harmonize and integrate the conflicting imperatives of art and the political

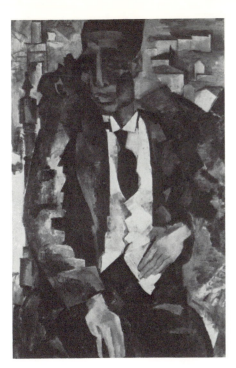

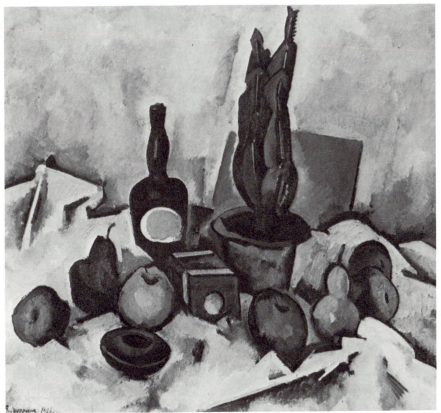

Top: Robert Falk: *Portrait of Refatov*, 1915. Tretyakov Gallery, Moscow

Above: Aleksandr Kuprin: *Still Life: Cactus and Fruits*, 1918.
State Russian Museum, Leningrad

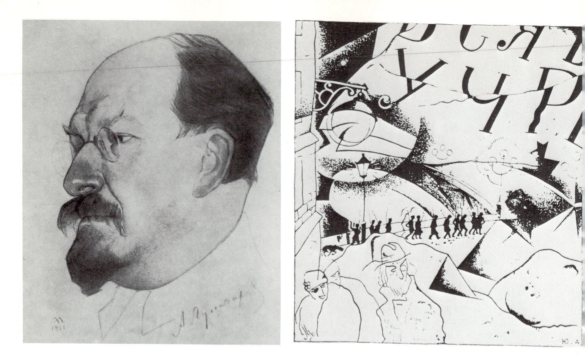

Above left: Nikolay Andreyev: *Portrait of Lunacharsky*, 1921.
Tretyakov Gallery, Moscow

Above right: Yury Annenkov: illustration for Aleksandr Blok's poem *The Twelve*.
Thomas P. Whitney Collection, Connecticut

Below: Yury Annenkov: *The Storming of the Winter Palace*, 1919–20

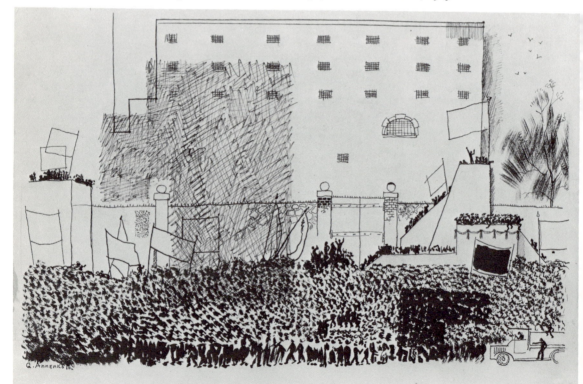

Lazar (El) Lissitsky:
*Tatlin Working on the Monument
of the Third International*,
1921–22

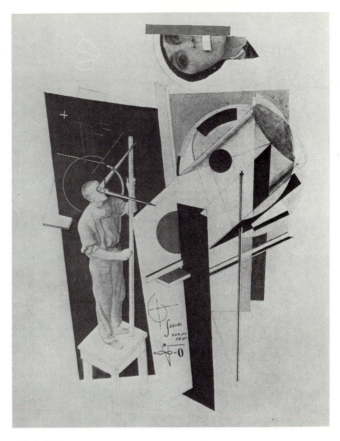

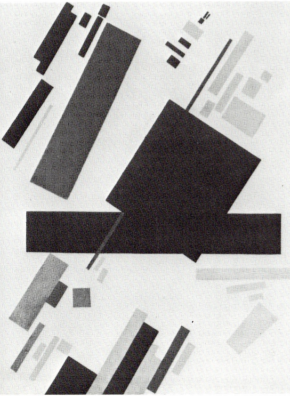

Kazimir Malevich:
Suprematist Painting, 1916.
Stedelijk Museum, Amsterdam

Sergey Shchukin in Paris after the Revolution

line. The degree of his success or failure may be gauged by the judgment of a critic of French art of our own time: 'There is the "good" Ternovets and the "bad" Ternovets, the names are identical, and one must be careful not to get the writers mixed, for the two men are completely opposed.' This comment was based on the two articles of 1925 and 1934 published in Paris and Moscow respectively. The downgrading of aesthetic factors in favour of political commentary marked the passing of modern Western art in Russia for the next twenty years.

The demise of the collections was imminent. In 1936 the *New York Times* reported the move away from modern art: 'Drive Against Leftism Opens'. (In the Soviet lexicon at that time, the artistic 'left' comprised the modern artists: Impressionists, Cubists, Futurists, etc. The representational painters – the Wanderers and their heirs, the painters of Socialist Realism, inhabited the right. Thus Shchukin was said by Ternovets to have created 'an Academy of left art'.) In 1938 the *Times* reported 'the purge of decadent modernism ...'. At the height of Stalin's period, when all contacts with the West were suspect, the Shchukin and Morozov paintings had moved into total eclipse.

At the outbreak of World War II, the Museum of Modern Western Art was closed and the pictures hidden away for safekeeping. After the war, the Museum was not re-opened. Government policy was still hostile and in 1948, the Museum of Modern Western Art was abolished by law. The holdings were divided into two parts; a portion entered the Pushkin Museum of Fine Arts in Moscow and a great number were assigned to the Hermitage. The paintings were not placed on general view; access was restricted to foreign visitors, art scholars and writers with a special interest. This policy continued until the death of Stalin in 1953. It was during the thaw produced by the brief conciliatory period of Malenkov that the holdings of the former Museum were exhibited again. The actual number of Impressionist canvases on view was limited at first, but slowly the works began to re-appear. A small inaccessible back room at the Pushkin Museum held three Matisses and three Picassos. In an adjoining area there were Van Gogh's *Landscape at Auvers* and *Prisoners' Round*, and Renoir's *Portrait of Jeanne Samary*, all of which had belonged to Ivan Morozov.

At this time, the government was persuaded to send some of its treasures abroad. In 1953 an important Picasso exhibition in Italy held thirty-six of Shchukin's Picassos and Morozov's *Portrait of Vollard*. The following year, the exhibition opened in Paris at the Maison de la Pensée Française, with the addition of twelve early Picassos which had belonged to Gertrude Stein, on loan from Alice B. Toklas. The Russian canvases had not been seen in Paris since they had been shipped to Moscow before 1914, and the exhibition promised to provide a rare survey of the artist's early work as well as a glimpse of a celebrated era.

There are two catalogues from this exhibition: the first, published in June 1954, is entitled *Picasso, Oeuvres de 1900–1914*; the second, issued in late July, *Picasso, Deux Périodes: 1900–1914 et 1950–1954*. The change of programme was necessitated by dramatic circumstances. Shchukin's daughter Irina, now the Countess de Keller,* decided to sue the Soviet government for possession of her father's paintings. It would have been a formidable inheritance, for the list included *After the Ball*; the lovely Cubist portrait of Fernande Olivier, *Young Woman*; Shchukin's earliest Picasso, *The Embrace*; and the overwhelming *Friendship* which had been the target of so much invective from the critics when it had hung in the Trubetskoy Palace forty-six years before.

The suit was enough to close the exhibition immediately, and it was rumoured that in the middle of the night, a van was backed up to the building and the paintings were spirited away. Perhaps the tale was apocryphal, but the incident must have been enough to instil once more within the Soviet hierarchy a suspicion of instability and chanciness in dealing with the West.

The Countess de Keller lost her action and it was felt that the exhibition should be resumed, but there was no possibility of persuading the Russians once again to part with the paintings and the Stein pictures were insufficient to carry the show. At this time Picasso himself consented to lend thirty-seven of his own works, dated from 1950 to 1954, as a substitute for the missing segment. There is a footnote to this episode. When the French government once again wished to borrow works from the Shchukin collection, Mme Matisse was asked by the French officials to approach the Countess de Keller to obtain her assurance that her previous course of action would not be repeated. Mme Duthuit, Matisse's daughter, was entrusted with this mission, and until the promise was forthcoming, the Shchukin paintings were not sent abroad again. In 1955–56 comprehensive surveys of French art in the Soviet Union were put on view at the Hermitage and Pushkin Museums, and they included many important works by Picasso, Matisse, Cézanne, Van Gogh and Gauguin, among others.[27] In 1960 selected paintings by Van Gogh were seen in Paris and Bordeaux. After this, the tempo quickened and a series of major exhibitions featuring the Shchukin and Morozov paintings opened in Tokyo, Otterlo in the Netherlands, New York and Washington.[28] A representative selection from the merchant collections was available outside Russia for the first time, and in cities accustomed to outstanding exhibitions, the quality, density and historical importance of the works were a revelation.

* * *

* Both of Shchukin's daughters, Irina and her half-sister Yekaterina, married members of the same family.

Many diverse elements in her history have contributed to the evolution of art in Russia: the Church, the individual rulers, the struggle between Slavophile and Westerner, the merchants, and finally, the Revolution. In Malevich's words:

> the oppressed revolt
> artists break away
> create new traditions
> prefigure great changes.[29]

The course of modern art in Russia provides an insight into the forces at work in that culture. Neither secular painting nor revolution evolved naturally out of the country's structure and history. Each was imported, a foreign object which took root and flourished in a violently unpredictable manner, explored and exalted with the passion and energy peculiar to the Russian people. Politically there was no broad, well-grounded tradition of rebellion among the masses, no progressive legacy in this Byzantine society. Marx despised Russia as the most reactionary of the great powers. With its agricultural economy, an illiterate, apathetic peasantry and the absence of an urban proletariat, it seemed unlikely to generate the socialist revolution. Yet Russia moved shatteringly from the absolutism and despotism of the Tsars into the most radical political manifestation in history.

Shchukin helped to precipitate the final brief synthesis of the art of East and West in an isolated and divided culture. Under the impact of his collection, there was a moment when a remarkable band of artists was exposed to the means by which they might effect a major breakthrough, not only in art, but through art, in society as a whole. With extraordinary sensibility they adapted the most unorthodox and experimental techniques of the West to the task of shaping a new and ideal society. In the process, their work, for all its unfamiliarity, retained an essentially Russian spirit. The almost metaphysical zeal and dedication which infused their effort for a time placed the artists of the Soviet Union ahead of the West in terms of imagination and new forms. Many modern painters and sculptors, the abstractionalists and minimalists who have been hailed for their audacity – Barnett Newman, Ben Nicholson, Ellsworth Kelly, Alexander Calder, Franz Kline, Ad Reinhardt – were anticipated by the radicals of Russia: Malevich, Tatlin, Rodchenko, Rozanova, Gabo, Lissitsky and others. 'Cubism and Futurism were revolutionary movements in art, anticipating the revolution in economic and political life.'[30] Ironically, at the end, the apocalyptic vision of a world revolution became the province of the modern Russian artists, the mystics and dreamers who considered themselves radicals and who finally became obsolete because their art was expressed in terms that were obscure to the mass of the people.

Malevich assessed a vital aspect of Shchukin's contribution to his work when he wrote:

> Evolution and revolution in art have the same aim which is to arrive at unity of creation – the formation of signs instead of the repetition of nature. One can point to Cézanne as a clear example of this movement. Cézanne, the prominent and conscious individual, recognized the reason for geometricization and, with full awareness of what he was doing, showed us the cone, cube and sphere as characteristic shapes on the basis of which one should build nature, i.e. reduce the object to simple geometrical expressions. ...[31] His self-portrait (in the S.I. Shchukin collection in Moscow) is his best painterly work; he did not so much see the face of the portrait, as invest in its forms something painterly that he felt rather than saw. Whoever feels painting, sees the object to a lesser degree; and whoever sees the object feels less what is painterly. ...[32]
>
> In the works of Cézanne the essential thing was the object's weight or heaviness; Picasso succeeded in developing this, in a resistance powerful enough to turn the earth from its course (see the S.I. Shchukin collection in Moscow). ...[33]
>
> Cubism is not, as the socialists think, bourgeois decadence ... it marks the artist's emancipation from slavish imitation of the object and the beginning of his search for direct discovery of creativity. There has never been a case when reason has failed to later recognize what it had earlier rejected ... the whole of French society ... honours Cézanne, whose best works are in Russia; they were collected by the art lover Sergey Ivanovich Shchukin who scorned public opinion and collected art's 'monstrosities'.[34]

The merchants were discarded as parasites, but during their short years of power they expanded the artistic heritage of their country and emancipated its artists. To the tradition of religious art and that of the aristocracy with its propensity for scale and grandeur, they added an intensely personal, individualistic, even selfish passion for beauty and innovation which left an indelible mark on the art and culture of their homeland and made Russia a historic and indispensable centre of twentieth-century painting.

Shchukin died in Paris, but his collection and his bequest survived the Revolution, Marxist evaluation and ideological burial, actual burial in World War II, resurrection and rehabilitation in the fifties. It has remained in his country as he wished. Shalyapin summed up the role of Shchukin and his friends: 'All these Russian muzhiks ... I cannot but marvel at their gifts and merits. ... What trumps they were in the national game.'[35]

THE WANDERERS

EARLY MEMBERS

Ge, Nikolay Nikolayevich (1831–94). Religious paintings. Portraits. Participated in Wanderers' first exhibition, November 29, 1871.

Klodt, Mikhail Petrovich (1835–1914). Landscapes.

Kramskoy, Ivan Nikolayevich (1837–87). Leader of the 'Fourteen' rebels (Artel Khudozhnikov) and the Wanderers. Polemicist for a national art. Portraits and religious paintings. Shown in Wanderers' first exhibition.

Makovsky, Konstantin Yegorovich (1839–1915). Member of the 'Fourteen'. Genre painting. Portraits. Son of the Kremlin architect Yegor Makovsky. Father of the critic and editor of *Apollon*, Sergey Konstantinovich Makovsky.

Makovsky, Vladimir Yegorovich (1846–1920). Brother of Konstantin. Genre paintings.

Morozov, Aleksandr Ivanovich (1835–1904). Genre paintings. Member of the 'Fourteen'.

Myasoyedov, Grigory Grigorevich (1835–1911). Genre painting.

Nevrev, Nikolay Vasilevich (1830–1904). Genre scenes.

Perov, Vasily Grigorevich (1833–92). Genre scenes. Portraits. Work shown in the Wanderers' first exhibition.

Polenov, Vasily Dmitrievich (1844–1927). Religious paintings. Landscapes.

Pryanichnikov, Illarion Mikhailovich (1840–94). Genre painting. Historical scenes. Shown in Wanderers' first exhibition.

Repin, Ilya Yefimovich (1844–1930). Portraits. Genre scenes. Historical painting.

Savrasov, Aleksey Kondratevich (1830–97). Landscapes. Work shown in the Wanderers' first exhibition.

Shishkin, Ivan Ivanovich (1832–98). Landscapes.

Savitsky, Konstantin Apollonovich (1844–1905). Genre painting.

Yaroshenko, Nikolay Aleksandrovich (1846–98). Genre painting. Portraits.

Mention should be made of:

Antokolsky, Mark Matveyevich (1843–1902). Sculptor. His historical figures, immediately recognizable, embodied the narrative power and emotional impact which was characteristic of the early Wanderers.

Kuindzhi, Arkhip Ivanovich (1842–1910). Influential landscapist. Member of the Wanderers from 1874 to 1879. His preoccupation with the lyrical effect of light on the Russian landscape gave his paintings a poetic identity, but made them unacceptable to his more conservative compatriots.

<p style="text-align:center">* * *</p>

Even a movement as cohesive as the Wanderers had its lateral branches: men philosophically attuned to the idea of a national art, yet dissatisfied with the propagandistic portrayals of Makovsky, the sombre colours and moral strictures of Ge. After a time these artists moved toward a more vibrant, decorative and colourful painting.

Historical and mythological themes. Scenes of Old Russian life:
Surikov, Vasily Ivanovich (1848–1916).
Vasnetsov, Apollinary Mikhailovich (1856–1933).
Vasnetsov, Viktor Mikhailovich (1848–1925).

Their influence was visible in the work of a later generation:
Arkhipov, Abram Yefimovich (1862–1930). Also studied with Perov and Polenov.
Kustodiyev, Boris Mikhailovich (1878–1927). Studied with Repin.
Malyavin, Fillip Andreyevich (1869–1940). Studied with Repin.
Roerich, Nikolay Konstantinovich (1874–1947). Studied with Repin.
Ryabushkin, Andrey Petrovich (1861–1904). Studied with Pryanichnikov and Perov.
Vinogradov, Sergey Arsenyevich (1869–1938). Studied with Polenov.

Savva Mamontov's colony supported the cause of Russian art, but at Abramtsevo the aesthetic element predominated:
Golovin, Aleksandr Yakovlevich (1863–1930). Portraits. Theatrical designs.
Korovin, Konstantin Alekseyevich (1861–1939). Landscapes. Portraits. Theatrical designs.
Levitan, Isaak Ilich (1860–1900). Landscapes.
Nesterov, Mikhail Vasilevich (1862–1942). Religious paintings. Portraits.
Ostrukhov, Ilya Semyonovich (1858–1929). Landscapes.
Serov, Valentin Aleksandrovich (1865–1911). Portraits. Landscapes.

Totally outside the worlds of Moscow and St Petersburg was Mikhail Vrubel (1856–1910), whom Naum Gabo has credited with preparing the eye of the Russian artist for Cézanne. Vrubel, who had studied with the realist artist Pavel Chistyakov and with Repin, who worked at Abramtsevo and was associated with the *Mir iskusstva* circle, remained to the end a unique, brilliant and unclassifiable talent.

THE MYSTERIOUS LETTERS:

Shchukin to Matisse, March 31, 1909 and August 22, 1912

Several years ago Dr Alfred Barr alerted me to a curious riddle with regard to Sergey Shchukin and *Dance* and *Music*. Unfortunately, at that time, I did not have enough information to ask the right questions, but circumstances which developed later, combined with the courtesy of M. Pierre Matisse, enabled me to find the answer. Dr Barr was encouraging to me as he was to so many others, and my only regret is that I did not have the opportunity to share with him the solution to the mystery.

Two letters written by Shchukin to Henri Matisse have caused a great deal of speculation about the dates and particulars of the arrival in Moscow of *Dance* and *Music*. In *Matisse, His Art and His Public*, Dr Barr explored the problem. The complete letters have been published in French in the Appendix of his book. The English translation follows:

Moscow, 31 March 1909

Dear Sir:

I find your panel 'The Dance' of such nobility that I have resolved to defy our bourgeois opinion and to place on my staircase a subject with NUDES. At the same time it will be necessary to have a second panel of which the subject might very well be music.

I was very pleased to have your answer: accept a firm order for the panel 'Dance' at fifteen thousand francs and the panel

Moscow, 22 August 1912

Dear Sir,

I have received today your letter of the 17th of August and I consent with pleasure to have you show at the Salon d'Automne, 'Nasturtiums with the Dance'. But I beg you to send the other two paintings ('The Moroccan' and the 'Goldfish') to Moscow without delay. I think a great deal of your blue painting (with two people), I find it like a byzantine enamel, so rich and deep in colour. It

'Music' at twelve thousand, price confidential. I thank you very much and I hope soon to have the sketch for the second panel.

The weather in Moscow is very bad, very cold and always raining. My health is very good.

I hope that you are fine and that the work goes well.

Do not forget the companion-piece for my fish.

My compliments to Mme Matisse.

Please be assured of my complete devotion.

Serge Stschoukine

is the most beautiful painting in my memory.

In my house we have a great deal of music. Each winter there are some ten classical concerts (Bach, Beethoven, Mozart). The panel 'Music' ought to indicate a little of the character of the house. I have great confidence in you and I am sure that the 'Music' will be as successful as the 'Dance'.

I beg you to give me news of your work.

All my reservations in my two preceding letters are annulled by my telegram of last Sunday. Now you have my definite order for the two panels. My compliments to Mme Matisse.

Awaiting your news, I remain,

Your very devoted

Serge Stschoukine

A comparison of the above letters reveals the problem. In 1909 Matisse received a 'firm order' for *Dance* and *Music*. The question obviously is why, in the letter of August 1912, almost three years after he had ordered the two works, should Shchukin write once again to Matisse about his need for the *Music* panel, explain its subject and reconfirm his order? This made no sense, particularly since his son Ivan, in our first interview a few years ago, remembered so clearly that *Music* was in place in the Trubetskoy Palace in 1911 in time for Matisse's visit.

Dr Barr, who had photocopies of the letters, reviewed the sequence in his book. After an account of the meeting between Matisse and Shchukin in 1909 in which he covered the creation and early stages of *Dance* and *Music*, Shchukin's hesitancy and cancellation of the commission, his odd infatuation with the Puvis and his final acceptance of the panels, Dr Barr wrote: 'Probably it was after Matisse returned from Spain in January 1911 that the two mural panels together with the two big still-lifes he had painted in Spain were packed and shipped to Moscow.' He went on to comment on the inconsistency: 'All this would seem to have been leading toward a happy ending were it not for a letter written by Shchukin to Matisse and clearly dated August 22, 1912. After a few agreeable or businesslike remarks about other paintings, Shchukin leads into his subject obliquely:

In my house we have a great deal of music. Each winter there are some ten classical concerts (Bach, Beethoven, Mozart). The panel 'Music' ought to indicate a bit of the character of the house.

I have full confidence in you and I am sure that the 'Music' will be as successful as the 'Dance'.

I beg you to give me news of your work.

All my reservations in my two preceding letters are annulled by my telegram of last Sunday. Now you have my definite order for the two panels.'

Dr Barr continues: 'It had been almost two years and nine months since March 31, 1909, when Matisse had received a letter from Shchukin giving him a "firm order" for the *Dance* and *Music*, and a year and a half since he had had Shchukin's second confirmation and had shipped the panels early in 1911. Matisse, when asked a second time if he could explain Shchukin's letter of August 12, threw up his hands.* He had already made clear, however, that he had not supervised the actual installation of the panels when he was in Moscow in the fall of 1911. To judge from Shchukin's August letter, *Dance* had been put into place but not, apparently, *Music* which had originally caused the most embarrassment. Ultimately both were hung, the *Music* with some slight "fig-leaf" retouching done in Moscow, and the story comes to an end.' With these words Dr Barr concluded his summary.

There was a second inconsistency. In the first missive of 1909, the collector wrote toward the end: 'N'oubliez-pas le pendant pour mes poisons [sic].' ('Do not forget the companion-piece for my fish.') The only painting by Matisse on record in Shchukin's collection which conforms to this description is *Les Poissons Rouges* which had not been painted at that time. It was painted in 1911.

We are left with two questions. How, in 1909, could Shchukin mention his 'fish' when there was no fish in his collection?

How in 1912 could he write to commission the panels when they were already on his walls?

It became clear after several readings that the contradictions were contained in the final portions of both letters. If one could draw a line through the middle of the text in each, after which the concluding sections of the letters were exchanged, then the events would follow logically and all the incongruities would be eliminated. The sequences would blend. The letters would read (translation by B.W.K.):

Moscow, 31 March 1909	Moscow, 22 August 1912
... I was very pleased to have your answer: accept a definite order for the	... But I beg you to send the other two paintings (The 'Moroccan'† and

* Dr Barr was interviewing Matisse in preparation for his book which was published in 1951.
† *Amido the Moor* (*The Moroccan*), early 1912.

panel 'Dance' at fifteen thousand francs and the panel 'Music' at twelve thousand, price confidential. I thank you very much and hope soon to have a sketch of the second panel.

(*second page*): In my house we have a great deal of music. Each winter there are some ten classical concerts (Bach, Beethoven, Mozart). The panel 'Music' ought to indicate a little the character of the house.

I have great confidence in you and I am sure that the 'Music' will be as successful as the 'Dance'. ...

the 'Goldfish'*) to Moscow without delay. I think a great deal of your blue painting (with two people),† I find it like a Byzantine enamel, so rich and deep in colour. It is the most beautiful painting in my memory.

(*second page*): The weather in Moscow is very bad, extremely cold and always raining. My health is very good.

I hope that you are fine and that the work goes well.

Do not forget the companion-piece for my fish.

My compliments to Mme Matisse.

...

Since Dr Barr had been working from photocopies, it was necessary to examine the originals and they were in the possession of M. Pierre Matisse. If the stationery or the writing invalidated the theory, another answer would have to be found. M. Matisse graciously produced the two letters: the one from 1909 was black bordered (Shchukin's wife, brother and two sons had died recently); the notepaper from 1912 was completely different, lighter and larger. The sheets were not interchangeable.

However, an examination revealed that each letter had been written on a single sheet of paper. The second page of each was on the reverse side of the first, a fact not evident from the copies. The first and second pages of each letter had been photographed separately, and in all there were four separate photocopies, one for each page. The originals could not have been shuffled, but *the duplicates of the second pages had been exchanged*. The end of the first pages coincided with the imaginary line and a perusal of the text confirmed the logical chronology. The question resolved in such a simple fashion revealed the capacity of modern science to frustrate the efforts of the finest scholars.

* *The Red Fish* (*Les Poissons Rouges*), painted in 1911, is known also as *Goldfish*. Dr Barr lists it under this title. Charles Sterling in his book *Great French Painting in the Hermitage* (Harry N. Abrams, New York, 1958, second edition, p. 179) refers to *Goldfish*, though he remarks on 'the dazzling cinnabar of the red fish.' However, it is carried in Shchukin's collection list as well as in a number of other publications as *Les Poissons Rouges*.

† *Conversation*, 1909.

THE SHCHUKIN COLLECTION

BRAQUE, GEORGES
The Castle at La Roche Guyon (Le Château à La Roche-Guyon), 1909

BRANGWYN, FRANK WILLIAM
The Market (Le Marché)
Compassion (La Miséricorde), 1890

BURNE-JONES, SIR EDWARD
The Adoration of the Magi (L'Adoration des mages), tapestry executed by the studios of W. Morris at Merton Abbey after a design by Burne-Jones

CARRIÈRE, EUGÈNE
Woman Leaning on a Table (L'Accoudée)
Woman Holding a Child (Maternité), originally Pyotr Shchukin collection
The Sleeper (La Dormeuse)
Woman Removing a Splinter from her Finger (Femme enlevant une écharde de son doigt)

CÉZANNE, PAUL
Bouquet of Flowers in a Vase (Bouquet de fleurs dans un vase), c.1873–75
Still Life, Fruits (Fruits), 1879–80
Self-Portrait (Portrait de l'artiste par lui-même), 1880
Mardi gras (Mardi gras), 1888
Lady in Blue (La Dame en bleu), c.1899
Man with a Pipe (L'Homme à la pipe), c.1890
The Aqueduct (Paysage d'Aix), c.1890
Mont Ste Victoire, c.1905; dated by Venturi, Dorival and Barskaya

COTTET, CHARLES
View of Venice from the Sea (Venise), 1896
Marine with a View of Venice (Marine avec Venise dans le lointain), 1896
Stormy Evening (Soir orageux)

COURBET, GUSTAVE
The Swiss Chalet (La Chaumière), 1874

CROSS, HENRI EDMOND
View of the Church of Santa-Maria degli Angeli near Assisi (Santa-Maria degli Angeli, près d'Assise), 1909

DEGAS, EDGAR
Woman Combing Her Hair (La Toilette), 1885–86, formerly Pyotr Shchukin collection
Dancers in Blue (Danseuses en bleu)
Dancer at the Photographer's Studio (La Danseuse chez la photographe)
Dancers at Rehearsal (Danseuses à la répétition)
Horses at the Racecourse (Chevaux de course)

DENIS, MAURICE
Portrait of the Artist's Wife (Portrait de la femme de l'artiste), 1893
The Visitation (La Visitation), 1894
Christ Visiting Martha and Mary (Le Christ chez Marthe et Marie), 1896
Sacred Grove (Le Bois sacré), 1897, formerly Pyotr Shchukin collection

DERAIN, ANDRÉ
The Port at Le Havre (Port), 1905–06
Montreuil-sur-mer (Harbour)/Montreuil-sur-mer (Port), 1910
The Castle (Le Château), c.1912
The Grove (Bois), 1912
The Rocks at Vers (Les Rochers), 1912
Still Life with Skull (Tête de mort), 1912
Earthenware Jug, White Serviette and Fruit (Nature morte), c.1912
Still Life (Nature morte), c.1912–13
Harbour in Provence, Martigues (Port en Provence), 1913
Saturday (Samedi), c.1911–14
The Lake (Le Lac), c.1913–14
Girl in a Black Dress (Portrait de jeune fille), 1914
Portrait of a Girl in Black Dress (Portrait de jeune fille), 1914
The Old Bridge (Le Vieux Pont)
View from the Window (Vue de la fenêtre)
Portrait of an Unknown Man with a Newspaper (Chevalier X), 1914

DÉTHOMAS, MAXIME
Waiting (L'Attente)

FANTIN-LATOUR, HENRI
The Bathers (Baigneuses)

LE FAUCONNIER, HENRI
Village among the Rocks (Village dans les rochers), 1910

FORAIN, JEAN-LOUIS
The Horse Race (Les Courses)
The Masked Ball (Sortie du bal masqué)
Lobby of the Theatre (Foyer de théâtre)

FRIESZ, OTHON EMILE
The Harvest (Travaux d'automne), 1907, oil sketch
Roofs and Cathedral at Rouen (La Cathédrale de Rouen), 1908
Mountains (Montagnes)

GAUGUIN, PAUL
Still Life with Fruit (Nature morte aux fruits – à mon ami Laval), 1888
Self-Portrait (Portrait de l'artiste par lui-même), 1890
What, Are You Jealous? (Eh quoi, tu es jalouse?/Aha oe feii?), 1892
Vairaoumati Is Her Name (Elle se nomme Vairaoumati/Vairaoumati tei oa), 1892
Nativity (Naissance du Christ à la tahitienne/Bébé), 1896
Scene from Tahitian Life (Scène de la vie des Tahitiens), 1896
Two Tahitian Women Indoors (Deux Tahitiennes/Ei aha ohipu), 1896
Woman with Mangoes (Femme aux mangoes/Te Arii, Wahine), 1896
Man Picking Fruit from a Tree (Homme cueillant des fruits dans un paysage jaune où sont deux chèvres blanches), 1897
Blue Idol (Le Dieu bleu/Rave te hiti aamu), 1898
Tahitian Woman with Flowers (Femme tenant des fleurs/Te avae no Maria), 1899
The Gathering of the Fruits (Cueillette des fruits/Rupe rupe), 1899
Landscape (Paysage), 1899
Maternity. Women by the Sea (Femmes au bord de la mer. Maternité), 1899
The Ford (Le Gué), 1901
Sunflowers (Tournesols sur un fauteuil), 1901

GIRAN, EMIL
Interior (Intérieur)

GUÉRIN, CHARLES
Lady with a Rose (La Dame à la rose), 1901
Young Girls on a Terrace (Jeunes filles sur une terrasse)

GUILLAUMIN, ARMAND
The Seine (La Seine)
Landscape with Ruins (Paysage aux ruines), 1890s(?)

GUILLOUX, CHARLES
Moonlight Night in Montmorency (Claire de lune), 1897

GUIREAUD, PIERRE
Peonies (Pivoines), 1906

HERBIN, AUGUSTE
Landscape (Paysage)

LACOSTE, CHARLES
Small House in a Garden (Maisonette au fond d'un jardin), 1905

LA TOUCHE, GASTON DE
The Transference of Holy Relics (Translation de reliques), 1899

LAURENCIN, MARIE
Artemis (Arthémise), 1908
Bacchante (Bacchante), 1911
Head of a Woman (Tête de femme)

LEHMAN
Mountains (Les Montagnes)

LIEBERMANN, MAX
Young Girl (Jeune Fille assise)
The Cowherd (La Gardeuse de vache)

LOBRE, MAURICE
The Dauphin's Room at the Palace of Versailles (Le Salon du Dauphin), 1901
The War Room at the Palace of Versailles (La Salle de la guerre), 1903
The Library of the Dauphin (La Bibliothèque du Dauphin)

MAGLIN, FERNAND
Townscape with a Cathedral (Bourg avec cathédrale), 1899
The Hamlet (Le Hameau), 1898
Springtime at Bouchet (Printemps au Bouchet)

MANGUIN, HENRI CHARLES
Woman on the Shore of Cavaliere Bay (Morning) (Au bord d'un lac), 1906

MARQUET, ALBERT
The Milliners (Les Modistes), c.1901–02
View of Saint-Jean-de-Luz (St-Jean-de-Luz), 1907
Port of Honfleur (Honfleur), 1907–11
Port of Hamburg (Port de Hambourg), 1909
Vesuvius (Le Vésuve), 1909
Paris in Winter. Notre Dame (Paris en hiver. Notre Dame), 1910
Pont Saint-Michel, Paris (Paris en hiver. Le Pont St-Michel), 1910
Pont Saint-Michel (Le Pont St-Michel), 1912
Rainy Day in Paris (L'Inondation à Paris), 1910

MATISSE, HENRI
Still Life with Tureen (Nature morte à la soupière), 1900
Still Life: Dishes and Fruits (Nature morte: Vaisselles et fruits), 1901
The Luxembourg Gardens (Le Jardin de Luxembourg), 1901–02
The Bois de Boulogne (Le Bois de Boulogne), 1902
Still Life with Vase, Bottle and Fruit (Nature morte), 1903–06
The Fisherman (L'Homme à l'hameçon/Le Pêcheur), 1905, pen sketch
View of Collioure (Vue de Collioure), 1906
Dishes and Fruit on a Red and Black Carpet (Nature morte), 1906–07
Lady on a Terrace (Dame sur une terrasse), 1906–07
Nude, Black and Gold (Nu), 1908
Still Life in Venetian Red (Nature morte en rouge de Venise), 1908
Game of Bowls (Jeu de balles), 1908
Harmony in Red (The Red Room) (La Desserte/La Chambre rouge), 1908–9
Coffee Pot, Carafe and Fruit Dish/Blue Tablecloth (Nature morte), 1909
Flowers (Bouquet de fleurs), 1909
Spanish Dancer (L'Espagnole au tambourin), 1909
Nymph and Satyr (La Nymphe et le Satyre), 1909
Woman in Green (La Dame en vert), 1909
Conversation (Conversation), 1909
Dance (La Danse), 1909–10
Music (La Musique), 1910

Still Life with a Red Commode (Nature morte au commode rouge), 1910
Girl with Tulips (La Jeune Fille avec tulipes), 1910
Still Life (Vases) (Nature morte, Chartres), 1910
Still Life, Seville (Nature morte, Séville), 1911
Spanish Still Life (Nature morte, Espagne), 1911
Goldfish (Les Poissons rouges), 1911
The Painter's Studio (L'Atelier du peintre), 1911
Family Portrait (La Famille du peintre), 1911
Vase of Irises (Les Iris), 1912
The Moroccan (Amido) (Le Marocain), 1912
Moroccan Woman (Zorah Standing) (La Marocaine), 1912
Corner of the Studio (Coin d'atelier), 1912
Nasturtiums and the Dance I (Les Capucines à 'La Danse' I), 1912
Moroccan in Green (Riffian) (Le Marocain), 1912–13
Bouquet of Flowers/Nature morte; arums (Sur la terrasse), 1912–13
Arums, Iris, Mimosa (Le Vase bleu), 1913
Arab Café (Café arabe), 1912–13
Portrait of Mme Matisse (Portrait de la femme de l'artiste), 1913

MÉNARD, EMIL-RENÉ
Landscape (Paysage)

MEUNIER, CONSTANTIN
Head of a Worker (Tête d'ouvrier), 1870s(?)

MILCENDEAU, CHARLES
Fruit Stand (Fruiterie)

MONET, CLAUDE
Luncheon on the Grass (Le Déjeuner sur l'herbe), 1866
Woman in a Garden (Une Dame dans le jardin), 1867
Lilacs of Argenteuil (Lilas d'Argenteuil/Lilas au soleil), 1873
Rocky Coast at Etretat (Les Rochers d'Etretat), 1886
Rocks of Belle-Île (Les Rochers de Belle-Île), 1886
Meadows at Giverny (Les Prairies à Giverny), 1888
Cathedral at Rouen (noon) (La Cathédrale de Rouen (à midi)), 1894
Cathedral at Rouen (evening) (La Cathédrale de Rouen (soir)), 1894
Cliffs near Dieppe (Falaises près de Dieppe), 1897
Waterlilies (Les Nymphéas), 1899
Town of Vetheuil (Vetheuil), 1901
Haystack (Moule de foin)
The Seagulls (Les Mouettes), 1904

MORET, HENRI
The Port (Le Port), 1896

PATTERSON, JAMES
The Enchanted Castle (Le Château enchanté), 1896, sketch

PICASSO, PABLO RUIZ
The Embrace (Rendez-vous) *(L'Étreinte),* 1899
Absinthe Drinker (Buveuse d'absinthe), 1901
Portrait of Jaime Sabartès (Portrait du poète Savartez/Le Bock), 1901
The Two Sisters (Les deux soeurs/L'Entrevue), 1902
Portrait of Soler (Portrait du tailleur Soler), 1903
The Old Jew and the Boy, The Old Jew (Le Vieux Juif), 1903
Woman with a Kerchief (Tête de femme), 1903
Boy with a Dog (Garçon au chien), 1905
Majorcan Woman (Espagnole de l'île Majorque), 1905
Mountebanks (Les Saltimbanques/Les Bateleurs) (Charcoal and gouache), 1905
Head of an Old Man with a Crown (Tête de vieillard à la tiare; gouache and
 aquarelle), n.d.
Glass Vessels (Nature morte), 1906
Naked Youth (Nu masculin), 1906
Nude (Torse de femme nue), 1907, related to *Demoiselles d'Avignon*
Nude with Drapery/Dance of the Veils (La Danse aux voiles), 1907
Still Life with Skull (Composition, tête de mort sénile), 1907
Study for *Still Life with Skull (Étude),* 1907*
Friendship (L'Amitié), 1908
Study for the painting *Friendship* (I) *(Étude pour le tableau 'L'Amitié'),* 1908
Study for the painting *Friendship* (II) *(Étude pour le tableau 'L'Amitié'),* 1908
House in a Garden (Maisonette dans un jardin), 1908
House in a Garden (Maisonette dans un jardin), 1908
Three Women (Trois femmes), 1908
Three Women (Trois femmes: étude pour le grand tableau de Stein), 1908
Bather (La Baignade), 1908
Woman with a Fan (La Dame à l'éventail), 1908
After the Ball (Après le bal), 1908
The Farmer's Wife (La Fermière), 1908
The Farmer's Wife (half-length) *(La Fermière–buste),* 1908
The Dryad (Dryade/Paysage avec un nu féminin), 1908
Woman Seated (Femme assise), 1908

* Listed only in Pyotr Pertsov, *The Shchukin Collection of French Painting,* Moscow, 1927,
p. 114.

Still Life (Green Bowl and Black Bottle) (Nature morte), 1908
Still Life (Pot, Wine-Glass and Book) (Nature morte), 1908
Still Life (Decanter and Tureens) (Nature morte), 1908
Still Life (Flowers in a Grey Jug and Wine-Glass with Spoon) (Nature morte)
 (Bouquet de fleurs), 1908
Man with Crossed Arms (L'Homme aux bras croisés), 1909
Female Nude (Femme nue), 1909
Queen Isabeau (La Reine Isabeau), 1909
Young Woman (Jeune Femme), 1909
Woman Playing the Mandolin (Femme jouant de la mandoline), 1909
Factory at Horta (L'Usine de Horta de l'Ebro), 1909
Still Life with a Bowl of Fruit (Nature morte: Vase de fruits), 1909
Musical Instruments (Les Instruments de musique; oval shape), 1912
Bottle of Pernod/Table in a Café (Le Café), 1912
The Ham (La Guinguette; oval shape), 1912
Still Life (Nature morte: Livres; gouache), n.d.
The Violin (Le Violon; oval shape), 1912
Flute and Violin (La Flûte et le Violon), 1913*
Violin and Guitar (Le Violon et la Guitare), 1913*
Composition. Bowl of Fruit and Sliced Pear (Nature morte), 1914
Fruit Vase and Bunch of Grapes (Nature morte), 1914

PIET, FERNAND
The Market at Brest (Le Marché à Brest)

PISSARRO, CAMILLE
Place du Théâtre Français (Place du Théâtre Français, Paris), 1898
Avenue de l'Opéra (Avenue de l'Opéra), 1899

PUVIS DE CHAVANNES, PIERRE
The Poor Fisherman (Le Pauvre Pêcheur), 1879
Pity (La Pitié), 1887, pastel

PUY, JEAN
Portrait of the Artist's Wife (Portrait de la femme du peintre)
Pont Romain at St Maurice (Pont romain à St Maurice)
Landscape (Paysage)

* Boris Ternovets and Louis Réau give 1912 as the date for these paintings. Contemporary Russian scholars list the year as 1913 in *French Painting from the Hermitage Museum*, Aurora–Abrams, Leningrad–New York, Nos 246 and 248.

REDON, ODILON
Woman Lying under a Tree (Femme couchée sous un arbre), occasionally
 entitled *Homme sous un arbre*
Woman at the Window (Femme à la fenêtre)
Spring (Le Renouveau)

RENOIR, PIERRE AUGUSTE
Woman in Black (Dame en noir), 1876
Two Girls in Black (Jeunes Filles en noir), 1881
Anna (Femme nue), 1876

RODIN, AUGUSTE
Study (Étude)

ROUAULT, GEORGES
Bather (Baignade), 1907

ROUSSEAU, HENRI
*In a Tropical Forest. Battle Between the Tiger and the Bull (Combat du tigre et
 du taureau.* Reproduction faite par Henri Rousseau de son tableau exposé
 dans le Salon des Indépendants en 1908), 1908
*Bridge at Sèvres (Vue du pont de Sèvres et des côteaux de Clamart, St Cloud et
 Bellevue)*, 1908
*View of the Fortifications on the Left Side of the Gate of Vanves (Vue prise
 commune de Vanves à gauche de la porte de ce nom)*, 1909
View of the Park de Montsouris (Vue du parc de Montsouris)
*The Luxembourg Gardens. Monument to Chopin (Jardin de Luxembourg.
 Monument à Chopin)*, 1909
The Muse Inspiring the Poet (La Muse inspirant le poète), 1909
Horse Attacked by a Jaguar (Cheval attaqué par un jaguar), 1910

SIGNAC, PAUL
The Port of Hue (Sandy Shores), 1890
The Bertaud Pine-Tree (Le Pin de Bertaud St Tropez), 1899

SIMON, LUCIEN
The Boatmen (Les Mariniers)

SISLEY, ALFRED
Village on the Banks of the Seine (Villeneuve-la-Garenne), 1872

STEVENSON, MACAULAY
Forest Scene (La Forêt)

THAULOW, FRITZ
Icy River (La Rivière gelée)
Boulevard de la Madeleine (Le Boulevard de la Madeleine), 1895
Venetian Scene (Coin de Venise)

TOULOUSE-LAUTREC, HENRI-MARIE-RAYMOND DE
Woman at the Window (Dame à la fenêtre), 1889

VAN DONGEN, KEES
Spring (Le Printemps), c.1908
Woman in a Black Hat (La Dame au chapeau noir), c.1908
Antonia la Coquinera (Antonia la Coquinera)

VAN GOGH, VINCENT
The Arena at Arles (Arène d'Arles), 1888
Promenade at Arles (Memory of the Garden at Etten), 1888
Portrait of Dr Rey (Portrait du docteur Rey), 1889
Bushes/Lilac Bush *(Buissons),* 1889

VLAMINCK, MAURICE DE
View of a Town by the Lake (Bourg au bord d'un lac), 1907
View of a Small Town (Bourg), 1909
View of a Small Town with a Church (Bourg avec église), c.1911

VUILLARD, JEAN EDOUARD
The Room (Intérieur), 1893, originally in the Pyotr Shchukin collection

WHISTLER, JAMES MCNEILL
Marine. Arrangement in Blue and Black (Marine. Arrangement en bleu et noir)
Marine. Arrangement in Grey and Black (Marine. Arrangement en gris et noir)
Woman Selling Oranges (La Marchande d'oranges)

ZULOAGA, IGNACIO
The Hermit (L'Ermite)
Spanish Women on a Balcony (Espagnoles dans une loge)

NOTES

1 MOSCOW VERSUS ST PETERSBURG: HISTORY OF A SCHISM

1 Nikolay Bukharin, *Historical Materialism. A System of Sociology*, Russell and Russell, New York, 1965 (authorized translation from the third Russian edition), p. 199.

2 Nikon, patriarch of the Russian Orthodox Church from 1652 to 1666, was determined to remove from the liturgy many 'errors', embellishments added by Russian clerics, which had accrued to the Russian ritual over the centuries, and he sought to turn once again toward the 'purity' of the Greek services. A symbol of his resolution was the edict which prohibited any future erection of the old tent-shaped churches and ordered a return to the Byzantine domes. It was the occasion for the religious schism which resulted in the exodus of the Old Believers from the Church and which led to the first organized repression of a minority in Russia. It continued in one form or another for one hundred and fifty years, until the legal recognition of the Old Believers in 1905.

3 Pierre Descargues, *The Hermitage*, Thames and Hudson, London, 1961, p. 14.

4 The influx of Western artists continued after Peter's death. Among them were George Christopher Grooth (arrived 1743), Pietro Rotari (1757), Louis Tocqué (1756) and Stephano Torelli, who arrived in the first year of the reign of Catherine II (1762).

5 Among the first Russian painters to work in the European style were Ivan Bezmin and F. Abrosimov.

6 Alexander Pushkin, *The Bronze Horseman*, lines 30–42, translated by Antony Wood (unpublished).

7 *Memoirs of Catherine the Great*, translated by Katharine Anthony, Tudor Publishing Company, New York, 1935. Based on the German edition, edited by Erich Boehme, Insel-Verlag, Leipzig, p. 326.

8 Alexandre Benois, *The Russian School of Painting*, introduction by Christian Brinton, Alfred A. Knopf, New York, 1916, p. 26.

9 It was Diaghilev who in 1904 established the existence of this previously unknown serf-artist. That year, in an article in *Mir iskusstva*, he traced the origins of the well-known portrait to Mikhail Shibanov. Before that time the work had been credited to

a minor Russian painter, a free man, a pupil of D.G. Levitsky, Aleksey Petrovich Shabanov. It was one of Diaghilev's more interesting ventures into pure scholarship. His task was made more difficult by the fact that there were no references to this shadowy serf-artist in the archives of the Academy of Arts. Out of this piece of artistic research, like an archaeologist with a bone, he established the identity and outline of a man whose presence had been ignored completely.

10 Fyodor Stepanovich Rokotov (c.1735–1808), a popular portrait painter and teacher at the Academy, executed several likenesses of the Empress Elizabeth. According to Professor John Bowlt, he was so much in demand that he painted only the faces of his subjects, leaving the background and dress to be completed by his pupils.

11 *Ivan Sergeyevich Aksakov v yego pismakh* (*Ivan Sergeyevich Aksakov in his Letters*), Part II, Vol. 4, St Petersburg, 1896, p. 18 (letter to M.F. Rayevsky, Moscow, April 13, 1859).

12 *Sochineniya I.S. Aksakova: Slavyanofilstvo i zapadnichestvo 1860–1886; Stati iz 'Dyna', 'Moskvy', 'Moskvicha', 'Rusi'* (*The Works of I.S. Aksakov: Slavophilism and Westernism 1860–1886; Articles from 'Den', 'Moskva', 'Moskvich', 'Rus'*), Vol. 2, Moscow, 1886, p. 71.

13 Benois, *Reminiscences of the Russian Ballet*, Putnam, London, 1947, p. 16.

14 Ivan Nikolayevich Kramskoy, *Pisma 1862–1875* (*Letters 1862–1875*), Vol. 2, Gosudarstvennoye Izdatelstvo Izobrazitelnykh Iskusstv, Leningrad, 1937, p. 27 (letter to P.M. Tretyakov, Paris, June 13/25, 1876).

15 The names are obscure. In addition to Kramskoy, they include B.B. Venig, A.K. Grigoryev, N.D. Dmitryev-Orenburgsky, F.S. Zhuravlev, A.I. Korzukhin, K.V. Lemokh, N.S. Shustov, N.P. Petrov, A.D. Litovchenko, K.Ye. Makovsky (Konstantin Yegorovich, not to be confused with his brother Vladimir), A.I. Morozov (Aleksandr Ivanovich, not to be confused with Ivan Abramovich, the collector), M.I. Peskov, and V.P. Kreytan, the lone sculptor.

16 Nikolay Gavrilovich Chernyshevsky (1829–89) had revered Alexander II as the man responsible for freeing the serfs, but he had grown impatient with the slow pace and incomplete execution of the agrarian reforms, and had broken with the gradualists in the Liberal party. He created and became the leader of the Radical party which advocated total and immediate reform. In an alliance with the Nihilists, he increased his political agitation until his arrest in 1862. During his incarceration in the Peter and Paul fortress in St Petersburg, he wrote *Chto delat?* (*What Is to Be Done?*) for which he was sentenced to exile in Siberia in 1864. In 1889, his health destroyed, he was permitted to return to Saratov, his birthplace, where he died a few months later.

17 V.V. Stasov, *Izbrannoye: Zhivopis, skulptura, grafika* (*Selected Works: Painting, Sculpture, Drawing*), Tom II: *Iskusstvo XIX veka* (Vol. 2: *Art of the Nineteenth Century*), Iskusstvo, Moscow/Leningrad, 1951, p. 159.

18 An article in *Sankt-Peterburgskiye vedomosti* (November 1865) two years after the formation of the Artel took note of the desperate plight of the artists: 'It is astonishing that these young painters have sufficient courage and firmness to continue in their thankless work.' The writer noted that they produced the paintings which were

exhibited each year, 'alone, without aid or comfort in the face of coldness and general apathy. V.S.' (Vladimir Stasov?).

19 *Ivan Nikolayevich Kramskoy. Yego zhizn, perepiska i khudozhestvenno-kriticheskiye stati 1837–1887 (Ivan Nikolayevich Kramskoy. His Life, Correspondence and Artistic-Critical Essays)*: *Zametki ob Arteli Khudoznikov i Tovarishchestve peredvizhnykh vystavok (1882)*, Aleksey Suvorin, St Petersburg, 1888, pp. 683–84.

20 N.G. Chernyshevsky, 'Esteticheskiya otnosheniya iskusstva k deistvitelnosti' ('The Aesthetic Relationship of Art to Reality') in *Estetika i poeziya (Aesthetics and Poetry)*, M.N. Chernyshevsky, St Petersburg, 1893, p. 108.

21 Kramskoy, op. cit., pp. 350–51 (letter to A.S. Suvorin, St Petersburg, 1885).

22 R.F. Christian, *Tolstoy's Letters. 1880–1910*, Vol. 2, Charles Scribner's Sons, New York, 1978, p. 508 (letter from Leo Tolstoy to Pavel Tretyakov, Yasnaya Polyana, June 7/14, 1894).

23 A.P. Botkina, *Pavel Mikhaylovich Tretyakov v zhizni i iskusstve (Pavel Mikhaylovich Tretyakov in Life and Art)*, Izdatelstvo Gosudarstvennoy Tretyakovskoy Gallerey, Moscow, 1951, p. 85 (letter from Pavel Tretyakov to Leo Tolstoy, July 9, 1894).

24 Igor Emmanuilovich Grabar, *Moya zhizn – Avtomonografiya (My Life – Autobiography)*, Iskusstvo, Moscow/Leningrad, 1937, p. 9 (extract of a letter from Repin to V. Stasov dated June 27, 1899).

25 Mikhail Yevgrafovich Saltykov-Shchedrin, *O literature i iskusstve – Izbrannyye stati, retsenzii, pisma (On Literature and Art – Selected Articles, Reviews, Letters)*, 'Pervaya russkaya peredvizhnaya khudozhestvennaya vystavka' ('The First Russian Exhibition of the Peredvizhniki'), Iskusstvo, Moscow, 1953, pp. 545–53.

26 V.V. Stasov, *Izbrannoye sochineniya v trekh tomakh – zhivopis, skulptura, muzyka (Selected Works in Three Volumes – Painting, Sculpture, Music)*, Vol. 1, Iskusstvo, Moscow, 1952, p. 207.

27 ibid., p. 207: *Peredvizhnaya vystavka 1871 goda (The 1871 Peredvizhnik Exhibition)*.

28 Kramskoy, op. cit., p. 27 (letter to P.M. Tretyakov, Paris, June 13/25, 1876).

29 Vissarion Grigorevich Belinsky, *Estetika i literaturnaya kritika (Aesthetics and Literary Criticism)*, Vol. 1, Gosudarstvennoye izdatelstvo khudozhestvennoy literatury, Moscow, 1959, pp. 621–23.

30 The association was dissolved officially in 1923.

2 HIGHLIGHTS OF ST PETERSBURG'S GOLDEN AGE

1 Alexandre Benois, *Reminiscences of the Russian Ballet*, Putnam, London, 1947, p. 181.

2 Konstantin Stanislavsky (Alekseyev), *My Life in Art*, translated by J.J. Robbins, Little, Brown, New York City, 1924 (Theatre Arts Books edition), p. 197.

3 Emile Zola, *Vystavka kartin v Parizhe (An Exhibition of Paintings in Paris)*, *Parisian Letters* III, *Vestnik Yevropy*, Vols 5–6,

4 ibid., p. 884.

5 Emile Zola, *Vystavka kartin v Parizhe (An Exhibition of Paintings in Paris)*, *Parisian Letters* III, *Vestnik Yevropy*, Vols 5–6, St Petersburg, 1875, p. 887.

6 ibid., p. 889.

7 Benois, op. cit., p. 159.

8 ibid., pp. 182–83.

9 ibid., p. 176.

10 ibid., p. 158.

11 ibid., p. 161.

12 ibid., p. 160.

13 Camilla Gray, *The Russian Experiment in Art: 1863–1922*, Harry N. Abrams, New York, 1970, p. 40.

14 Benois gives conflicting dates for this Scandinavian exhibition. In *Reminiscences of the Russian Ballet* (p. 185) he states that it took place in the autumn of 1896. In *Vozniknoveniye 'Mira iskusstva'* (see note 19 below), he places the showing in the fall of 1897. The later date is corroborated by letters he received from Diaghilev in 1897, and by the fact that Diaghilev visited him in Brittany in 1897, 'while travelling from Stockholm where he had been preparing a Scandinavian exhibition planned for the fall' (p. 26).

15 Serge Lifar, *Serge Diaghilev: His Life, His Work, His Legend*, G.P. Putnam's Sons, New York, 1940, p. 4.

16 V.V. Stasov, *Izbrannoye: Zhivopis, skulptura, grafika*. Tom I: *Russkoye iskusstvo. (Selected Works – Painting, Sculpture, Graphics*. Vol. I: *Russian Art*), Iskusstvo, Moscow/Leningrad, 1950, p. 336.

17 Sergey Diaghilev, 'Slozhnyye voprosy' ('Complicated Questions'), *Mir iskusstva*, Vols 1–2, 1899, p. 3.

18 Stasov, op. cit., p. 335.

19 Benois, *Vozniknoveniye 'Mira iskusstva' (The Origins of 'Mir Iskusstva'*), Komitet populyarizatsii khudozhestvennykh izdaniy pri gosudarstvennoy akademii istorii materialnoy kultury, Leningrad, 1928, pp. 27–28.

20 ibid., p. 20.

21 Benois's reputation had been enhanced in 1893 when at the age of twenty-three he had written the chapter on Russian art in Muther's *History of Painting in the Nineteenth Century*. In 1896 he received his first important recognition as a painter when Pavel Tretyakov purchased his painting *The Castle* for the Tretyakov Museum.

22 Benois, *Vozniknoveniye 'Mira iskusstva'*, pp. 30–31.

23 Diaghilev, op. cit.

24 Diaghilev, 'K vystavke V.M. Vasnetsova' ('On Vasnetsov's Exhibition'), *Mir iskusstva*, Vols 7–8, 1899, pp. 66–67.

25 Benois, *Vozniknoveniye 'Mira iskusstva'*, p. 26.

26 Princess M.K. Tenisheva, *Vpechatleniya moyey zhizni (Impressions of My Life)*, Russkoye Historiko-Genealogicheskoye Obshchestvo Vo Frantssi, Paris, 1933, p. 178.

27 ibid., p. 278.

28 *Mir iskusstva*, Vols 1–2, 1899: *Zametki (Notes)*, p. 9.

29 Tenisheva, op. cit., p. 277.

30 The cartoon, entitled 'Idyll (World of Art)', was by Pavel Shcherbov, whom Benois called 'the Old Judge'. It appeared in the publication *Shut* (*Buffoon*) in 1900.

31 Tenisheva, op. cit., p. 278.

32 The final issue of 1899 (Vol. 24) carried an advertisement for subscriptions to the journal for 1900. The names of Tenisheva and Mamontov no longer appeared. Diaghilev was listed as sole editor and publisher.

33 The portrait was destroyed in 1917 during the storming of the Winter Palace.

34 Benois, *Reminiscences* ..., p. 187.

35 Benois, *Vozniknoveniye* ..., p. 38.

36 The first issue of *Mir iskusstva* appeared in November 1898, but was dated 'Volume I 1899'. Thus the journal is said to have begun in 1899.

37 Benois, *Reminiscences* ..., p. 193.

38 Benois was the centre of a Russian mini-colony in France. Konstantin Somov was living nearby, Bakst came for a time and Yevgeny Lancéray was studying in Paris. A newcomer to the circle was Anna Petrovna Ostroumova-Lebedeyva, a talented artist who had been a pupil of Repin at the St Petersburg Academy and who now was studying with Whistler at the Academy Carmen in Paris. Eventually she became an important contributor to *Mir iskusstva*. The group was augmented by Benois's friendship with many prominent artists of the French salons, among them Lucien Simon, Charles Guérin and Gaston de La Touche, who were featured in many of the foremost Russian collections. When Benois returned to St Petersburg he introduced his friends to the work of Felix Vallotton, and the graphics of this artist were a regular feature in *Mir iskusstva*.

39 Benois, *Vozniknoveniye* ..., pp. 40–41. Letter to Benois from Nouvel, June 15/27, 1898.

40 As a result of Diaghilev's support, Vasnetsov dominated the issue. Twelve illustrations – battle scenes, bogatyrs, illuminations, drawings, landscapes, designs for porcelains, ornaments and furniture – filled the first section. The sole exception in these early pages was a portrait by Repin – a likeness of Vasnetsov, loaned to *Mir iskusstva* by Yelizaveta Mamontova. Despite this extensive coverage, Vasnetsov was offended by the tone of the biographical notes which were published in the journal, and as a result withdrew from Diaghilev and his friends.

41 In 1899, in *Mir iskusstva* (Vols 7–8, pp. 66–67) Diaghilev wrote a critique of Vasnetsov's exhibition at the Academy of Art. It was a favourable appraisal of the painter as one of a group 'which has defined the course of all contemporary Russian painting.' He linked Vasnetsov with Repin and Surikov: 'Russian art has never expressed national self-recognition so strongly as in the paintings of these masters.' The exhibition, according to Diaghilev, 'secured the respect of all who went there. ... It is the apotheosis of Vasnetsov's *significance* [Diaghilev's emphasis]. I don't want to say creation because I am sure he will create more.' Obviously Diaghilev responded to the mythic 'Russianness' of Vasnetsov's work, yet he was still ambivalent, for with great adroitness he managed to praise Vasnetsov's historic role in Russian art without once commending his technique or his style.

42 Diaghilev, 'Slozhnyye voprosy' (Part IV), *Mir iskusstva*, Vols 3–4, 1899, p. 57.

43 Benois, *Vozniknoveniye 'Mira iskusstva'*, p. 42. Bakst letter dated October 24, 1898.

44 Igor Grabar, 'Pisma iz Myunkhena' ('Letters from Munich'), *Mir iskusstva*, Vol. 8, 1899, p. 77.

45 Diaghilev, 'Slozhnyye voprosy' (Part I), *Mir iskusstva*, Vols 1–2, 1899, pp. 1–16.

46 Benois, *The Russian School of Painting*, introduction by Christian Brinton, Alfred A. Knopf, New York, 1916, p. 145. (Apollinary Vasnetsov, like his brother Viktor, was a member of Mamontov's Abramtsevo circle.)

47 Levitan's landscapes have survived successive trends in Russia. In the *Mir iskusstva* exhibition of 1899, he showed *Silence*, a landscape which evoked the blue, still moment before dusk. This work was included with those of Poussin and Caravaggio in the exhibition of Master Paintings from the Hermitage and the State Russian Museum sent abroad by the Russian government in 1975.

48 Ilya Repin, 'Po adresu "Mira iskusstva" – Pismo redaktsiyu zhurnala "Nivy"' ('Concerning "Mir iskusstva" – Letter to the Editor of "Niva"'), *Mir iskusstva*, Vol. 10, 1899, pp. 1–4.

49 V.P. Lapshin, *Soyuz russkikh khudozhnikov* (*Union of Russian Artists*), Khudozhnik, RSFSR, Leningrad, 1974, p. 32 (letter from Diaghilev to Serov, October 15, 1902).

50 Igor Emmanuilovich Grabar, *Moya zhizn – Avtomonografiya* (*My Life – Autobiography*), Iskusstvo, Moscow/Leningrad, 1937, p. 188.

51 Diaghilev, 'V chas itogov' ('At the Hour of Reckoning'), *Vesy*, Vol. 4, Moscow, 1905, pp. 45–46.

52 Benois, *Reminiscences . . .*, p. 371.

53 ibid., p. 239.

54 Daniel-Henry Kahnweiler with Francis Cremieux, *My Galleries and Painters*, Documents of 20th Century Art, Viking Press, New York, 1971, p. 58.

55 Benois, 'Besedy khudozhnika . . .', *Mir iskusstva*, Vol. 6, 1899, p. 49.

56 ibid., p. 49.

57 ibid., p. 51.

58 ibid., p. 49.

59 ibid., p. 51.

3 THE GREAT MERCHANT PATRONS

1 Konstantin Stanislavsky, *My Life in Art*, Little, Brown, New York, 1924, p. 12.

2 Andrey Bely (Boris Nikolayevich Bugayev), *Mezhdu dvukh revolyutsii* (*Between Two Revolutions*), Izdatelstvo Pisateley, Leningrad, 1934, p. 224.

3 ibid., p. 223.

4 A.P. Botkina, *Pavel Mikhaylovich Tretyakov v zhizni i iskusstve* (*Pavel Mikhaylovich Tretyakov in Life and Art*), Iskusstvo, Moscow, 1960 (letter from Tretyakov to Leo Tolstoy, June 18, 1890), pp. 227–28.

5 ibid., p. 228.

6 Before 1863 a tax farmer in Russia held a licence from the government which empowered him to act as an agent to collect taxes from a state monopoly which were then forwarded to St Petersburg. He retained a percentage of the tax as a fee for his

services. It was a lucrative occupation and before the practice was outlawed, several major fortunes had their origins in it.

7 The Mamontovs had eight children: four girls and four boys. The brothers were Fyodor, Savva, Anatoly and Nikolay, in that order.

8 Repin painted Yelizaveta Mamontova in 1878. The pose is simple, a seated frontal view, hair drawn back from a centre parting, the somewhat heavy features redeemed by gentle, expressive eyes. Repin saw rectitude, tranquillity and a quiet indomitability, in marked contrast to the outgoing Savva.

9 Sergey Timofeyevich Aksakov (1791–1859) was the author of a number of classics: *Chronicles of a Russian Family, Autobiography of a Russian Schoolboy* and *Recollections of Gogol*. After he settled in Moscow in the 1830s, his home became a centre of Slavic thought for intellectuals and students at Moscow University. His sons Konstantin and Ivan inherited their father's Pan-Slavic views. Konstantin, in 1860, the year of his death, excoriated St Petersburg as a 'repudiation of Moscow', a solitary city for those who could not live with Russia. Konstantin's younger brother Ivan was a poet, activist, editor and publisher of several Pan-Slavist journals. These were closed down periodically, and in 1878, Ivan was exiled from Moscow. After his return in 1880, he became the editor of *Rus*, the literary arm of the Slavophile party.

10 Aleksandr Nikolayevich Serov had died two years earlier at the age of fifty-one. Igor Stravinsky, in his autobiography, characterized him as a 'composer of the second rank'. However, his opera *Judith* was one of the staples of the Russian repertoire, and is still played occasionally today.

11 The figure of Christ was an extremely popular subject in Russian art during the latter part of the nineteenth century. It occasioned bitter differences between the Wanderers, whose Christ was vulnerable and mortal, and the Academy, whose serene 'iconized' version disturbed Tolstoy. After Ivanov's influential work, the Wanderers' distinctive blend of humanism and religious feeling was exemplified by Ge, Repin, Kramskoy and Polenov.

12 *Mark Matveyevich Antokolsky. Yego zhizn tvoreniya – Pisma i stati (Mark Matveyevich Antokolsky. His Life Works – Letters and Articles)*, edited by V.V. Stasov, M.O. Volf, St Petersburg, 1905, p. 69.

13 In one of his best known works, *They Did Not Expect Him* (1884), Repin set the drama of his returning soldier within the sunny confines of Abramtsevo, faithfully depicting the patterned wallpaper, the comfortable armchair with its flowered chintz cover and the wooden floors characteristic of this rambling old house. Repin also worked on *Religious Procession in the Province of Kursk* (1880–83) at Abramtsevo. The owner of the neighbouring estate had been given the right to clear the woods near Abramtsevo and the stumps are visible in the background. The setting here is less interesting, but many faces in this procession are those of peasants who lived in the area, or of actual pilgrims on their way to the Trinity Monastery at Sergeyevsky Posad (Zagorsk). Both paintings are in the Tretyakov Gallery.

14 The landscape and figures of Abramtsevo were part of every aspect of Vasnetsov's work. Portraits of Yelizaveta Mamontova (1883), Mark Antokolsky (1884) and Vera Mamontova (1896) were only a few that he completed during these years. Natalya

Mamontova provided the likeness for Helen the Fair in his *Ivan Tsarevich Riding the Grey Wolf* (1899). His popular *Alyonushka* was an unusually soft and limpid view of the reflecting pool on the estate, and the scene for the Prologue of *Snegurochka* (1885) showed the snow-covered birches and fir trees of Abramtsevo on a winter night.

15 Serov has left some idea of the warmth and serenity of the surroundings in his portrait of Mamontov's daughter Vera Mamontova. Today it is still one of the most popular pictures in the Tretyakov Gallery. In *Girl with Peaches* (1887), the light from the windows in the background illuminates every corner of the canvas. The young girl seated at a table gazes at the viewer; she has selected a peach, velvety and fragrant, from the leaf-lined basket. The tremulous heat of a Russian summer afternoon is palpable; both she and the fruit are sun-drenched. The shimmering ripeness of the work is the closest Serov ever came to Impressionism. The air of tranquillity illustrates the attraction of Abramtsevo for those artists who were buffeted by the pressures and uncertainties of Moscow.

16 According to Professor John E. Bowlt, Nesterov's painting *The Vision of the Child Bartholomew* (1889–90) is also set amid the countryside of the Mamontov estate.

17 Fyodor Shalyapin (Chaliapin), *Man and Mask*, translated from the French by Phyllis Megroz, Alfred A. Knopf, New York, 1932, p. 80.

18 The Vasnetsov brothers, Vasily Surikov and later, Nicholas Roerich represented the small deviationist group of nationalist painters, neither orthodox Wanderers nor adherents of *Mir iskusstva*, whose work and imagination were captured by Russian history and legend. Viktor Vasnetsov's bogatyrs and saints were redolent of ancient Russia; Roerich's themes were similar but his figures were more solid, the colours deeper. Surikov's work features many incidents from the Petrine era: *The Morning of the Streltsy Execution* (1881) and *The Boyarina Morozova* (1887) portray the vengeance of Peter I on rebels and Old Believers and, like posters, are notable for their primary colours and studied theatricality.

19 Stanislavsky, op. cit., pp. 13–14.

20 ibid., p. 14.

21 In January 1885, Mamontov had presented three operas as part of his private opera: *Rusalka (The Water Sprite)*, *Faust* and *The Merry Wives of Windsor*, but public and critical reaction was adverse and the series closed in less than three weeks. The first full season of the Opéra Privé opened seven months later.

22 Stanislavsky, op. cit., p. 144.

23 *Chaliapin. An Autobiography as Told to Maxim Gorky*, translated by Nina Froud and James Hanley, Stein and Day, New York, 1969, p. 118.

24 Shalyapin, *Man and Mask*, p. 50.

25 *Chaliapin. An Autobiography ...*, p. 121.

26 ibid., p. 122.

27 Shalyapin knew that if he broke a contract with the Imperial Theatres, he was subject to a fine of several thousand rubles. For this reason he hesitated to join the Moscow company, and returned briefly to St Petersburg. However, when Mamontov offered to pay half the penalty, the decision was made.

28 Shalyapin, *Man and Mask*, pp. 75, 79.

29 ibid., p. 158. Shalyapin sang Salieri in Rimsky-Korsakov's *Mozart and Salieri* which had its première at the Opéra Privé on December 7, 1898.

30 Repin's painting *Ivan the Terrible and his Son, Ivan, November 16, 1581* (1885), showing a crazed Tsar cradling the body of his murdered son, is one of the painter's most melodramatic works. It is now in the Tretyakov Gallery.

31 *Chaliapin. An Autobiography* ..., p. 127.

32 Shalyapin, *Man and Mask*, p. 74.

33 Maxim Gorky described his reaction to these productions in a letter to Chekhov from Nizhny-Novgorod, dated October 1/7, 1900. 'I have just returned from Moscow where I spent a whole week rushing around and feasting my soul on such marvels as *The Snow Maiden*, Vasnetsov, the death of *Ivan the Terrible* and Chaliapin.' *Chaliapin. An Autobiography* ..., p. 231. Text of letter taken from Gorky's complete works in 30 volumes, State Publishing House, Moscow, 1952. Reprinted from Gorky Literary Archives.

34 Alexandre Benois, *Reminiscences of the Russian Ballet*, Putnam, London, 1947, p. 197.

35 Alexandre Benois, *The Russian School of Painting*, Alfred A. Knopf, New York, 1916, p. 169.

36 ibid., p. 149.

37 Shalyapin, *Man and Mask*, p. 358.

38 Sergey Shcherbatov, *Khudozhnik v ushedshey Rossii* (*The Artist in Old Russia*), Izdatelstvo imeni Chekhova, New York, 1955, p. 39.

39 *Konstantin Korovin: Zhizn i tvorchestvo: Pisma, dokumenty, vospominaniya* (*Konstantin Korovin: His Life and Work: Letters, Documents, Memoirs*), edited by N.M. Moleva, Izdatelstvo Akademii Khudozhestv, SSSR, Moscow, 1963, p. 69.

40 Shcherbatov, op. cit., p. 57.

41 ibid., p. 57.

42 *Konstantin Korovin* ..., pp. 180–81.

43 ibid., p. 181.

44 ibid., p. 181–82.

45 ibid., pp. 70–71. Vsevolod (Voka) Mamontov later became curator of the Abramtsevo Museum.

46 ibid., pp. 70–71.

47 Stanislavsky, op. cit., p. 143.

48 Shcherbatov, op. cit., p. 264.

49 Toward the end of the 1880s, the circle had widened to include the landscapist Ilya Ostrukhov, Mikhail Nesterov, whose religious overtones were reminiscent of Nikolay Ge, and Leonid Pasternak, who had returned to Russia after studying in Germany and who had found a warm welcome at Abramtsevo. He became particularly close to the Polenovs.

50 *Konstantin Korovin* ..., p. 68.

51 Princess Tenisheva, herself a mezzo-soprano, had auditioned years earlier for Mamontov's opera company, and she attributed her rejection to the presence of

'Mme L'. Later, in her memoirs (*Vpechatleniya moyei zhizni* (see Chapter 2 note 26 above), p. 96) she commented on the relationship. 'The trouble was that my voice and repertoire made me a rival of one singer who had an important position in the theatre. Thus, they couldn't stand good mezzo-sopranos and wouldn't let them in. The person turned out to be L. who was known not only for her voice and talent, but as a close companion of a wealthy Moscow merchant. He had created the theatre for her, made her a star, and had wasted easy money to create this theatrical atmosphere for her.'

52 Shcherbatov, op. cit., p. 53.

53 M. Kopshitser, *Savva Mamontov*, Iskusstvo, Moscow, 1972, p. 222.

54 Stuart Grover, *Savva Mamontov and the Mamontov Circle: 1870–1905. Art Patronage and the Rise of Nationalism in Russian Art*, University of Wisconsin, 1971 (PhD thesis), p. 202. In a footnote, Stuart Grover cites an untitled pamphlet in the Tretyakov Gallery Library, #K 37205, which contains a short article written by Dr Ya.L. Vikker in the 1930s, 'K materialy o zabolevanii Vrubelya', which states that syphilis was responsible for Vrubel's deterioration. It would explain the erratic pattern of his illness, the combination of mental and physical symptoms, and during periods of remission, he would have been able to work normally. The data used were from the Baminsky Hospital where Vrubel was hospitalized in 1907 and 1908.

55 Shalyapin, *Man and Mask*, p. 158.

56 John E. Bowlt, 'Two Russian Maecenases, Savva Mamontov and Princess Tenisheva', *Apollo*, December 1973, p. 450.

57 S.K. Averino, 'Russkiy Samorodok – S.I. Mamontov' ('A Russian One-of-a-Kind – S.I. Mamontov'), *Vozrozhdeniye*, Paris, May–June, 1950, p. 105.

58 Kopshitser, op. cit., p. 218.

59 Ye.V. Sakharova, *Vasily Dmitrevich Polenov, Yelena Dmitrevna Polenova. Khronika semi khudozhnikov (Vasily Dmitrevich Polenov, Yelena Dmitrevna Polenova. Chronicle of a Family of Artists)*, Iskusstvo, Moscow, 1964 (letter from V.D. Polenov to A.A. Lopukhin, Moscow, October 16, 1899), pp. 628–29.

60 Kopshitser, op. cit., p. 218.

61 M. Gorky, *Sobraniye sochineniy v triatsati tomakh (Collected Works in Thirty Volumes)*, Tom 28: *Pisma, telegrammy, nadpisi 1899–1906* (Vol. 28: *Letters, Telegrams, Inscriptions 1899–1906*), Moscow, 1954, p. 133 (letter, Gorky to Chekhov, October 1/7 (14/20), 1900, Nizhny-Novgorod).

62 Kopshitser, op. cit., p. 220.

63 Shcherbatov, op. cit., p. 55.

64 Sakharova, op. cit., pp. 634–36. The Opéra Privé continued for several years after Mamontov's financial collapse. In 1900 *Tsar Saltan*, with décor by Vrubel, and Nadezhda Zabela-Vrubel in the leading role, was presented with great success. The first season was acclaimed despite the departure of Korovin and Shalyapin, but without Mamontov's direction and backing, the momentum slowed, former stars defected and the company started to lose money. There were no successors to Mamontov to make up the deficit. Savva Ivanovich visited the rehearsals several times, but without funds, he had lost much of his authority. The opera moved to a smaller house, and finally closed in 1904.

65 Shcherbatov, op. cit., p. 41.

66 P.A. Buryshkin, *Moskva kupecheskaya* (*Merchants of Moscow*), Izdatelstvo imeni Chekhova, New York, 1954, p. 191. According to Buryshkin, 'Maklakov was a talented raconteur and could imitate animals wonderfully. His best number was the "leap of a panther in love" ...' Ryabushinsky used this as the title for the article, a decision which could have closed down the newspaper permanently.

67 Shcherbatov, op. cit., p. 41.

68 ibid., p. 41.

69 Saratov was the birthplace of Viktor Yelpidiforivoch Borisov-Musatov (1870–1905), considered by many to be the spiritual father of the Russian Symbolist painters. He has also been classified as an Impressionist, but his work has more in common with that of Puvis de Chavannes and the Nabis. He looked to the past rather than the future, and his scenes of dream-like gardens, pools, distant mansions and women in crinolines are permeated with reverie and silence.

70 The membership included: Pavel Kuznetsov (1878–1968), Sergey Sudeykin (1882–1946), Nikolay Sapunov (1880–1912), Arthur Fonvizene (1882–1973), Martiros Saryan (1880–1972), Anatoly Arapov (1876–1949), Vasily Milyoty (1875–1943), Nikolay Milyoty (1874–1962) and Nikolay Feofilaktov (1878–1941).

71 'K nashim chitatelyam' ('To Our Readers'), *Zolotoye runo*, Vols 11–12, 1909, pp. 105–07.

72 *Zolotoye runo*, No. 1 January 1906 (Editor's Note), pp. 5–6.

73 Within the pages, Filosofov and Benois continued their unending debate: technique versus emotional content. *Benois* : 'In our day, artists are more valued for invention, for those *feelings* they arouse, than for that which is the only eternal aspect of art – skill. I would like to live until such time as this position changes, and the real spirit of artistic works, their form, becomes for us primary.' *Zolotoye runo*, Vols 7–9, 1907, p. 32.

 Filosofov: 'Art works have never throughout history been evaluated on the basis of form. There has always had to be some additional "plus" (a plus as I see it, perhaps a "minus" according to Benois ...). Benois is dreaming about a golden time when all mankind will be overcome by a carefully drawn Bryullov "trace" or a refined hue of Monet. But I can tell Benois that this is sheer dreaming. No one will ever see this time. ...' Filosofov ended by declaring himself 'against tendencies in general and Benois's tendencies in particular.' *Zolotoye runo*, Vol. 1, 1908, pp. 71–76.

74 L.F. Dyakonitsyn, *Ideynyye protivorechiya v estetike russkoy zhivopisi kontsa 19 – nachala 20vv* (*Ideological Contradictions in the Aesthetics of Russian Painting at the Turn of the Twentieth Century*), Permskoye Knizhnoye Izdatelstvo, Perm, 1966, p. 145. Dyakonitsyn quotes Petrov-Vodkin at a 1938 lecture.

75 John E. Bowlt, 'Nikolay Ryabushinsky: Playboy of the Western World', *Apollo*, London, 1973, p. 448.

76 *Zolotoye runo*, Vols 11–12, 1909, pp. 105–7.

4 THE MOROZOVS

1 For a detailed account of this episode, see Valentine T. Bill, *The Forgotten Class*, Praeger, New York, 1959, pp. 25–26.

2 A.V. Krivosheyn and K.D. Artsybushev, two close friends of Savva Mamontov, were arrested and tried with the industrialist in 1899 and acquitted with him in 1900.

3 Maxim Gorky, *Sobraniye sochinenii v vosemnadtsati tomakh* (*Collected Works in Eighteen Volumes*), Gosudarstvennoye izdatelstvo khudozhestvennoi literatury, Moscow, 1963, Vol. 18 (*Savva Morozov*), pp. 217–39.

4 ibid., p. 227.

5 ibid.

6 ibid., p. 218.

7 ibid., pp. 230–31. Morozov had a theory that the merchant-industrialist families of Russia and the United States shared this tendency. 'Third generation wealthy merchants make up a large percentage of the neurotically and mentally ill. . . .' He had done extensive research on this phenomenon, and quoted the statistics: Russian and American names, as well as clinical symptoms and evidence of their deterioration.

8 Bill, op. cit., pp. 25–26.

9 Vladimir Ivanovich Nemirovich-Danchenko, *Iz proshlogo* (*From the Past*), Academiya, Moscow, 1936, p. 135.

10 Savva Morozov's house served as headquarters for the American Relief Administration during the Revolution.

11 Fyodor Shalyapin (Chaliapin), *Man and Mask*, Alfred A. Knopf, New York, 1932, p. 142.

12 Gorky, op. cit., p. 223.

13 Nemirovich-Danchenko, op. cit., p. 135.

14 Konstantin Stanislavsky (Constantin Stanislavski), *My Life in Art*, Theatre Arts Books, New York, 1948, p. 387.

15 Savva Timofeyevich was not the only radical member of this complex family. He was basically a constitutionalist who believed that the revolution which he foresaw could not be put down by the bourgeoisie. His nephew Pavel, also a backer of Lenin's publication, was, like Savva, a supporter of the Bolshevik faction. Another Morozov became a revolutionary martyr; Pavel's nephew, Nikolay Pavlovich Schmidt, owner of a furniture factory, aided the uprising in 1905. A year later he was arrested in Moscow. Despite the power of the family, Nikolay was jailed, tortured and died in prison. In her memoirs, Nadezhda Krupskaya, Lenin's wife, claimed that he was tortured to death; others have written that he committed suicide. Whichever version is true, Nikolay left his fortune to the Party, and the Revolution acquired a new icon. Krupskaya noted that these funds were left to the Bolsheviks. The bequest aggravated the tensions between the Mensheviks and the Bolsheviks, and triggered a chain of intrigues between the two factions to control the money.

16 Gorky, op. cit., p. 224.

17 Bauman was killed by an agent of the Okhranka in 1905.

18 After Morozov's death it was rumoured among the employees of the factory that he had not died, that another had been buried in his place, and that Morozov, having renounced his wealth, was going from one plant to the next, preaching to the workers about how they should live.

19 She did not share Savva's love of the Moscow Art Theatre, however. When Stanislavsky and Nemirovich-Danchenko approached her for financial assistance for the project, Nemirovich-Danchenko remembered years later the look of 'frozen intentness' which came into her eyes as she listened to their proposal. 'With a cold smile she refused us' (op. cit., p. 115).

20 Ambroise Vollard, *Souvenirs d'un marchand de tableaux*, Albin Michel, Paris, 1948, p. 158.

21 ibid., p. 168.

22 Michael Waldy (Mikhail Vladimirov), personal interview, New Jersey, 1978.

23 One of the few modern paintings to leave Russia after the Revolution, *Night Café* was purchased by an American dealer in the thirties and re-appeared in the collection of Stephen C. Clark. It is presently a part of the Yale University collection.

24 *Mme Cézanne in the Conservatory* also became a part of the Clark collection.

25 In the catalogue of the State Museum Kröller-Müller, Otterlo, *Van Gogh to Picasso*, 1972, the date for Morozov's *Smoker* is given as 'about 1900'. In the catalogue of the National Gallery of Art, M. Knoedler and Co., *Impressionist and Post-Impressionist Paintings from the USSR*, 1973, the date is given as 1896–98. Shchukin's version is dated 1896 in an article in *L'Amour de l'Art* (Paris, 1925) written by B. Ternovets, Director of the Museum of Modern Western Art, Moscow.

26 Sergey Makovsky, 'Frantsuzkiye khudozhniki iz sobraniya I.A. Morozova' ('The French Artists in the Morozov Collection'), *Apollon*, Moscow, Vols 3–4, 1912, p. 13. Sergey Makovsky was the son of Vladimir Makovsky, one of the original Wanderers, and an example of the rapidly changing tastes in Russia.

27 Mme Georges Duthuit (Marguerite Matisse), personal interview, Paris, 1974.

28 Matisse was particularly fond of *Bottle of Schiedam* and was delighted that Morozov had purchased the picture. His scrupulous concern with every aspect of his work was evident in a letter he wrote to Ivan Abramovich in 1911: 'Sir, I have just learned that you have acquired from Bernheim-Jeune one of my favourite *natures mortes*; although it is one of my old works, it is somewhat annoying to me that they are sending it to you in such a banal frame. If you intend to give it a more suitable one, I shall be happy to do you the favour and find an old frame at a price of about 150 fr. (from 100 to 150) which seems to be the necessary complement to this picture. I beg you to excuse my boldness, sir, and also to accept the expression of unchanging devotion to you. Henri Matisse – Issy, Route de Clamart, 92.'

29 *Matiss – zhivopis, skulptura, grafika, pisma* (*Matisse – Paintings, Sculptures, Drawings, Letters*), Leningrad, 1969, p. 136 (letter from Henri Matisse to I.A. Morozov, September 29, 1912).

30 ibid., pp. 136–37.

31 Alfred H. Barr, Jr, *Matisse, His Art and His Public*, Museum of Modern Art, New York, Arno Press, 1966, p. 159.

32 Letter from Sergey Shchukin to Henri Matisse (courtesy M. Pierre Matisse).

33 In his letter of April 13, Matisse had offered to send Morozov photographs of *Arab Café* and *The Riffian*.

34 Quoted in Barr, op. cit., p. 160.

35 Mme Georges Duthuit (Marguerite Matisse), personal interview, Paris, 1974.

5 THE SHCHUKINS

1 Fyodor Shalyapin (Chaliapin), *Man and Mask*, translated from the French by Phyllis Megroz, Alfred A. Knopf, New York, 1932, p. 141.

2 Mme Georges Duthuit (Marguerite Matisse), personal interview, Paris, 1974.

3 Maurice Baring, *What I Saw in Russia*, William Heinemann, London, 1927, pp. 1–2.

4 Ivan Sergeyevich Shchukin, personal interview, Beirut, Lebanon, 1974.

5 *M.P. Mussorgsky. Pisma i dokumenty (M.P. Mussorgsky. Letters and Documents)*, edited by A.N. Rimsky-Korsakov, Gosudarstvennoye muzykalnoye izdatelstvo, Moscow/Leningrad, 1932, p. 48 (letter from Mussorgsky to M.A. Balakirev, June 23, 1859).

6 Ivan Shchukin, interview.

7 Isaiah Berlin, *Russian Thinkers*, Viking Press, New York, 1978, p. 25.

8 ibid., p. 229.

9 As he grew older, Vasily Botkin became disillusioned with the course of the liberal movement, and as so often happens, he retreated into an extreme conservatism. During his progressive period, however, he was prominent in reformist activities, a persuasive speaker and writer who conducted an extensive correspondence with Turgenev, Tolstoy, Belinsky and the poet A.A. Fet.

10 Dmitry was one of the many Russian admirers of Puvis de Chavannes. In 1900 he purchased from Durand-Ruel the artist's *Village Firemen, Neuilly*, painted in 1857. Puvis's harmonious colours, his spiritual and romantic approach, made him a favourite of Russian collectors. Dmitry Filosofov believed that his work was attractive to those Russians who were 'tired of opinions', who sought an escape in art that was 'peaceful, musical and proportionate'.

11 Ivan Shchukin, personal interview.

12 Sergius Yakobson, 'Richard Cobden's Sojourn in Russia, 1874', *Oxford Slavonic Papers*, New Series, Vol. 7, 1974, p. 73.

13 Michael Ginsberg, 'Art Collectors of Old Russia. The Morozovs and the Shchukins', *Apollo*, December 1973, p. 470.

14 Obituary of P.I. Shchukin, *Golos minuvshego*, Moscow, January 1913, pp. 279–81. The reference is to Vladimir Yaklovlevich Stoyunin.

15 Sergius Yakobson, op. cit., p. 66.

16 According to Michael Ginsberg (op. cit., p. 476), the structure was considered 'the greatest example of wooden architecture in Muscovite Russia and was sometimes referred to as the eighth wonder of the world.'

17 Other examples of French painting which passed from Pyotr to Sergey Shchukin in 1912 were Maurice Denis's *Spring Landscape with Figures* (*Sacred Grove* 1897), a

forest scene of filmy classicism complete with nymphs, and *The Room*, a tranquil interior by Edouard Vuillard, in soft, misty tones of blue and grey-green, painted in 1893.

18 Count Rupert de Keller (Sergey Shchukin's grandson), personal interview, Paris, 1973.

19 Ivan Shchukin, interview.

20 ibid.

21 Pyotr Shchukin, *Shchukinskiy sbornik* (*The Shchukin Collection*),Vypusk desyatyy (Issue Ten), Izdaniye otdeleniya Imperatorskago Rossiyskago Istoricheskago Muzeya imeni Imperatora Aleksandra III – Muzeya P.I. Shchukina, Moscow, 1912. 'Vospominaniya P.I. Shchukina' ('Memoirs of P.I. Shchukin'), p. 148.

22 Michael Ginsberg, op. cit., p. 482.

23 ibid.

24 The tea merchant Aleksandr Kuznetsov exemplified this extravagant way of life. Head of the firm Gubkin-Kuznetsov, he had a splendid house in Moscow which still exists on Chekhov Street, filled with old masterpieces and Russian works of art. He was wealthier even than the Botkins, and his firm was one of three tea companies which dominated the market: Gubkin-Kuznetsov (Russian), Karavan (German) and Vyssotsky (classified as Jewish). Because of his precarious health, Kuznetsov built a palace in the Crimea, below the Baydarsky Gates, and a French specialist was imported to plant vineyards which are still famous in Russia. The massive church, with its graceful spires and domes which he commissioned, sat at the top of a cliff overlooking the Black Sea, the interior decorated with icons created particularly for this setting by Konstantin Makovsky. Kuznetsov, like so many of his contemporaries, suffered from tuberculosis all his life; he believed that the sea air might effect a cure, and his yacht *Foros* was a familiar sight in Western ports, serving as the scene for many prodigal dinner parties for Russian grand dukes, the Prince of Mecklenburg and the Prince of Wales, later Edward VII. Kuznetsov's villa is used now as a government resort and sanitorium. Each year the pebbled beaches of his estate are filled with Russian workers sent to the seashore for a summer vacation.

25 Louis Fischer, *The Life of Lenin*, Harper and Row, New York, 1964, p. 32. Another socially enlightened accomplishment received an accolade from an unexpected source. A Soviet guide book published a photograph of an impressive building and underneath, this inscription: 'This is the technical school built and furnished by the Gubkins. It must be said that not all capitalists and merchants in Old Russia were blood-suckers and oppressors.'

26 Surikov is still one of Russia's most admired artists. Today *The Boyarina Morozova* hangs in the Tretyakov Gallery.

27 Shalyapin, *Man and Mask*, p. 129.

28 ibid., p. 149.

29 Arnold Haskell in collaboration with Walter Nouvel, *Diaghileff – His Artistic and Private Life*, Simon and Schuster, New York, 1935, p. 129.

30 Count Rupert de Keller, personal interview.

31 Sergey Shcherbatov, *Khudozhnik v ushedshey Rossii* (*The Artist in Old Russia*), Izdatelstvo imeni Chekhova, New York, 1955, p. 40.

32 Alexandre Benois, 'Sergey Ivanovich Shchukin', *Posledniye novosti*, January 12, 1936 (obituary of Shchukin), p. 4.

33 Shcherbatov, op. cit., p. 189.

34 Pyotr P. Pertsov, *Shchukinskoye sobraniye frantsuzskoy zhivopisi* (*The Shchukin Collection of French Painting*), Muzey Novoy Zapadnoy Zhivopisi (Museum of New Western Art), Moscow, 1921, p. 80.

35 Nikolay Bukharin, *Historical Materialism. A System of Sociology* (authorized translation from the third Russian edition), Russell & Russell, New York, 1965, p. 213.

36 Sergius Yakobson, personal interview, Washington, DC, 1975.

37 Bukharin, op. cit., p. 213.

38 Mme Georges Duthuit (Marguerite Matisse), personal interview.

39 Ivan Shchukin, personal interview.

40 There are several versions of this event. One has Dmitry buying the painting from Ilya Ostrukhov, but when questioned, Ivan Shchukin was emphatic that his uncle had chosen this painting from an art catalogue. Michael Ginsberg (op. cit., p. 478) states that Ostrukhov sold the painting to Dmitry Shchukin.

41 After Ivan's death, his library was acquired by the Ecole des Langues Orientales, where it is still considered the finest and most complete collection of Russian philosophy and religion. It was donated to the institution by the Shchukin family.

42 Alfred Barr, Jr, 'Portrait by Matisse', *Time*, February 11, 1957, pp. 76–79.

6 THE PARIS SCENE

1 Zuloaga was a popular artist in Russia at this time. His portrait of Ivan Shchukin became a part of Sergey's collection after Ivan's death. It now hangs in the Hermitage.

2 Alexandre Benois, 'Sergey Ivanovich Shchukin', *Posledniye novosti*, Paris, January 12, 1936, p. 4.

3 When questioned during an interview, Ivan Sergeyevich Shchukin identified Fyodor *Vladimirovich* Botkin as his father's uncle, the brother of Sergey's mother, Yekaterina *Petrovna* Botkin. Because of the patronymic contradiction one must assume that he was mistaken – either in the relationship or in the name.

4 Yakov Tugendkhold, 'Frantsuzskoye sobraniye S.I. Shchukina' ('The French Collection of S.I. Shchukin'), *Apollon*, Vols 1–2, Moscow, 1914, p. 8.

5 E. Tériade, 'Matisse Speaks', *Art News Annual*, Vol. 21, New York, 1952, p. 47.

6 Roger Marx, June 18, 1904, preface to the catalogue of Matisse's first one-man show given at the Vollard gallery. Quoted by Alfred H. Barr, Jr, *Matisse, His Art and His Public*, Museum of Modern Art, New York, Arno Press, 1966, p. 45.

7 In his book *Matisse, His Art and His Public*, op. cit., pp. 316–17, Alfred Barr illustrates this development photographically.

8 Marcelle Nicolle, *Journal de Rouen*, November 20, 1905. Quoted by Bernard Dorival, *Le Fauvisme et le Cubisme. 1905–1911*, Vol. 2, Gallimard, Paris, 1944, p. 74.

9 Leo Stein, *Appreciation: Painting, Poetry and Prose*, Crown, New York, 1947, p. 158.

10 Gertrude Stein, *Autobiography of Alice B. Toklas*, Random House, New York, 1933, p. 35.

11 Jean-Baptiste Hall. Quoted by Dorival, op. cit., p. 74.

12 Leo Stein, op. cit., p. 158.

13 André Gide, 'Promenade au Salon d'Automne', *Gazette des Beaux Arts*, Paris, December 1905, pp. 483–84.

14 Maurice Denis, *Théories 1890–1910 du symbolisme et de Gauguin. Vers un nouvel ordre classique* (*Theories of Symbolism and Gauguin 1890–1910. Toward a New Classical Order*), L. Rouart and J. Watelin, Paris, 1920, p. 208.

15 Guillaume Apollinaire, *Apollinaire on Art/Essays and Reviews. 1902–1918*, edited by Leroy C. Breunig, translated by Susan Suleiman, Viking Press, New York, 1972, p. 42.

16 Pierre Matisse, personal interview, New York City, 1974.

17 Leo Stein, op. cit., p. 195.

18 Gertrude Stein, op. cit., p. 33.

19 Interview with Gertrude Stein taped in Paris by William Sutton from questions submitted in America by Robert Bartlett Haas, January 5/6, 1946. 'Gertrude Stein Talking – A Transatlantic Interview', *Uclan Review*, University of California, Los Angeles, Summer 1962, pp. 8–9. Quoted by Leon Katz, *Matisse, Picasso and Gertrude Stein. Four Americans in Paris*, Museum of Modern Art, New York, 1970, p. 52.

20 Gertrude Stein, op. cit., p. 34.

21 Leo Stein, op. cit., p. 158.

22 Gertrude Stein, op. cit., pp. 241–42.

23 Guillaume Apollinaire, 'Death of M. Clovis Sagot', *L'Intransigeant*, February 13, 1913. Quoted in *Apollinaire on Art* . . ., p. 272.

24 Daniel-Henry Kahnweiler with Francis Cremieux, *My Galleries and Painters*, translated from the French by Helen Weaver, Viking Press, New York, 1971, pp. 36–37.

25 Daniel-Henry Kahnweiler, personal interview, Paris, 1974.

26 Françoise Gilot and Carlton Lake, *Life with Picasso*, McGraw-Hill, New York, 1964.

27 Guillaume Apollinaire, *Je dis tout*, Paris, 1907. Quoted in *Apollinaire on Art* . . ., p. 29.

28 ibid., p. 39.

29 Gertrude Stein, op. cit., p. 61.

30 ibid., p. 59.

31 ibid., p. 134.

32 Pierre Matisse suggested the possibility. It was confirmed to the present author by Ivan Shchukin.

33 Fernande Olivier, *Picasso et ses amis*, Librairie Stock, Delmain et Bonteveau, Paris, 1933, p. 107.

34 In exchange, Mme Duthuit remembers, Picasso gave Matisse 'a *nature morte*, a harmony in green with three ovals: one oval was the mouth of a jar, one, a top of a pan, the third, a lemon shape in yellow.'

35 Kahnweiler, op. cit., p. 38.

36 Fernande Olivier, op. cit., p. 143.

37 Notes for *The Making of Americans*, Collection of American Literature, Beinecke Rare Book and Manuscript Library, Yale University.

38 Alfred H. Barr, Jr, *Picasso: Fifty Years of His Art*, Museum of Modern Art, New York, 1974, p. 272. Picasso made these remarks during a conversation with Christian Zervos in 1935. They were published originally in *Cahiers d'Art*, Paris, 1935, Vol. 10 number 10, pp. 173–78.

39 Kahnweiler, op. cit., p. 39.

40 Françoise Gilot and Carlton Lake, op. cit., p. 197.

41 Mme Georges Duthuit (Marguerite Matisse), personal interview.

42 Ilya Ehrenburg, *People and Life. Memoirs of 1891–1917*, translated by Anna Bostock and Yvonne Kapp, MacGibbon & Kee, London, 1961, p. 208.

43 E. Tériade, op. cit., pp. 49–50.

44 J.F. Schnerb, 'Exposition Henri Matisse (Galerie Bernheim-Jeune)', *La Chronique des Arts et de la Curiosité (Supplément à la Gazette des Beaux Arts)*, Paris, 1910, p. 59.

45 Apollinaire, *Apollinaire on Art* ..., p. 66.

46 Gertrude Stein, op. cit., p. 92.

47 ibid., p. 65.

48 Leon Katz, 'Matisse, Picasso and Gertrude Stein' in *Four Americans in Paris*, catalogue, Museum of Modern Art, New York, 1970.

49 Gertrude Stein, op. cit., p. 88.

50 ibid., p. 38.

7 SHCHUKIN'S COLLECTION

1 Yakov Tugendkhold, 'Frantsuzskoye sobraniye S.I. Shchukina' ('The French Collection of S.I. Shchukin'), *Apollon*, Vols 1–2, Moscow, 1914, p. 37.

2 Alfred H. Barr, Jr, *Matisse: His Art and His Public*, Museum of Modern Art, New York, 1951, p. 106.

3 Daniel-Henry Kahnweiler with Francis Cremieux, *My Galleries and Painters*, Viking Press, New York, 1971, p. 60.

4 Shchukin owned four paintings by Carrière. One, *Mother Holding a Child* (*Maternité*), was purchased originally by his brother Pyotr. It entered Sergey's collection in 1912.

5 Kahnweiler, op. cit., p. 42.

6 Julius Meier-Graefe. Quoted by Pyotr P. Pertsov, *Shchukinskoye sobraniye frantsuzskoy zhivopisi (The Shchukin Collection of French Painting)*, Museum of New Western Art, Moscow, 1921, p. 26.

7 Ivan Shchukin, personal interview.

8 Charles Sterling, *Great French Paintings in the Hermitage*, Harry N. Abrams, New York, 1958, p. 148.

9 Kahnweiler, personal interview.

10 Quoted in Tugendkhold, op. cit., p. 19.

11 ibid., p. 24.

12 Ambroise Vollard, *Souvenirs d'un marchand de tableaux*, Albin Michel, Paris, 1948, p. 170.

13 Gertrude Stein, *Gertrude Stein on Picasso*, edited by Edward Burns, Liveright, New York, 1970; postscript by Leon Katz and Edward Burns, p. 96.

14 *Nude, Black and Gold* has been dated variously 1905 (Alfred Barr, *Matisse, His Art and His Public*, p. 106) and 1908 (Anna Barskaya and Antonina Izerghina, *French Painting from the Hermitage Museum*, No. 152). The latter date seems more probable, for that year Morozov purchased a companion piece (*Woman Seated*) which is almost identical. This was signed and dated 1908, and was shown in the Salon d'Automne in 1908. Also, the painting which Matisse sent to Ilya Ostrukhov after his visit to Moscow, which appears to be a study for Shchukin's work, carries the inscription 'Etude faite en 1908'.

15 Mme Georges Duthuit (Marguerite Matisse), personal interview.

16 Letter from Gilbert Gruet, Bernheim-Jeune & Cie, to Mme Duthuit, Paris, October 17, 1974.

17 *French Painting from the Hermitage Museum*, compiled by Anna Barskaya, Aurora, Leningrad/Harry N. Abrams, New York, 1975, Nos 163–64.

17A Pertsov, op. cit., p. 87.

18 Ivan Shchukin, personal interview.

19 Tugendkhold, op. cit., p. 23.

20 René Fülöp Miller and Joseph Gregor, *The Russian Theatre*, translated by Paul England, Benjamin Blom, New York and London, 1968, p. 90.

21 Henri Matisse, 'Le Chemin de la Couleur', *Art Présent*, No. 2, Paris, 1947, p. 23.

22 Tugendkhold, op. cit., p. 37.

23 Guillaume Apollinaire, *Apollinaire on Art/Essays and Reviews. 1902–1918*, edited by Leroy C. Breunig, translated by Susan Suleiman, Viking Press, New York, 1972, p. 13.

24 ibid., p. 16.

25 Kahnweiler, *My Galleries and Painters*, p. 92.

26 Leo Stein to Mabel Foote Weeks, letter of April 2, 1914. Collection of American Literature, Beinecke Rare Book and Manuscript Library, Yale University.

27 Leo Stein to Mabel Foote Weeks, letter of November 29, 1905; ibid.

28 Ivan Shchukin, personal interview.

29 Kahnweiler, personal interview. Kahnweiler also remembered one or two other patrons: Wilhelm Uhde, the German writer and art historian, and V. Kaneash, a Czech who later became a director of the Prague Museum.

30 Hilton Kramer, *New York Times*.

31 Sophie de Enden, personal interview, New York City, 1975.

32 Sergey Bulgakov, 'Trup krasoty – Po povodu kartin Pikasso' ('The Corpse of Beauty – Apropos of Picasso's Paintings'), *Russkaya mysl*, Moscow and Petrograd, August 1915, p. 94.

33 Pertsov, op. cit., pp. 96–97.

34 ibid., p. 96.

35 Ivan Shchukin, personal interview.

36 Bulgakov, op. cit., p. 105.

37 ibid., p. 91.

38 ibid., p. 94.

39 Pertsov, op. cit., pp. 94–95.

40 Gertrude Stein, *Autobiography of Alice B. Toklas*, Random House, New York, 1933, p. 91.

41 Tugendkhold, op. cit., p. 35.

42 Kahnweiler, *My Galleries and Painters*, p. 84.

43 Bulgakov, op. cit., p. 93.

44 Georgy Chulkov, 'Demonyi i sovremennost – Mysli o frantsuzskoy zhivopisi' ('Demons and Modernity – Thoughts on French Painting'), *Apollon*, Vols 1–2, Moscow, 1914, p. 74.

45 Gertrude Stein, op. cit., p. 22.

46 ibid., p. 92.

47 Kahnweiler, *My Galleries and Painters*, p. 59.

48 Count Rupert de Keller (Sergey Shchukin's grandson), personal interview.

49 E. Tériade, 'Matisse Speaks', *Art News Annual*, Vol. 21, 1952, p. 47.

50 Bulgakov, op. cit., p. 94.

51 Carol Cutler, 'Russia Sends Us a Prize Package of Modern French Art', *The Smithsonian*, Washington, DC, April 1973, p. 22.

8 OPEN HOUSE

1 Ivan Aksyonov, *K voprosu o sovremennom sostoyanii russkoy zhivopisi* (*On the Problem of the Contemporary State of Russian Painting*), Knave of Diamonds, Moscow, February 1913. Quoted in *The Documents of Twentieth Century Art. Russian Art of the Avant-garde: Theory and Criticism 1902–1934*, edited and translated by John E. Bowlt, Viking Press, New York, 1976, p. 61.

2 Quoted by Pyotr Pertsov, *Shchukinskoye sobraniye frantsuzskoy zhivopisi* (*The Shchukin Collection of French Painting*), Muzei Novoy Zapadnoy Zhivopisy, Moscow, 1922, p. 17.

3 Approximately one thousand dollars at that time.

4 Yakov Tugendkhold, 'Frantsuzskoye sobraniye S.I. Shchukina' ('The French Collection of S.I. Shchukin'), *Apollon*, Vols 1–2, Moscow, 1914, pp. 18–19.

5 Both *Nativity* and *Idol* were exhibited at the Vollard gallery in 1903. *Nativity* was shown in the 1906 Salon d'Automne Exhibition. *Idol*, which had been in the Gustave Fayet collection, was part of the Gauguin retrospective at the Salon d'Automne in 1907.

6 Sergey Shcherbatov, *Khudozhnik v ushedshei Rossii* (*The Artist in Old Russia*), Izdatelstvo imeni Chekhova, New York, 1955, p. 36.

7 Louis Vauxcelles. Quoted in *Impressionist and Post-Impressionist Paintings from the USSR*, National Gallery of Art, Washington, DC, M. Knoedler, New York City, 1973, p. 28.

8 Mme Georges Duthuit (Marguerite Matisse), personal interview, Paris.

9 Ivan Shchukin, personal interview, Beirut, 1974.

10 Ivan Shchukin, who was present on that day, remembered his father's relief.

11 Henri Matisse, 'Le Chemin de la Couleur' ('The Way of Colour'), *Art Présent*, No. 2, Paris, 1947, p. 23.

12 Tugendkhold, op. cit., p. 23.

13 Count Rupert de Keller, personal interview, Paris.

14 Pertsov, op. cit., p. 98.

15 ibid., p. 98.

16 John Russell, introduction to Daniel-Henry Kahnweiler with Francis Cremieux, *My Galleries and Painters*, Viking Press, New York, 1971, p. 8.

17 Daniel-Henry Kahnweiler, personal interview, Paris, 1974.

18 Quoted by Tugendkhold, op. cit., p. 33.

19 Sergey Bulgakov, 'Trup krasoty – Po povodu kartin Pikasso' ('The Corpse of Beauty – Apropos of Picasso's Paintings'), *Russkaya mysl*, Moscow and Petrograd, August 1915, p. 97.

20 Pertsov, op. cit., pp. 92–93.

21 Shcherbatov, op. cit., p. 39.

22 ibid., p. 39.

23 ibid.

24 ibid., p. 38.

25 ibid., p. 37.

26 ibid., p. 38.

27 E. Tériade, 'Matisse Speaks', *Art News Annual*, New York, 1952, Vol. 21, p. 49.

28 Shcherbatov, op. cit., p. 38.

29 Ivan Shchukin, personal interview.

30 Tugendkhold, op. cit., p. 30.

31 Alexandre Benois, *Reminiscences of the Russian Ballet*, Putnam, London, 1947, pp. 199–200.

32 Pertsov, op. cit., p. 63.

33 Benois, op. cit., p. 165.

34 David Burlyuk, Colour and Rhyme, edited by David Burlyuk, Vol. 57, Hampton Bays, New York, 1964, p. 31.

35 Shcherbatov, op. cit., p. 40.

36 ibid.

37 ibid., p. 39.

38 Andrey Bely (Boris Nikolayevich Bugayev), *Mezhdu dvukh revolyutsii* (*Between Two Revolutions*), Izdatelstvo pisateley, Leningrad, 1934, pp. 223–24.

39 David Burlyuk, *Golos impressionista – v zashchitu zhivopisi* (*The Voice of an Impressionist – In Defence of Painting*), Catalogue to the 'Link' exhibition, Kiev, November 1908.

40 K.S. Malevich, *Essays on Art, 1915–1928*, translated by Xenia Glowacki-Prus and Arnold McMillin, edited by Troels Andersen, Borgen, Copenhagen, 1971, Vol. 1, p. 102.

41 ibid., p. 99.

42 Kazimir Malevich, *Ot kubizma i futurizma k suprematizmu. Novyy zhivopisnyy*

realizm (From Cubism and Futurism to Suprematism: The New Painterly Realism), Moscow, 1916. 'The Art of the Savage and its Principles', p. 120.

43 Malevich, *Essays on Art, 1915–1933*, translated from the Catalogue for the 'Tenth State Exhibition' by Xenia Glowacki-Prus and Arnold McMillin, Rapp & Whiting, London, 1969, p. 122.

44 Malevich, *Ot kubizma i futurizma k suprematizmu* ... Quoted in Bowlt, op. cit., p. 135.

45 ibid., p. 144.

46 Kahnweiler, *My Galleries and Painters*, p. 43.

47 Rozanova advocated the Intuitive Principle as a major factor in the evolution of a work of art. When this was combined with the Abstract Principle – Calculation – a picture was built. 'This establishes the following order of the process of creation: 1) Intuitive Principle. 2) Individual transformation of the visible. 3) Abstract creation.' She enlarged upon this theory in her article 'The Bases of the New Creation and the Reasons Why it is Misunderstood', which appeared in *Soyuz Molodyozhi (Union of Youth)*, St Petersburg, March 1913. The text is translated, edited and reproduced in Bowlt, op. cit., p. 103.

48 Alexandre Benois, *Poslednyaya futuristskaya vystavka (The Last Futurist Exhibition)*, lecture, Petrograd, January 9, 1916, p. 3.

49 Shcherbatov, op. cit., pp. 191–92.

50 In *Bouquet of Yellow Crocuses* (1907) the solid angular construction of the table is a new tactic for Larionov, an echo of Cézanne; *Still Life on a Small Scale* from the same year is evocative of an early Matisse in Shchukin's collection. The cup and saucer, thickly outlined in black, next to a splash of citron are balanced perilously on a blue-white table cloth; all these against a background of sharp blue-green.

51 Mikhail Larionov and Natalya Goncharova, 'Luchisty i budushchniki: Manifest' ('Rayonists and Futurists: A Manifesto'), Osliniy khvost i mishen (Donkey's Tail and Target), Moscow, July 1913. Quoted in Bowlt, op. cit., p. 90.

52 Benois, *Reminiscences ...*, p. 363.

53 Vladimir Markov, 'Printsipy novogo iskusstva' ('Principles of a New Art'), *Soyuz Molodyozhi (Union of Youth)*, St Petersburg, April and June 1912. Quoted in Bowlt, op. cit., p. 29.

54 Ivan Shchukin, personal interview.

55 David Burlyuk, *Colour and Rhyme*, op. cit., p. 31.

56 Igor Emmanuilovich Grabar, *Moya zhizn – Avtomonografiya (My Life – Autobiography)*, Iskusstvo, Moscow and Leningrad, 1937, p. 224.

57 Alexandre Benois, *The Russian School of Painting*, introduction by Christian Brinton, Alfred A. Knopf, New York, 1916, p. 144.

58 Letter quoted by courtesy of Pierre Matisse.

59 Shcherbatov, op. cit., p. 210.

60 Telegram quoted by courtesy of Dr Alfred Barr.

9 WAR AND POST-REVOLUTIONARY RUSSIA

1 Alexander Kerensky, 'Inside the Russian Revolution', *New York Times Magazine*, May 8, 1927.

2 R.H. Bruce Lockhart, *British Agent*, G.P. Putnam's Sons, New York, 1933, p. 110.

3 The former name of the capital was changed on August 3, 1914.

4 Inessa Armand, a beautiful young woman with thick golden braids and the round, guileless face of a Matryoshka doll, married a Moscow textile merchant, Aleksandr Armand, a member of the capitalist élite and a companion of the Morozovs and Ryabushinskys. In 1908 she had been exiled to northern Russia as a dangerous radical. Later she became a close friend and supporter of Lenin.

5 H. Taine, *Philosophie de l'art*, Vol. 1, 1909, p. 55. Quoted by Nikolay Bukharin, *Historical Materialism. A System of Sociology*, Russell & Russell, New York, 1965, p. 195.

6 K.A. Jelenski, 'Avant Garde and Revolution', *Arts Magazine*, New York, Vol. 35, No. 1, 1960, p. 36.

7 Alexandre Benois, *Poslednyaya futuristskaya vystavka* (*The Last Futurist Exhibition*), lecture, Petrograd, January 9, 1916, p. 3.

8 ibid., p. 3. Benois takes his quote from Malevich's essay *Ot kubizma i futurizma k suprematizmu. Novyy zhivopisnyy realizm* (*From Cubism and Futurism to Suprematism. The New Painterly Realism*), Moscow, 1915.

9 ibid., p. 3.

10 Kazimir Malevich, *O novykh sistemakh v iskusstve* (*On New Systems in Art*), Vitebsk, 1919. Quoted in K.S. Malevich, *Essays on Art, 1915–1928*, Vol. 1, translated by Xenia Glowacki-Prus and Arnold McMillin, edited by Troels Andersen, Borgen, Copenhagen, 1971, p. 94.

11 Benois, op. cit., p. 3.

12 Blaise Cendrars, *Poèmes élastiques*, October 1913. Quoted by Franz Meyer, *Chagall*, Harry N. Abrams, New York, p. 145.

13 From a table compiled in October 1917 by a joint committee from the Moscow Chamber of Commerce and the Moscow Section of the Ministry of Labour, *Novaya zhizn*, October 26, 1917. (*Novaya zhizn* was Gorky's newspaper.)

14 Vladimir Mayakovsky, *Poems*, translated by Dorian Rottenberg, Progress Publishers, Moscow, 1972: 'It', p. 76.

15 New calendar.

16 Fyodor Shalyapin (Chaliapin), *Man and Mask*, Alfred A. Knopf, New York, 1932, p. 273.

17 In the turbulent aftermath of the Revolution when Sergey Ivanovich no longer had the means to look after the two girls, they were parted and lost track of each other. The Shchukins heard nothing further until one evening in 1973 in Beirut. There was a knock on Ivan Shchukin's door, and an elderly lady standing outside introduced herself as Varya Mollman-Ibsen. She was living at that time in Denmark, and while on a trip abroad, she had tried to locate any members of the Shchukin family. They spent several hours together and Ivan learned that Anya (now Anya Smuslova) had

married and remained in the Soviet Union. It was the last time they would meet. Varya returned to Denmark and Ivan was killed a year later during the war in Lebanon.

18 Scattered around the painted interior are the works the collector knew so well: *Young Sailor II, Corsican Landscape*, the curving outlines of small bronze sculptures, *Jeannette IV, Decorative Figure*, a ceramic plate adorned with a reclining nude, and in the foreground, the familiar straight-backed chair.

19 Prince Kropotkin lived first in Petrograd, then in Moscow. Upon his return he was welcomed and consulted by Kerensky, but after the Bolshevik takeover he moved to Dmitrov, a small town outside Moscow. Seventy-five years old and frail, he remained inactive politically until his death in 1921 at the age of seventy-eight. His book *Ethics* on which he was working at that time was published posthumously.

20 Excerpt from the *Anarchist Manifesto*, Geneva, Switzerland, 1882.

21 *Kropotkin's Revolutionary Pamphlets. A Collection of Writings by Peter Kropotkin*, edited by Roger N. Baldwin, Benjamin Blom, New York and London, 1968, p. 243.

22 Shalyapin, op. cit., p. 280 (*The New York Times* on April 22, 1918, p. 6 carried an item: 'Soviet troops have effectively stamped out the anarchist organization in Moscow. Its members have departed and the city is now quiet.')

23 John Reed, *Ten Days that Shook the World*, Vintage Books, Random House, Knopf, New York, 1960, p. 326.

24 Michael Waldy (Mikhail Vladimirov), personal interview, New Jersey, 1978.

25 P.A. Buryshkin, *Moskva kupecheskaya (Merchants of Moscow)*, Izdatelstvo imeni Chekhova, New York, 1954, p. 141.

26 Ivan Shchukin and Count Rupert de Keller, personal interviews, Beirut and Paris.

27 Ilya Ehrenburg, *Men, Years, Life. First Years of Revolution, 1918–1921*, MacGibbon & Kee, London, 1962, Vol. 2, p. 55.

28 Yury Annenkov, *Dnevnik moikh vstrech – Tsikl tragedii (People and Portraits – A Tragic Cycle)*, Inter-Language Literary Associates, New York, 1966, Vol. 2, p. 242.

29 *Bolshaya sovetskaya entsiklopediya (Great Soviet Encyclopaedia)*, Moscow, 1933, pp. 819–22 (despite the numbering these are consecutive pages).

30 See Antonina Izerghina's introduction to *French Painting from the Hermitage Museum* published in Leningrad in 1975.

31 Ivan Shchukin, personal interview.

32 Ivan Shchukin, personal interview.

33 John Reed, op. cit., p. 342.

34 Ivan Shchukin, personal interview.

35 Harold Rosenberg, 'The Art World. Avant-Garde Masterpieces', *The New Yorker*, Vol. 49, November 12, 1973, p. 124.

36 Letter from Sergey Shchukin to Henri Matisse, March 31, 1909.

37 Mme Georges Duthuit (Marguerite Matisse), personal interview.

38 Pierre Matisse, personal interview.

39 Mme Georges Duthuit (Marguerite Matisse), personal interview.

40 Alexandre Benois, 'Sergey Ivanovich Shchukin', *Posledniye novosti*, Paris, January 12, 1936, p. 4.

10 THE LEGACY IN THE SOVIET ERA

1 Nikolay Bukharin, *Historical Materialism. A System of Sociology*, Russell & Russell, New York, 1965, p. 201.

2 Anatoly Lunacharsky, quoted in V.D. Barooshian, 'The Avant-Garde and the Russian Revolution', *Russian Literature Tri-Quarterly*, Fall 1972, no. 4, p. 348.

3 Lissitsky had been a disciple of Chagall's at one time. His illustrations for children's books had been among the most fanciful of the genre, and he had led a movement to restore Jewish art in St Petersburg. However, his architectural studies in Darmstadt took him into new experiments with form, and a close association with Malevich in Narkompros (People's Commissariat for Enlightenment) was instrumental in shaping his work further. His knowledge of architecture and admiration for Suprematist theories enabled him to transform abstract designs into three-dimensional constructions. Like Tatlin, he wished to inject art into every area of daily life, and his *Proun* series (*Proekty ustanovleniya novogo* – 'Projects for the establishment of the new') were, in effect, a bridge between Suprematism and Constructivism.

4 Kazimir Malevich, *Ot kubizma i futurizma k suprematizmu: Novyy zhivopisnyy realizm (From Cubism and Futurism to Suprematism: The New Painterly Realism)*, Moscow, 1915, translated by John E. Bowlt in *Russian Art of the Avant-Garde*, Viking, New York, 1976, p. 122.

5 Kazimir Malevich, *Essays on Art, 1915–1928*, translated by Xenia Glowacki-Prus and Arnold McMillin, edited by Troels Andersen, Borgen, Copenhagen, Vol. 1, 1968, pp. 126–27.

6 Kazimir Malevich, *Essays on Art, 1915–1933*, translated by Xenia Glowacki-Prus and Arnold McMillin, edited by Troels Andersen, Rapp & Whiting, London, 1969.

7 Kandinsky did not leave Russia until December 1921.

8 Malevich, Essays on Art, 1915–1933, p. 122.

9 Vladimir Tatlin, Catalogue for the Modern Museum Exhibition, Stockholm, 1968, p. 79.

10 Yury Annenkov, *Dnevnik moikh vstrech – Tsikl tragedii (People and Portraits – A Tragic Cycle)*, Inter-Language Literary Associates, New York, 1966, Vol. 2, pp. 301–02.

11 Irina Kuznetsova, Curator of European Painting, Pushkin Museum, Moscow, personal letter, January 15, 1973.

12 Boris Ternovets, *Musey novogo zapadnogo iskusstva (The Museum of Modern Western Art)*, Ogiz Izigiz, Moscow, 1933, p. 6.

13 Robert C. Williams, *Russian Art and American Money, 1900–1940*, Harvard University Press, Cambridge, Mass., 1980, p. 33.

14 ibid., p. 34.

15 P.A. Buryshkin, *Moskva kupecheskaya (Merchants of Moscow)*, Izdatelstvo imeni Chekhova, New York, 1954, p. 142.

16 Louis Fischer, *The Life of Lenin*, Harper & Row, New York, 1964, p. 496.

17 *French Painting from the Hermitage Museum*, compiled by Anna Barskaya, Aurora, Leningrad/Harry N. Abrams, New York, 1975, p. 12.

18 L'Amour de l'Art, *Paris, December 1925, No. 12, pp. 455–88.*

19 *Shchukin's copy of the publication is now in the possession of the writer, who received it from his daughter, Irina de Keller and her husband, Count Boris de Keller.*

20 *B.N. Ternovets*, Museum für Moderne Kunst des Westens *(Museum of Modern Western Art)*. Museen und Sammlungen in der Sowjetunion *(Museums and Collections of the Soviet Union), edited by S.A. Abramov, Ogiz-Izigiz, Moscow, 1934; Staatsverlag für Bildende Kunste (State Publishing House of Descriptive Arts), Kleine Kunstbibliothek des Isogis (Small Art Library of Izigiz), Vol. 1, p. 11. In this German edition the political line was much stronger, the words more uncompromising than in the Russian version.*

21 *ibid., p. 13.*

22 *ibid., p. 14.*

23 *ibid., p. 7.*

24 *ibid., pp. 11–14.*

25 *Ternovets, Muzey novogo zapadnogo iskusstva*, p. 11. The German edition of this work (see above, note 20) is dated 1934. The year 1933 for the Russian volume seems correct because the *Great Soviet Encyclopaedia* lists a book of that title by Ternovets for that year.

26 Ternovets, ibid., pp. 13–14.

27 *French Art from the Fifteenth to the Twentieth Century*, Pushkin Museum, Moscow, 1955. *French Art from the Twelfth to the Twentieth Century*, Hermitage, Leningrad, 1956.

28 Paris and Bordeaux received 'Chefs d'oeuvre de la peinture française dans les musées de Leningrad et de Moscou' in 1965. In the 1970s important exhibitions were held in Tokyo: 'Masterpieces of Modern Painting from the Soviet Union' (1971) and at Otterlo in the Netherlands 'From Van Gogh to Picasso' (1972). New York and Washington were scenes of two exhibitions: 'Impressionist and Post-Impressionist Paintings from the USSR' (1973) and 'Master Paintings from the Hermitage and the State Russian Museum' (1975–76). This last exhibition contained none of the works of the Russian avant-garde.

29 Kazimir Malevich, *The Non-Objective World*, Paul Theobald, Chicago, 1950. First German edition published by the Bauhaus in 1927.

30 Malevich, *Essays on Art, 1915–1928*, Vol. 1, p. 94.

31 ibid., p. 94.

32 ibid., p. 98.

33 ibid., p. 112.

34 ibid., p. 102.

35 Fyodor Shalyapin (Chaliapin), *Man and Mask*, Alfred A. Knopf, New York, 1932, pp. 340–41.

BIBLIOGRAPHY

Aksakov, I.S., *Sochineniya I.S. Aksakova: Slavyanofilstro i zapadnichestvo 1860–1886*; *Stati iz 'Dnya', 'Moskvy', 'Moskvicha', 'Rusi' (The works of I.S. Aksakov: Slavophilism and Westernism 1860–1886; articles from 'Den', 'Moskva', 'Moskvich', 'Rus')*, Vol. 2, Moscow, 1886

Aksyonov, I.A., *Pikasso i okrestnosti (Picasso and Environs)*, Tsentrifuga, Moscow, 1917 (cover by A.A. Ekster)

Anderson, Troels, *Moderne russisk kunst 1910–1930*, Borgen, Copenhagen, 1967

Annenkov, Yury, *Dnevnik moikh vstrech – Tsikl tragedii (People and Portraits – A Tragic Cycle)*, Inter-Language Literary Associates, New York, 1966

Bakst, Lev, 'Puti klassitsizma v iskusstve' ('Paths of classicism in art'), Part I, *Apollon*, Vol. 2, 1909, pp. 63–78

Belinsky, V.G., *Estetika i literaturnaya kritika (Aesthetics and Literary Criticism)*, 2 vols, Gosudarstvennoye izdatelstvo khudozhestvennoy literatury, Moscow, 1959

Benois, Alexandre, 'Besedy khudozhnika – Ob impressionizme' ('Discussions of an artist – on impressionism'), *Mir iskusstva*, Vol. 6, 1899, pp. 48–52

'Vystavka Vereshchagina' ('Vereshchagin's exhibition'), *Mir iskusstva*, Vol. 3, 1900, p. 67 ff.

'Dnevnik khudozhnika' ('An artist's diary'), *Rech*, St Petersburg, October 21, 1913

Memoirs, translated from the Russian by Moura Budberg, Chatto & Windus, London, 1960

Berdyayev, Nikolay, *Krizis iskusstva (The Crisis of Art)*, Moscow, 1918

Billington, James H., *The Icon and the Axe: An Interpretive History of Russian Culture*, Weidenfeld & Nicolson, London; Knopf, New York, 1966

Botkina, A.P., *Pavel Mikhailovich Tretyakov v zhizni i iskusstve (Pavel Mikhailovich Tretyakov in Life and Art)*, 2nd edition, Iskusstvo, Moscow, 1960

Burlyuk, David (ed.), *Color and Rhyme*, Hampton Bays, New York, c.1964

Chamot, Mary, *Russian Painting and Sculpture*, Pergamon, London, 1969

Chernyshevsky, N.G., *Estetika i poeziya (Aesthetics and Poetry)*, M.N. Chernyshevsky, St Petersburg, 1893

Esteticheskiye otnosheniya iskusstva k deystvitelnosti (The Aesthetic Relation-ship of Art to Reality), Gosudarstvennoye izdatelstvo khudozhestvennoy literatury, Moscow, 1955

Custine, Astolphe Louis Léonard, Marquis de, *La Russie en 1839*, Brussels Société Typographique, 1843

Denis, Maurice, *Théories 1890–1910 du symbolisme et du Gauguin vers un nouvel ordre classique*, L. Rouart and J. Watelin, Paris, 1920

Dorival, Bernard, *Les étapes de la peinture française contemporaine*, Gallimard, Paris, 1944

Elgar, Frank, 'D'une esthétique de la couleur' ('On the aesthetics of colour'), *Art Présent*, No. 2, 1947, pp. 25–28

Fullop-Muller, René, *The Mind and Face of Bolshevism: An Examination of Cultural Life in Soviet Russia*, Putnam, New York, 1928

Gide, André, 'Promenade au Salon d'Automne', *Gazette des Beaux-Arts*, December 1905, pp. 475–85

Golovin, A., *Vstrechi i vpechatleniya – Pisma – Vospominaniya o Golovine (Meetings and Impressions – Letters – Recollections of Golovin)*, ed. A. Movshenson, Moscow/Leningrad, 1960

Gorky, Maksim, *Zhizn Klima Samgina, 1925–1936 (The Life of Klim Samgin, 1925–1936)*, in *Polnoye sobraniye sochineniy (Complete Works)*, Navka, Moscow, 1974

Grabar, Igor (ed.), *Geschichte der russischen Kunst*, translated from the Russian by Kurt Küppers, VEB Verlag der Kunst, Dresden

Imgardt, D., 'Zhivopis i revolyutsiya' ('Painting and revolution'), *Zolotoye runo (The Golden Fleece)*, Vol. 5, pp. 56–59, Moscow, 1906

Jelenskii, K.A., 'Avant-Garde and Revolution', *Arts Magazine*, Vol. 35, No. 1, October 1960, pp. 36–41

Kandinsky, Vasily, *Über das Geistige in der Kunst*, Piper, Munich, 1912

Khomyakov, Aleksey Stepanovich, *Polnoye sobraniye sochineniy (Complete Works)*, Universitetskaya tipografiya, Moscow, 1900

Kovalenskaya, T., *Iskusstvo vtoroy poloviny XIX-nachala XX veka (Art at the Turn of the 20th Century)*, Moscow, 1970

Kulbin, N., 'Kubizm' ('Cubism'), *Strelets*, Vol. 1, pp. 197–216, Petrograd, 1915

Lapshin, V.P., *Soyuz russkikh khudozhnikov (The Union of Russian Artists)*, Khudozhnik RSFSR, Leningrad, 1974

Lifar, Serge, *Serge Diaghilev: His Life, His Work, His Legend*, G.P. Putnam's Sons, New York, 1940

Livshits, B., *Polutoraglazyy strelets (The One-and-a-half-eyed Archer)*, Leningrad, 1933

Lockhart, R.H. Bruce, *British Agent*, G.P. Putnam's Sons, New York, 1933

Malinsky, D.L. (ed.), *Muzei i vystavki Moskvy (Moscow's Museums and Exhibitions)*, Rabochiy, Moscow, 1947

'Matisse Speaks', *Art News Journal*, Vol. XXXI, No. 36, June 3, 1933, p. 8

Melgunov, S.P., *Religiozno-obshchestvennyye dvizheniya XVII–XVIII vv. v Rossii (Russian Religions and Social Movements in the 17th–18th Centuries)*, Zadruga, Moscow, 1922

Milyukov, Pavel Nikolayevich, *Ocherki po istorii russkoy kultury (Works on the History of Russian Culture)*, Paris, 1931
Outlines of Russian Culture, Vol. 3, ed. Michael Karpovich, translated from the Russian by Valentine Ughet and Eleanor Davis, University of Pennsylvania, Philadelphia, 1942

Mussorgsky, M.P., *Pisma i dokumenty (Letters and Documents)*, ed. A.N. Rimsky-Korsakov, Gosudarstvennoye Muzykalnoye Izdatelstvo, Moscow, 1932

Olivier, Fernande, *Picasso et ses amis*, Librairie Stock, Paris, 1933

Pozharskaya, M., *Russkoye teatralno-dekoratsionnoye iskusstvo kontsa XIX–nachala XX veka (Russian Theatrical and Stage Design at the Turn of the 20th Century)*, Moscow, 1970

Réau, Louis, *L'Art Russe des Origines à Pierre le Grand*, Laurens, Paris, 1921
Catalogue de L'Art Français dans les Musées Russes, Librairie Armand Colin, Paris, 1929

Repin, I.E., *Pisma k khudozhnikam i khudozhestvennym deyatelyam (Letters to Artists and Art Colleagues)*, Iskusstvo, Moscow

Ripellino, Angelo, *Maïakovsky et la théâtre russe d'avant-garde*, L'Arche, Paris, 1965

Salmon, André, *L'Art russe moderne*, Laville, Paris, 1928

Saltykov-Shchedrin, M.E., *O Literature i iskusstve (On Literature and Art)*, Iskusstvo, Moscow, 1953

Sidorov, A., *Russkaya grafika nachala XX veka (Russian Graphic Art at the Beginning of the 20th Century)*, Moscow, 1970

Stein, Leo, *Appreciation: Painting, Poetry and Prose*, Crown, New York, 1947

Stepanov, I., *Za 30 let, 1896–1926 (For 30 Years, 1896–1926)*, Leningrad, 1928

Stepun, G., *Khudozhestvennaya zhizn Rossii na rubezhe XIX–XX vekov (Russian Artistic Life at the Turn of the 20th Century)*, Moscow, 1970

Trifonov, N.A., *Russkaya literatura XX veka – Dooktyabrskiy period (20th Century Russian Literature – the Pre-October Period)*, 3rd edition, Prosveshcheniye, Moscow, 1971

Volykin, N. (ed.), *Ocherki istorii russkoy kultury vtoroy poloviny XIX veka (Works on the History of Russian Culture during the 2nd Half of the 19th Century)*, Moscow, 1976

Williams, Robert, *Russian Art and American Money, 1900–1940*, Harvard University Press, Cambridge, Mass., 1980

Woinow, Igor, *Meister der Russischen Malerei*, Diakow, Berlin, 1924

Index